LATER...
with Jools Holland

LATER...
with Jools Holland

30 Years of Music, Magic and Mayhem

Mark Cooper

With photography by Andre Csillag

WILLIAM COLLINS

William Collins
An imprint of HarperCollins*Publishers*
1 London Bridge Street
London SE1 9GF

WilliamCollinsBooks.com

HarperCollins*Publishers*
1st Floor, Watermarque Building, Ringsend Road
Dublin 4, Ireland

First published in Great Britain by William Collins in 2022

2023 2025 2024 2022
2 4 6 8 10 9 7 5 3 1

A catalogue record for this book is available from the British Library

ISBN 978-0-00-842437-4 (hardback)
ISBN 978-0-00-857993-7 (trade paperback)

Typeset in Minion Pro by Palimpsest Book Production Ltd, Falkirk, Stirlingshire
Printed and Bound in the UK using
100% Renewable Electricity at CPI Group (UK) Ltd

This book is produced from independently certified FSC™ paper
to ensure responsible forest management.

For more information visit: www.harpercollins.co.uk/green

For Siân who has been with me every step of the way

Contents

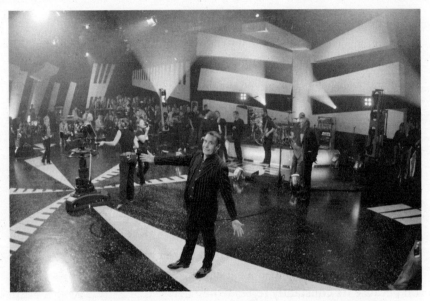

'Welcome to my world!', TVC, series 28, episode 1, November 2006.

Foreword by Jools Holland

In the dead of night some years ago, I was visiting the 1930s BBC boardroom in Old Broadcasting House. I had crept in to borrow a cup of sugar. While rummaging through the Director-General's desk, my torch flashed across the inscriptions painted around the top of the room: 'Educate, Inform and Entertain' and 'Nation shall speak peace unto Nation'. On reflection it has struck me that this early BBC mission statement may have been made for us.

I certainly never imagined back then that I would be writing the foreword to a book celebrating thirty years of *Later... with Jools Holland* and *Jools' Annual Hootenanny*. People sometimes ask me how I've kept *Later...* on for so long. The simple answer is: I haven't. The show stays on because it's constantly refreshed by new music, which is what keeps it alive. Since it began, the vision of myself, Mark Cooper, Janet Fraser Crook and Alison Howe has evolved into the wonderful show that we have today.

I make the boastful claim that I have probably worked on more music television programmes than any other living mortal, but none of those other shows had quite the same goal as this one. Our object has been to feature legends alongside newbies and importantly, to be a home for music that doesn't have a home elsewhere on television, like folk music, world music, jazz music, European music – the list is endless. The show is sold and broadcast around the world and many more people see it internationally than they do here in Britain. International guests often tell me they wished they had a programme like this in their own country. It's a unique British export of which we should all be proud.

We have witnessed the birth of new talent before they have become

global stars and captured some of the giants before they have passed away. I hope that perhaps we have also opened people's minds to enjoying styles of music they haven't listened to before. All of us working on the show try to be the servant of the songs and the music. Surprisingly this isn't the case with all music on television, which is often thought by programmers not to be interesting enough in its own right, and therefore has to be enlivened by novelty dances with wet kippers or people bursting into tears.

When the show started, the only platforms we knew of were ones you caught trains from. We could never have foreseen the explosion of the different music platforms that exist today. The shows in our first series would maybe get less than a million viewers; now some performances from the shows will have had up to 20 million hits on YouTube.

It's wonderful that Mark Cooper has taken the time to put his memories of the show into this book. I'm afraid I cannot verify if any of it is true or not, as I was so busy being lost in all the incredible music. But if even half of what you read here is true, it would be amazing.

Despite the changes in technology and society, the timeless ethos of the artists and all the people that work on the show remains the same. These, along with the people that have watched the show over the years, are the people I most want to thank.

I look forward to our one hundredth birthday in 2092. Save the date.

Jools Holland, 2022

'You can't park here, sir, it's a restricted area…',
opening titles, 1992. (BBC film still)

1

Tell It Like It Is

In the Beginning

It is an early October afternoon in 1992 and I am heading down the gantry ladder to the studio floor of TC7, one of the smaller studios at Television Centre and the home of BBC2's arts and media late-night magazine, *The Late Show*. New Orleans' Neville Brothers have just given their all in a second rehearsal of their cover of Steve Miller's 'Fly Like an Eagle' from their sixth studio album, *Family Groove*, and they are now circling the floor impatiently like factory workers approaching the end of their shift. I go up to Aaron, who has massive forearms, a cross tattooed on his cheek, a prominent mole above his right eye and a permanently wary look on his face. No matter that I interviewed him for the *Guardian* while he hefted weights in his garage in east New Orleans when the Daniel Lanois-produced 1989 *Yellow Moon* album finally made the brothers a commercial proposition just three years ago, that I have enjoyed them in full flight on their home turf at Tipitina's and at Jazz Fest, and am a massive fan, right now I am an apologist for the BBC, which is delaying their early evening escape for a flight to Germany where they are about to launch a tour. The floor manager has done his best to explain why we need another rehearsal, but the Nevilles are already tired, while up in the gallery the director Janet Fraser Crook is chafing at the bit. I mutter apologies to Aaron and plead for just one more take.

We are recording for the first *Later…* and Janet is working with a recalcitrant camera crew who aren't quite on her side as she scrabbles to adapt her shooting script to capture the complex blood harmonies of the Nevilles in full flight. Aaron looks through me with the kind of infinite weariness that comes with scoring your first and only major solo hit way back in 1967 when only the Monkees' 'I'm a Believer' kept his 'Tell It Like It Is' on the tiny local label Par-Lo from topping the Billboard

Top 100. Aaron was in his mid-20s then and had been trying to live off his tremulous falsetto since he first fell in love with the plaintive sweetness of doo-wop as a teenager in the 1950s. Even when he finally scored that hit, Aaron had explained to me, he'd had to take blue-collar jobs to support his family. 'I was a longshoreman, housepainter, ditch digger, truck driver you name it. The people on the job would say, "Man, you got no business in this shithole, you should be out there singing."' He and his three brothers are now musical royalty back in the Big Easy. They released their debut album back in 1978 and until recently have struggled to catch fire, remaining big fish in the small pond of New Orleans. Things have looked up since Bill Graham started managing them and *Yellow Moon* took off, but none of that is speeding along this taping. We haven't even got to the plaintive 'Tell It Like It Is' just yet. Aaron turns to his brothers – Charles, Art and Cyril – 'The bitch screwed it up', he shrugs wearily and they get ready to go again.

This very first *Later... with Jools Holland* aired at around 23.59 on Thursday, 8 October 1992, right off the back of *The Late Show* with presenter Tracey MacLeod handing over the studio to Jools, his piano and a soul-themed bill featuring Brits the Christians, D'Influence and

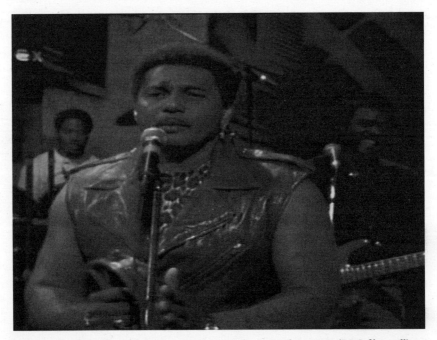

Aaron Neville tells it like it is, series 1, episode 1, October 1992. (BBC film still)

Nu Colours alongside the Nevilles. Midnight wasn't exactly primetime – but any slot was precious, while the lateness of the hour, the day of the week and a run of ten shows arguably gave us time and space to either find our feet or fail quietly.

First came the original titles – Jools stumbling out of a Jaguar XJ12 towards a dark and semi-deserted Television Centre. Veteran actor Lloyd Lamble's old-school security guard explains, 'I am sorry, sir, you can't park here, it's a restricted area,' while Jools simply gestures at his watch. Before you know it, he's hurrying through the stage door, explaining to the receptionist that he doesn't have time to take a call – 'I'll take it later!' after waving at yours truly. I am feigning sleep in a leather jacket on one of the sofas where visitors waited to be escorted into the building and production team would loiter waiting for taxis home if they'd worked late enough to be allowed to order one. On Jools sweeps, down empty corridors and past a grumbling and unimpressed cleaner in a pink polyester housecoat to TC7. Tracey greets him in the doorway like a game but wary gatekeeper as she exits *The Late Show*. It's a takeover and she asks him to clean up what Jools himself has called 'the mess' when he's finished.

Jools has stormed a half-asleep BBC but with the gentlest and, well, most old-fashioned of manners. There's a cast of character actors, big band boogie-woogie as the theme tune, a fob watch, and a Bentley – hardly the stuff of cutting-edge rock 'n' roll. Shot in a day on a Steadicam in the rush to launch this first series, the titles were a collaboration between Jools and director Janet, with Jools championing the casting of Ealing Studios' veterans in the cameo roles. 'Bird Cage Walk (doing the)', the excitable and now long-serving title music, was co-written with Jools' faithful drummer Gilson Lavis and features bassist extraordinaire Pino Palladino and what was then called the Jools Holland Big Band flexing some early muscle.

Moments later, Jools is at the piano and the Nevilles and the rest of the cast are vamping contentedly away on a simple groove that is in no rush to end. D'Influence are opposite the Nevilles, vocal group Nu Colours are gathered around the piano and the Christians are at the far end of the studio. Although the bands are all in the same room at the same time, they might as well be socially distanced. There's not much sense of togetherness, few shots that show the geography of the whole, and Jools doesn't get around the room, spending most of the show sitting at the piano. The bare studio walls are broken up with

banners of iconic pop music imagery and Jools claps each performance enthusiastically with a little support from the twenty or thirty guests standing behind the banners. His every piece to camera addressing the viewer is laced with the knowingly ingratiating sobriquet, 'Ladies and gentlemen…' and, early doors, there's something of a mission statement. 'So what – you are asking yourselves – are the elements of this show? Well, there's me and there is the piano, ladies and gentlemen, there's a studio, hopefully we'll be having some cameras and some lights and, more importantly, we'll be having some very carefully chosen performers and artists from every musical sphere.'

How did we get this far? The BBC hadn't launched a new live music performance show since Janet Street-Porter, the new head of Youth and Entertainment, called time on the already abbreviated *Old Grey Whistle Test* in 1987 and conceived the early-evening *Def II* strand with inter-view-based music magazines like Antoine de Caunes' *Rapido*, indie-centric *Snub TV* and *Dance Energy*, a day-glo *Ready Steady Go!* for the clubbing generation. *Top of the Pops* lumbered along, passing its quarter-century in 1989 but with the show's entertainment values and squeaky-clean presenters increasingly at variance with the fragmenting charts and emer-gent genres like dance and hip-hop. Meanwhile Channel 4 had been casting around trying to find a show that could match the success of its irreverent music flagship *The Tube*, which had run out of steam in spring 1987 just as the *Whistle Test* ended. Music television had lost its way.

I'd been a pop writer since reviewing the Sex Pistols' last gig in San Francisco in 1978, but my first job in television was working as a researcher on 1988's *Wired*, which was led by Malcolm Gerrie who had originated *The Tube* and featured many of the production team who'd worked on its last few series. As a child of the 1960s I'd grown up watching music television, from *Top of the Pops* to *Ready Steady Go!*, but I knew little about it. I had been pinned back in my armchair by Talking Heads on *The Old Grey Whistle Test* and Fine Young Cannibals on *The Tube*, but I didn't know how or why. *Wired* was short-lived and, if it is remem-bered at all, it's either for its striking and expensive title sequence and/ or for a bare-chested, forty-one-year-old Iggy Pop jumping on the tech-no-crane at Pinewood while performing 'I Wanna Be Your Dog'. There was a sense that pop music was growing up and so was its audience and that the time was ripe for some thoughtful journalism. But what I

observed most at *Wired* was the relentless pressure on the live producers to deliver big names to promote international distribution. The show's bookers seemed obliged to chase after what was big rather than champion what was good.

Wired only lasted a series, I returned to freelance writing about music and film for the *Guardian* and those recent monthly magazines for grown-up fans, *Q* and *Empire*. Channel 4 tried other music shows like *Big World Café* and *Rock Steady* but nothing stuck. While working on *Wired* I'd interviewed for the job of music researcher on BBC2's new media magazine show, *The Late Show*, which launched in January 1989, but Graham Smith, another former *Record Mirror* writer, got the job. Graham set the template for *The Late Show*'s music coverage but now he was moving on, and I walked into Lime Grove to take his place on 3 January 1990. A new decade was beginning.

The Late Show was based in Lime Grove Studios in Shepherd's Bush about half a mile from Television Centre. Gaumont Film Company had opened Lime Grove in 1915 and the BBC took it over in 1949. *Steptoe and Son*, *Doctor Who* and *Top of the Pops* had all once come from there but by 1990 it felt like the land that time forgot. There was black-cladded piping snaking industrially from corridor to corridor and only the odd fire escape countered the subterranean aura of the place with its nest of studios that were shortly destined to become a block of flats. Michael Jackson, editor of *The Late Show*, was in his early thirties but had a forensic sense of the media landscape, television history and the value and richness of the BBC archives. *The Late Show* harked back to the 1960s and *Late Night Line-Up*, the television discussion and review show that helped launch BBC2 and spun off the short-lived music show *Colour Me Pop* when the channel went colour in 1968. Jackson's *Late Show* empowered a new generation of music and arts producers broadcasting live four nights a week with a magazine blend of short films, interviews, discussions and performances. The show was still reeling from the infamous visit of the Stone Roses in November 1989 in which the band had their power cut less than a minute into their performance of 'Made of Stone' after turning up the volume at the last minute. Tracey MacLeod had been obliged to jump in front of a sniggering band and introduce a VT on documentary photographer Martin Parr while lead singer Ian Brown paced the floor behind her before yelling out the wounding jibe, 'Amateurs!'

One of the first members of *The Late Show* team I met that first day was the striking and glamour-power clad Janet Fraser Crook, one of the show's two studio directors, who leaned across my empty desk and imperiously demanded that I book her lots of bands to shoot. The template for what was to be a wonderfully fruitful and sparky relationship had immediately been struck. Janet had started out in news in the south-west and now at Lime Grove she was desperate to enrich her directorial skills but felt like a fish out of water in the competitive but scruffy college common room ambience of the production office. Our best meetings were always in the canteen, which remained unchanged since the era of Ealing comedies, and the best times were in the studio where we were free to experiment, restricted only by the sense that the place truly belonged to the lighting directors, sparks, scenic artists, sound supervisors and camera crews who ruled the roost and liked to boss us televisual naïfs about.

The Stone Roses' debacle I so narrowly missed had been occasioned by the band tripping the Ames minimum decibel limit, designed to protect the hearing of the camera crew and studio technicians, and represented by a traffic light in the corner of the studio but in the band's line of sight. When the amps went above 80 decibels the green light went amber and then red a few seconds later, at which point the

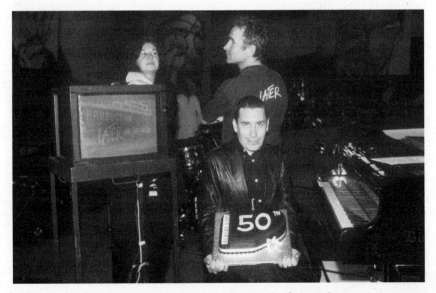

Janet, the author and Jools celebrating the first 50 shows,
series 8 episode 1, November 1996.

band's power source was automatically cut. The trouble was the cut-off point was ludicrously low in volume and constricted bands who needed a level of volume to get their juices stirring. Even in 1992 when PJ Harvey and then Suede debuted on *The Late Show*, now based in Television Centre, each band struggled to get going at such restricted volume and resented their first experience of a television studio. Bernard Butler turned up his amp just before the band launched into 'The Drowners', but although the Ames minimum traffic light no longer presided over the studio, the ensuing live mix was a cavernous mess as the BBC sound supervisor struggled to adjust his balance against the sudden surge of noise coming from Bernard's guitar.

The Late Show was the school that brought Janet and I together and eventually resulted in *Later...* First I had to find my feet – with Janet, fellow director Rena Butterwick, Tracey MacLeod (who knows and loves her music) and the rest of the team – while campaigning to get more artists into the studio and get more slots on the shows. Tracey and I both loved country music and the British record industry was determinedly trying to launch the burgeoning New Country genre in the UK while tacitly trying to lose the old 'Country and Western' audience of shuffling middle-aged couples in Western gear. Somehow this involved a double-decker bus driving around London with various million-selling, Stetson-sporting singers on board, stadium superstar Garth Brooks squeezing onto the tiny stage of the Cambridge Theatre and even smaller shows from the likes of Clint Black and Alan Jackson. Tracey and I produced a six-part series, *New West*, at Lime Grove in 1990, filming Clint, Rosanne Cash, George Strait et al. in the afternoon and early evening when that evening's edition of *The Late Show* placed few demands on the studio.

I also compiled *Late Rap*, a compilation of hip-hop performances from the likes of Ice-T, Queen Latifah, KRS-One, Public Enemy and Jungle Brothers. *The Late Show* had a generous budget at this point and each rapper had their own set. Ice-T, his hype man and his DJ had a low-lit, empty but graffitied studio in which to spar with a Steadicam that seemed to want to hunt them down. Public Enemy were surrounded by barbed wire through which director Sheree Folkson framed the twitching cheekbones of the S1W security guards who flanked Chuck D and Flavor Flav. But there were also sessions with Richard Thompson, Ahmad Jamal, R.E.M., Cowboy Junkies and so many more. I was learning

about lighting, staging, camera angles and the vagaries of the artistic temperament in the pressure cooker of the studio. Michael Jackson remarked in passing that a producer was ultimately responsible for everything on-screen – the whole picture – and I took him seriously.

The live-to-air performances were the best: the adrenalin and excitement of rehearsing in the early evening, the band huddling together on the floor and then the tension and reward of band and cameras in splendid sync as we broadcast 'to the nation' just before midnight. I'd book the artists, secure their stage plans and the appropriate monitor system then write the introductory link in consultation with that particular show's producer and presenter. Actress turned chanteuse Julee Cruise's live performance of 'Rockin' Back Inside My Heart' was directorial magic and a real breakthrough, Janet's cameras waltzing in tandem with the finger-popping band, the backing singers in vintage wedding dresses, the demure Julee in eye-fluttering close-up. The band were spread out across the studio floor, emerging from darkness in James Campbell's haunting tableau lighting while Julee glowed in close-up as she whispered Angelo Badalamenti and David Lynch's mysterious tale of longing and picnics. *Twin Peaks* didn't air in the UK until that October so here was an early preview of its beguiling and spooked atmospherics. I was watching Janet grow as a director in front of my eyes.

In Lime Grove some of the tools of the trade belonged to a different era. Janet only had a small camera crew with which to conduct and capture every nuance of Julee's performance and leading it was a giant horse-like iron contraption called the Heron. The driver sat low down at the back with a steering wheel while the camera supervisor sat mounted high astride the great beast, operating his mounted camera and grandly urging his driver on as the Heron glided across the studio floor to peer down into Julee's endless false eyelashes. Every shot counted and built towards the total picture while the pace of the cuts and mixes between cameras built the mood. Shooting a performance in a studio is a dance in space and time; when it's done well the rhythm of the pictures match the heart and drive of the music and make it sing.

In the autumn Janet and I flew to New York to film an early version of what became the *Songwriters' Circle* show with country-folk singers Mary Chapin Carpenter, Rosanne Cash and Nanci Griffith at the Bottom Line. I was already drawn to circular shows in which artists shared a

stage and collaborated. I convened a Battle of the Bands with Stan Tracey and John Harle's large jazz bands facing each other across the studio for a Duke Ellington tribute and invited veteran double bassist Danny Thompson to collaborate in three small band line-ups – folk, jazz and world – dotted round the studio and threaded through an evening's running order – inching towards a *Later...* setup. Sheree Folkson directed an extended self-portrait of Vivian Stanshall, combining Viv's autobiographical reflections on his troubled relationship with his father with some wonderfully staged and inventively shot band performances that used the whole of the studio, uniting music and drama. *Spreading His Light* starred Viv in Jesus mode, walking on the water, and featured two of *The Late Show*'s young coordinators in lobster outfits moving cardboard waves from side to side in true panto tradition. Viv was insecure but excited to be working, back on television and confronting his demons. I'd go over to his flat in Crouch End to discuss the writing and staging of the piece as he smoked in the bedroom in which he'd fall asleep and burn himself to death a few years later. We called the fifteen-minute piece 'Crank', and shot it in a couple of afternoons and early evenings before handing back to the studio for that night's *Late Show* links.

I was learning about wrangling artists in the hothouse of the television studio but I was still more student than producer. I'd loved Van Morrison's music since coming across *Astral Weeks* at college and playing it every day for a year. I'd seen his triumphant show with the Caledonian Soul Orchestra at the Rainbow in 1973 when he stormed the stage, joyously returning to the UK after his years in the States and reclaiming and reinventing his legacy with the resulting live album... *It's Too Late to Stop Now*. Van had just released *Enlightenment*, the latest in a long run of spiritually centred albums searching for peace, and his new label Polydor had persuaded him to grant us his first studio performance at the BBC since the *Whistle Test* back in 1984.

Van arrived unannounced at Lime Grove an hour before his call time in the middle of the afternoon while the band were still setting up on the studio floor. I took him into the Green Room on the ground floor near the building's entrance. He marched twice around the long oval table in the room's centre and straight back out of Lime Grove while I was still explaining that we weren't quite ready to rehearse. This was long before mobile phones were in common usage and Polydor's Glaswegian plugger Jimmy Devlin had no way of contacting Van. We

both feared he'd gone for good, but bandleader Georgie Fame dryly reassured us he'd be back 'sometime soon'. Van had a house in nearby Holland Park at the time and must have slipped home. When he came back an hour or so later, he was steaming.

He stormed into the studio and soon had Devlin backed up into the camera bay where the equipment was caged overnight. Raised voices could be heard with Van raging at Devlin that he was personally ruining his life, forcing him to do promotion and destroying his privacy. Van hadn't yet taken to wearing the low-brimmed hats and dark glasses that would become part of his post-millennium persona. Devlin had worked in management with Simple Minds at home in Scotland and was built like a burly Glasgow docker. He towered over his charge, but Van soon had him backed against the wall, jabbing his finger up at Jimmy's chest while swearing at him in his broad Belfast accent. Out came some choice words, Jimmy turned white but soaked it up. After five minutes of mounting and noisy recrimination, Van finally stormed out of the camera bay, picked up his guitar and clicked his fingers at the band who launched straight into the soothing 'Enlightenment'. Moments before he'd been screaming but now Van was sailing into the mystic. It was as if he'd needed to vent at Devlin long enough to calm his nerves so he could become the sage in the studio. Live that night Van was majestic, whispering wonderingly, shushing the band and the world as the cameras closed in, 'So Quiet in Here'. After the show Van quickly disappeared into the West London night, the band looked relieved while Jimmy Devlin kept asking himself and us why he hadn't decked him in the camera bay.

I loved the studio and working first-hand with musicians to give them a platform where they could do their best work, but it was Janet who kept insisting we get real and do a proper music show while I kept fobbing her off. I'd seen so many music shows come and go on Channel 4 and all I could see were the pitfalls. I loved the wide variety of music and artists we featured but *The Late Show* was a Music and Arts show which needed to be both discerning and reputational but had no real obligation to be popular. But a standalone music show would be a different kettle of fish altogether. We'd been learning about collaborative shows, about staging and lighting, and if we could showcase every kind of music on *The Late Show* why couldn't we showcase all those artists in the same studio at the same time? I kept shrugging and Janet kept pushing. *The*

k.d. lang coming into her own, series 1,
episode 2, October 1992. (BBC film still)

Late Show had a small family of presenters but the house style was stiff-backed and determined to impress, more telling than showing, and while the likes of Matt Collings and Sarah Dunant liked their music well enough, their style was too intellectual and too formal for a music show. *Late Show* presenters didn't need to move or engage too much with their guests, they just needed to seem smarter than you. I talked it over with Michael Jackson who simply suggested I go and meet Jools Holland…

I'd first seen Jools on his debut tour of the US with the band that was initially obliged to be renamed UK Squeeze in North America because of a largely unknown but litigious rival outfit. Squeeze crowded on to the stage of the Old Waldorf nightclub in San Francisco's Financial District in July 1978 to play songs from their eponymous debut album, for the most part produced by John Cale. The shocking pink cover featured the torso of a Mr Universe type muscleman and Cale had reputedly pushed the band towards a heavier, 'less weedy' style and seedier subject matter. As Jools later recalled, Cale was in his drinking and drugging phase and on one occasion fell asleep in the studio. Jools

seized the moment by writing the 'C' word on Cale's forehead in felt tip, sniggering with his bandmates when the great man woke up and led them all out to the pub without so much as glancing in a mirror. Miles Copeland, the band's brash manager, and brother of the Police drummer Stewart Copeland, was out on the road with UK Squeeze, which perhaps explains why three-quarters of the way through their set an actual muscleman strutted out in speedos and proceeded to flex his consider-able muscles up and down stage. Jools MC'd the show from behind a wobbling keyboard in a bow tie while puffing away on a cigar and had a solo spot attacking Ray Charles' '(Do The) Mess Around'. The whole gig was jolly and juvenile and only hinted at the band Squeeze would rapidly become. After the show I went backstage to chat to the band as a fellow Englishman and South Londoner abroad. They had already been in the US playing virtually every night for two months and still had a couple of weeks to go. Exhaustion and sweat filled the dressing room but Jools was the life and soul of the party as he had been onstage. New Wave bands were stuffed with larger-than-life eccentrics but Jools already seemed a little large for Squeeze even though he'd formed the band with Chris Difford and Glenn Tilbrook in Blackheath back in 1974.

I am quite sure that Jools had no memory of this brief encounter when I bowled up at his studio near Blackheath midway through 1992. Helicon Mountain was then both a building site and a dream in progress. The chap that greeted me that day was Jools at his scruffiest: loose jeans and beaten-up old biker jacket. I would quickly learn that Jools likes to oscillate between looking like a mechanic or a besuited spiv. A ramshackle collection of outbuildings and garages perched above Westcombe Park station and looking down on the River Thames, Helicon was hidden behind ramshackle gates that gave little hint of the work-in-progress blossoming within. Jools was already transforming Helicon into a magic kingdom of its own with a gypsy caravan parked out front and the studio building decked out like one of those obscure railway stations that Richard Beeching had somehow missed in his Sixties' closures. Imagine an ever-proliferating folly with fantastical Italianate features in the style of Portmeirion, the model village near Porthmadog in North Wales, that I soon learned had provided the location for Jools' favourite television series – Patrick McGoohan's *The Prisoner*. Squeeze through the front door, past the studio that was then but empty space and plaster, and up the narrow stairs to the office that Jools shared with Vic Reeves and Bob

Mortimer and was run by his Aunt Val. There were books and records everywhere and photos of Jools with some of his greatest heroes, notably Dr. John and your man both dressed up in coat and tails and top hats for a piano duet. The back room was cosy enough for a chat and there was always Jools' favourite café, Frank's, just down the hill…

Jools was already a music television veteran when we met, although he'd barely been on British terrestrial television since he'd told viewers to 'be there or be ungroovy fuckers' in a live trail for *The Tube* early in 1987. Jools' five years on *The Tube* had made him something of an icon with his distinctive blend of enthusiasm and nonchalance, his 'TV marriage' with Paula Yates and his camaraderie with musicians, particularly the older ones. Jools seemed to get on with Miles Davis and French and Saunders equally well and he clearly had a profound love of the roots of American music, which shone through in his own piano playing and in the occasional Channel 4 travelogue like 1985's *Walking to New Orleans*. Even back at the Old Waldorf Jools had already seemed like his own creation, a man out of time building his own droll persona from a love of Ealing comedies and Ray Charles. Fourteen years later he was now busily fashioning a world consisting entirely of things he loved, whether that be boogie-woogie, vintage vehicles or Italianate follies.

After *The Tube* Jools had spent eighteen months flying back and forth to New York to co-host *Sunday Night* with saxophonist David Sanborn. *Sunday Night* featured sessions with jazz and soul legends, world music stars, avant-garde minimalists and roots artists, many backed by Marcus Miller's crack house band which often included Jools on piano. Quite how NBC had been persuaded to fund the first series or how Michelob were convinced to sponsor the second syndicated outing remains a mystery, but Jools added his wit and his own considerable chops to this brilliantly high-minded musical mix, gradually shifting his own musical allegiance from the sometimes sneering world of New Wave to a simpatico sense of musical heritage. Alternative bands like Pixies and Red Hot Chili Peppers joined the jazzers on *Sunday Night*'s second series but executive producer Lorne Michaels and his producer John Heard had run out of road. Jools had rejoined Squeeze back in 1985 and now also set about trying to build his solo music career back in the UK, sometimes going out on the road as a duo with drummer Gilson Lavis, his old mucker from Squeeze. When Jools came across the Deptford Dance Orchestra featuring brass players

Phil Veacock, Roger Goslyn and Paul Bartholomew one night in 1989, his vision of a British big band began to click into place, and he left Squeeze for a second and final time early in 1990.

While Jools had recently presented a couple of series of the revived *Juke Box Jury* on the BBC and had been hosting his own music and alternative comedy vehicle *The Happening* on BSkyB, both shows had finished in 1991. The Irish journalist Dave Fanning had presented Channel 4's last two stabs at the grown-up music market, *Rock Steady* and *Friday Night at the Dome*, but neither had prospered. If Jools suspected a gap in the music television market or dreamed of becoming British television's Mr Music once more, he didn't let on. In fact, he didn't seem too bothered about anything. I learned straight away that Jools is rarely stressed. We drank tea and chatted about our mutual South London ties and my sister's years in a flat in nearby Blackheath. Then there was the state and history of music, what we loved and what we both thought a show should be. I talked about the diversity of genres that *The Late Show* hosted and filling our studio with this broad range of music 'all at once'. We both agreed that the artists had to play live, that everybody had to be in the room together and that we should film it all live and in one go. We wondered together about what might make the presenter's home. Neither of us wanted a desk and Jools liked the idea of roaming around the studio but he was certain that his piano should be his base, that he could interview the guests there and that it should the heart and soul of the show. We didn't talk too long and Jools didn't seem to have any side. Above all, he was never earnest, which all *The Late Show* presenters were obliged to be. I caught the train back to Charing Cross buoyed up, thinking for the first time that this could actually work.

But while Jools and I agreed on the show's musical aesthetic, it was Janet who'd long been telling me that she had the vision of how to stage and how to shoot it. As she explains in the *Later 25* programme, 'When *The Late Show* had moved to Television Centre I organised a demonstration shoot in the round... The layout had a couple of chat areas, a band and art installation: all four corners utilised to maximum effect – with cameras filming in the middle of the performance areas. Although this was complex to film, particularly in working out where to "hide" the cameras as they moved around, I realised that it was something that hadn't been attempted before, moving from one item

to another with a central circle of cameras. What if this concept could be used with just music performances, completely in the round, 360 degrees, a gladiatorial ring, everyone facing each other, cameras in the middle with the audience being the viewers at home?'

Janet had drawn this for me – probably several times – with stick figures for bands and camera crew – but the minute the cameras started tracking around the room and the bands, the arrows that tracked their path soon seemed to converge into concentric circles of chaos. That's the trouble with biro! Janet's brilliant conception simply turned the studio inside out. The cameras would take centre stage, they would be the audience's eyes and they would see everything first. Jools would conduct the viewer around the room and then step back as the cameras would push into the artist then taking centre stage. The cameras would share Jools' perspective with the viewer and together they'd have the best seat in the house. Most classic music shows film the kinetic exchange between performer and audience. Think of *Ready Steady Go!*, *Top of the Pops* or *Soul Train* – the studio audience are half the point. We are watching the audience as well as the bands. How do they move, what are they wearing, what have they done with their hair and what are they up to with each other? We are all voyeurs and music shows had always been windows into the lives and moves of the kids, but maybe we were moving into an era that was more about the music and less about this exchange? After all, why should the viewer at home get a third-hand experience, watching the lucky few who have gone to the ball showing off in front of their favourite bands?

The truth is that I am not sure we had thought all of this through at the beginning. So many of the implications of Janet's conception would reveal themselves in their own good time. *The Late Show* didn't have an audience and our first series would piggyback on its studio so we could only have a handful of guests lurking behind the banners and whooping enthusiastically. We certainly didn't know that *Later...* would soon turn both into a musical meeting place and a cutting contest. Right now, we had to sign up Jools, book some bands and persuade Michael Jackson to actually let us give it a go. *The Late Show* often only used the studio for live links or a short discussion late in the evening. How about we 'borrowed' the empty studio for the day, loaded in the gear, shot the show and then bailed, leaving an exhausted Janet to turn around and shoot that evening's *Late Show* guests live to air in some rapidly installed

armchairs? A small outlay for the BBC and a pilot series for us. Jools' then manager John Lay got busy with the BBC contracts department, signing him up as associate producer with his name in the titles, I set about booking the shows while Janet and script supervisor Amelia Price started scripting the songs and scheduling equipment arrivals, sound-checks, camera rehearsals, Jools' link rehearsals, the actual show recording and the equipment removal so there wasn't a traffic jam in the ring road that encircled the studios at Television Centre.

As much by accident as by design, *Later...* began with a fully formed sense of its mission and identity that has changed very little over the years. The budget, the set and the ambition have all grown and evolved but the heart of the show has always remained Jools introducing some carefully curated artists. *Later...*'s only narrative has always been music. If you wanted a hi-concept pitch you'd claim it as 'the show where a bunch of different artists all play together at the same time'. The groove that launched the first show was mostly a spur-of-the-moment decision that seemed the obvious response to having all those players so close together in a single room. That last-minute wheeze, the opening groove, would kick off the show for years to come before moving to the backend of the hour-long recorded show some time after *Later...* went live in 2008. It wasn't always musical, particularly when the beat slipped or someone turned up their amp and drowned out the others, but it was a statement of democratic intent, an acknowledgement that the musicians in the room were all equal and all in this together. After all, we had no stages, and all the bands shared the same studio floor...

Initially, Jools would conduct or initiate from his piano and so the groove announces a show that's by and for musicians. Mind you, it was always more rhythmically successful when a drummer counted off and held down the beat and when the vamp was as simple and clap-along as possible. I was always bothering Jools by suggesting riffs that seemed germane that week while Jools preferred it when a band took responsibility and led it off themselves. So too did our sound supervisor Mike Felton, tasked with rescuing something approaching coherence from a bunch of stylistically divergent bands sounding off at each other on a chord that Jools had just yelled across the room moments before. Sometimes of course the groove was an unholy row – what would you expect when Sonic Youth and Shabba Ranks share a studio? – and in the early days it felt a bit of a cheeky ask, as if we were obliging musicians to join a club or a singalong.

k.d. lang pours her heart out, series 1,
episode 2, October 1992. (BBC film still)

Certainly, the more enigmatic lead singers like Brett Anderson or Morrissey would instinctively disappear behind the drum riser during the groove because it's clearly not in their job description to be joiners. Jah Wobble was the only musician who ever directly disdained the groove after arriving in the studio with his Invaders of the Heart towards the end of our third series in June 1994. He regarded it as an insult to the seriousness of his musicianship and refused to join in with Bonnie Raitt, Jimmy Vaughan and G. Love & Special Sauce who, despite their chops, had no such qualms. Never mind. The groove wasn't meant to be compulsory, and Wobble was right in as much as it certainly wasn't always musical.

The variety of musical styles and moods, the age range of the performers and the low-key role of the studio audience ensured that *Later...* was not a lifestyle show and nor was it aimed at a particular demographic. It was never primarily about being cool or sexy, which is perhaps why it has lasted. *The Word* and then *TFI* were designed to exuberantly launch the weekend, late night or early evening on a Friday. They rocked and they shocked and they were 'youth TV'. *Later...* set

out its stall as a show for music lovers of all ages, whether playing in the studio or watching at home. Of course, this multi-generational approach was perhaps finding its time in the early 1990s as it became clear that the teenagers who'd fallen in love with music in the 1960s and 1970s were not about to lose interest as they grew older and nor were many of the artists they'd first fallen in love with. The Beatles and the Stones may have started out thinking they had but two or three years before they'd need to get a proper job but gradually they'd realised they'd stumbled upon a lifelong career. The chancers and ne'er-do-wells were now on a course that would eventually make them knights of the realm. Punk had thought to get rid of the 'boring old farts' who preceded it, but Live Aid demonstrated how the older and newer artists – and both baby boomers and their offspring – could now happily share the same stadium and the same enthusiasms. Pop music, it turned out, was for life and already had accumulated a long tail, aided and abetted by the CD revolution. The Nevilles were mostly in their fifties in 1992 while young Londoners D'Influence had just released their debut album, *Good 4 We*.

k.d. lang was coming to town to launch the swoonsome *Ingenue* album after a session for our *New West* country series a couple of years before, Dwight Yoakam was also passing through town, albeit not on the same day, and then there were London hillbillies the Rockingbirds and singer-songwriter Loudon Wainwright III who sadly would not return until a further 350 shows were in the can! So here was the first show we actually taped in late August 1992 and the second we TX'd. I thought we had a country theme, but after an introductory hoedown with the Rockingbirds Jools explained that 'tonight's musical theme is bloody exciting, ladies and gentlemen!' k.d. couldn't make camera rehearsals in the afternoon so Janet beavered away with her backing singer standing in, but come showtime there she was, radiating flirtatiously away in a glittering jacket with a rockabilly quiff. k.d. is still technically the best singer I ever saw on *Later...* with the greatest range and control and she became a star in front of our eyes that night. Catching that moment in a career when an artist realises and directs all their powers, when they enter their imperial phase, would be crucial to *Later...*'s longevity. While it's great to showcase a brand-new artist announcing themselves, nothing quite matches an artist finally taking total command of their gifts and what they need to say with them.

Nick Cave and Miles Shane MacGowan's balancing act,
series 1, episode 5, November 1992. (BBC film still)

We also get to witness Jools' gift for putting his guests, particularly his female guests, at ease for the first time. Their chat at the piano, heads bobbing close together, is coyly flirtatious as Jools enquires after the identity of Miss Chatelaine, the subject of k.d.'s opening song. 'Well,' twinkles k.d., 'Miss Chatelaine is the adolescent inside every woman who experiences emotional puberty; she's very much like Doris Day. It's sort of like when Doris Day goes to Paris for the first time; she's feeling very continental but, on closer inspection, she's actually quite naive.' k.d. and her band the Reclines had come out of 'alternative country' but *Ingenue* was altogether more individual, blending French chanson and the confessional. Not many Canadian country artists were openly gay in the early 1990s(!) but k.d. had come out to *The Advocate* a couple of months before and unashamedly erotic torch songs like 'Constant Craving' are a celebration and exploration of her sexuality. A few country stations would subsequently ban her music and she was picketed at the Grammys but her famous 1993 Herb Ritts' *Vanity Fair* cover with Cindy Crawford didn't suggest repentance. Jools simply enjoyed k.d.'s stunning voice and recognised her fearlessness. He put

her at ease because she recognised a fellow traveller and that gave *Later...* an immediate authority. We were up and running.

We had a studio and we wanted to fill it with as many musicians as possible. At first, I thought we'd theme all the shows. The Neville Brothers-led first show had a 'soul' theme, the second show was a 'country' stew, the third was all Black artists and the fourth had an all-female cast led by Carmel. The themes were fun but ultimately constricting. While it was important for the shows to have a shape, I just wanted to be able to book the best artists available that week across genres. So slowly but surely out went the themes and in came vive la difference! *Later...* was destined not only to be multi-generational in terms of acts and audience but also an almost wilfully broad church, global and multi-genre in its booking policy. The greater the variety of artists, the broader the musical narrative and the greater the contrast – or even clash – between musical styles. Old and new, loud and quiet, big band or solo, the show would henceforth be built on ringing the changes. *Late Reviewer* Paul Morley caught something of this fledgling eclecticism in a *Guardian* review of the sixth show from the first series in which Nick Cave and Shane MacGowan teamed up to sing each other's songs and duet on 'What A Wonderful World', New Jill Swing stars En Vogue sang 'Yesterday' acapella, Felt founder Lawrence debuted his new band Denim and their affectionate yet satirical take on Seventies pop with songs like 'The Osmonds', and veteran singer-songwriter John Prine reprised his classic 'Angel from Montgomery' with the help of Jools and his rhythm section. 'It works positively as a grown-up rock show because it owns up to the fact that there is so much music to choose from, so many past and present styles of fashions that can be jammed together...', wrote Morley. 'The more witty and weird the contrast of acts, the better the show.'

That first series seeded so many of the furrows that *Later...* would plough in the years to come. There was the Malian music of Baaba Maal and Oumou Sangaré, both of whom would return again and again and who sang together on our third show, the rather more dressed-down British indie rock of Inspiral Carpets, Denim and Morrissey, legends from Joan Baez to Smokey Robinson, classic soul from the Nevilles and Ann Peebles whose voice gave out as she finished the seventh show with her signature song, 'I Can't Stand the Rain', conscious hip-hop from dc Basehead and Me Phi Me, forthright female voices like k.d. lang, Tori Amos and Mary

Sonic Youth get loud and dirty, series 1,
episode 9, December 1992. (BBC film still)

Chapin Carpenter, one-off collaborations between first John Martyn and
Andy Sheppard and then Shane MacGowan and Nick Cave, new artists
like D'Influence and David Gray, whose first album wasn't released until
six months later and who would eventually top the album charts with
his fourth album *White Ladder* in 2000, eight years later! I'd seen Gray
at the tiny Troubadour on the Old Brompton Road where Dylan once
did a floor spot, and booked him on our fifth show, alone in the middle
of the floor, obliged to follow Joan Baez's performance of her nostalgic
love letter to Bob, 'Diamonds and Rust'. 'Birds Without Wings' was
twentysomething David's very first release, a state-of-the-nation address
with the frustration if not the optimism of 'The Times They Are
A-Changin', denouncing a fractured landscape, 'lacklustre times' and
'hollow people' – 'birds without wings' – as only a young man can. We
would become familiar with the debutant's stare that stole over his face
when he'd finished, part triumph, part sheer relief.

There were eccentricities too, bravura moments that were there to
entrance with their sheer musicality: the late British saxophonist Barbara
Thompson playing the haunting folk tune 'The Fanaid Grove' solo, the

recently formed Russian gypsy violin quartet Loyko named after the legendary eighteenth-century violinist Loyko Zabar who was said to have given Paganini a run for his money, the percussive slide guitar of Louisiana's Sonny Landreth, Jools duetting with Texan swamp boogie queen Katie Webster, En Vogue and Tori Amos singing acapella, albeit not on the same show! The emerging template was to be curious rather than cool. The 1980s had placed digital machines at the heart of popular music and replaced the naturalism of the music show with the big budgets and technological innovations of the video. I figured what studio television could best offer was curation and intimacy, a unique collection of artists doing something well in front of your very eyes.

Whether this eclectic mix chimed with the spirit of 1992 is another matter. The penultimate show probably came closest to putting its finger on the contemporary pulse by staging Sonic Youth opposite Shabba Ranks. 'There are soft musical textures,' explains Jools, caressing a note on his piano, 'and there are hard musical textures,' he continues, crashing discordantly down on the keys. 'That's the sort of direction we're going to be going in this evening...' By this point we were managing to beg a little money for a few of our own set pieces and designer Sarah Greenwood enclosed Sonic Youth in a metal header that refracted and distorted the lights studded around their set. As Jools introduced their opening number, 'Drunken Butterfly', citing their emergence from the New York 'no wave' scene and their influence on the then all-powerful grunge style led by Nirvana, Sonic Youth simply crashed in, amps turned up to 11, lights blazing and bouncing against the large strip of metal that framed them. Shabba Ranks had just described ragga as 'Jamaican street culture' while Apache Indian had volunteered that his Brummie fusion of ragga and bhangra should be called 'bhangramuffin'. Both momentarily wilted in the face of this full-frontal assault from Sonic Youth. Fortunately, we'd managed to get our sympathetic engineering manager to forgo the Ames minimum traffic light that would surely have combusted on the spot if confronted with this sonic bombardment.

We piloted *Later...* with a core production team who were on the side of the music and the burgeoning demands of our ambition. Episode to episode, day to day, *The Late Show* studio was assigned staff from an in-house roster of technical talent – lighting, sound, set and sparks teams. But we needed our own committed team, so Janet and I set about recruiting the key personnel who would be our partners in crime.

This pool of talent worked on all manner of television programmes from sitcoms to panel shows and were mostly BBC born and bred. But *Later...* offered a new challenge and music performance gave everybody a rare freedom to express themselves.

James Campbell was a lighting director on *The Late Show* where we'd first encountered his lazy eye, his soft Scottish burr and his quiet resolve. James had a rare gift for tableau lighting and loved working out of the darkness that is late-night television's fitting backdrop, framing each group in an empathetic colour palette while giving his close-ups the shade and depth of portraiture. He gave every artist both character and definition and, by skilfully raising or lowering the lights of each position as appropriate, he orchestrated the show's unfolding narrative, its transitions between artists and shifts of musical mood. James also had to be able to raise the lights in the room as a whole so that Jools could walk around and show off the entire cast at once. Lighting an entire studio was a rare challenge for any LD, particularly on a Music and Arts budget, but in a studio largely without a set his lighting unobtrusively animated the whole show. James Campbell was then in his early thirties and newly appointed to the role of lighting director but he rose to the challenge quietly and determinedly, giving *Later...* The Look.

We knew it was crucial that the musicians should like their TV sound if we were going to recruit the best artists to play the show. Although image had become more and more important during the 1980s the kind of artists who played *Later...* were then more focused on their sound mix than their lighting. Resources kept insisting that there was only one possible candidate for this role, although neither Janet nor I could recall meeting Mike Felton on *The Late Show*. Mike was already in his mid-forties, much of his hair had already vanished, and he had an abstracted, private air which could make him hard to reach. He certainly didn't sell himself and making conversation for the sake of it still isn't one of his fortes. We took Mike on trust and never looked back. As the show grew, we'd often accommodate four or even five band setups plus a couple of smaller and often acoustic performances, and he never said 'No!' Instead, he and his assistants, first Dave Lee then Tudor Davies, would lash one and sometimes two smaller mixing desks to the main sound desk and simply mix additional performances there. Most bands would have a tour manager or a sound guy who'd pop into the sound gallery and advise, or often the artists themselves would pop in to listen to a playback

and offer notes. Mike embraced all the music put in front of him and he loved the more musical and the more eccentric guests. The sound gallery would often be packed with artist representatives who would marvel at Mike's quiet dignity and his brilliant mixes. Jools, Mike and I remain the only people not to miss a recording of *Later...* from this first series to Series 53 in 2018, some 400 shows.

But it was the camera crew who were arguably faced with the biggest challenge when *Later...* began. In Janet's fiendish conception they had to be able to move from artist to artist without getting in shot. They each had to develop a constant awareness of one another's position in the studio because their job was to be invisible and the only place to hide was behind the camera or cameras 'on shot' as they converged on the next target. Camera supervisor Gerry Tivers had worked on innumerable multi-camera shows – including *Reginald Perrin*, *EastEnders* and *Top of the Pops* – since starting at the BBC at the dawn of the 1970s. A mild but deter-mined gentleman, Gerry not only led his six-person crew with charm and equanimity but he supported and encouraged Janet as she evolved her flowing style, cameras always on the move, the jib arm sweeping across the studio floor, the sense of space and the gift of attention. His dialogue with Janet was constant and he would always offer alternatives, expanding her vision with his own quiet suggestions. Gerry also quickly forged a crucial partnership with Jools, picking him up at the piano for his links and escorting him from stage to stage around the studio. Jools loved to tease him and try and catch him out of position or get him in shot, while Gerry was often Jools' shepherd, gesturing which way and which artist Jools should head towards in the next link when he'd been too busy at the piano to prepare for what was coming next or when we'd run out of rehearsal time to fully walk Jools through his positioning. Gerry particu-larly loved his classic artists and would get Eric Clapton or Neil Diamond to sign his ped camera when they appeared on the show, which surely stuck out when he found himself shooting a sitcom later in the week. Gerry's handpicked crew loved their music and grew with the show. Eric Metcalfe, who took over as camera supervisor when Gerry retired, had been there since the beginning and would prove as vital. This is also the team that would cover the Pyramid Stage at Glastonbury when we first went to a horrifically muddy and waterlogged Worthy Farm in 1997.

As *Later...* evolved so too did the camera crew's carefully coordinated choreography. They began to swish swiftly and silently around the floor,

dressed in black so as to be invisible as ninjas, advancing and retracting like a hydra with its many heads. Janet had to have a constant 360-degree awareness of the studio like a chessboard in her mind. Together with Gerry she'd work out when to release a couple of the cameras towards the end of a song in order for them to get in position for the next artist, often at a different end of the studio. This constantly moving dance between the cameras, Jools, and the circle of artists spread out around the studio took time to gel. When we kicked off our third series in 1994 with Elvis Costello snarling out the disenchanted songs from *Brutal Youth* with his reunited Attractions, Gerry and the crew were still mastering the particular demands of shooting in the round. 'Turn up your televisions,' advised Jools. 'We are now going to start the show in a very vigorous manner indeed!' and Elvis came screaming out of the blocks with a particularly ferocious version of '13 Steps Lead Down', the chord progression of 'Pump It Up' revisited in proto-grunge mode. As the song reached its climax Gerry and a couple of the other cameras piled into each other right in front of Elvis, who never took his foot off the accelerator. The camera crash couldn't really be undone in the edit, so I had to rush down to the studio floor to ask Elvis to go again while the cameras disentangled themselves and Counting Crows waited their turn to follow with their debut single, 'Mr. Jones'. Elvis and the Attractions had barely been in the same room together for eight years and he was having none of it. 'We'll never be that bloody good again tonight!'

Jools' presence at the heart of the show shaped how the production team behaved in the studio. Television can be a cold and dictatorial medium, but we wanted *Later...* to be television in service of the music. Not only was the show set up as a musical event that we filmed but from the first it was paramount to us that the guests felt comfortable, that they looked and sounded good and that they'd come to a place that was there to serve them. My years as a journalist and working at record companies meant I'd interviewed or worked with quite a few of our guests that first series. I'd once flown with Morrissey from London to Liverpool to introduce him to Ian McCulloch of Echo and the Bunnymen for a *Number 1* feature and even tried to sign the Smiths to Virgin. I'd adored John Cale since 'Slow Dazzle' and spent a day following him around San Francisco on his confrontational 1979 'Sabotage' tour when he sported a worker's hardhat onstage, bellowing 'Ready for War' through a megaphone. I'd hung out

with John and his band at an in-store signing and wound up throwing up outside a Berkeley venue when I'd tried to keep up with his prodigious beer consumption. I'd booked John Martyn to play at my school when I was seventeen and used to see him regularly at Cousins at the end of the 1960s. I'd been Tom Verlaine's press officer when I arrived at Virgin in the mid-1980s and he released his fourth solo album, *Cover*. I'd escort Tom in his black coat and his Doc Martens up and down Ladbroke Grove while we plotted his progress. Tori Amos had set up camp in London for the release of her debut album, *Little Earthquakes*, in 1992 and I'd interviewed her for a broadsheet, struck by her honesty as she explained how she was emerging from a religious upbringing and being raped at knifepoint when she was twenty-one. There were plenty more guests I hadn't encountered before, but I was excited by all the artists I'd booked, how they'd fit together and what they might bring to the show. I wanted every player to feel they'd come to a place where they were welcome and where they could do their best work. I'd encountered artists as a journalist and within record companies. I was a fan and often in awe, but I didn't want to be their friend. I wanted us to meet our guests with something to share, to be on their side and enable them to shine. I wanted *Later...* to have its own character that would be broader than any of us, a character that would be more about art than ratings, more about being good than being big, more about music than the music business. Charts shows were already struggling, how about a show driven by taste?

But it was having Jools as our host that personified the ethos of the show. Here was a musician presenting a show for musicians. Obviously, Jools already knew many more of the guests than I did and he was one of them. Squeeze had been well known in the US and they'd toured the UK with the likes of Blondie at the height of punk. He'd played the brilliant piano coda on the The's 'Uncertain Smile' in 1983, and he'd been hosting musicians on television for years while always seeing himself more as a pianist than a presenter. Jools would arrive towards the end of rehearsals and walk round greeting every musician on the floor. Then he would return to one of the inarguably bleak dressing rooms at Television Centre and chat with whoever he was playing with on that night's show. A piano was delivered to his dressing room every week, and when he wasn't running a tune with an artist the sound of boogie-woogie would usually fill the corridor. That first series Jools sat in with John Martyn and Sonny Landreth, duetted with Katie Webster and backed everyone

from Nick Cave and Shane MacGowan to Mary Coughlan, often with his rhythm section of Gilson, bassist Dave Swift and guitarist Mark Flanagan in tow. Jools thrived on his musical involvement, which enabled me to book artists who didn't have a band but wanted backing. While most acts would show up at the studio in promotion mode, practised from the road or a day or two in a rehearsal studio, there was often a campfire, impromptu feel to Jools' comparatively under-rehearsed collaborations which had only come together earlier that evening and arrived on the show hot off the griddle. I figured that the more involved and the more committed Jools was as a musician, the better it was for the show, and that the two should grow hand in hand. Jools' piano keys became the central motif for the show's graphics and would soon wind their way around the studio floor, all kinds of music in every kind of key.

We were learning what made Jools comfortable in the studio, what he liked to do and what he didn't. As the perfect English gentleman, he wanted to be sure to introduce and then thank every artist and he was as good at arranging the show around his manners as he was at designing Helicon Mountain. Jools had a strong sense of where he wanted to position himself for every link, where and when he wanted to move and when he didn't. He needed to feel the studio in his body to take control of it. While he would listen to Janet in terms of her camera plans and he was always unfailingly polite, he was already wary of doing anything that wasn't on his own terms. His years in television had taught him that he needed to be in control to be comfortable. Even though *The Tube* had finished five years earlier, it was as if that was still his true TV home and *The Tube* team his TV family. We had to win his trust.

To our surprise we discovered that Jools had never worn an earpiece connecting himself to producer and director in the gallery and that he wasn't about to start now. Once we'd started recording the show the running order was king and Jools was in charge. I couldn't whisper in his ear or intervene, he was his own man. He would constantly surprise us in the gallery with what he would say and what he would suddenly do. Mostly he made us laugh a lot. Jools has always been fundamentally unafraid of television and disinterested in its need for perfection. Jools had been conducting the interviews for *The Beatles' Anthology* documentaries that year. Like the Fab Four he wouldn't kowtow to the topdown conformity television tends to demand. He prefers a nod or wink to camera to let the audience know he's on their side.

For many years I would write a script for the show with ideas for each link. I didn't expect Jools to stick to this script but to use it like a road map. The odd phrase or fact would pop out as Jools guided us between acts, but he had his own playful voice and quickly distilled from my fact-filled scripts the only essential information he believed we needed to convey: 'The name of the artist, the song, the album and where they are from.' The floor manager or stage manager was tasked with writing these bullet points on large white sheets of cardboard that Jools cheerfully revealed are called 'idiot boards' in the trade. Then they would place themselves next to but just behind Gerry Tivers' main ped camera between songs, safely out of shot, so Jools could glance at this old-school version of autocue and thank the artist we'd just enjoyed before sharing the odd nugget about whoever was up next.

Jools quickly grew in confidence as he settled in to that first series of *Later...* By the time Inspiral Carpets arrived for our fifth show with its tentative touring theme he was almost boasting. 'Where does the performer appear on major dates in the British Isles, ladies and gentlemen? What sort of a place do these people play? It could perhaps be Glasgow Barrowlands or maybe Birmingham NEC, perhaps World of Leather M25... and increasingly here in Studio 7 in London's fashionable Shepherd's Bush. Interrupting their British tour, Oldham's own, Inspiral Carpets!' Jools probably missed the live theatre of *The Tube* but from the first he treated the *Later...* studio as a playground where he could ham it up and let his imagination roam. Come Morrissey's visit for the ninth episode alongside Tori Amos, Matthew Sweet, Sonny Landreth and Loyko, and there he was wandering the studio brandishing a model aeroplane while claiming that Moz had just arrived on a BOAC flight from an American tour.

Every show of that first series was a marathon run like a sprint. Gear would arrive in the studio in fits and starts throughout the morning, banners would be shifted around the studio, monitor systems humped across the floor, microphones set. Gradually each band's stage setup would emerge from a chaos of wires, cables, amps, keyboards and drums. TC7 was one of the smaller studios in Television Centre and already it seemed as if it was bursting at the seams with artists squeezed up close to one another, side by side or facing each other across the studio. Every show felt like a house of cards that might collapse at any moment. All that gear in one studio felt like tempting fate, then there were all the different musicians with their different needs, and then there was Janet

learning how to make the show fly and how to shoot all those songs and the links in between. She and Amelia would break down the songs from CDs only to discover that the live touring version of songs was different and the carefully prepared shooting scripts needed rapid tweaking.

The day's schedule felt relentless. That night's *Late Show* live broadcast was always hurtling towards us and bands were often late or stuck in traffic. Janet would fret and fume in the gallery at any time lost from camera rehearsals, demanding explanations of feckless pluggers, trying to urge the show forward, half furious, half terrified. Janet wasn't the only one who was intimidated. John Martyn had apparently driven several times around Shepherd's Bush explaining to Gareth Davies, his plugger, why he simply couldn't do the show, overwhelmed with nerves. When John finally arrived at Television Centre he swanned through the stage door, larger than life and twice as overwhelming, talking ten to the dozen in several accents at once, throwing out suggestions for songs he might perform, band trailing in his wake, lording the place. Yet by the end of the night when we collected in the Green Room, artists and crew, with *Late Show* finally off-air and our show transmitting on the televisions mounted high in the corners of the room, John sat in the corner with a brandy or two and watched himself deliver a fluid version of 'May You Never' with Jools and Andy Sheppard sitting in, acoustic guitar strapped on and that thumb plucking a funky backbeat. I do believe he shed a tear that night, tears of sweet relief, which we all could share.

John Martyn, a lesson learned in our time, series 1, episode 5 November 1992.
(BBC film still)

k.d. lang

Later…'s very, very different from any other television show I've been on! It's always felt like its absolute sole purpose is to present music and artists as purely and as directly as possible. You're in a setting that's hospitable with a competitive edge; you're sharing the stage with four or five performers, watching them side by side, and they watch you. It creates this unique atmosphere that's not even replicated by a festival setting because in this setting you are participating in physical proximity and that creates a unique and charged atmosphere, one that's extremely musical. The atmosphere made me nervous, it made me raise my game and it inspired me.

The second time I was on with Radiohead, Foo Fighters, Alison Krauss and Union Station. I was there just with my piano player, alongside these guys I totally admire and respect; man, just having to sing in front of those guys was exhilarating. I got to sing 'Till the Heart Caves In', which Roy Orbison had written with T-Bone Burnett; to have the freedom to sing Roy's song, an obscure album cut, to be able to go deep like that on television is rare. I wanted to raise the bar, I wanted to be profound, I wanted to meet them. I remember walking across the circle to introduce myself to Thom Yorke who I hadn't met before. It was just so intense. The bands were loud, and the piano player and I were quiet.

I always felt that *Later…* provided a gallery setting that was framed with electricity, each piece was made more profound by its neighbour and their style of music; the context gave a perspective on each performance and style of music and an inclusivity too. The pacing of the show contributed to the vibe because it moved so fast and each performer goes bang right after another and that creates and builds a lot of celebratory energy. Jools is a huge part of that energy because he's not a TV host like David Letterman or Johnny Carson, he's a true musician and

k.d. detaching Jools' head, series 9, episode 4, May 1997.

he has a musician's way of thinking and understanding of a musician's mindset, which isn't always the most linear or coherent.

You know usually on television you are on at the end after the chat and you are selling your product, it's a marketing tool. But *Later…* wasn't about that; it felt like we were there for the music and that feeling and spontaneity were welcome. I got to sing a snatch of 'MacArthur Park' to Jimmy Webb's sons at Jools' piano, but I felt comfortable with Jools and humour is a huge part of music. He understands that. I remember the atmosphere and the dressing rooms; it was like playing the Albert Hall and I was exhilarated and exhausted, one of those moments that you are on a plateau. I was on in 2011 with Hugh Laurie. I had a good friend in his band, he was at the height of his *House* fame in the US. I was so intimidated that he was there and so filled with emotional stuff that I forgot an entire verse of 'Constant Craving' and said 'Sorry, I fucked up!' on mike…

jools. we are always grateful to be here.

love ya big time

k.d. lang

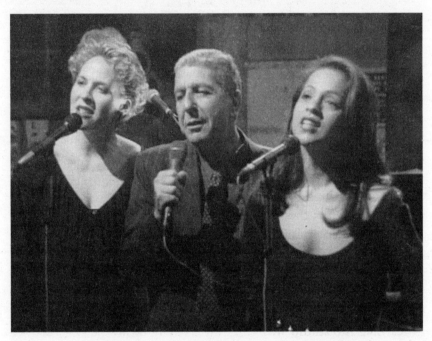

Leonard Cohen with Julie Christensen and Perla Batalla,
the sisters of mercy, series 2, episode 2, May 1993. (BBC film still)

2

Dance Me to the End of Love

In the Round

Leonard Cohen taught us what *Later...* could become. He would show us how the show could be much more than the accidental sum of its parts. Our layout wasn't only a way of filling a studio with a variety of bands and filming them from the inside out, it could be a humming dynamo, a circle of energy. Leonard would involve the other artists he was facing across the room and unite them in a shared orbit. The bands could drive each other forward and raise each other's game; the 'story' of the show was the contrast between the artists; momentum came from the power of the performances and their variety, from not knowing what was coming next. The early series were tough to film and to sequence as Janet had to realise how best to shoot her conception and keep it moving and I had to learn what combination of bands might spark. Some nights it began to feel like the studio was vibrating as song followed song, sparks flew, and the temperature rose. We were building an engine and the man his critics used to sneeringly call 'Laughing Len' was the first to make it roar.

When I bought Leonard Cohen's debut album back in 1967, he was very much the bedroom poet, beloved of students and girls in bedsits – handsome, groomed, and older than most of his peers. My brother and I regarded Leonard's songs like the Sermon from the Mount if secretly finding them just as inscrutable, and my English teacher mother generously admired their lyricism. But my father couldn't bear Leonard's lugubrious voice and every time he entered the front room when 'Suzanne' was on the radiogram, he'd groan loudly and repeatedly until we took the record off. Only when I first saw Leonard at the Royal Albert Hall in May 1970 and then again

at the Isle of Wight festival later that year in August did I learn that at thirty-five he was a performer as well as a poet and that he demanded a special kind of fervour from the audiences that gathered at his feet.

I'd followed Cohen ever since, reviewed his brilliant 1988 comeback album *I'm Your Man* for *Q* magazine when Leonard embraced synths and writers like me finally clocked his gift for irony and self-deprecation as he deadpanned that he'd been 'born with the gift of a golden voice'. Even my father might have chuckled. Five years later, towards the end of 1992, he'd released the biting *The Future*. Now he was coming over on tour to play a couple of nights at the Royal Albert Hall and Columbia could perhaps persuade him to bring his eight-piece band to Television Centre on his day off! I was beside myself with excitement which Jools and Janet clearly shared. This was why we'd begun *Later...*, to provide a space for artists of quality, and we had to do the great man justice.

If the first series was an extended pilot in compromised conditions, our second was the chance to stand on our own two feet. When we finally resumed five months after that first outing and after what felt like years of internal wrangling, we were given our own studio day in the larger TC3. We had won a standalone series commission almost by stealth but, consequently, we'd be dogged for years by the fact that we'd begun on the cheap, piggyback style. We'd remain perpetually underfunded as a result. But such headaches felt like mere chaff in the breeze once Leonard was lined up for the second show of this second series in May 1993.

In the meantime, there was the small hurdle of our first show back... I was learning how to produce a show from scratch and frequently coming up short. Despite booking Sounds of Blackness, I quickly discovered how small and lost even this joyful twenty-six-piece Afrocentric choir could look in the larger but somehow emptier studio. Although we'd ordered a few more banners to encircle the studio, bare walls poked through everywhere as if the BBC itself had been wrapped in aspic since the end of the *Whistle Test*. A few more audience members stumbled in and were silhouetted in the gaps between bands, but despite the odd shot of Maria McKee's band watching a windswept-looking Polly Harvey perform 'Naked Cousin', our first show felt as if a few groups had been abandoned in a museum

The author, Janet and Jools plotting the way forward.

at night. Perhaps to try and hide the draining emptiness, the lights were low and muted while the bands seemed miles apart.

We were still umbilically tied to *The Late Show*, which had enabled me to stockpile the odd session from touring bands and I'd assembled a compilation of new alternative rock performances from the likes of Rage Against the Machine and Pearl Jam for the *No Nirvana* programme earlier that February. Seattle's Alice in Chains had missed that boat, but they'd eventually made it to the studio a week or two before *Later...* returned and I edited them into the mix. But their physical absence from that first show's studio ensemble and their nihilistic, metal-flavoured grunge only deepened the gloomy lack of atmosphere. The whole shebang felt like a collection of separate sessions, even though Gilson Lavis put himself about, drumming with both Maria McKee and Vince Gill.

Up in the gallery, I knew we were missing the mark, but down on the studio floor Martin Wroe of the *Independent* was enjoying the camaraderie of that night's lengthy recording session as the crew got used to the jib arm that Janet was now using to sweep dramatically across the cavernous studio floor. 'The huge keyboard player from

American dance-gospel choir The Sounds of Blackness is chatting to the diminutive singer-songwriter Maria McKee. A few yards away PJ Harvey is talking to Jools Holland who has just ably acquitted himself on a performance of Willie Dixon's 'Wang Dang Doodle' while country singer Vince Gill, the man who turned down the chance to join Dire Straits, is swapping guitar talk with other Blackness members... for an elite audience in the studio at Television Centre, jammed with bands and gear, with lights, cameras and action, it [Later...] is a memorable night. A mixture of drummers' mums, band hangers-on and record companions, Later... is a hot lig – entrance is free, you get to see a clutch of cool bands playing music within inches of your face and the only risk is a telling-off from the floor manager for wandering into shot.' While the musicians and the odd ligger may have enjoyed themselves, something was missing. 'There is no journalism involved, it's a show, an entertainment. There will be no reports on Northern Soul ten years on,' I'd claimed pompously to Wroe before the recording, but, in truth, our return didn't feel like a hot ticket for the viewers, hamstrung as it was by the gloom, the lack of performance theatrics and the unfeatured and tiny smattering of audience that the cameras largely ignored. It wasn't very entertaining, and it didn't catch fire. We had to bring the studio gathering to life onscreen.

I was discovering the obvious, that shows are all about the moment, the atmosphere, and their dynamic, something greater than the sum of their parts. Leonard Cohen had last performed on the BBC for *Once More with Julie Felix* in 1967. Now here he was back at Television Centre at last, clad in a dark pinstriped suit and drinking canteen coffee out of a paper cup. He was courteous, reserved and chatted like a jazz hipster, calling me 'man'. Janet rehearsed each song meticulously and now the jib was coming into its own, capturing the space in the arrangements, gliding over Leonard and his backing singers to find the military tattoo on the drums driving 'Democracy', cameras catching every fill from Paul Ostermeyer's saxophone, Bob Metzger's guitar and Bob Furgo's hot violin. The tone of *The Future*'s songs was scathingly bitter and yet defiantly hopeful; Leonard was already pushing sixty, his grey hair worn in something close to a crew cut, and he commanded the songs with quiet authority, an unassuming prophet. He'd found a way to inhabit the stage that fitted his years and the songs. He felt like a leader who'd found his congregation and his theme.

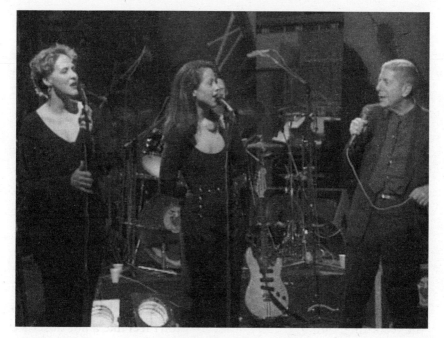

Perla Batalla all tied up, series 2,
episode 2, May 1993. (BBC film still)

Come the recording, a hundred or so audience members were
ushered in to stand between and behind the banners as Aztec Camera,
San Francisco's retro pop-proggers Jellyfish and a newly solo Shara
Nelson gathered on the floor. 'Democracy' opened the show, Leonard
prowling the floor, eyeballing Gerry Tivers' camera with his apocalyptic
lyrics that are hopeful and hopeless at once, with their dismissive nod
to 'hopeless' television screens. The heart of his performance is his
interplay with backing singers Julie Christensen and Perla Batalla who
flank Leonard throughout, sighing and cooing their call-and-response
as he looks the world bleakly in the eye. They are Leonard's angels, the
women who will save him, and he clearly trusts and adores them.
Cropped blonde Julie sings with her head thrown back; the darker,
shorter Perla is slyer, more contained. They are bonded as sisters and
yet both are profoundly and individually aware of Leonard's every move
and every note as he prowls – now beside them, now between them.
The dapper Leonard wasn't tall at five foot nine and the women look
almost protective as they stand abreast. There's something playfully but
respectfully sexy in their interplay, especially when Leonard comes over

to join them for 'Democracy', a sometimes scabrous update of Paul Simon's 'American Tune'.

A few minutes later, after Jellyfish's retro prog-pop tune 'The Ghost at Number One', the camera pans across the room to Cohen, sitting close to Jools at the piano, applauding the band. He leans forward to explain that his first influences, even ahead of literature, were country singers Hank Snow, Roy Acuff and Merle Haggard. He'd catch them beamed out of West Virginia while hiding under the blankets with a radio in Montreal. 'I strive to achieve their simplicity and sincerity of thought,' Leonard observes. He explains that he later got into poetry to win women's hearts. 'Did it work?' enquires Jools. 'Yes it did,' nods Leonard as a slow and perhaps slightly envious grin spreads over Jools' face. 'What's the job of a poet?' asks Jools. 'Search me...' is the quick reply.

Leonard goes on to explain he's lived in Canada, Greece and, back in 1959, in London but now lives in Southern California. 'Los Angeles is a terrific place to live because it's right on the edge of destruction, the ground itself is trembling, the landscape is about to blow apart, the social fabric is about to tear and many novelists have documented the fragmentation of the psyche. It's a place right on the edge of things where everything is about to fall apart and it's a very nourishing place for that reason.' When Jools then asks him if he's an optimist, Leonard's reply further sums up the spirit of the songs he's performing: 'Well, I think those descriptions are obsolete these days; everybody's hanging on to their broken orange crate in the flood and when you pass someone else to declare yourself an optimist or a pessimist or pro-abortion or against abortion or a conservative or a liberal, these descriptions are obsolete in the face of the catastrophe that everybody is really dealing with.'

It's the way that Leonard participated in *Later...* that suggested how it might knit together and come alive. He seemed to include the whole room – Jellyfish, Roddy Frame's Aztec Camera and Shara Nelson, the voice of Massive Attack's 'Unfinished Sympathy' – in his benign gaze. He'd requested that his closing song be 'Dance Me to the End of Love', the first song from 1984's *Various Positions* which would open nearly every Cohen concert right until his last shows in 2013. Columbia president Walter Yetnikoff had famously derided *Various Positions* when Cohen and producer John Lissauer delivered

Jools and Leonard smouldering at the piano, series 2,
episode 2, May 1993. (BBC film still)

it, remarking 'Look, Leonard, we know you're great, but we don't
know if you're any good...', even though it included at least two of
Cohen's best-known and most enduring songs, 'Hallelujah' and
'Dance Me to the End of Love'. The latter seems part Greek, part
Eastern European, hinting at the Klezmer roots that would feature
prominently in Cohen's twenty-first-century tours, as it hangs and
sways in the air, never rushing as it builds into a trance. It's an
invocation, a song of surrender to both love and death, that began
when Leonard learned that string quartets formed within certain
concentration camps were forced to accompany their fellow inmates'
walk to the ovens.

Leonard Cohen and his band must have played 'Dance Me to the
End of Love' for well over ten minutes that night in Television Centre;
through the verses, through solos, on and on through many choruses,
as the power of the song built and built. During one verse, Leonard
moves behind Julie and Perla, who begins to smile; he is surely
surreptitiously binding her wrists. They smirk knowingly and Perla's
arms remain behind her back for the rest of the song. It's a secret

moment between the three of them that the camera can only imply but it's there in their knowing eyes as they sway back and forth, bound together as if in a trance. As the three of them climb deeper and deeper into the song so does the band and the rest of the room. Jools is at his piano and both Jellyfish and Aztec Camera step up to their microphones and begin to sing along through the endless choruses, strumming along silently, 'La la la la la la la la' repeating over and over as if it will never end until the whole room is gathered in communion, transported somewhere holy. The cameras keep rolling and eventually Janet pans around the rapt room which is swaying as one, united.

I guess Leonard was incidentally showing us what the studio was for, what was implicit but yet untapped in our layout, what the circle of artists might mean to each other and how we might better present them. We had staged our bands around the room to enable us to shoot them and to get as much music as possible into a finite space. But we were still working out what impact our circular design might have on the artists and their performance. Each week the opening groove previewed our cast, convened together for one night only, united to make music. Until Leonard, there was little interaction between the bands after that circular opening shot which followed the groove around the studio or even much sense of the room as a whole. But as we learned to let the show run in real time, the bands began to listen and respond to each other. Jools was still growing into the show, and after his introductory walkabout most of his links found him safely ensconced behind his piano talking directly to camera before throwing an arm in the direction of the next artist. He wasn't yet the mobile ringmaster walking between the acts to cue them in turn, driving the programme forward and animating the room as a whole.

We still didn't really have a studio audience to speak of as the friends of friends who made it to our late recordings were squirrelled behind banners, arms often folded across their chests, craning their necks to catch the action at the other end of the studio. The inside-out staging and filming inevitably meant that any audience could only stand behind and between the bands. This wasn't the most comfortable of vantage points and those that did drop in largely came to gawk rather than to dance, to see rather than be

seen. But we clearly needed more punters to energise the artists. We'd spend years trying to make our studio audiences come alive and stop them looking like footballers lining up in a human wall to block a free kick, hands guarding their privates. As yet, they were an afterthought. The hymnal 'Dance Me to the End of Love' suggested a way forward, that it was our job to bring the room to life and give it warmth so that the artists and audience could truly begin to respond to one another.

We began to light the studio more warmly, and designer Sarah Greenwood came up with some boldly coloured cyclorama cloths to cover the bare walls behind the banners. Our ten-part series had begun in May but by the time Lenny Kravitz arrived in full psych funk-rock god mode two months later, right after Glastonbury 1993, the studio was a blaze of colour. The show was rapidly becoming an occasion rather than a recital. Lenny stomped out 'Are You Gonna Go My Way?' propelled by his new drummer Cindy Blackman. Twice as many audience members were squeezed into the studio, which was rapidly filling up. Mind you, I'd had to persuade Lenny's touring crew that he didn't need the mighty stack of amps that he deployed on tour and which had been determinedly wheeled into the studio as though he were playing Wembley rather than Television Centre. I am not sure that Lenny himself quite got the collective experience we were trying to build. He left the studio flanked by minders between each of his numbers, to await his next moment on camera in the solitude of his dressing room. After that, we requested that all the artists remain in the studio throughout, as most of the guests were already doing and which they have done ever since. We'll often show glimpses of that night's cast, sitting on amps or drum risers, watching whoever's on the mike and in the spotlight, waiting their turn as the show builds up a collective head of steam. We struggled to convey the growing atmosphere on the floor onscreen, but it was palpable in the quality and energy of the performances. The artists made each other tick.

The ambition and the eclecticism were expanding too. Flanking Lenny was Gloria Estefan and her large Latin band, clad all in cruise-ship white and returning to her Cuban roots in a pre-Buena Vista world with the bolero 'Mi Buen Amor', former Replacement Paul

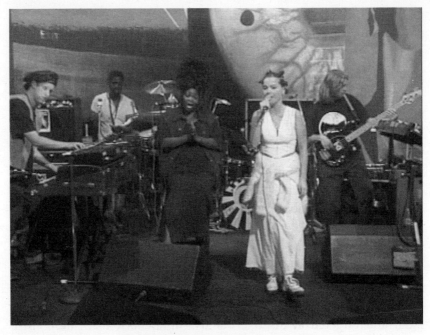

Björk debuting with D'Influence, series 2,
episode 8, July 1993. (BBC film still)

Westerberg launching his solo career with garage punk fervour on
'World Class Fad', Tim Finn and Richard Thompson combining around
the piano on the song they'd written together, 'Persuasion', and finally
the very first television appearance of a solo Björk, whose *Debut* album
had just come out. Björk too was all in white but rather more bohe-
mian in style with a sweater tied round her waist and her hair knotted
in curlers. She'd only left the Sugarcubes a year before and didn't yet
have her own a band so her passionate plugger Pam Ghuneim and I
hatched the plan of getting D'Influence to return to back her. 'Aeroplane'
has an early trip-hop vibe with a mad horn break while the band's
vocalist Sarah-Ann Webb nods along on a stool, lending the ensemble
a charmingly down-home vibe. Björk already sounds like no one else
on earth, wild and uncurbed, full of big-time sensuality, violently
happy. She'd return again and again over the years, always vital and
always singing with utter conviction, mouth wide open as if releasing
everything inside.

By the time Al Green arrived for the tenth show of this second series,
we'd begun to clock that *Later...* would be about communion as well as

diversity, congruence and incongruence. Everybody wanted to be there, everybody wanted to be at their best. Already it was clear that the newer artists loved being on with the legends whose music they'd grown up with and the legends loved sharing the floor with young artists who made them feel current. Both young and old liked meeting artists from other parts of the world, from Africa, Brazil and beyond. I'd been worried that some bands might baulk at our level studio floor, at joining our circle that wasn't just about them and where they would have to wait their turn to shine. But it turned out they liked to mingle, to meet and hear artists from other genres whom they might not run into elsewhere. They willingly subscribed to *Later...*'s ethos. 'Build it and he (they) will come,' says a mysterious voice to Kevin Costner's Iowan farmer in the 1989 hit movie, *Field of Dreams*. He builds a baseball diamond in a cornfield and the ghosts of baseball's greats appear...

The American artists were particularly enthused by our field of dreams from the get-go. Their music was rigorously segregated by radio and targeted at discrete demographics back then: even their festivals were genre-bound and marketed at specific audiences. Garth Brooks must have been the biggest act in the US when he came on *Later...* a couple of years later in 1995. He'd turned country into a stadium genre with his embrace of rock theatrics and had already sold well over 50 million albums in the US alone. He kicked off with a cover of Aerosmith's 'The Fever' and, with Jools at the piano, reprised his signature song, the 1990 ballad 'The Dance', that had so touched American troops and their families during the Gulf War. Garth loved the *Later...* studio and took off his Stetson to wander around the room, examining Soul II Soul's and Blur's equipment, and wondering aloud why there wasn't a show like this back home. Brooks came from an advertising background and while he chatted excitably in Shepherd's Bush of bringing *Later...*'s 'in the round' layout and eclectic musical mix back home with him, he must ultimately have accepted that an eclectic bill and a disregard for demographics were more a public service proposition than an advertiser's goldmine. I still remember North Carolinian R&B singer Sunshine Anderson enthusing as if she'd won a 'get out of jail' card after sharing the studio in 2001 with Cesária Évora, Neil Finn, Spek, Shaggy, the Bad Seeds and Manic Street Preachers because she was on a show with Nick Cave, who she told me 'really had soul!'

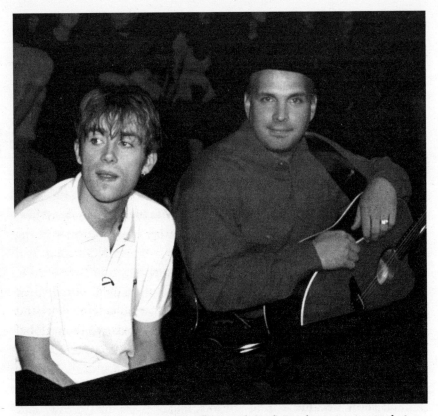

'Friends in Low Places' – Damon Albarn and Garth Brooks, series 6, episode 3, November 1995.

Jools and his grand piano were quickly bedding in as the root of the whole show. His curiosity about all kinds of music was already rampant and he was always such a generous advocate of its harmonising properties that our first guests felt readily welcomed into the circle of dreams. Here was a musician helming a music show with a production team who shared his values and put the music first. Jools could play anything, he had years on the road, but he also had a very particular musical affiliation – the boogie-woogie that came out of Texas and boomed in the USA in the Twenties – a style as out of time and out of place as his suits and frock coats. Jools himself hankered after a vanished era in which Londoners still had singalongs in pubs and bet on the greyhounds. In black and white. His retromania made him delightfully particular, that rare contradiction that is a jolly fogey, dwelling in a parallel universe to everything that was cool and current

in the image-obsessed British music scene and yet as blithe and care-free as the stride piano fills that he could play at finger-popping speed. Boogie-woogie doesn't care, it's piano for dancing and boasting – fast, frenetic, and fun. Jools could welcome and encourage every musician who came through our studio doors because he had his own musical identity, his own fixed point on the compass. He knew where he came from and who he was, which enabled him to be a great cheerleader for others.

Mick Hucknall would later describe *Later...* as 'gladiatorial' and other artists have called it a 'cutting contest' or a 'battle of the bands'. Sure, the studio circle could be intimidating, particularly for debutants, but the *Later...* floor plan surely turned out to be more inspiring than competitive. Chris Martin loves to mock grumble that we had placed Coldplay in an impossibly daunting position in the running order and in the studio on their show debut in 2000, sandwiched near a solo Gary Brooker performing 'A Whiter Shade of Pale' and Youssou N'Dour and Neneh Cherry on a rare reprise of their global hit, '7 Seconds'. The 23-year-old Chris still looked like a student back then with his curly mop and scruffy clothes, but Coldplay weren't short of ambition and didn't sink but swim.

Each show became a unique gathering for one night only with the acts, audience and crew all in it together, putting on a show for the viewers at home. I think Leonard Cohen understood this instinctively. There's a shared purpose, a common challenge, and a mutual curiosity amongst musicians of different stripes. *Later...* swiftly became a meeting place, a Glastonbury of the studio, where artists cross paths and friendships are born, where Courtney Love could meet her muse Marianne Faithfull, where David Byrne could team up with Morcheeba, where Bon Iver might bond with the Staves, where Annie Lennox could link arms with Oumou Sangaré, where Tricky could chat with Isaac Hayes or Lana Del Rey bond with the Weeknd.

Blues guitarist Gary Clark Jr. found himself on a bill with Paul McCartney and Arctic Monkeys. 'I guess you have to bring your A game to this show,' he told me in his Texas drawl. As the show grew year on year and major artists confronted each other in the studio, often only yards apart, the temperature of the show kept rising. By chance some weeks our bills would stack the talent particularly high

– Foo Fighters and Coldplay, Radiohead and Mary J. Blige, Kings of Leon and Kanye West, Foo Fighters and Jay-Z, Adele and R. Kelly, on and on. Yet far from turning into showdowns, these match-ups never felt like stand-offs but more like love-ins. The marquee names would inspire each other, but however well they delivered there'd also be four or five other acts in the room, often unkown dark horses, each with their own musical vision and their own distinct character, and with equal opportunity to grab the moment and make their mark.

Each show was like stacking a tiered and potentially unstable house of cards – squeezing the studio space and the rehearsal schedule to pile in the artists. The integrity of the show was predicated on the combination of artists assembled in the studio, a unique gathering for an hour or so for one night only. Unity of time, place and action: the pillars of Greek tragedy. If all the artists had to be in the same room at the same time, each waiting their turn on the level playing field of the studio floor, then for the duration of the show all the artists were equal, a troupe of Japanese drummers or a folk duo as valuable as some international superstar. We could help kickstart a career, but while there was something gladiatorial about our setup, ultimately the show was about taking part, not winning. It wasn't aspirational but idealistic. I wanted a show that would be larger than the sum of its parts, a show that you could believe in, that was about the art of music and not solely about the charts, commercial success and the ambitions and priorities of the major record companies, a show that couldn't lie and couldn't be bought. *Later...* was never a talent contest like *Pop Idol* or *The X-Factor* and there were never any judges. As Portishead's Geoff Barrow memorably said when their debut album *Dummy* won the Mercury Music Prize in 1994, 'I really don't believe music is a competition, you cannot say out of ten albums there's only one winner!'

The first series was squeezed into TC7, one of the smaller studios in Television Centre, where we'd struggled to accommodate more than a couple of full bands. We were now in a larger studio which was thus more of a challenge to light and design. Although we now had our own slot on Fridays at 23.15, we were still filming the whole show from scratch in a single long day. This nearly killed everybody, particularly the studio staff, and left no margin for error as we were about

to discover. The penultimate show of the second series in July 1993 brought together a revitalised Paul Weller, the Celtic mist of Clannad, piano man A.J. Croce, son of Jim, and erstwhile enfants terribles the Jesus and Mary Chain. Paul was focused on demonstrating that his fire hadn't really gone out, that although the soul-drenched, sometimes androgynous but always fashion-conscious Style Council years had petered out and his debut album underperformed, he was firing on all cylinders again, ready to lay claim to the 1990s and beyond. He wanted to be part of the show; we discussed various ideas for collaborations over the phone and came up with 'What's Going On' with British singer-songwriter Lena Fiagbe whose 1994 debut album *Visions* would inspire future duet partner Corinne Bailey-Rae without matching the commercial success of future Weller collaborators including Amy Winehouse, Adele and Celeste.

But Paul's *Later...* debut that night was overshadowed by the anguish and frustration of East Kilbride's the Jesus and Mary Chain. Five albums into a career that had begun on Creation back in 1984

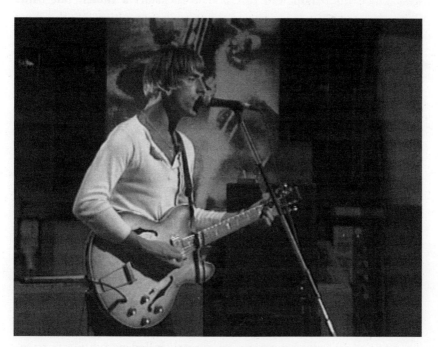

Paul Weller rediscovering his fire, series 2,
episode 9, July 1993. (BBC film still)

with *Upside Down*, the band's combination of sweet melody and dissonant feedback had never quite delivered brothers Jim and William Reid the success or respect they deserved. Their provocative, druggy lyrics and refusal to play the game by performing twenty-minute gigs with their backs turned to the crowd had confirmed their legend with readers of the *NME* in the mid-eighties but hadn't always advanced their cause with the all-important Radio 1. In 1993 on the eve of Britpop, the Jesus and Mary Chain were fast becoming prophets without honour on the British 'indie' scene. Perhaps that's why they'd entitled their latest album *Stoned and Dethroned*, even if the self-aware 'I'm in with the Out Crowd' would only make the deluxe reissue. What was immediately clear on this July night was that the Reid brothers were essentially shy men who instinctively hated the 'show' side of the music business and were probably rather appalled by the *Later...* proposition of unity in diversity. In addition, the brothers didn't seem to like each other very much anymore; fraternal tension would split up the band five years later.

Throughout their allotted soundcheck, the Mary Chain struggled to balance Jim's light and breathy sneer of a vocal with William's overdriven guitars. Jim's vocal had to be loud enough to stand out against the band but each time his vocal mike was turned up, it squealed. In his face. The monitor engineer and road crew scratched their heads. Eventually we ran out of time for further rehearsal and started taping the show after a late dinner break, around ten in the evening. There was only a smattering of audience hiding behind the banners that then passed for a studio set but Weller came hurtling out of the traps with the incendiary opening salvo of 'Sunflower', only for the Jesus and Mary Chain to stall, second up. Not that they couldn't play but here they were awkward and conceptual outsiders in a room full of accomplished veterans, and their cause wasn't aided by the errant high-pitched howls that rang out uncomfortably over their every attempt at a take. After a few aborted stabs at taping 'Something I Can't Have', we agreed that we'd record the rest of the bands and then come back to tape their two songs and Jools' links. The howls from Jim's microphone were ruining every take, not only for the band but for our audio recording. This wasn't the feedback or distortion that was intrinsic to the Jesus and Mary Chain's aesthetic; it was just a bit rubbish.

Whether the brothers blamed each other or the monitor engineer who simply couldn't find a balance between Jim's whispery voice and William's overloaded guitars was academic. It was now around 23.30, the other artists and the small crowd all looked like they were beginning to wonder when and how they might get home. While we recorded the rest of the show, the Jesus and Mary Chain slunk off down to their dressing room in TVC's basement and continued drinking wine. Bottles had already clinked during the camera rehearsal; the band were unhappy and perhaps a bit humiliated, although what was happening wasn't really their fault. They'd never worked with the monitor engineer before. They'd made five albums and toured the world but that night in our studio their aesthetic seemed more theoretical than deliverable. By the time they returned to try their two songs again, the brothers were largely pissed, and the vibe had become a touch confrontational. On live television, the Jesus and Mary Chain could at least have turned the friction into theatre; all we wanted from them was a performance that looked and sounded up to their standards, let alone ours.

By now it was well after midnight, Jim was clutching a bottle of red, and after a couple more takes beset by ringing howls, Weller was in my ear and probably theirs too, suggesting we get this done and sharpish. We'd kept the other bands in the studio so Jools could retake his links into each artist, walking or gesturing between acts and thereby linking the room together. Janet's single-shot aesthetic was proving hard to contrive when it didn't flow naturally. The Jesus and Mary Chain now seemed even more disenchanted than usual. Eventually we managed to get a usable take of 'Something I Can't Have' with only the odd minor howl that we could mostly edit out. The band's lighting glowed pulp lurid in the nocturnal studio – deep reds, rich blues, and a discomfiting lilac against darkness. A pale Jim blanked the camera, took the odd glug of wine, and remained stony-faced as the band somehow merged the prettiness of the Beach Boys with the sonic overload of the Velvet Underground.

The second song, the appropriately titled 'Snakedriver', seemed to have bottled much of the oxymoron of loathing and longing at the heart of the Jesus and Mary Chain. Jools introduced it from his seat at the piano, muttering something like 'It's getting rather late, isn't it?' Janet had decided to shoot the whole song on the single camera of the jib arm. The small camera pointed directly into Jim's

face as he tried to sing; sometimes coming so close you could see its menacing, *Alien*-style shadow on his cheekbone, one moment uncomfortably close, the next backing off to reveal the whole band before elevating directly above William and all his pedals for the guitar break. The camera constantly encroached into the band's space like a predatory animal sniffing for food. In the final take, Jim pushes away the intruding jib camera in disgust as if he's confronting the show, the viewer and perhaps the whole bloody world. It's the one moment when Jim can't quite maintain the Jesus and Mary Chain's studied sullenness because he's simply too pissed off: his gesture's at one with the menacing snarls coming out of William's guitar.

There's still the odd suppressed howl from Jim's mike but the palpable air of tension between that prying camera and the joyless brothers captures the resentment and sense of violation at the band's heart, a victory of a sort. We finished around 1.30 a.m. and everyone dragged themselves home, more dead than alive. It clearly wasn't always going to be easy for everyone to embrace the *Later...* circle, particularly with artists who were the very antithesis of a communal vibe; there had to be room for dissent, for artists who didn't want to belong. The mix didn't need to be comfortable, it just needed to fire. Difference and tension too could be drivers, but all those cables, cameras, monitors and mikes had to work or everything ground to a halt. If the show didn't flow, the bands couldn't bounce off each other. We were learning too that *Later...*'s single-shot aesthetic was tricky to fix. If somebody wanted to record a song again, we had to go back to the previous band, get them to play the last few bars of the song they'd just finished and reshoot Jools' link out of them and into the band that followed. Everybody had to act and the circle was stitched together somewhat awkwardly. Fluency is hard to fake...

If the Jesus and Mary Chain were almost defeated by circumstance, Al Green reminded us to stay together on that tenth and final show of the second series. Green had just released the *Don't Look Back* album which turned out to be his sole release with RCA and had been touring in Scandinavia. His voice was hoarse, and he seemed to be exhausted when he first sat down at the piano. But when Jools asked him who he'd heard as a child that made him want to become

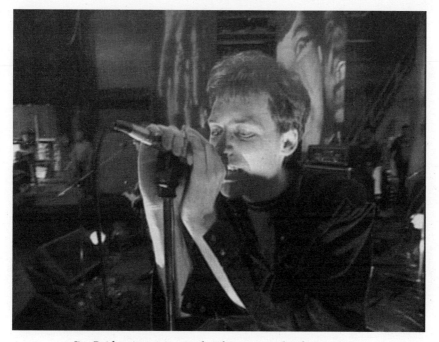

Jim Reid trying to ignore the jib camera in his face, series 2,
episode 9, July 1993. (BBC film still)

a singer, he replied 'Sam Cooke!' and without pausing burst into an
acapella rendition of 'Bring It on Home to Me', suddenly mobile and
alive as he sang before collapsing smiling on his beaming host's
shoulder. 'Ah, beautiful!' cried Jools in admiration; he knew he had
the best seat in the house. A few minutes later Green conducted his
band through a riveting take on his 1972 cover of the BeeGees' 'How
Can You Mend a Broken Heart?' It's as if he's living the song for the
first time, from the inside out: his heart is all over his face throughout
and yet it's pure showmanship too, a performance refined over years.
No one had told Green how he could mend his broken heart, how
he could fix what time had done, how he could ever live again. It's
a confessional plea for help and rebirth. A few songs later, Green
closed the show with 'Let's Stay Together', the voice is ragged now
but, like Leonard Cohen, there's a sense that he's lit up the whole
studio and brought it together.

Green's 'How Can You Mend a Broken Heart?' remains one of the
greatest *Later...* performances and he and Jools clearly bonded because

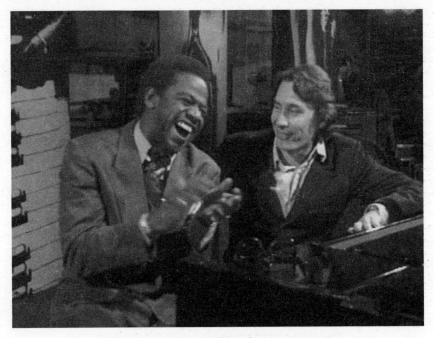

Al Green sings Sam Cooke at the piano, series 2,
episode 10, July 1993. (BBC film still)

when the Reverend returned to London in 2008, Jools brought in his band to back him. The Killers, Damon Albarn's Monkey, Pendulum, Little Boots and Fleet Foxes were all gathered in a packed studio, but Al Green was in his dressing room down in the basement and he simply wouldn't come out. He was due to play something from his comeback Blue Note album, *Lay It Down*, and one of his classic hits but we never saw him on the floor and Jools' band sound-checked without him. I am not sure they ever rehearsed together and as the recording of the hour-long show we were to transmit that Friday night barrelled along and Green still refused to emerge, I kept moving his spot further down the running order. Finally, finally – there he was! – just in time to take the penultimate spot before the Killers' finale of 'Spaceman'. A little fuller now in the face, sporting the smartest of suits and completely indifferent to all the flap and fuss or what had been going on in the show in the meantime.

Al Green was a shot of sunshine in the studio that night. Damon had been sitting next to a giant panda all evening on the Monkey stage, staring daggers at the Killers. Blur too had once been a hit

machine, up there in the rock 'n' roll firmament, but now Damon glared at Brandon and co. as if they were mere commercial fodder, the embodiment of everything he now loathed. Or maybe it was just personal? He and Mark Stoermer the bass player even had a scuffle outside in the Horseshoe after the show. So, there was tension and dissonance in the room but with the Reverend came joy. There was no longer time for anything from the new album but twenty minutes later we went live, and Al Green sang 'Let's Stay Together' one more time, as possessed as ever by the joy of the music, his mobile face beaming in soulful communion, Damon and the whole room clapping along, the Reverend visibly transported, along with everyone who's playing or watching, creating a congregation. In the round.

Richard Thompson

Later... with Jools Holland has always been a bit special, and I think this is a combination of a few factors that make it unique among British music shows. I have been playing the show since the second series and, in a way, it's always felt the same. The values have been very consistent even as the show has grown and expanded. The basic idea of having everybody on the floor live, taking it in turns and swapping songs, artists listening to each other, that's such a wonderful and democratic concept. I've always loved the idea of the groove, all the musicians vamping on some sort of shared riff; it's always chaos of course but it's a lovely thing and brings everyone together. It may not always be musical, but its heart is in the right place! Whether it is live to air or recorded as live doesn't make much difference. We've always felt that once it's your turn, 'This is it! No second chances!'

Having everyone in the studio at the same time, plus a live audience, gives such an energy to the music. It's also a great leveller – I've watched with amusement some acts with larger egos than most, squirming with obvious discomfort at having to sit through everyone else's contribution. You get to see people with larger egos – I shall name no names, although Lenny Kravitz springs to mind – just deeply uncomfortable at having to stand there and listen to other people.

You are on your toes because you are being judged by your peers. Normally you play a concert or a festival, someone goes on and comes off and you go on, etc. It's an on-off thing, and maybe you check out somebody from the side of the stage, but you can't hear that well. At *Later...* you are listening in a way you don't normally get the chance to, and there's a real sense of appreciation for other people's music; it's not competitive, it's mutually supportive: all the musicians know it's

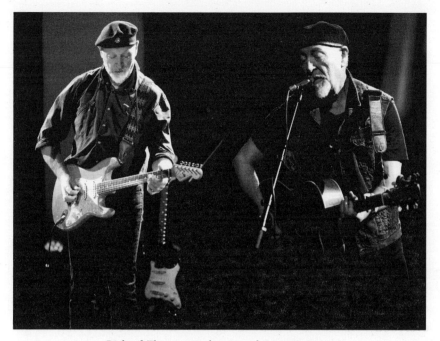

Richard Thompson, electric and acoustic, 2015.

hard to put on a good musical performance and they'll encourage you rather than shoot you down. The general feeling is that everybody wants the show to be a success; you're a component of that success and everybody else is too, so there's mutual support and a common aim.

Jools is such a likeable, eloquent presenter, whose sense of humour is always bubbling away just beneath the surface – note the ever-present twinkle in the eye. There's always a bit of sparkle about him. Having a musician who can muck in occasionally with the guests adds to the charm of the show. I can't imagine a regular TV host, a professional TV presenter; the show would have a very different flavour if it was someone like Brian Matthew from *Thank Your Lucky Stars* back in the 1960s!

I have had some great times and discovered some great music. The booking policy has always been exceptional, bringing together such a wide range of talents that strain the boundaries of 'rock' or 'pop'. You know that whoever you're on with is going to be of a certain musical standard; it doesn't matter if bands are in the charts, people are completely obscure, if they are dinosaurs or newbies on the block, you

know that the show's got good taste and you're going to come away having found some good music. Perhaps you don't like everything, but you always discover something that you like on that floor.

The last time I did *Later...* I came to Maidstone in 2017 and this extraordinary young Japanese pianist Hiromi was there. She was this strange and rare combination of things; she's obviously hugely technically accomplished and clearly schooled in some seriously difficult classical music, Liszt's piano concertos and stuff like that; she had that classical side to her, but she was also right in the jazz tradition, playful with the ability to improvise. She had the ability and the fun to mess around. Very unusual and that night she was a tour de force – she played the theme from 'The Tom and Jerry Show' at blinding speed and she also duetted with Jools. Extraordinary!

Favourite moments? We were on with Al Green the first time I came, and my son Teddy was in my band. We were standing about ten feet away from Al Green, listening to his sublime voice; he's singing great, the band are really good, but between verses he suddenly turns round to the band and he's screaming at them – he's gesticulating and mouthing off and then he turns round and he's charming again with the cameras on him. And then after the next verse Al does it again! He'd go off camera mid-song and give them absolute shit. He's screaming at the band for some apparent faux pas that we haven't noticed. It was just really comical – funny even! We had to follow him which was a bit of a nightmare. After we finished, Al said to Teddy that he liked his harmonies and I think Teddy was a bit moved by that! If it's good enough for Al Green, it's clearly pretty good!

Then watching the incomparable Little Jimmy Scott in 1999, still a musical magician, in the last years of his career... I got to say 'Hello' but I didn't quite know what else to say. I told him that I had his records and loved his music. Then playing alongside some of my favourite bands like Squeeze, Crowded House and Madness, flag-bearers for the melodic traditions of popular music. My all-time best memory may be backing Norma Waterson on 'There Ain't No Sweet Man' in 1996; that was quite a band – Martin Carthy, Dave Mattacks, Danny Thompson and Eliza Carthy. I was glad to be asked! Whatever Norma sang, she owned. There is a bit of gypsy in the Watersons. The grandmother sang to them round the fire – show tunes, musical hall, traditional songs, everything. Norma had that same breadth, she sang with such joy and

freedom, and she could sing anything, she could sing the telephone directory. Still up there on YouTube, still sounds great!

Later... must have this incredible archive now after all these years, and it's not just commercial artists but rare birds like Norma or Hiromi or Little Jimmy Scott and, unlike *Top of the Pops*, they are playing live. You won't find them anywhere else; it's a treasure trove.

Dear Jods,

Just great to be on the Show again, again. Always good to hear your fab guests up close and live! Sorry, writing in the dark.

All best,

Richard Thompson

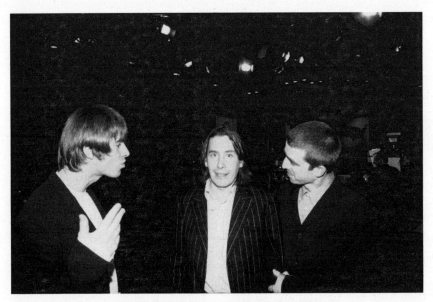

Liam, Jools and Noel compare hairstyles, series 4,
episode 6, December 1994.

3

Connection/Glory Box

Britpop/Trip hop

British alternative music was in the doldrums when *Later...* began in 1992. There was the blissed-out passivity of shoegazing, Primal Scream's blend of indie and rave, and then there were the grebo and 'comedy' bands – the Wonder Stuff, Ned's Atomic Dustbin, Pop Will Eat Itself, Carter USM – that seemed more like good-time Charlies than bands you could believe in. Meanwhile Nirvana had captured a generation, the torch had passed to America and, by and large, British bands seemed terrified of shooting for the moon. Yes, there were Suede and PJ Harvey, both singing like their lives depended on it in our second series in spring 1993, but they both seemed like anomalies, out on their own.

But PJ and Suede felt key to *Later...*'s expanding ambition because they both felt so vital and so fresh. Much later, Robbie Williams with a twinkle in his eye would refer to *Later...* as '*Top of the Pops* for grown-ups', and it's true that Jools' already storied career, our shared love of the past and the broad church of our circle of dreams were intrinsically adult. All the broadsheets were now writing thoughtfully about music, the Mercury Music Prize launched in 1992, Mojo a year later. An adult audience of music lifers was coming of age and that audience was conditioned to look forward as well as back.

Hankering after something new and original had been in my blood since I first heard 'Love Me Do' when I was ten. I'd grown up on the weekly buzz of the *NME*, I'd always hungered for the Next Big Thing, the passing of the torch. We wanted a broad church, but we wanted to reflect what was going on right now, to be editorially and journalistically topical, fingers on the button. The best new rock 'n' roll bands and the best new solo artists began to launch their careers on *Later...* alongside the best in less commercial genres. *Later...* wasn't a chart show, it was

all about taste and curiosity, but it was always fiercely contemporary. I wanted the show to be in the know and showcase the best.

Although Björk, Tori Amos, Sinéad O'Connor, Alanis Morissette and Polly Harvey were each exploring their own way to confront the suffocating demands of femininity, their sheer individuality initially seemed to separate rather than unite them. PJ Harvey the trio had performed the stuttering 'Dress' for *The Late Show* the year before; the lyrics tensely deconstructed dressing to please a man and Polly herself seemed intent on sidestepping the male gaze, hair scraped back into a bun, happy just to be in the band, staring back curiously at the camera. I'd tried to make the studio seem a welcoming place, but from the swooping cameras to the restrictive volume levels, she was clearly in alien territory and, as yet, she had no persona, no protective armour. Now she was travelling deeper into Captain Beefheart's fractured blues with the traumatised loop of 'Naked Cousin' which plays over and over in bright, burning sunlight while she recruited Jools on piano for the cover of Willie Dixon's 'Wang Dang Doodle', which she'd been playing out on the road. Here was Polly with her hair down, minimal make-up and a long black dress: she's a hippie child straight out of *Wuthering Heights*. She was still fronting the trio which would split up later that year and it's PJ's least theatrical *Later...* performance, although she was already feeling for the transgressive and lovesick storytelling of 1995's debut solo album, *To Bring You My Love*, even if she'd yet to put on the pink catsuit and the false eyelashes.

Meanwhile Suede were out on their own, louche and loud. In March 1993, their debut album had gone straight in at Number 1, selling 100,000 copies in its first week with its proudly androgynous cover. Suede's alienation, their romanticism and their glam tendencies all felt intensely British, especially when contrasted with Fishbone and Soul Asylum across our studio floor, although perhaps Bryan Ferry at the piano offered some kinship. Brett Anderson was bare-chested under his jacket with an earring, that floppy fringe and those sculptural cheekbones: a 1990s rock 'n' roll star with a vulnerable falsetto for the have-nots and the dispossessed. Guitarist Bernard Butler's cheekily abstracted air as he cocked his head sideways at the passing camera during his sheet-metal intro to 'My Insatiable One' showed why he was Brett's perfect foil. I remembered them both from their disastrous *Late Show* debut the year before, Brett the charming but meticulous group

ambassador, Bernard the incandescent kid, always on the edge of combustion, jousting with the world.

Suede in the first flush of fame were like creatures from another planet, self-possessed and icily indifferent, as they contemplated Minneapolis' Soul Asylum in their torn jeans and work shirts surging emotively through 'Runaway Train' across the studio floor. Earlier they had opened the show with 'So Young', and while it's a compassionate portrait of drowning and drugged youth, it's also written in the first-person plural: the band themselves are young and in their moment. Their sheer bravura was a rallying cry and their determination to focus on their own world would be the key to what would soon be coined 'Britpop'. Suede were so proudly fey and English, singing about the hunger and hopelessness of being trapped in stalled dormitory towns like Haywards Heath where Brett had grown up. They sounded like they didn't belong, they longed for another world somewhere, and, like PJ Harvey, they wouldn't really fit in with Britpop either.

Early 1990s youth shows like *The Word* were smart, trashy and ironic; the bands were booked to fuck shit up. The job was to be cheeky and confrontational. If the Stone Roses' gear had packed up on *The Word*, they'd have destroyed it and then turned on the cameras. On the BBC they could only complain in the background. There's a school of thought in which rock 'n' roll TV is only worth watching when it's shocking, when television's bland surface gets ruffled. I get why you'd want to see telly shaken up but ultimately that felt like a rather reductive corner in which to box new music. Good television but a narrow and exploitative take on music. We weren't exactly or solely a rock 'n' roll show; I ultimately preferred emotional heft; the many ways the music can make you feel.

The bands on *Later...* played for the cameras, for each other and for posterity, not just for their fan base or for thrills. We offered a level studio floor on which all artists might shine whether famous or obscure, legendary or contemporary. Our studio audience lingered around the back of the set and shifted uncomfortably when the band in front of them struck up. I guess we saw the studio audience and the viewers at home as one and I certainly didn't want to herd them around like they were at *Top of the Pops* or tell them how to act. They brought a warmth that *The Late Show* had never had but we were still working out if they were part of the show. They didn't come to dance; mostly they were

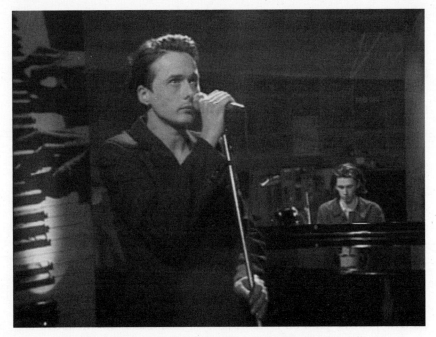

Brett Anderson and Bernard Butler contemplate the next life,
series 2, episode 4, June 1993. (BBC film still)

the kind that stand at the back at gigs. I once heard television audiences
described as 'warm props'. Ours hadn't come dressed to show off or to
pledge allegiance but to be touched. What, after all, would be the
appropriate outfit, the one-size-fits-all costumed response to *Later...*'s
blend of artists, its multiple genres and moods? We weren't tribal or
Shock TV, but we didn't want to feel like a museum either. I just wanted
the music to come first.

I was learning that *Later...*'s job was not only to be a broad church
but also to find breakthrough artists as they blossomed and share the
bloom. There's nothing quite like the moment when an emerging artist
first announces themselves, even if that moment risks the lifespan of
a fruit fly – here today, gone tomorrow. But while it was thrilling to
share these moments of arrival, what we could also offer was a stage
where a band like Suede could flex its wings and be more than visceral
and immediate. Adult, even. When Brett stood stationary at the micro-
phone that June, accompanied only by Bernard on the piano, they
added another string to their bow. Together the two of them played
the haunting 'The Next Life', reputedly an elegy for Brett's dead mother,

in which he imagines they get another go at life where they'll escape 'far far away', although, heartbreakingly, that's only as far as Worthing, twenty-five miles from Haywards Heath on the Sussex coast. Brett and Bernard never played the show together again. When Suede returned with the cinematic sweep of *Dog Man Star* eighteen months later, Bernard had been replaced by seventeen-year-old guitarist Richard Oakes and Britpop was upon us.

Britpop could have done for *Later...* because Britpop was an extended Moment which could have swept everything else away. All the new guitar bands were as much pop as rock, they wanted to be popular, and they were certainly all young. By February 1996, Britpop would have its own television show, *TFI*, with Chris Evans' inventively throw-away take on showbiz and his flair for fooling about. From the moment *TFI* kicked off with Ocean Colour Scene's 'Riverboat Song' riffing away as the guests walked on, it felt tribal. Like a boxing match. The crowd down the front for the bands were young, sexy, and very much on camera. It was 6 p.m. on Friday night on Channel 4 and the kids were having it, presided over by Chris, who came over like a cheeky chem-istry teacher. The Premier League was four years in and in full flight, there was sunny Euro '96 with Gazza, Lineker and Three Lions on the shirt and then there would be the youthful Tony Blair, sweeping into Downing Street after seventeen years of Tory government. Camelot had briefly returned to Britain and Cool Britannia flickered. There was rather less androgyny now, but there were lads and ladettes and a lot of cocaine. All the bands sounded like they'd been to art school but spoke council estate. 'Bliss was it in that dawn to be alive/But to be young was very heaven,' Wordsworth had written about the French Revolution in *The Prelude* some two hundred years earlier, and Chris Evans appeared to feel the same about Britpop. Although we were on a different journey, Britpop would help music really matter again and it helped establish *Later...* as the music show of record.

But back in late 1994 when *Later...* launched its fourth series with the returning Suede and their ambitious second album, *Dog Man Star*, opposite J.J. Cale, Youssou N'Dour, Sharon Shannon and Terry Hall, Britpop hadn't yet been codified. Brett sported a blouse and delivered his pyrrhic version of Springsteen's 'Born to Run', daydreaming that his lover won't leave him, so that they can run with the dogs, away from

The generation game – Robert Plant and Justine Frischmann with Jools, series 4, episode 3, November 1994 (©BBC).

their parents' deeply mortgaged bungalows and somehow become 'The Wild Ones'. Jools had grown his hair long and floppy and he and Brett mumbled together at the piano, polite and studiedly nonchalant as they wished drummer Simon Gilbert 'Happy Birthday'. A couple of shows later Elastica joined Page and Plant accompanied by a hurdy-gurdy and a Moroccan orchestra, St Petersburg's balalaika-heavy Terem Quartet, world-punk French fusionists Les Négresses Vertes and English folk singer June Tabor in the round. Page and Plant stormed dramatically through 'Gallows Pole', all big hair, big drums, and full-frontal emotion. They were widescreen, grand and maximalist. I had seen Elastica raising the roof at The Astoria three weeks before and their sharp, succinct punk pop seemed perfect if ironic punctuation in this Womad-heavy mix. Question mark, exclamation mark, full stop.

Frontwoman Justine Frischmann had formed Suede with Brett in 1988 when they were at University College London together but moved in with Blur's Damon Albarn a few years later. Now here she was with her own floppy fringe falling across her right eye, fronting her own taut and female-centric band without any of Brett's doomed

romanticism. Elastica were post-punk, worldly and urgent with an obvious debt to both Wire and the Stranglers and they bounced their way knowingly through 'Connection' and 'Vaseline', looking impossibly young and devil-may-care while their little neon band sign glowed behind them. Three girls with guitars up front and Justine with her top tied around her waist like she'd been playing footie in the park. She sang smirkily about wanting her back on a bonnet in 'Car Song', a spiky, sexy take on Madness' 'Driving in my Car' complete with appropriate sound effects, but the cars that made Justine horny were comically suburban – Ford Fiestas and Hondas – more *Carry On* than *Born to Run*. Their three songs meant they kept popping up during the show like a youth club invasion. Page and Plant could have been their dads. Robert had more hair than the whole of Elastica between them.

Early in the running order and Elastica being a few months shy of releasing their debut album, Jools playfully offers to solicit title suggestions from the room. An immediately wary Justine reveals they have just settled on a title which, like a gameshow host, Jools begs her to reveal there and then. 'What's it worth?' taunts Justine. An undaunted Jools insists on running a few suggestions by her while apologising for their lameness. 'My title which was rejected was "Fly Me to Japan with a Wine-Style Drink",' he confesses before ploughing on with titles collected from the studio audience on a scrap of paper. '"Rubber"?' he offers doubtfully. 'Bit obvious…' 'Yeah it's useless…' '"Band Aid"?' 'I think it's been used before…' rejoins Justine, wrinkling her nose. '"Plastering"?' 'Not bad…' '"Now!" with an exclamation mark!' 'Quite like that,' admits Justine. 'That sounds pretty good actually. I think we could do something with that one.' Jools seems about to give up. 'I can't even read this last one,' he complains, staring at his desultory list. 'How about we build to the end of the show, and you could just tell us what the title is?' he wheedles. 'All right. *Later*…' winks Justine to Jools' delight. He then introduces 'Vaseline', having checked with Justine he's got the right song.

'We've got the right band in the right place at the right time – Elastica!' he genuflects to camera with that already familiar introductory flourish of the right arm, like an enthusiastic footman at a ball. I am not sure that Justine ever spilled the beans that night, but when the album came out in March 1995 it was self-titled, eponymous, and went straight to Number 1, the fastest-selling debut album since Oasis' *Definitely Maybe*

some six months before, a record that would hold until Arctic Monkeys' *Whatever People Say I Am, That's What I'm Not* came out in 2006. Elastica spent most of that year touring America and promptly got derailed by exhaustion, Class A drugs and Britpop the fad. They eventually released their second album *The Menace* in 2000 but their moment had long gone, and they finally broke up a year later. Damon and Justine too were done, memorialised in 'Tender', the gospel-inspired valediction from Blur's *13* album with which they opened series 13 of *Later...* in April 1999.

Oasis and Blur both followed Elastica into the studio within the following four weeks, Oasis for the last show of the series and Blur on the second ever *Hootenanny*. *Parklife* had come out earlier in the spring and *Definitely Maybe* at the end of the summer and their much-vaunted rivalry was still a thing of the future. Even in February 1994 at the Brits when Blur won big, Damon 'shared' Best Album with Oasis from the podium. Oasis weren't so humble when their roadies rolled up to *Later...* ignoring the schedule and taking over the entire floor to the manner born. The band themselves were young, cocksure and on a mission. They stared the world in the eye, waiting for it to blink or look away. They hadn't yet hit the boutiques and still dressed like scallies, but they were just beginning to grab the nation in their grasp. There was a buzz throughout Television Centre as if the whole place was walking on eggshells and the air seemed to crackle. 'Live Forever' and 'Cigarettes and Alcohol' had gone Top 10 in recent months. Liam was the rock 'n' roll star of the moment and Jools' former 'TV wife' Paula Yates came down to the studio to chase him around, even though she'd already had more than half an eye on Michael Hutchence when INXS had come on a few weeks earlier. Liam was twenty-two and looked scared to death. Meanwhile, although the crew acted like they were headlining their own show at Wembley, the Gallaghers had come to make a musical point.

Noel was in his imperial phase as a songwriter, tossing off B-sides that could open other bands' albums and already well into the songs for *(What's the Story) Morning Glory?* He was happy to tell the press how he was writing a classic a day. He wasn't boastful so much as phlegmatic at this stage, calmly observing his own hot streak which he had no reason to believe would ever end. But Noel also wanted to parade Oasis as a classic rock 'n' roll band in a proud working-class

Blur on the riser, 2nd *Annual Hootenanny*,
December 1994.

British lineage linking back to the Beatles via the Stone Roses, the Smiths and the Sex Pistols. So, what we got was Oasis at their most ambitiously adult, displaying their musical ancestry while Mary Chapin Carpenter, Spearhead and Zap Mama looked on as if they were witnessing the return of the Fab Four. *Later...*'s agenda was global with a strong sense of what Paul Morley used to deride as 'rock's rich tapestry'. Oasis clearly had their own take on the past but at that moment they also felt like a new broom – proud, populist and Mancunian.

Oasis were tilting at the Christmas Number 1 with the one-off single 'Whatever', which showed Noel transitioning from the raw rallying cries of their debut to the anthemic balladry of their supposedly 'difficult' second album. As we'd come to know, Noel admired a rich lineage of pop songwriters including Burt Bacharach, the Bee Gees and ABBA, but 'Whatever' was Beatlesque to the point of pastiche, with an obvious nod to 'All You Need is Love' but actually a greater debt to the rather more obscure title track of Neil Innes' 1973 debut solo album, 'How Sweet to be an Idiot.' Innes had been principal songwriter for 1960s' eccentrics the Bonzo Dog Doo-Dah Band and had gone on to form

Beatles' parodists the Rutles with Monty Python's Eric Idle. Noel's publishers settled out of court for 'Whatever's' 'borrowing' from Innes' tune and he is now listed as co-writer. But Innes or idiots weren't the crux of the matter in December 1994. It wasn't too hard to head past Tony McCarroll's Ringoesque drum fills, Bonehead's opening acoustic guitar and Noel and Nick Ingham's sweeping string arrangement and just hear Liam's almost scornful opening declaration of liberation. No one had sounded that free or that self-assured since grunge began, least of all anyone British. Liam wasn't baring his soul; he was calling out yours and he refused to know his place.

Oasis are all dressed up for the show in smart black jackets while Liam's long hair is carefully brushed like a boy going into town with his mother. They'd brought eight string players from the London Session Orchestra whom we'd doubled up on a riser, stage left of the band, a pianist conducting from the floor beneath, a large backdrop painting of a cityscape behind the spread-out band. 'Whatever' opens the show at a mere five minutes – a minute and a half shorter than the single – and Liam sounds free and unapologetic. There's an earnest determination and epic reach from the get-go that isn't totally undercut by the solitary orange sitting on top of Noel's Orange amp. Yet there's the air of a recital about the performance, as if they're all concentrating hard on getting it right. Even when Liam's singing is done and he turns to pick up a tambourine as Noel takes his solo, the usual swagger is muted. The lights in the studio are dropped for Noel's solo, twelve-string take on 'Sad Song', an extra track from the *Definitely Maybe* sessions which was fast becoming a regular feature of his mid-set Oasis solo spots. Noel's voice is high and plaintive as he admonishes us not to throw it away. Oasis sound like they've been finally let out of school as they finish with a cover of 'I Am the Walrus'; a garage band in concert, guitars turned up and strings sawing away, as Liam almost snarls his hero John Lennon's surreal lyrics. He's unmoving throughout, nose balanced beneath his microphone, his head tilting upwards and the voice like a power tool; what would become iconic and then predictable felt shocking, even radical, in December 1994; Liam was never a song-and-dance man, he doesn't budge, and he makes the world come to him.

A week later and Blur arrived for the *Hootenanny* with Phil Daniels in tow. They were already on their third album, which had topped the

charts off the back of the sardonic disco of 'Girl & Boys' in the spring. After their 1991 hit with the Madchester-flavoured 'There's No Other Way', Blur had stumbled with their second album, 1993's *Modern Life is Rubbish*, which came out at the height of grunge. Now they sounded on the money, as much pop as rock 'n' roll, with Graham's guitar to the fore and Damon's knowing mockney take on Modern Britain. They recalled the mid-Sixties, the Kinks of 'Sunny Afternoon', the Who of 'Happy Jack', the Small Faces of 'Lazy Sunday' but a lot leerier – like they were in the crowd as well as on the stage – but with that old fey British melancholy on tunes like 'To the End' and 'This is a Low'.

We'd already filmed Blur and Paul Weller opposite each other *Later...* style in the studio for that year's first televised and third ever Mercury Prize, broadcast from the Savoy in mid-September. The dancefloor pop of M-People's *Elegant Slumming* pipped them both – and Pulp's *His 'n' Hers* for good measure: perhaps counter-intuitively the rock snob's prize went out of its way to eschew irony and indie rock, embracing the emerging interface between the clubs and the high street. We used the same giant cyclorama of the cover of *Parklife* for both the Mercury Prize and the *Hootenanny* sessions and Blur borrowed four of the horns from the Rhythm & Blues Orchestra. A sampled dog barks, Graham's opening chords ring out and Damon and Phil are airborne, having the time of their lives. Phil plays the geezer to the hilt while Damon prowls back and forth behind him, waiting for the people's mockney chorus. It's everyday 1994 Britain in song, tawdry and thrilling at once, and there's some of the same fresh exhilaration as Oasis' *Supersonic* but with a whole lot more mugging. Halfway through, Phil is spieling about pigeons and Damon and his fringe bounce past behind him, hands flapping like wings, a photo-bomb ahead of its time. Damon jogs too, falls over at one point and does his best to telegraph every lyric. It's silly and fun and comple-mented later by the frenetic 'Bank Holiday', another punky snapshot of British life. Damon's a cartoonist with melancholy touches at this point and he's punch-drunk in the limelight. In 1994, Oasis are deliv-ering empowerment anthems by the people for the people while Blur are observers getting their heads turned by fame.

Britpop was gathering steam, but its course ran parallel with another very different take on Britain in the mid-1990s – trip hop. Journalist

Andy Pemberton had coined the term that June when writing about DJ Shadow for the dance and electronica magazine *Mixmag*. Something had been stirring in the sound system culture of Bristol since the late 1980s, an introspective blend of slow and loping beats, heavy basslines with an obvious debt to reggae, DJs sampling and scratching, muttered raps and soulful vocals. Britpop harked back to the 1960s and to New Wave in the late 1970s; it was smart, knowing and mostly anthemic. Trip hop's roots were in dub and hip-hop, and it sounded blurred – futuristic and haunted at the same time. Neneh Cherry was the harbinger of this new sound which she and husband Cameron McVey had been midwifing in their kitchen studio in Kensal Rise, when she came on *Later...* in June 1993 alongside the Kinks, Belly and Aimee Mann. Despite Neneh's intrinsic warmth and transplanted American optimism, 'Watusi' still sounds like a warning. Cherry's second album, *Homebrew*, had come out the year before and featured the young West Country DJ Geoff Barrow on 'Somedays'. Now here was Geoff on the decks behind Neneh while Talvin Singh provided tabla-heavy percussion and two backing vocalists harmonised and adlibbed behind her.

Neneh and co. didn't look like a band or a group or any recognisable form of pop combo but a shadowy gang without the familiar roles. We staged this posse close to the centre of the studio, as if they'd just wandered in and set up randomly in the middle of the floor. The decks and Talvin's table of percussion were portable enough to store against the set and then move forward into the room when they followed Aimee Mann's band. We were still exploring how to fill the whole studio with music and discovering the potential of these middle-of-the-floor spots. James Campbell would drop the lights on the band corners and dim the painted backdrops so they glowed in the dark. The whole room receded into darkness, leaving a residual sense of space as if Cherry and company had been abandoned in an empty warehouse. Geoff was sampling and scratching live, in the style of a 'proper' New York hip-hop DJ like Gang Starr's Premier, hair falling across his face. We couldn't just shoot the guitar parts and the drum fills because there weren't any. 'Watusi' seemed to come from everywhere and nowhere. It was all unanchored atmospherics.

Eighteen months later, the week before Elastica punctuated Page and Plant, Portishead made their television debut on *Later...* They had

Portishead rearrange the world, series 4,
episode 2, November 1994. (BBC film still)

released their debut album, *Dummy*, at the end of August 1994 on
Andy MacDonald and Lesley Symons' Go! Beat Records. Reviews were
good but the album was proving something of a slow burn when I was
invited down that October to see them give a showcase performance
in the basement of an unheralded café on the Wandsworth Road near
Clapham Old Town. Portishead had begun when Geoff and singer Beth
Gibbons had met on an Enterprise Allowance scheme in 1991. When
the pair bumped into guitarist Adrian Utley, who brought his avant-
garde jazz sensibilities and fascination with the spooky sound of the
theremin to the table, they ignited. *Dummy* redeployed the scratching
and sampling of early hip-hop, transplanting them to the shadowy
world of film noir. They created and played their own parts through a
half-broken amplifier which they then put on to vinyl before sampling
themselves alongside breaks they'd lifted from their record collections.
They even distressed their own recordings by walking all over them.
The result sounded like field recordings from the Deep South of the
1920s or the Vienna of *The Third Man*, complete with the scratchy wear
and tear of the degraded archive footage that is our portal to the first
half of the twentieth century. In sound, they call it 'hauntology'.

Dummy wasn't recorded digitally, which perhaps made it easier for

Portishead to now play it live. I didn't know any of this when I stumbled down the steps of the café, hot, bothered and fifteen minutes late, only to find their plugger Karen Williams and management having hot kittens. The basement was packed and the small crowd restless, but they'd hung on doggedly for my arrival. An appearance on *Later...* was their primary target. Mobile phones were still in the future and I was mortified. I was still red-faced when Portishead shambled onstage and began. They looked like jazz beatniks, dressed down and defiantly ordinary, but the playing and the soundscapes were immediately mesmerising. It was like being blindfolded, but when you are allowed to open your eyes you're back where you started but seeing the world as if for the first time.

Booking Portishead wasn't hard but getting them into the studio was tricky. I'd learn that it's always best to book the songs and the artist at the same time because it's always particular songs that make you love an artist and that as a producer you know will work in the context of the show. Sometimes artists have different ideas. I would never tell an artist what they had to play because what good would that do? So, I'd propose the songs I envisioned and then there'd be a dialogue via the plugger until agreement was reached. The record company and the management would also have a view. They'd see the choice of songs as promotional as they'd be investing in paying for the artist to play the show – the monitors, the transport, the clothes, the hotels, etc – whereas I saw it contextually, the best songs in the right place in the show. I would pore over each running order for maximum effect, like sequencing an album or playing a DJ set. I would quickly learn that no one would ever argue about performing their next single, which in this case was 'Glory Box', but I wanted 'Sour Times' as their second song while Portishead were artistically bent on 'Wandering Star'. They hadn't yet been on television, *Dummy* was a slow burner, but they were determined. So too was I, but there came a point where I had to concede. Geoff, Beth and Adrian are proper punks, determined and uncompromising. That's why they'd made such a brilliant record.

Portishead would share the studio with INXS, Edwyn Collins, Sarah McLachlan and Percy Sledge. It was November 1994 and, in their wisdom, BBC2 had decided to schedule our fourth series at 8 p.m. on a Saturday evening, something of a Bermuda Triangle for telly watchers and music lovers alike. There's a knockabout, casual air to Jools' look

and presenting that's pure mid-1990s. He's sporting floppy long hair, a vintage leather jacket and a Sun Record T-shirt. He's more big brother than elder statesman, not too much older and likely to be as cheeky as most of the newer artists coming through. Jools clearly loves the music and the musicians, but he can't take television even half as seriously as it takes itself. Yet there's a sense of a changing of the guard when Portishead appear, perhaps because no one had heard or seen anything quite like them before.

The whole show is charmingly but amateurishly bumbling, offhand. Percy Sledge is dressed like he's on a cruise ship, bright red blazer with a white handkerchief in the top pocket, white shirt with a wide collar, white slacks, white pumps, a broad smile with that famous gap in his teeth. He tells Jools that 'When a Man Loves a Woman' began with a different lyric, 'Why did you leave me baby?' He sings it beautifully but perhaps a semitone flat, his pitch distorted by years of fronting loud bands in small clubs. The debonair Edwyn Collins previews what is about to be his biggest hit since Orange Juice, 'A Girl Like You'. The Sex Pistols' Paul Cook is on drums, the guitarist uses the very amp that Joe Meek had employed on 'Telstar' and Edwyn finishes his second song, 'Gorgeous George,' by dropping his white guitar on the floor where it promptly breaks. Edwyn is no Pete Townshend and sniggers like a guilty schoolboy. 'Jools, I am facing a bit of a dichotomy here. On the one hand I think Zoo TV really should be Zoo TV, on the other hand I'm appalled at myself.' 'You've decapitated your guitar!' responds a delighted Jools. 'I'm ashamed,' acknowledges a blushing Edwyn. 'Well, there we are, that's rock 'n' roll, don't be ashamed, just go with the flow,' advises Jools before introducing Michael Hutchence, who's balanced on the lip of Jools' piano for an unplugged version of 'Never Tear Us Apart'.

Jools is chatting with INXS' Hutchence and Tim Farris at the piano when he first introduces Portishead and suddenly it's as if the rest of the show doesn't matter. No one has seen Portishead before and they immediately suck you into their black hole. The drummer's on the floor on a tiny jazz kit, Adrian's hidden behind shades, there's that walking bass line, the keyboard player leans on the chords sampled from Isaac Hayes' 'Ike's Rap II' from the 1971 *Black Moses* album and Geoff's on the decks at the back, scratching away like a worried voice as 'Glory Box' lurches hypnotically into view. Portishead look more

like a cooperative than a band. The lights are way down but there's a floor spot behind Beth that illuminates her hair like a halo, and from the moment she sings, it's all about her. She's dressed all in black and hanging off her mike stand like it's there to keep her upright. Beth looks frail, tortured even – blonde hair, eyes half-closed, red lipstick – and much of 'Glory Box' is shot in intense close-up as if to climb inside her head.

A 'glory box' is an antipodean expression for the box or trunk in which a woman hoards the glad rags for her wedding. Beth sings in two distinct voices: the first sounds decades old, like a mummified Billie Holiday. This ancient voice claims to belong to a temptress almost coyly, curdled in its own wily femininity, a female cupid, complete with bow and arrow. It's a voice almost sick of its own mission with a bluesy tone that will influence many of the British female divas to follow. Amy Winehouse, Adele, Duffy, Paloma Faith – they will all sound soulful, retro, black. Then there's Beth's other voice – anguished and unmediated – a voice without attitude or pretence. Beth sings the chorus like she has no choice, like she's longing for a more authentic womanhood. She's pleading for something more honest, less sexualised. Adrian's guitar wanders spikily behind Beth like her dissonant echo before escaping into a howling solo. 'Glory Box' is nearly done when the Drop appears some three and a half minutes in, and it's as if the bottom has fallen out of the world. The jib camera wanders over above the musicians to find Barrow at his decks but it's more what the musicians aren't doing at this point that counts; everything briefly halts, emptiness rushes in before Beth quickly comes back in, searching for a reason for everything.

'Wandering Star' is more of the same, another slow pulse bass line, a starring role for Geoff soloing on the decks, Beth trapped in the headlights. It's emptier even than 'Glory Box', as Beth stares into the void and looks to share her grief. A sampled harmonica that appears intermittently could have made it campfire cosy, but it just sounds like an eerie trace of a vanished world. I couldn't exactly tell you what 'Wandering Star' is about but it's not hard to feel the sadness that possesses 'Dummy' and Beth is a Cassandra throughout, testifying to all that we've lost and can no longer feel; all that remains is an empty shell. Trip hop feels like the antithesis of Britpop. There's no invitation to join the gang or sing along. It's introspective, music for 'wandering stars', the aban-

doned and alone, doomed Melmoths who've fallen by the wayside and now can only wander. You could say it's as retro as Britpop, but this is more a bricolage of broken elements from the past recombined in the present, shards from an archaeological dig. Trip hop is all character and atmosphere; it's only inadvertently communal and it doesn't invite anyone to join in.

Portishead felt like a revelation on *Later...* that night – the intensity, the drama, the newness. These were ordinary people doing something extraordinary. They'd found a new musical language and it was well suited to television because all you could do was watch. Portishead were all about the wonder of sound. There was craft in how they were making this music before your eyes, but it was more than the sum of its parts. It was concert music, music to listen to and to feel and it suited our capture – the moody lighting, Janet's brave camera work, the perfect sound – like this was what *Later...* was for. There was so much emotion and intelligence in their music and that's what we wanted to match with our capture, we wanted to use our craft skills to share and evoke how the music made us feel when you watched the people playing it.

Portishead took off after *Later...*; seeing was believing. Soon *Dummy* was everywhere, perhaps most famously on the soundtrack of BBC2's 1996 'yuppie' drama series, *This Life*. The mood of the album and the title came in part from a 1970s television drama about a young deaf woman who becomes a prostitute. *Dummy* was sad, desperate and understated but ironically enough, it became a kind of coffee-table album. Success familiarises and denatures everything and Portishead themselves resented it. A drunken Barrow could only shake his head and complain when *Dummy* won the Mercury Music Prize in September 1995 while Beth and Adrian looked too pissed and too surprised to say anything at all.

If 1994 was the beginning of both Britpop and trip hop when British pop music really began to matter all over again, 1995 would be their annus mirabilis. I spent much of the first few months of the year beginning a Britpop collection for *The Late Show* that would become August's *Britpop Now* compilation and trying to entice Massive Attack on to a returning *Later...* in May. It wasn't that the latter didn't want to be on, but they weren't quite sure how to do so, how they could

and should perform their music. As their manager Marc Picken patiently explained, they came from sound system culture, not rock 'n' roll, and they certainly didn't want to appear like anything as clichéd as a band. Fellow Bristolians Portishead and Earthling had both already featured and their old sparring partner Tricky was lined up for later in the series on the back of his debut album, *Maxinquaye*, which came out in February 1995. Massive Attack had already had one go-round with the BBC when *Blue Lines* took the world by storm in 1991. The Corporation had forced them to drop the 'Attack' from their name during the Gulf War and they'd 'solved' performing 'Unfinished Sympathy' on *Top of the Pops* by sending on its vocalist Shara Nelson with an extensive string section of classical players who looked like they'd got lost on their way to the Proms. Now they were about to release their second album, *Protection*, and Picken was desperate for them to perform it live. So was I.

Eventually Massive Attack settled on a kind of collective approach and gathered in the studio like a cross between a beatnik sit-in and a student debating society. They certainly didn't look like a band. We

Marianne and Courtney compare notes, series 5,
episode 1, May 1995.

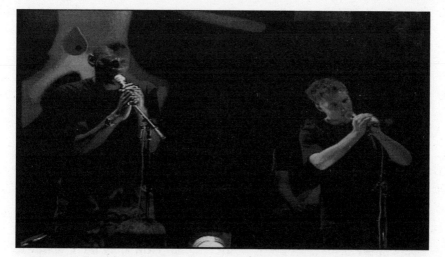

Massive Attack's Grant 'Daddy G' Marshall and Robert '3D' del Naja double up,
series 5, episode 1, March 1996. (BBC film still)

had Hole to do that as grunge continued to reverberate, although no
one looked at Hole the band because no one could take their eyes off
their frontwoman Courtney Love in her distressed party frock, a ruined
fairy who's tumbled off the tree to argue with the feminine in 'Doll
Parts'. Courtney had lost Kurt Cobain thirteen months previously and
seemed half-crazed, half-free spirit. She was thrilled to meet Marianne
Faithfull and get some tips on surviving the life of the reluctant muse.
Her dressing room was like a performance space where she terrified
Jools and I by wandering around déshabillé, apparently unaware of our
blushes as she removed yet more of the little clothing she still had on
while rambling unstoppably, before eventually collapsing on a chair,
legs akimbo, like someone had dropped her puppet strings.

If Courtney Love was full of herself, Massive Attack came reluctantly
from the shadows. A couple of keyboards stage left, Tracey Thorn and
Ben Watt of Everything but the Girl who guest on their second tune,
'Better Things', hang out adjacently in front of an amp, looking at their
knees. Talvin Singh is stage centre on a carpet playing 'Karmacoma''s
hypnotic pulse on a tabla with two chums on Indian percussion, the
bassist stage left. Behind them in front of a large backdrop of what looks
like a Hindu cartoon, Daddy G and Robert del Naja are lurking at their
mikes, taking turns to mutter confessionally that they have nothing to
give. There's a casual intensity about them both throughout but the

theatre of the performance is all in what they don't share. They are stationary and both shot in profile. There's audience studded around, silhouetted whether standing or sitting, part of the murky ambience. What sounds like a scouring wind fills the emptiness occasionally, resolving into that high-pitched whistle straight out of Morricone. When the seemingly nonsense chorus of 'Karmacoma' finally ends the Indian percussion gathers pace into a finale. It's a slow burn, cool but with a hint of Pinteresque menace. When Ben and Tracey front 'Better Things', it's equally understated, Tracey in jeans and pumps, her vocals too are dressed down and yet refuse to flinch, Ben's guitar ringing out in a repetitive figure. The song's drenched in sadness as Tracey bemoans her partner's refusal to admit that they've run out of steam and that he wants out. Once again, less is more. The emotion is all the greater for the refusal of any emoting, the deliberate omission of any crowd-pleasing gesture. A year later Todd Terry will take Everything but the Girl's 'Missing' and turn it into a global hit by combining their tristesse with a house beat, and a catchy phrase about deserts longing for rain, Tracey's mournful, uninflected voice in an electronica/dance context. Massive Attack are downbeat and desolate, but 'Missing''s blueprint is surely here.

Later... itself grew prodigiously throughout 1995. Now we had two days in which to produce the show, the first day to bring in the set, programme the lights and sound-check the artists, the second for camera rehearsals, fine lighting, Jools' rehearsal and collaborations and then the show itself. The set had got bolder and more ambitious with the bare walls of the studio now encircled by a dramatically painted cyclorama and changing frontispieces for each of the group areas, usually giant paintings based on that week's guests' album artwork. There was still a scenery department at the BBC with skilled staff on hand from whom Miranda Jones our designer commissioned the paintings that helped the studio transform into a colourful and vital space. So too did the audience numbers, which had at least doubled in a year. When Paul Weller returned in June as the godfather of Britpop with songs from the soon to be ubiquitous *Stanley Road*, the studio was mobbed to the rafters with ticket holders squeezed in between and around the bands and raised up on risers everywhere. When Paul kicked off with 'Woodcutter's Son' followed swiftly by Supergrass with 'Alright', the room seemed to bounce up and down as

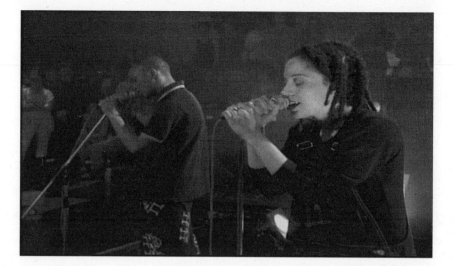

Tricky and Martina Topley Bird, don't look in my eyes, series 5, episode 6,
June 1995. (BBC film still)

one. They spearheaded an eclectic running order that also included Baaba
Maal, the Vulgar Boatmen, Joan Armatrading, and a pre-recorded Scott
Walker as we continued to flex our diverse musical agenda, but by 1995
British music had got everybody excited again and helped bring a palpable
sense of event to every show.

I don't know if Tricky and Björk had already started their brief romance
when they both appeared on *Later...* in June but they both demonstrated
that trip hop and electronica were studio creations that had to be rein-
vented to be performed. Tricky was lively, feral, inexhaustibly curious
about everything and everyone. It was his first time on television and so
he wandered around the studio examining the other artists' gear and the
cameras, full of questions. Tricky was delighted to meet one of his
oft-sampled heroes, Isaac Hayes, who was there to chat about what was
to prove his last album, *Branded*, but spent most of his time telling Jools
how he and David Porter had come up with 'Hold On, I'm Coming'
during a toilet break before singing a snatch of 'When Something is
Wrong with My Baby'. Tricky had named *Maxinquaye* after his dead
mother and recorded it at his home studio in London, Loveshack Eastcote,
but he'd grown up in the poor Knowle West neighbourhood in Bristol
and, as Tricky Kid, he'd been a member of Massive Attack, contributing
to *Blue Lines* and, more recently, 'Karmacoma' which he'd reworked as

'Overcome' for his own album. He'd also hung out with Portishead, making his own use of the 'Ike's Rap II' sample they'd used on 'Glory Box' for 'Hell is Round the Corner'. Tricky and co-vocalist Martina Topley-Bird had worked together since he spotted her singing on a wall while she was doing her GCSEs at Clifton College. There was seven years between them, but they'd been a couple for a while and had a daughter, Mina Mazy, only a month after *Maxinquaye* came out.

Tricky took you inside his drug-fuelled and claustrophobic mind while Martina was his unblinking sparring partner. 'We're documentarians. That's what we do. We document the situation around us. Violence. Death. Sex. Money. Deviousness,' Tricky told *Melody Maker*'s David Bennun at the time. They'd only played a handful of live dates before they came on *Later...* although they'd wind up playing nearly ninety shows that year. Tricky was nothing if not counter-intuitive and he and Martina didn't try to recreate the dub-filled tension of the studio. Instead, they were backed by a fairly rudimentary rock 'n' roll band led by the former Boomtown Rat Pete Briquette on bass who turned 'Suffocated Love' into something close to a calypso. But the intimate delivery and the dialogue between Tricky and Martina carried the day, the dense witty lyrics playing out their relationship under a microscope, Tricky owning up to all his tricks and bad faith, Martina responding in counterpoint, as candid and as vocally restrained as Tracey Thorn, a caged bird. 'Suffocated Love' is a contemporary duet, Johnny Cash and June Carter's 'Jackson' with no chance of flight. But the roles are a lot less clear. There's something androgynous about Tricky in his sari and Martina in her dungarees. The lights in the studio are bedroom low and the drama of their dialogue is all in the cross shots as Tricky and Martina cling to their mikes; they stand apart and stare straight ahead, but as Janet cuts between them, they are singing to each other. Sometimes their single shots are mixed over each other as if they are different sides of the same person. Their cover of Public Enemy's 'Black Steel in the Hour of Chaos' follows, their contemptuous but dispassionate voices intertwine but they stand apart, eyes closed, and the band are hired hands, learning on the job.

Tricky was everywhere that spring and summer. He'd produced two tracks on Björk's second album, *Post*, which was released the second week of June, the week they both appeared on *Later...*, and now they were standing across from each other in the studio. The first time Björk

appeared she didn't have a band and had 'borrowed' D'Influence. She didn't have a band this time either, but she'd found her own way to realise each song from *Post* although she was yet to tour it. Her set that night is more of a concert recital than a band performance. There are paintings of colourful and blooming flowers behind her – Georgia O'Keeffe without the skulls. She opens the show with 'Hyperballad' with the eight-piece, all-female Electra Strings, a sequencer keyboard, decks, and a drummer playing a single snare with brushes that sound like autumn leaves rustling in the wind. The song is all love and vulnerability, and she sings as if she can't contain herself as the brushes speed up climactically. Then there's 'Venus as a Boy' from *Debut* as a solo ballad while Björk stands by the harpsichord like a saloon singer. Finally, there's the melancholy and jouissance of 'Possibly Maybe', backed by drums, keys and B.J. Cole's limpid and lovely pedal steel which swoons around the delight in Björk's voice as she sings about what might be happening. When she's finished and Jools walks in front of her to close the show, Björk half curtsies. Between songs she stoops to tug up her half-length black stockings like a schoolgirl. Her hair's dyed deep black, her lipstick dark and she wears a simple but elegant dress just below the knee. She's a beguiling mixture of the sophisticated and the naive. Björk's clearly used to being watched but she often acts as if no one else is there. The power of the performance is all in her rapt, declarative voice and the projected force of her personality. There's something of trip hop in her whole approach to the material but there's nothing muttered or muted in Björk and she's vocally fearless. No one has seen or heard the songs from *Post* before and they are stunning. Björk's becoming a star before our very eyes.

Björk and Tricky shared that final June episode with Wallasey's the Boo Radleys whose album and single 'Wake Up Boo!' had jauntily propelled them into the gathering Britpop tribe. A month or so later they came back to *The Late Show* studio where I was busy compiling performances for another zeitgeist-surfing compilation, *Britpop Now*, which finally aired on 16 August, the week that Oasis and Blur squared off for the Number 1 spot. *Later...* wouldn't return until November, but over the summer, director Geraldine Dowd and I had filmed with Supergrass, Sleeper, Elastica, Menswear and many more. The pièce de résistance was Pulp's performance of their spring anthem, 'Common

People', alone in an empty studio with only a Steadicam which wandered snakelike amongst the band. There was no cable connection to restrict the camera's roaming or share its pictures. Geri and I could only observe blindly from above as Pulp flounced away on the floor and the camera op glided among them, always returning to Jarvis and his wagging finger for the chorus. Afterwards the band came up to the gallery and together we played back the performance the Steadicam had captured, thrilled by what the immersive experiment had delivered.

Ultimately however *Britpop Now* belonged to Damon Albarn, who was determined not only to beat Oasis to Number 1 but to affirm his Anglophilia. I'd just moved into an office in the East Tower that overlooked Television Centre's studios and when Blur arrived to film 'Country House', Damon came up after soundcheck and we puzzled over an introductory link in which he could take steerage not only of the programme but Britpop itself. Minutes later, the floppy-fringed Damon lounged on an armchair in the studio, giving it his best Tracey MacLeod. 'Three years ago, in the spring of 1992, Blur had embarked on their second tour of America. We'd been there the previous autumn and been really well received, but this time it was very different. In short, Nirvana, Nirvana, everywhere Nirvana. America had found a voice and a face capable of expressing its anxiety and self-loathing, an angelic face amongst the shopping malls. If America felt like this then the whole world had to feel the same way. In short, if you were in a band that was not Nirvana or a diet Nirvana you were nothing. Well,' says Damon pausing for a moment to reset himself in the leather chair we'd managed to wangle out of props, 'I think all that's changed now. British bands are no longer embarrassed to sing about where they come from, they've found their voice. So, for the next forty-five minutes, enjoy some of the best music in the world, the new Britpop.'

Damon the presenter retains just enough insouciance not to sound pompous. But his role as Britpop spokesman is a trifle undercut by Blur's ensuing performance of 'Country House'. Damon comes out fighting dressed like Harry Enfield's Lord Ralph Mayhew from *The Fast Show*, complete with Meerschaum pipe, deerstalker hat, bow tie, waistcoat, plus fours and a lot of tweed. He's in full pop star mode, gurning and eyerolling overtime at the camera, giving an impossibly knowing performance and it's probably not the Blur that has endured. But it's

the Blur that was big in 1995 and perhaps *Britpop Now* even helped them edge ahead of Oasis' 'Roll With It' in that Friday's chart, disproving the *Guardian's* midweek headline, 'Working class heroes lead art school trendies'. Noel and Liam now began to diss Damon ever more publicly; they were proud rock 'n' roll stars while portraying him as a comedy pop star; Oasis were working-class, Northern and authentic; Blur were middle class, Southern and art school. The chart battle quickly turned the Britpop soap opera toxic. Blur won the battle but, as the cliché goes, they lost the war. Oasis' second album, *(What's the Story) Morning Glory?*, came out seven weeks later and turned into a juggernaut, going on to become the bestselling British album of the decade.

When Blur finally made their *Later...* debut proper that November on our sixth series, I don't think what was happening had quite dawned on them. Oasis were no longer a band but a phenomenon. *The Great Escape* had come out early in September and would sell a million, *(What's the Story) Morning Glory?* came out less than a month later and would eventually sell five times as many. The 1990s were nothing if not commercially attuned and Oasis were not only great copy, but they were also raking it in. As Oasis became bigger, Blur were increasingly portrayed as somehow lesser. Blur were always leery in the studio, bored by camera rehearsals and generally acting like naughty boys in class, which must be how the BBC made them feel. When Damon and Graham chatted with Jools, they haltingly told him they'd met at school in the music portacabin and that their formative inspirations had been the Who and the films of Mike Leigh. Jools explained on camera that I'd found the rare footage of The Who we showed them during the interview and that it was my birthday. He didn't mention I was already forty-three.

A crescent moon fashioned from gleaming metal hangs over Blur's corner. Damon is dressed down for the occasion but once again he plays the rabble-rouser for the opening 'Stereotypes'. The verses are obvious suburban satire, but the chorus is a lament for England's dreaming. Their three-song set is a reminder that behind the perky brass stabs and Damon's antics, Blur are essentially observational songwriters affectionately disturbed by dysfunctional Britain. Damon acts out the lyrics, but it is Graham's slashing guitar that is their uncomfortable heart. 'He Thought of Cars' has Damon behind a keyboard and suddenly Blur are more XTC than Madness as the melancholy and

loneliness that underpins so much of *The Great Escape* shines through this Ballardian tale. The closing 'The Universal' is a cautionary tale that's driven by a string quartet and remains one of Blur's prettiest and most despairing songs. There's a heartbroken timbre to Damon's voice as he paints a dystopian picture of a looming brave new world. He's turning the clock forward a few years to the next century, to a world saturated with screens where we've all surrendered to the blank but 'happy' future that could well envelope us. Who's to say it hasn't?

Damon would return to *Later...* perhaps more than any other artist over the years and 'The Universal' is an early hint of the musical ambition and restless curiosity that would drive him relentlessly forward with Blur, Gorillaz, the Good, the Bad and the Queen, Africa Express, *Dr Dee*, Monkey and so many other projects. His fearlessness as a producer, songwriter and collaborator has long since encompassed the rock 'n' roll of Britpop, the hip-hop beats of trip hop and much, much more. He's always an obnoxious teddy bear in the television studio, railing against time restrictions, and often appalled by his fellow guests – even on that debut Blur appearance trying to make sure he wasn't photographed standing anywhere near Garth Brooks or his Stetson. Although I think he approves of *Later...*'s global outlook, Damon's always been particularly intolerant of its more mainstream acts. 'Why are they on?' he'd ask me accusingly, pointing at an arena act's gear while accompanying one of the many more left-field acts he's championed – Chicago's Hypnotic Brass Ensemble or the exiled Orchestra of Syrian Musicians. Britpop has long since ceased to define Damon but there will always be a competitive edge to his talent.

Two weeks later, Oasis returned to Television Centre as all-conquering heroes. Or, at least, they should have. *(What's the Story) Morning Glory?* had just gone five times platinum, even if first Simply Red and then Robson and Jerome kept it from returning to the top spot. Creation had already taken four singles from it, the last of which, 'Wonderwall', was fast becoming a mid-1990s national anthem. Later that December, the Mike Flowers Pops would film their easy listening version for the third *Annual Hootenanny* which would peak at Number 2 just as the Oasis' original had done a month or so before. Oasis had just performed two back-to-back nights at London's Earl's Court, the biggest

ever indoor gigs in Europe at the time; they were having it large in every kind of way.

The 23-year-old Liam Gallagher had certainly been having it large when he rolled into Television Centre on 28 November 1995 looking like he'd been sleeping in a haystack. He hadn't shaved or changed clothes in days. He didn't seem to be speaking much to the rest of the band but then he couldn't speak much full stop. The band weren't speaking to him much either. Less than a month before he'd swaggered on to the Earl's Court stage and stood there immobile staring down the faithful. Now he looked like he was in trouble, and he knew it. I wasn't too happy with the state of him either. But the band had sound-checked without him and Noel was down to sing 'Wonderwall' with a string quartet. All Liam had to do was front 'Cum on Feel the Noize', a Slade cover which had closed the Earl's Court shows and which was destined to be a B-side on 'Don't Look Back in Anger' early in 1996, and 'Round Are Way' which had been a B-side for 'Wonderwall'. It was a perverse set of tunes, but this was Oasis in their imperial phase, and they did whatever Noel wanted. I was frustrated because the song choices seemed a missed opportunity given that Oasis were down to open the show playing opposite David Bowie. Bowie's star had fallen over the last decade and he was then a long way from the legend he'd been in the 1970s or that he'd become once again with his death. He'd reunited with Brian Eno and pianist Mike Garson for his latest album, which had a certain bravura and industrial density without sounding entirely convincing. *Outside* had entered the album charts at a lowly Number 8 but this was his *Later...* debut and he was David Bowie ffs.

Liam had been on a three-day bender, I was told, and after running croakily through a couple of songs and lurking for a few minutes behind the drum kit, he retreated to the BBC canteen in search of chips. When showtime came he didn't look like he'd perked up. I don't know what he'd done in make-up, if anything, but it hadn't helped. Jools and Bowie sideman Mike Garson led the groove with a piano duet in which Garson suddenly metamorphosed into a florid scene-stealer. Liam struggled gamely through the opening 'Cum on Feel the Noize' but the usual incisive thrust of his voice was only intermittently there. There was a certain undeniable pathos to his struggle, although Oasis weren't covering this raucous rocker to show vulnerability but to raise the roof.

Wolverhampton's men of the people, Slade, had taken it to Number 1 in 1973 a month or two before Bowie released *Aladdin Sane*. These were big shoes to fill...

Noel didn't look happy when the song finished, and Liam slunk doubtfully away from the mike. I was called down to the floor. Liam wasn't anywhere to be seen and Noel and his management team were insistent that we start the show again and that Noel would now be singing throughout. Jools repeated the opening groove with Mike Garson, apologised for his cold, introduced David Bowie as one of England's greatest ever stars and halted just before Oasis came into view. 'I have some good news and some bad news. Our next guests are one of the greatest groups in Britain at the moment. Unfortunately, Liam – I must have coughed in his tea or something – he's now got my throat and is unable to sing. So, we're going to have a one-off, where they are going to perform without him.' Jools stumbles a bit and looks apologetic. He almost shrugs his shoulders. He knows he can't quite 'big-up' this 'one-off'.

Noel doesn't have Liam's blowtorch rasp or his cocksure inscrutability. The band lurch forward driven by new recruit Alan White on drums and the rhythm guitar attack of Noel and Bonehead. It's meat and potatoes rock 'n' roll but it's loud and dirty enough even if Noel is more Pete Townshend than Roger Daltrey on lead vocals. When it's David Bowie's turn he comes out all guns blazing, channelling the Thin White Duke as his thunderous art-rock band tears into 'Hello Spaceboy': three keyboards, two guitars, Gail Ann Dorsey's bass. Bowie looks impossibly poised and handsome as he later reprises 'The Man Who Sold the World' before an operatic, elegiac 'Strangers When We Meet', an epic hit that never was. Noel sits on a stool to deliver an affecting acoustic 'Wonderwall' with strings before he and Oasis finish on the brass-driven knees-up of 'Round Are Way'. Neither artist seems to acknowledge the other across the floor at any point. Bowie has everything except his old command of the zeitgeist, Oasis have the world at their feet but don't seem bothered. It's that chutzpah – not their performance – that allows them to rule the roost, even without Liam.

Noel's interview with Jools seated at the piano surrounded by chuckling punters is perhaps the high point of Oasis' night. 'Where is Liam?' asks Jools. 'Gone for his MOT,' replies Noel, all eyebrows and mod

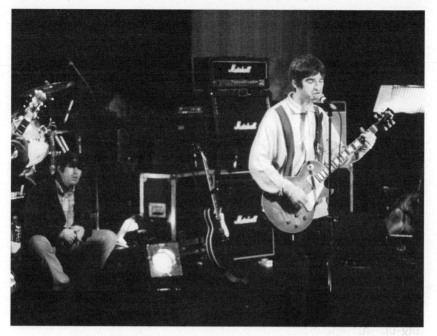

Liam watching Noel play big brother and about to go home,
series 6, episode 5, December 1995.

jumper. 'Will he fail it, do you think?' 'Yes, he will. His voice has gone; he stayed up too many nights partying.' 'I've not given it to him?' asks Jools, heavy with cold. 'I'm going to give it to him in a bit when I see him, I tell you that!' smirks Noel. He then shares glimpses of his musical education, remembering watching a clip of the Beatles shake their mops to 'She Loves You' as a child, school music lessons. 'I was left-handed, but I played guitar right-handed. They tried to get me to play left-handed but I couldn't get my head round it, so they kicked me out.' 'That's not right,' says Jools. 'Not really,' agrees Noel looking straight down the lens. 'I'd like to say if my old teacher is watching, do you want to borrow a tenner?' When Jools asks him how long he thinks Oasis will last, Noel is suddenly humbled. 'I dunno, I don't like predicting the future. As long as people want us, I suppose,' he mumbles. He sounds like the Beatles in the first flush of fame and perhaps Liam going walkabout has briefly dented his confidence.

We'd recorded the whole of the show's false start and when I watched the opening 'Cum on Feel the Noize' in the edit the next day I thought we should show it. A struggling Liam seemed better than no Liam at

all when he and Oasis were riding so high. There was something musi-
cally compelling in Liam's vocal struggles too: it was, as journalists like
to say, good copy. If I'd known Liam wasn't coming, Bowie could have
opened the show. I felt railroaded. Karen Williams, Oasis' plugger, kept
asking me not to show it. But wasn't Liam's take, failing voice and all,
more rock 'n' roll than Noel's? After all, Noel had dissed his own version
in the interview with Jools. I was torn and eventually I called Jools. He
was clearly on the side of the band. 'We are a musicians' show and if
Oasis don't want it shown and don't think it was good enough, we
shouldn't show it.' He was probably right. That's why artists came to
the show. They knew Later... belonged to them and was there for them
to do their best work. But how I wished we'd been live to air when the
show began that night!

Britpop and trip hop had arrived, perhaps even peaked. Cool Britannia
was upon us. 1996 would belong to the Euros, to Oasis, to the Manic
Street Preachers, Ocean Colour Scene, Morcheeba, Cast, the Bluetones
and so many more. Tony Blair and the economy were on the ascent,
the Channel Tunnel was open. Oasis and Blur were locked into a game
of reputational snakes and ladders that would last for years. Oasis never
returned to the show... although we shot a Later... Presents concert
special with them in 2000 when they released Standing on the Shoulder
of Giants. In 1997, Director Mike Connolly and I flew on a private jet
with the band back to Manchester to visit their old haunts including
Maine Road, Manchester City's ground, for a documentary to accom-
pany the launch of Be Here Now that August. As Noel explained, 'The
reason the majority of the people in this country like my band is because
we're like the majority of people in this country. We still go to football
matches, we still go to the pub, we still get nicked and busted like
everybody else does.' We shot an acoustic performance of 'Stand By
Me' in a boutique garden in Cheshire and drove round Moss Side while
I interviewed Noel and Liam from the back of the Prius. Oasis were
defiantly a working-class band and they remained all aspiration. As
Liam insisted to me at the start of the film, 'I don't believe in miracles.
You've got to do it for yourself, haven't you? Can't wait about for anyone
else to do it for you. Wasn't a miracle that I got up off my arse and
joined the band. There was no opportunities involved; it was me going
to be someone. Because I wanted to.' Mike and I probably swallowed

the band's people power myth a little too whole and when the bombastic *Be Here Now* was quickly adjudged to flatter to deceive, the altogether poppier Robbie Williams was waiting in the wings. The anthems were heading for the high street and the shopping centre.

 Yet Noel and Liam have continued to be part of the *Later...* story, both appearing frequently in the 2010s as solo artists, while seeming to conduct their own war game version of snakes and ladders. Noel's post-Oasis career got off to a flying start with his High Flying Birds while Liam struggled with Beady Eye. When Liam finally went solo with *As You Were* in October 2017, he was suddenly a star again, launching our fifty-second series playing straight-ahead rock 'n' roll, tweeting wittily and sparring endlessly with Noel who, in turn, sparked a social media frenzy five weeks later when High Flying Bird Charlotte Marionneau from French experimentalists Le Volume Courbe played scissors on 'She Taught Me How To Fly'. No one could quite believe that Noel would entertain anything quite so arty. It was a moment of a kind, but it shouldn't have been such a surprise to see Noel stretching his wings. Earlier that year he had provided guitar and backing vocals on 'We Got the Power' for Damon's Gorillaz album, *Humanz*. 1995 no longer defined either one of them.

Paul Weller

I'd started up again in the early 1990s but when my first solo album came out in 1992, we did *Top of the Pops* and we had to mime and we all agreed, 'No more, this is nonsense.' So, when *Later...* started I loved the fact that we could play live, and although we did our latest single, it wasn't just about that but showing more breadth of what we were doing, album tracks, collaborations. We were confident, we'd been playing shows and we were tight. I was back, I suppose; people were starting to take notice again and get excited; you could feel the lift, the buzz, at some of the shows we'd been doing. I saw 'Sunflower' on YouTube recently and it is strong. We came out firing. But that show was a difficult record; we had to wait around because of the Jesus and Mary Chain's sound problems. You can hear Jim's voice on the end of their last song as the credits roll, 'I can't hear myself!'

I have been on *Later...* fifteen times without the Hootenannies and the concert specials, more than anybody apart from Jools and I am really proud of that. Straight away I loved the fact that it wasn't only a rock 'n' roll show, that the music was varied and diverse. I thought at last there's something that really matters on; I loved the breadth of artists and music. There are a lot of different artists that I've discovered through the show – and there's a lot of people who've never been heard of since too! The first time I came across Villagers was on *Later...* in 2010; it was Conor's debut and he was playing on his own. The first time I saw or heard Laura Marling was there too, this young Joni Mitchell-like singer-songwriter on her own acoustic. It's a place of discovery, a lot of great people make their first bow on *Later...* Gregory Porter, that African band Orchestra Baobab. I think it's important it's not just Western rock 'n' roll or pop. You had Anoushka Shankar on,

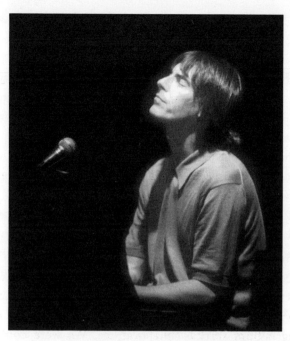

'How many times have I been on?', Paul Weller,
series 5, episode 4, June 1995.

yeah, it's important to show music from all over and how relevant it
is and how it speaks to us wherever in the world it's from; it unites us
and brings us together.

I like the format – the circle and the togetherness. Even though
you're performing for the cameras because it's a television show obvi-
ously but you're also conscious of the other artists watching you and
the audience around you. I like that thing of being surrounded; there's
people behind you, bands across from you, you feel that you're amongst
it. I think it probably also propels the artists to do even better than
they know they can, because you're engaged in watching each other.
If you've just seen someone be fucking amazing, you really want to dig
in and give your best. It's a driver.

I sit and listen to whoever's on before me or after me between my
songs. I'm interested and if I don't like it I'll pop out for a quick ciga-
rette. I like being there with everybody; there isn't any separation
amongst the people. And you feel that even though you're performing
you're still part of the audience in a sense. It doesn't feel too compet-
itive. Everyone wants to do their best, you want to look and sound

good, you don't fucking want to blow it, but that's also because there's a communal spirit to it. You're part of the show and you feel a responsibility to it. You're serving something larger than just yourself.

There's the *Hootenanny* too. Amy Winehouse in 2006 is the standout one for me because she was just so wonderful. It was just before it all really blew up really big, before she got properly involved in whatever she got involved in. We did 'I Heard It Through the Grapevine' and 'Don't Go to Strangers (Come to Me)' together and that will always be a really special moment for me. I remember I was playing the piano and Jools was on the Wurlitzer in front of the orchestra with Amy between us. I sang the first verse, Amy started the second verse, and I just turned and looked at Jools and we both looked at each other and we both had great big beaming smiles on our faces as she sang because we knew it we were in the presence of something and someone very special; everybody knew it, which makes what happened even more tragic but, all that aside, it was a very beautiful moment and Jools' band is so good, they're all such good players. It was a good show that night – Lily Allen was there, Sam Moore, Ray LaMontagne, Seasick Steve. I sang with Tom Jones on the *Hootenanny* too. That was a bit of a moment for me too, doing Ray Charles' 'Hallelujah I Love Her So' with my band in 2015 – we just ran it at soundcheck. He's a bit of a lege, isn't he?

I remember the *Later...* we did around *Stanley Road* in 1995. The show had got bigger since the first time, the studio was rammed, Supergrass was on doing 'Alright', Baaba Maal, Joan Armatrading. Then we did the *Later...* concert special a year later, with Carleen and Jhelisa Anderson on backing vocals and Rico on trombone on 'Broken Stones'! There was so much excitement in the air around then, perhaps it was the last boom time for music, so many bands playing live again; I know people call it Dad Rock or Britpop or whatever, but I am always suspicious when they put a name on it, confining it into a little compartment. It was just people getting excited about seeing bands again.

I've just kept on making new music and I kept on coming back. People ideally just want to hear the Greatest Hits now. Even with me. People just want to hear songs from their youth. But if you're not making new music as an artist, it's kind of death. But it's got harder: people want to hear stuff they're familiar with, which I find odd because if I'm a fan of someone, I'm always interested in what they do next. One of the best things I have done on *Later...* in the studio was the

last thing in Maidstone in 2018. I did 'Gravity' from *True Meanings* with a string quartet and it sounded so good.

You get to play live, you get to do your thing as you want to do it and the capture is so good, it's one of the things that the BBC is really good at, the sound was always great, and I could go and discuss it with Mike Felton after rehearsal and he was open to it, which is rare, and then the director Janet took such care and would think on her feet too. I was never too worried about the visuals because I knew she always did a brilliant job; people don't realise what goes into that kind of work.

When we do *Later...* we always feel really involved in the show, we always try a little bit harder. I always say, 'This is a serious thing, you know!', we always feel involved perhaps because we've been on so many times and we've grown together. We always try to give a great performance which I am not going to say we always manage either. But we feel a sense of responsibility to the show and to ourselves because it matters. Without *Later...* where else can you play live on TV? You can play your single on *Jonathan Ross* or *Graham Norton* at the end, but they are chat shows first and foremost. *Later...* is a music show, you can play more songs and it's all about the music. It's art, it's all right to say that I think, it's not just promotion.

To Later...Crew

Happy 25th !!

I Love you all Very much!

Thank you getting & keeping LIVE music on the Tele !!!

Paul Weller

more power To you !!

Björk

[Written on iPad on tour]

Do you remember the first time you performed on Later... with D'Influence when you were about to release Debut?

Yessss!! I remember fondly the first time I came on *Later...* in July 1993 the week my first album came out on One Little Indian!! I didn´t really have a band at the time, the Sugarcubes had ended in December 1992 after we toured with U2, and it came as a surprise how well *Debut* was received... and D'Influence were generous enough to rehearse and perform someone else's tune!

What did you make of the show that first time? / There isn't too big an audience in the studio at Later... do you feel that you are playing to the other musicians in the room? / You have played on TV shows across the world, is Later... different from other TV shows you've played on? / Is it hard to trust a TV show to do justice to your performance in terms of vibe, sound, lighting?

Well, obviously, *Later...* has the reputation of being the only show in the world of its kind. where musicians can perform for an hour, one song each, once a week!!!

It is unbelievably wonderful statistics!!! It beats any talk show anywhere or any place else! I think also the engineers really care about the sound there. I don't want to slag off universal TV but often when you play just one song in a talk show, the sound is all wrong. A very common error is that the vocals are very loud and the rest of the music far away like the engineers have been taught it is a narrator

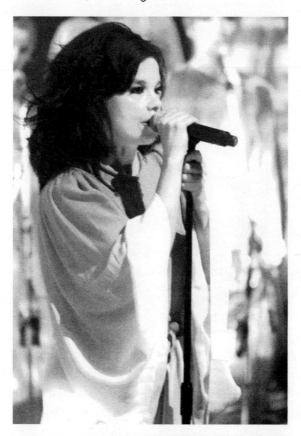

Björk declares independence to Paul McCartney and Adele,
series 29, episode 6, June 2007.

with incidental noise in the back. In *Later...* there is no such thing.
You get soundcheck and the sonic respect as if you were playing your
own show.

*How is playing Later... different to playing one of your own shows or a
festival?*

Just focusing on one or two songs is always interesting... and in between
other people's music... it is a very musical gesture to set something
like that up, and on the several rehearsals you slowly tune into each
other and build a 'build-up' with all of the songs in the whole show.
So, it is humbling in the right way... accentuates what this show is all
about: music.

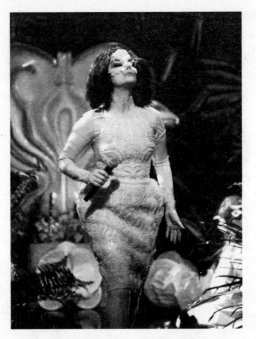

Björk blissing out in the jungle in Maidstone,
series 52, episode 3, May 2018.

What difference does it make to Later... having Jools a musician as host?/
What do you think is the essential spirit of Later...?

I think it makes a humongous difference to have a musician running
it... the whole setup has respect for the sensitivities of musicians. It is
not about the gossip or many of the tedious attachments of stardom
but very cut-the-crap: let's play some music! and when there is talk, it
is about the work, not the personal lives. Also, Jools´s humour and
relaxed nature really floats in the air of the show... he carries integrity
and down to earth-ness that brings out the best in the musicians...
TV situations can be stressed, stuffy and rigid so this is an extremely
precious part of his characteristic that smittens the whole show.

What is your favourite Later... performance and why?

Hmm... tough ask... because all of them were precious to me... the
team at the show always went out of their way to help us set up what
were sometimes brave combinations... doing 'So Broken' with
Raimundo Amador seems like a magic bullet in time for me... also

bringing the Icelandic strings of 'Homogenic' has fond memories...
and in 'Utopia' we brought a jungle with us!!! I sincerely think these
are some of the moments of my work that I am proudest of!! I am
extremely grateful for *Later...* to capture them.

thanks for the
courage & the
persistance to
keep on doing this
for all these years.
it is the only
show of its kind
I know of!!

warmth

björk

p.s. thanks for
allowing space &
welcoming me w/my
quirky noises.

David Bowie and Jools discuss South East London watering holes,
series 20, episode 1, October 2002.

4

What Becomes a Legend Most?

From the 1960s to Now

I am standing in the cavernous TC1 late in the afternoon of 1 July 1994, wondering if Johnny Cash is going to show. Round the studio floor, Johnny's old friend from the Civil Rights era, Pops Staples, is sitting in with Carleen Anderson and her band while the sparse but epic Mazzy Star have already run through their college radio hit, 'Fade Into You'. There's two stages set up for The Man in Black; the first is presided over by a giant blow-up of the cover of his eighty-first album, *American Recordings*, produced by Rick Rubin and released a couple of months ago. In the cover photo Cash is towering over a wheat field framed against a cloudy sky with a dog on each side. He is wearing a long black coat that's billowing in the wind, his dark guitar case almost hidden in his open hands. He looks like a fire and brimstone Southern preacher straight out of *Night of the Hunter*. Perhaps surprisingly, British photographer Andy Earl grabbed the shot in Werribee, near Melbourne, on tour. The dogs appeared out of nowhere and belonged to the local stationmaster.

I have just reviewed *American Recordings* for *Mojo* and gushed that it's 'a breathtaking blend of the confessional and the self-mythologising that makes Cash seem all the larger for his admissions of weakness'. Rubin has helped Johnny believe in himself once more and brought him contemporary songs that speak to his dark psyche like Glenn Danzig's 'Thirteen' or Tom Waits' 'Down There by the Train'. I am a lifelong fan, hooked since I first heard Cash sing 'Orange Blossom Special' on my parents' radiogram in suburbia in 1963. His voice immediately seemed unfathomably deep and mature compared with Cliff Richard or the Beatles. I had no idea that it was Johnny himself urging the train noises out of the harmonica, but I knew that he was nothing like my father or the other commuters catching the train up to Charing

The Man in Black, Johnny Cash, series 3,
episode 7, July 1994. (BBC film still)

Cross. He sang like a man just itching to get out of town. I don't know
if The Man in Black ever rode the rails, but he always sounded like he
did. Now Johnny Cash sounds like a man who wants to settle his account.
Our third series finished a month ago but I have somehow wangled an
extra budget out of what was then branded 'BBC2' to host Johnny Cash,
Later... style, in the studio with some fellow artists. The whole show has
been convened in Cash's honour but now that he is several hours late, I
am wondering if my enthusiasm has got the better of me.

Johnny's band, the Tennessee Three, are set up beneath that looming
preacher photo and they sound-checked a couple of hours ago. His
veteran drummer, W.S. Holland, is back on stage adjusting his simple
kit. He's been with Cash since 1959. The second area is simply a small
circular stage in the middle of the studio floor where Johnny will play
solo acoustic, and which will be surrounded by our invited audience
seated café style. There's a giant guitar neck bearing Johnny Cash's name
painted on the studio floor but there is still no sign of the man himself.
He played Glastonbury a few days ago, almost singlehandedly initiating
the now customary Sunday teatime Legends slot, and his long-serving

manager Lou Robin tells me that Mr Cash is exhausted and unwell. In 1989 Johnny had a heart bypass operation, and in 1990 a dentist broke his jaw while attempting to extract a wisdom tooth. He's had years of addiction to amphetamines and then painkillers. Three years on he will be diagnosed with the neurodegenerative disease Shy-Drager. In 1991 I'd interviewed Johnny for Q magazine in a plush hotel in Piccadilly and seen for myself that he wasn't the healthiest of men. 'Up close,' I'd written, 'his face seems to have absorbed every mile and every sleepless night he has known in thirty-six years on the road. Despite the habitual comparisons, Cash looks nothing like Mount Rushmore. Mountains don't twitch or blink and while Cash has the reserve of a man who likes to keep his own counsel, his hands are restless, and his eyes sometimes seem about to roll over with exhaustion.'

But Johnny Cash is not George 'No Show' Jones. He's not a man who lets his fans or the BBC down. Suddenly here he is, bustling into the studio with the love of his life, June Carter, on his arm. June is bright and bubbly, spreading homespun Southern good cheer wherever she goes. Johnny is sixty-two, well over six foot and leans on his wife. He looks weary and a little wary. As Rubin recalled of their recording sessions, 'He didn't speak much but, if you drew him out, he seemed to know everything. He was shy and quiet but a wise, wise man.' I don't know whether Johnny's been feeling poorly this afternoon or simply had enough of hanging around television studios but he's here now and in moments the Tennessee Three have picked up their instruments, Cash has strapped on his acoustic guitar, and they are running 'Folsom Prison Blues' for the cameras. He's happy to do '(Ghost) Riders in the Sky' which he always seems to play in concert and which I hope will sit well next to the haunted Mazzy Star and later his own 'Get Rhythm', the B-side of his 1956 hit for Sun Records, 'I Walk the Line'. I wish I'd asked for that as well – but Johnny Cash is finally here, he's tired, and I tell myself not to be greedy.

Johnny's excited to sit on the stool on that tiny second stage, alone with his guitar as he is on his comeback album. Nick Lowe is hanging out at the back of the studio and June and Johnny are delighted to see him, even if his marriage to Carlene Carter ran out of steam a few years earlier. 'He's our favourite son-in-law!' June confides. Lowe has given Johnny one of his new songs, 'The Beast in Me', a bleak but witty confessional that is one of the key tracks on American Recordings, and clearly chimes with the Man in Black's own addictive personality

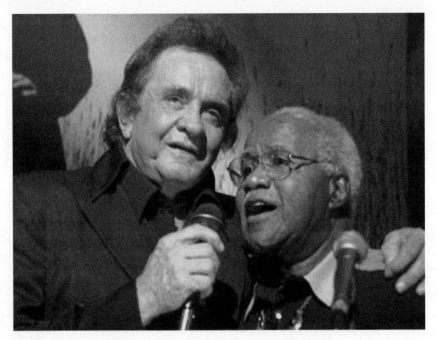

Johnny Cash and Pops Staples serve somebody,
series 3, episode 7, July 1994. (BBC film still)

and dark nights of the soul. Johnny is thrilled that Pops Staples is on the show. Johnny grew up in Dyess, Arkansas, and Pops in Drew, Mississippi, less than 150 miles apart. Both families were poor sharecroppers, picking cotton. Cash first introduced the Staples Singers on his network television series back in 1969. 'Is there any of us who at times hasn't needed a little inspiration to continue?' Cash asked as Pops and his daughters waited silhouetted in the shadows, 'And if you happen to need it right now, I am proud to say that here's the best in folk-gospel, the Staples Singers!'

Pops is seventy-nine now, eighteen years senior to Johnny Cash, and here with his own solo album, *Father Father*, but they greet one another with a hug like long-lost brothers. They decide to finish with 'Will the Circle Be Unbroken?', the 1907 Christian hymn whose lyrics were rewritten by June's uncle, A.P., for the Carter Family in 1935, with Johnny, June, and Pops each taking a verse, Carleen on the chorus and Jools on piano. Johnny's almost comfortable now and our veteran camera supervisor Gerry Tivers takes the opportunity to ask him to sign his ped camera, a rare request reserved only for true legends. Manager Lou and I are almost cooing with relief while Jools is

befriending Johnny, talking through the chat they will have at the piano and explaining how his songs will be interspersed with performances from Mazzy Star, Pops and Carleen.

An hour or two later the studio audience have filed in and are either standing against the walls, staring around the room at the set and the cameras, or sitting in the chairs we've managed to borrow from another studio. When Johnny Cash walks in, dressed in a dark suit, everybody spontaneously claps. I'd last seen Johnny play at the Royal Albert Hall in 1989 and I was one of the youngest people there, surrounded by a sea of grey. Tonight's audience are mostly half his age or younger. They haven't grown old with him, but they know the legend and maybe they just saw him at Glastonbury. There's a spring in his step when he strides forward to the microphone with his guitar raised and kicks straight into 'Folsom Prison Blues'. He's sweating under the lights but there's a light in his eye and the band are a-rocking and a-rumbling. Lead guitarist Bob Wootton is sporting a huge black Stetson and there's no frills in his picking which is spare and elemental. Johnny's working his old stage tricks, turning away from the mike in between verses only to spin back for the next line with a twist of the head and a shake of the leg. Suddenly he looks like a man who might well have shot a man in Reno just to watch him die. He doesn't exactly look regretful. He's stuck in Folsom Prison, twenty miles north-east of Sacramento, and he's tortured by the train he can hear whistling in the distance with its rich passengers, their coffee, and their cigars. They are moving and he's stuck in his cell. Time is dragging by but Johnny's lined face and staring eyes seem to accept that he had it coming, that he can't be free.

Later, when Johnny sits down at the piano, Jools asks him about the panthers and he mentions in the new album's sleeve notes. 'Well, when I was a boy,' explains Johnny, 'I'd go to a friend's house – he played guitar – and I would sing along with him. Then at night it would be a long walk back home. It's like a jungle out there in the Delta in Arkansas where I grew up. I would hear panthers out there in the night so I would sing as loudly as I could all the way back home on that gravel road, barefoot. I'd sing old folk songs, gospel and spirituals.' Jools asks him about the first songs he remembers hearing. 'Well, my mother played guitar,' recalls Johnny who folds his arms and turns towards Jools. 'One of the first songs I remember her playing was "What Would You Give in Exchange for your Soul?"' He nods at Jools

as if to underline the weight of the title. 'Then the first song I learnt was "Hobo Bill's Last Ride". I lived within hearing distance of the old Memphis radio stations when I was growing up so I heard a lot of blues and Black gospel and spirituals. Sister Rosetta Tharpe was one of my favourites – "This Train is Bound for Glory", "Didn't It Rain?" "Up Above My Head" – I still sing those songs.' After a few more questions Jools cannot resist asking Johnny if his new show is anything like Cash's old ABC television show which ran from 1969 through 1971 and was filmed at the Grand Ole Opry in the Ryman Theatre in Nashville. 'Yeah, it was a variety show like this,' Johnny nods, to Jools' visible delight. 'People from all walks of musical life, a different way of programming, the different setups, I like that.'

After Pops gently admonishes the room with a funky cover of Bob Dylan's 'Gotta Serve Somebody' with Carleen and cousin Jhelisa providing gospel support, Johnny sits on his stool with his guitar while the audience seated around him twist round to watch him. When he plays 'The Beast in Me' followed by his own allegorical 'Redemption', Cash is a man alone, facing up to his own sins, searching for forgiveness, looking to serve somebody. He's out there alone in the middle of the floor surrounded by a seated audience including the Jesus and Mary Chain's William Reid who are feet away from The Man in Black who is explicitly and deeply Christian. He wants to confront his failings and celebrate his redemption. Jesus bleeds from the cross – from his side, his feet, and his hands – and it is Christ's blood that enables Johnny to defeat his old enemy Lucifer, 'six-sixty-six'. Too much light spills from Johnny onto the audience around him so in the edit we put this acoustic section into black and white which seems to suit the message and the mood. Cash's guitar strumming is simple, his voice deep, but it is his steady stare as he confronts the camera with his own frailty that grips most of all. For the finale Jools chats briefly to June and then she and Johnny lead Pops and Carleen through 'Will the Circle Be Unbroken?' Pops has already thanked Johnny for his support in the civil rights struggles of the late 1960s. Now it is his high plaintive voice that rings out. The harmonies are unrehearsed and all over the place, but Johnny seems pleased just to be part of it. He has his arm around Pops' shoulder while the chorus goes round and round like a revival meeting, celebrating the life to come. Pops tries to get the audience to sing and clap along but I fear they've come more for Johnny the sinner

than Jesus the saviour. Nevertheless, by the time the song finally ends, Johnny and June look blissfully happy.

Years later in autumn 2007 I am sitting across from Neil Young in the Carlyle Hotel on the Upper East Side, about to film an interview for what will become Ben Whalley's BBC documentary, *Don't Be Denied*. Just before Neil entered the room, his manager Elliot Roberts leaned into my ear and urged me to stick to the new album, *Chrome Dreams II*. But I am here to try and initiate a career portrait of 'Shakey', a nickname that suits 'because nothing is too solid about the guy' according to his unofficial biographer, not to promote his twenty-eighth studio album. I start by asking Neil if he remembers the first time he played New York. When he tells me that it was with Buffalo Springfield on a bill with the Doors back in the 1960s, I know that, for once, he's prepared to play ball and go back. Near the end of the interview Neil will try and explain what's required to maintain a long career and how a legend is made. 'There's always another wave,' he assures me, pausing for effect. 'So, you're going to go up and down; waves are going to keep coming, every once in a while you're visible to the world and other times it's like you're in a trough, nobody cares. Everybody's looking at the whitecaps. They don't see you but then… you come up again, riding something and it's like, "Where the hell did they come from? I thought they were gone!"'

Neil Young has never played *Later…* and neither has Bob Dylan. Although Neil once claimed 'it's better to burn out than fade away' while Bob wished to stay 'forever young', it took Live Aid to heal the Oedipal scars of punk and welcome back the sixties artists that had been so summarily and scornfully dismissed as dinosaurs. Youth was no longer the prime currency of popular music once that first generation realised that they weren't doomed to fade away. They had a head start and could do this for life, growing old with their lifelong fans who would pass them on to their kids. They would always be the touchstone. The first episode of *Later…* featured Aaron Neville singing 'Tell It Like It Is' from 1962 and over the years we've hosted our fair share of these 'legends', often when they've got some new work to perform and are happy to trade an old 'classic' for a song or two from their latest opus. Some are riding a new wave like Johnny Cash back in 1994, some are in a trough and – as Iggy Pop apocryphally quipped

at the Reading Festival – 'glad to be here, glad to be anywhere'. Their voices have often deepened and sometimes they've fractured. They'll sit patiently at the piano and endure watching old footage of themselves when they were young and beautiful when Jools takes them 'down the time tunnel'. Their faces are lined and their hair either grey or mysteriously jet black but the songs of their youth endure and speak to new generations.

When *Later…* began in a physical world of record shops and music magazines, long before the internet, the originators of the 1950s and 1960s were in their middle years. Now they are senior citizens and well into their seventies. Their classic songs are their assets and their new songs the currency that keeps them vital. But television is a cruel mirror. Sometimes they will rage and struggle against their own suffocating legacy and the dying of the light. They know they are being honoured but they want to show who they want to be, not who they once were. There aren't really any precedents for the journey they are on, which is why these legends are so fascinating to observe.

I will never forget Ray Davies walking across the Horseshoe at Television Centre less than an hour before that evening's taping. A label had assembled a new box set and Ray had been booked to chat to Jools about his great body of work. But Ray has never a man who makes life easy for himself. I have got to know him a little since the Kinks gave one of their last appearances on *Later…* back in 1993. I remember that both Ray and Dave came up to the sound gallery separately after camera rehearsal and instructed sound mixer Mike Felton to ignore whatever sonic advice their sibling had just offered. I'd executive-produced a 1995 Vanessa Engle profile of Ray entitled *I'm Not Like Everybody Else* after the B-side of 'Sunny Afternoon'. I'd managed to forget the many impossible caveats that Ray had imposed during filming because he was always charming, he always seemed to be making life even tougher for himself than whoever he was sparring with, and he clearly suffered from something like stage fright. My wife worked with him for a time and when he returned a decade later in 2006 with the solo album, *Other People's Lives*, he wouldn't come out of the camera bay for the cast photo and she had to go and find him, wrap her arm around his and lead him towards the piano. But he was also and always Ray Davies of the Kinks, a national treasure, and once he was out there in the

spotlight, he would transform into one of our greatest frontmen with an indelible songbook.

Yet Ray couldn't help but be tricky. I'd nearly fallen out with an exhausted Rhythm & Blues Orchestra when Ray came on the *Hootenanny* to welcome in 2001 with 'You Really Got Me' and 'Lola'. The night before the show he insisted on riding in a new song, 'Yours Truly, Confused, N10'. The Orchestra had already arranged and learned twelve new songs for the occasion and here was Ray late in the evening on the studio floor, running through the many verses of the song and trying to get the brass players to come up with a head arrangement on the spot. Jools would later release it on one of his collaborative albums, 2002's *More Friends*, but that night I got it in the neck for not reining the great man in.

So as Ray walks towards me in the gathering dark outside our BBC Studio in November 2008 I know there will be a conundrum. There always is. Ray isn't even performing that night, just chatting. Maybe that's the problem. 'I've just come to explain to you why I can't come,' Ray explains obliquely as he gets within earshot. He's carrying a shoulder bag that surely contains an early pressing of the box set but it seems that a legal complication has arisen and, until it is sorted, Ray simply can't discuss said collection. There is something about a publishing dispute and I can only sympathise. I try to sound as calm as possible and not to put any pressure on Ray while letting him know that he'll be leaving a great big hole in the show that it is now too late for anybody else to fill. We talk about what else Ray is up to, notably his new musical, *Come Dancing*, even though it has just finished its run at Stratford East. Eventually, we agree that he will chat to Jools about this venture and a few other projects and I promise the box set will not be mentioned. Ray graciously pops up in front of Jools and his clipboard an hour later while younger acts including Stereophonics, Solange and Eli Paperboy Reed perform. He talks about *Come Dancing* and the music halls where his sisters danced in the 1950s and offers sage advice for young artists starting out. A few weeks later Sanctuary release the box set. A couple of years later and Ray returns to play 'Days/This Time Tomorrow' with Mumford & Sons from a new album of collaborations on Kinks' classics, *See My Friends*. At the end of 2013 he returns to play the *Hootenanny*, diso-

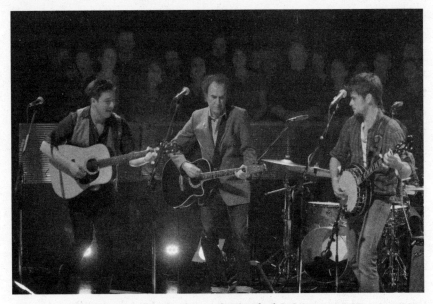

Ray Davies counts the days with Mumford & Sons, series 37, episode 5, October 2010.

riented and struggling with an ear infection. Ray's always in turmoil, always juggling the demands of his legend with his need to move forward.

Ray Davies helped me learn that not too many legends want to rest on their laurels or only play their old hits. So, the past and the hits become like bargaining chips in their fight to get an airing for the new work that no one's quite sure that they want to hear. In 2002 David Bowie returned to *Later...* for the third time. He'd just released *Heathen*, his twenty-second studio album and his first with producer Tony Visconti since 1980's *Scary Monsters*. Clearly caught up in the wake of 9/11, it's a brooding collection, heavy with alienation and loss. I am still recovering from Bowie's hit-packed Sunday night set at Glastonbury in 2000 where we were only allowed to broadcast a handful of the opening and closing songs to my chagrin and our viewers' utter dismay.

It's our 150th show and the start of our twentieth series. David is fifty-five and still fighting his way back from losing his way in the mid-1980s. All his recent albums are comebacks that please the faithful, but his imperial phase is behind him. 'I'm pretty much a realist,' he

tells *Entertainment Weekly*'s Jeff Gordinier. 'There's a certain age you get to when you're not really going to be shown (on TV) anymore. The young have to kill the old… that's how life works… It's how culture works.' Bowie is returning to *Later…* for the third time, topping a bill that includes Ms. Dynamite, the Coral and Beenie Man. From the very first *Later…* I have tried to curate the mixture of artists on the show, what they play and in what order. In a show that is only about Jools and the music, the blend of the cast, the sequence of the songs and the emotional trajectory of the hour are paramount. I don't try to tell artists what to play but it matters to me almost as much as to them: during the show's first decade we have built the shape and weight of each programme around the songs. The right songs.

David's the elder statesman but he won't discuss with me what songs he's going to play. He's huddled on the other side of the studio next to his band with his fearsome assistant Coco Schwab, publicist Alan Edwards and his plugger Tony Barker, whom I worked with at Virgin in the 1980s. I am desperate to get David to play either 'Everybody Says Hi' or 'A Better Future', the two most accessible songs from *Heathen*, oddly buried at the end of the record. I also wish he'd offer up something less dense than 'Look Back in Anger', the track from 1979's *Lodger* he's put forward as a second oldie. *Later…* regularly opens with something new and finishes on something old when there's a legend in the house. Tony comes over to the piano where I am skulking, hoping for an audience with The Dame, shaking his head. 'He won't talk to you, I'm afraid. He's decided on these four songs – "Heathen", "5.15 (Angels Have Gone)", "Look Back in Anger" and "Rebel Rebel".' The large band including three guitarists run judderingly through the tracks for the cameras; Sterling Campbell's drums sound cavernous, pianist Mike Garson solos wildly and Bowie soars operatically. I have always figured that 'Rebel Rebel' will close the show, but given what's on offer it's suddenly blindingly obvious that this should be our finger-clicking, hand-clapping show opener. Fortunately, David doesn't mind what order the songs come in and so this landmark episode of *Later…* begins with David Bowie tossing his fringe out of his eyes and leading an ecstatic studio audience through his Glam anthem from 1974's *Diamond Dogs*. It's not exactly contemporary but it is classic and, nearly ten years into the show, there's room for both. The denser, more demanding numbers come later.

I never get to speak to Bowie that night and he's destined never to return. A couple of years later he has a heart attack on stage and quits touring. There's a decade gap from 2003's *Reality* until his last two albums. Time and silence refurbish David Bowie's legend as does his twenty-fifth album, ★ (*Blackstar*), which comes out on his sixty-ninth birthday, just two days before his death on 10 January 2016. The accompanying 'Lazarus' video is as painfully mortal and unflinchingly artful as Johnny Cash's 'Hurt' and its timing as cannily stage-managed as anything from Bowie's 1970s. It is his greatest ever comeback. I am reminded once again that a career is like a game of chess and that a legend always knows best.

So too did David's old friend Lou Reed. I'd first interviewed Lou for both *The Late Show* and *Q* magazine in February 1992, a few months before the launch of *Later...* He'd just released *Magic and Loss*, a harrowing account of the loss of two friends, Doc Pomus and Rita, and published a book of his lyrics, *Between Thought and Expression*. His curls were shaped in a neck-length mullet, he talked technically and endlessly about recording guitars and worked hard to distance himself from the rock 'n' roll animal whom I'd seen as a student in 1972, pretending to shoot up onstage during 'Heroin'. Lou presented himself as a poet and reporter now, not a drug fiend tilting for rock stardom. He seemed to have shelved his desire to shock but he still wanted to spotlight ugly truths. His fiftieth birthday was a month away and he was already entering his elder statesman phase. 'No one treats Hamlet like a personal aberration of Shakespeare. I acted out a lot of my characters and, of course, I was some of them... but the writing is one thing and the person is something else. Drugs and liquor did not do me any good...' was all he would say about his 1970s. Now he was all about observation, empathy, and the craft. 'There's a lot of what you might call violent or vicious songs in my work but I feel compassion for the characters in them. Because I know what it's like to be on the outside. And I delineate these people because either I identify with them or I think that they deserve their moment in the sun. There's a line in "Street Hassle", "Everybody's a queen for a day." And I'm not saying that in a denigrating fashion.'

Eight years after that *Q* interview Lou came on *Later...* to promote 2000's wildly uneven *Ecstasy*, another concept album of sorts which explores marriage and relationships. It was his eighteenth solo album

and the last that's not a collaboration. He'd perfected a crunchily dynamic rock quartet with guitarist Mike Rathke whom he'd worked with since 1989's critical comeback *New York*, bassist Fernando Saunders and drummer Tony 'Thunder' Smith. I was thrilled that Lou was finally playing our show, kicking off a bill alongside fellow 1960s veterans Al Jarreau and Bert Jansch, Kelis, MJ Cole and Broadcast. We were still commissioning backdrops based on album-cover artwork and Lou's band was framed against four portrait shots from *Ecstasy*, his face tilted back, his eyes closed. Photographer Stefan Sagmeister had got Lou to masturbate behind a curtain to capture this expression of unashamed ecstasy.

The discussion over which songs Lou might play had never quite been resolved. We'd agreed on the mid-tempo 'The Modern Dance', a midlife meditation on the prison of marriage and paths not taken, in which Lou often sounds like a middle-aged American tourist. In one verse he even randomly wishes he were in Edinburgh, sporting a kilt, an image that's hard to get your head around. 'Edinburgh' is pronounced 'Edinboro' as if it's just over the bridge from Manhattan. It wasn't a show opener however and there were more rocking candidates on the album like 'Mystic Child' and the anthemic 'Big Sky'. He'd also offered up 'Sweet Jane' as an oldie and I'd bitten his hand off. Meanwhile Lou's representatives from the British wing of the record label kept mentioning 'Rock Minuet', a spoken word narrative in the brutal vein of 'Street Hassle'. Some of the album's songs were simply too long for television, notably the eighteen-minute 'Like A Possum', and 'Rock Minuet' was the second longest, clocking in at around seven minutes.

I doubt that Lou remembered our previous encounter although he pretended he did, but he was amiable, almost chatty, when we got talking on the studio floor as camera rehearsals began. He was clearly utterly determined to play 'Rock Minuet'. He wasn't interested in durations, tempo, or the shape of the show. He was going to play this slow, searing account of a gay guy distorted by hatred of the father who'd abused his mother and whose 'piss ugly soul' seeks relief in casual sex and eventually in violence. Seven minutes in three-four time, a slow stately dance with murder in its soul whose characters' sordid fate is related in Reed's stately drawl, 'Rock Minuet' is as much fatalistic as compassionate with Lou unblinkingly outlining the lurid appeal of the dark end of the street. It's half character study, half penny dreadful, and Reed himself is an unblinking witness, a professor of the New York

streets. I am not sure if he intended to shock but he certainly didn't want to look away.

I guess I was thinking about the show's running order but Lou had another focus. He had told me back in 1992 that he'd concluded that the most important thing in life is art and that's where he now went for sustenance. 'Rock Minuet' might well be art but 'Sweet Jane' is a joyous, up-tempo celebration of rock 'n' roll. So that episode of *Later...* opens with 'Sweet Jane', the Velvets' swaggering celebration of the redemptive power of rock 'n' roll from 1970's *Loaded*, Reed enjoying his legend as the show takes off. 'The Modern Dance' pops up halfway through; Lou's now in recital mode, reading lyrics from autocue, eyes downcast, the humour so dry it's easy to miss. 'Rock Minuet' is the finale and, goddammit, it sucks you in. In his latter years, Lou Reed could be a bit grand as a certain pomposity crept into his work and how he now regarded himself and his legend. But this performance of 'Rock Minuet' proves he still knew what he was doing, Mike Rathke's guitar soars like a cello and Lou narrates his slow, sad story. It's bleak and compassionate and I am so glad it exists. When Reed died in 2013 director Chris Rodley made a BBC Four tribute in a matter of weeks, *Lou Reed Remembered*, tracking his music over the years. Chris kept telling me that 'Rock Minuet' was one of the best things that Lou had ever recorded and that *Later...* had ever filmed.

When Lou returned in 2003, he had his Tai-Chi teacher and the then largely unknown Anthony Hegarty – now Anohni – of Antony and the Johnsons in tow. It was a late booking for the first show in our spring series, we already had five artists – four bands and South Africa's acapella Ladysmith Black Mambazo – but it was Lou Reed. I thought we'd booked a trio but Lou turned up with Rathke, Saunders and the cellist Jane Scarpantoni as well as Anohni and Master Ren Quang Yi. He'd just overseen a compilation of his work, *NYC Man (1967–2003)*, and he was upbeat, avuncular but still acerbic. We had to stop the show after Kings of Leon's debut performance and set his gear in place while Lou chatted with Jools at the piano. Jools asked him about his typical day and when Lou claimed he generally got up at three and started planning his evening, the studio audience whooped. When he announced he would play 'Perfect Day', they whooped again and Jools asked him what perfect day had inspired the song, originally the B-side for 1973's 'Walk on the Wild Side'. 'If

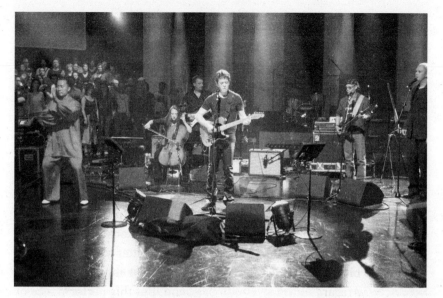

Lou Reed in search of a perfect day, series 21,
episode 1, May 2003.

I'd had a perfect day, I would never have written about it,' countered a smirking Lou. 'I wouldn't know a perfect day if it bit me.' After the contemplative 'Who Am I (Tripitena's Song)' from his Edgar Allen Poe opera, *The Raven*, another mid-paced song about ageing and the mysteries of fate, Lou launches into 'Perfect Day'. Master Ren is standing to one side effortlessly throwing various shapes in a red silk Chinese suit. A close-cropped, peroxide blonde Hegarty takes the second verse in his tremulous high croon. Just before Lou sings about reaping what you sow, Master Ren suddenly does the splits. The Velvets had the Exploding Plastic Inevitable, we had Tai-Chi. I guess Ren and Lou's partner Laurie Anderson, whom he'd marry in 2008, were helping him loosen up, have fun.

Lou once wrote a song entitled 'What Becomes a Legend Most?'. In his case, it was always pursuing his nose and his nose led him to some strange places. Reed first met Metallica at Neil Young's Bridge School Benefit Concert in 1997 and they'd performed together at the Rock and Roll Hall of Fame's 25th Anniversary Concert twelve years later. Metallica too had been on *Later...* a couple of times already when they teamed up with Lou in 2011 to record the *Lulu* double album, Lou's take on Wedekind's opera, with Reed half talking his lyrics over the

band's thrash dynamics. Now, months later, they were ready to give the BBC a sneak preview.

Lou was pushing seventy and looked frail and absent as he was supported over cables and behind curtains to the studio floor that November. But there is nothing frail about the performance of 'Iced Honey', James Hetfield playing the anchoring riff and then harmonising with Lou as drummer Lars drives the band relentlessly forward. Lou's lyrics are even more probingly psychological than 'Who Am I?' or 'The Modern Dance' as he quizzes his character's dysfunctional emotional make-up. When they close the live show with 'White Light White Heat', the transgressive garage rock of the 1968 original is given a berserk thrashing by a beast of a metal band with thirty years already on the clock. The Velvets' original is charmingly amateur in comparison: it sounds like something that's never been done before, chaotically but succinctly evoking an intravenous methamphetamine rush in under three minutes. It must have been shocking at the time. Metallica are like uber professionals in comparison; they know exactly what they are doing, they're highly skilled with musical chops that Reed, John Cale, Sterling Morrison and Mo Tucker with their punk approach to classic rock 'n' roll surely never imagined. Hetfield stands over the drums driving Lars forward, Kirk Hammett shreds, bassist Robert Trujillo pumps out notes in a half crouch and Lou presides at the mike in sensible spectacles, trying to harmonise with Hetfield. Or maybe Hetfield is trying to harmonise with him? They are like tribute acts to each other. I am not sure if the collaboration is any good but it's certainly compelling. Like rubbernecking a collision. Metallica let the dogs out as Reed stoops wearily over his guitar. The flesh is weak but the spirit's still wilful and perverse. Two years later Lou was dead.

The Sixties generation certainly didn't expect their time in the sun to last more than a few years when they started out. They'd been taught that a pop star has the life expectancy of a butterfly and, when quizzed in the first flush of fame, they'd mutter about hoping to keep going another couple of years and then writing for others. Even the first rock stars who'd set out to be more significant and less ephemeral once they'd smoked a joint and listened either to the blues, a classical symphony or both, always kept half an eye on the mirror. Then Punk gave these first veterans a proper scare just as they edged into their

Lou and Lars, 'White Light White Heat', series 39,
episode 8, November 2011.

thirties, insisting that rock music was a youth culture and that they no longer belonged. Yet in the long run, Punk was outdistanced by the originality and determination of that original rock generation. The baby boomers stayed faithful and they shared their commitment, their CD collections and their T-shirts with their children.

Youth became a proposition that had less and less to do with being young. By the millennium everyone dressed in jeans. As the Sixties originals got older and were canonised with terms like 'great' or 'legend', it was still the music they'd made in their teens and twenties that remained their primary calling card. The music of their youth. They were becoming 'forever young'. Unlike athletes or footballers, they could still do what they'd started out doing. They could tread the boards, they had voice recognition, they remained the chosen generation and this was now their life's work, not just the first flush of youth. Yet even if they wanted to leave their halcyon days behind, they couldn't. The artists that followed would find the same thing. Paul Weller's lifelong fans still call out for Jam songs, Madness have to play 'Our House', Elvis Costello still has to go to Chelsea. But they all need to make new music even as their glory days become a field of study. Perhaps it's that struggle that makes them living legends…

Paul McCartney, Bryan Ferry, Pete Townshend, Eric Clapton, David Gilmour, Joe Cocker, Steve Winwood, Eric Burdon, Jack Bruce, Van Morrison, Jeff Beck, Jimmy Page, the post-war British men that invented rock in the late 1960s, have all regularly returned to *Later...* while only Marianne Faithfull of that era's female pop stars has maintained a comparable steady flow of new work. Robert Plant remains perhaps the most restless and forward facing of this generation, constantly reinventing his sound and trying to move on from his daunting Led Zeppelin legacy. He thinks that legendary status is a kind of living death that he works tirelessly and anxiously to avoid.

Robert was blond, white smocked and solo, singing Tim Hardin's 'If I Were a Carpenter' in 1993 on our second series, his long curls falling in his face and using an old Shropshire/Black Country phrase to almost apologise to Jools for his Rock God days. 'I think music's responsibility is to bring a little light, rather than too much strutting... Mind you, I've had to go a long way to find that out, round the Wrekin.' A year later he was back in tandem with Page for the first time since 1980 to reimagine their Led Zeppelin catalogue, the traditional 'Gallows Pole' with a hurdy-gurdy and 'Four Sticks' reconceived with Egyptian musicians. Since then, Robert's returned with band after band, line-up after line-up – Strange Sensation, Band of Joy and the Sensational Shapeshifters – shimmying his way through his later years and finding time to team up with bluegrass star Alison Krauss for 2008's multi-Grammy winning album *Raising Sand* in which they blend his love of Black Southern blues with her high lonesome mountain music, distilling something witchily good that's a country mile from his lemon-squeezing twenties.

Krauss is precise and controlled in her music, Plant's a wayward fuse, a rock 'n' roll improviser, and yet somehow they click. Alison is nearly twenty-three years Robert's junior and when the odd couple came on to chat up that first album release in late 2007, she still remembered hearing her brother Viktor screaming to Led Zeppelin in his bedroom in Champaign, Illinois, in the 1970s. She didn't mention that some thirty years later she'd sung Robert's 'Big Log' on bassist Viktor's 2004 solo album, *Far from Enough*, as if already modelling their collaboration. Robert and Alison returned six months after that interview to play four songs from *Raising Sand* with a crack band featuring Nashville guitarist Buddy Miller and the man Robert had

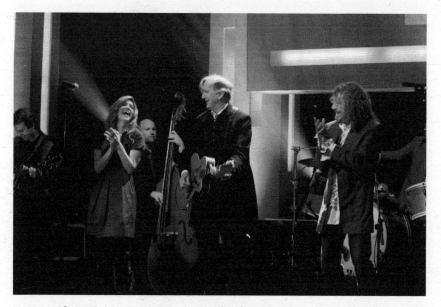

Alison Krauss, T-Bone Burnett and Robert Plant get gone, real gone,
series 32, episode 6, May 2008.

previously described as the 'Daddy' of the project, producer T-Bone
Burnett. T-Bone clearly enjoyed escaping the mixing desk and his record
library, strumming his acoustic guitar and standing upstage between
the unlikely front couple like a towering gooseberry. Robert dressed
up as a Southern gentleman in a frilled white shirt and stepped gamely
out of his comfort zone to give it his best George Jones phrasing on a
cover of Johnny Horton's 1956 hit, 'One Woman Man', that Jones had
taken back into the charts in 1988. Yet Robert and Alison also sang
with a sweet and subdued sadness on 'Killing the Blues', first recorded
by John Prine back in 1979, barely looking at each other but expertly
blending their voices.

Robert then came to Maidstone with singer-songwriter, Band of Joy
collaborator and sometime partner Patty Griffin for her *Later...* debut
in 2013. She was losing her voice and getting cold feet about even doing
the show that evening but he nursed her through, harmonising on her
'Highway Song', constantly reassuring her. He's always generous with a
gleam in his eye and a spring in his step, delighting in Jools' quirky
Britishness and their shared love of the blues. Led Zeppelin preferred
stadiums to television shows and famously made their own rules and
Robert has always been a little wary of TV's timings and constraints

which he'd never had to endure in their imperial phase. But he's always submitted to the process with good grace. He knows that his former band Led Zeppelin remain beloved, and he will patiently revisit the old tunes – 'Misty Mountain Hop' in 2017, 'Whole Lotta Love' in 2014, 'When the Levee Breaks' in 2005, 'Wanton Song' with Page in 1998 – always reworked. He's not in denial, he carries the past with him, but he always has new music to make. He helped define the rock god persona in the 1970s, shirt open, cooing and shrieking with desire, but he's redefined himself as a mostly sweet singer with the purest of tones and a keen ear for the desert blues and drones that lurk in the Bo Diddley meets African rhythms he's embraced. That long mane of hair is greyer now and often tied back but it's the only constant in a mercurial career driven forward by curiosity. He's refused to be defined as Led Zeppelin's rock god. In a very rock god way.

There's magic in the old songs and the artists we now call 'legends', sometimes sentimentally, sometimes seriously. *Later...*'s primary currency is new music. But when a legend steps forward with a song that's never lost its magic amidst a room of young artists and new releases, the legend and the song remain a kind of mirror, a reflection of our own lives. Perhaps it's trickier for rock 'n' rollers to know how to manage their lost youth because youth was often so much a part of their original proposition. Entertainers are less troubled by growing old. Sometimes too, it's their sheer character, the way they wear that journey, that embellishes their legend. Eartha Kitt was eighty-one and in what turned out to be the last year of a long life as an entertainer and activist when she popped into the show on her way to the Cheltenham Jazz Festival. In April 2008, Ms Kitt disappeared into Jools' dressing room to get reacquainted and rehearse while his rhythm section of guitarist Mark Flanagan, bassist Dave Swift and drummer Gilson Lavis set up in the studio. Jools and Eartha had met years before on his BskyB *The Happening* programme and she clearly knew she could have fun with this English gentleman with the twinkling fingers.

Eartha Kitt was born on a cotton plantation in South Carolina in 1927, started out in Harlem in the 1940s with the Katherine Dunham Company, the first Afro-American modern dance troupe, and starred as Helen of Troy in Orson Welles' stage production of *Doctor Faustus* in 1950. She was just getting started and proceeded to have her share

of hits with suggestive and cheeky show tunes right through the 1950s. In the late 1960s she'd played Catwoman in the third series of *Batman* and condemned the war in Vietnam to Lady Bird Johnson's face at a White House lunch. This didn't make her popular with the CIA but Ms Kitt clearly always spoke her mind, later espousing gay rights while retaining a gift for camp which shone out in her movie and theatrical work. As she explained to Dr Anthony Clare in a 1989 radio interview, 'We're all rejected people, we know what it is to be refused, we know what it is to be oppressed, depressed, and then, accused, and I am very much cognizant of that feeling. Nothing in the world is more painful than rejection.'

The Charlatans, Lykke Li and the Yamato Drummers of Japan are amongst those watching when the lights drop that night and Jools introduces Eartha, hammering into a stride intro to Fats Waller's impish celebration of fidelity, 1929's 'Ain't Misbehavin'. Kitt stands across from Jools in the well of the piano, a long red scarf around her neck. She starts with a finger to hold back the band and before you know it, she's relishing the first verse, making eyes at Jools, the object of her affection throughout, raising a leg and creeping round the piano to join him on his stool. Only Eartha could make fidelity sound quite so flirtatious as she goes to town on the lyric's insistence that she's now a one-man woman, happily out of the game. Jools is answering back on the keys while raising an eyebrow or two himself and suddenly Eartha's leg is up on top of the piano while she positively coos at him. 'Very sexy,' she mutters during his solo. She only has eyes for her host throughout and he is punctuating every phrase with a slap or tickle on the ivories, playing the foil. The voice is husky and no longer quite as certain of its pitch as in her heyday but Ms Kitt is holding court, scarf around her throat, long eyelashes fluttering, tongue firmly in her cheek. Rarely has a woman sounded quite so out on the tiles while insisting that she's staying home with the radio, renouncing misbehaving, a one-man woman. Right before the final chorus Eartha throws in a knee drop and almost purrs as Jools peers back round the piano. She's enjoying herself throughout and positively savours the dramatic long pause before her final phrase, after which she promptly breaks into a joyful cackle.

The whole performance is a triumph of persona, as close to acting as singing. She's hamming up her legend. Kitt has dropped in from

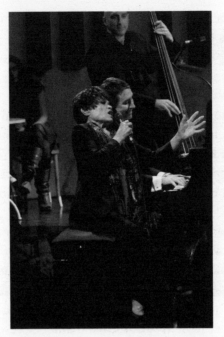

Eartha Kitt and Jools misbehavin', series 32,
episode 4, April 2008.

another age. But she couldn't have been more alert and alive. Or younger at heart. Her enduring survival had long been at the heart of her legend and enabled her to capture a studio full of musicians young enough to be her great grandchildren. Character and longevity have become key calling cards in pop's rich tapestry as the Sunday-afternoon 'Legends' slot at Glastonbury attests. In the early 2000s there was something ironic, almost camp, in this slot that might well have suited Eartha once upon a time. The evening headliners were still rockcentric but the teatime slot belonged to entertainers with a catalogue of hits and plenty of miles on the clock. As Glastonbury has become more part of mainstream culture and a television fixture, the Sunday legends are now embraced without irony and no longer treated like guilty pleasures. Suddenly everyone remembers they love them. They are on the crest of the wave. But these showbiz legends aren't tribute or oldie acts; they are still recording, still in the game.

So too are the Temptations, who released the single 'Is It Gonna Be Yes or No' with Smokey Robinson in 2021. But it's not new material that enables the group to regularly tour some of the UK's largest arenas,

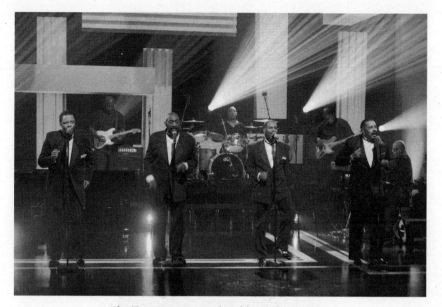

The Temptations suited and booted, series 49,
episode 6, October 2016.

usually in tandem with fellow Motown stalwarts the Four Tops. Both
groups have a set full of 1960s and early 1970s hits and retain that
crucial signifier of authenticity, an original member. No matter that no
fewer than twelve members of the Temps have died to date, founder
member Otis 'Big Daddy' Williams has remained a constant since 1960
when the very first line-up came together out of vocal groups the Primes
and the Distants, auditioning for Motown as the Elgins a year later.
Otis is a baritone and, like most of the original Temptations, was born
in the South, in his case in Texarkana, Texas, moving north with his
mother in 1941 as part of the Great Migration.

When the Temptations were awarded the Lifetime Achievement
Grammy in 2013 Otis took the stage alongside Dennis Edwards, who
would die in 2018, and the children of David Ruffin, Eddie Kendricks,
Paul Williams and Melvin Franklin. All six had been Temps in the
1960s although Ruffin didn't join until 1964 and was then replaced by
Denis Edwards in 1968. Otis has been the sole original member since
Franklin died in 1993 and clearly maintains quality control with the
help of Ron Tyson who joined in 1983 and Terry Weeks who stepped
up in 1997. Willie Green and Mario Corbino are recent recruits. When
I called up the British tour publicist Sharon Chevin, in October 2016,

and asked if the Temptations and/or the Four Tops would consider coming to Maidstone to play *Later...* I was afraid I might be enquiring about oldies' acts perhaps now best suited to cruise ships. I feared they might now seem like tribute acts to themselves, better suited next to the sofa on the odd breakfast show. But they were the Temptations for heaven's sake, they were still gigging, and Sharon moved heaven and earth to get their four-piece backing band in the country three days before their first arena show in Liverpool. the Four Tops couldn't make it in time but Abdul 'Duke' Fakir, their sole original member, also came along for a chat with Jools. I asked the Temptations for two Barrett-Strong Number Ones: 1969's 'I Can't Get Next to You' and 1971's 'Just My Imagination (Running Away with Me)', they invited Jools to sit in on piano and then I waited nervously for them to arrive Tuesday teatime, show day.

I should not have worried. Even in rehearsal the Temptations were dignified and magnificent. There is something immediately compelling, emotional even, about seeing five Black men of various ages line up together in formation across the floor, framed against our stick set, ready to take on all comers. The music starts and they step forward to their mikes in unison and, once they are singing, the vocal choreography that had been created by the former tap dancer Cholly Atkins and founder member Paul Williams at Motown all those years ago comes out automatically, as if they can't sing without moving as one. Out comes the Temptations Strut on the funky 'I Can't Get Next to You' which remains remarkably tough, street even, while 'Just My Imagination' is sweet and tender. The veteran group long poignantly together for the girl of their once youthful dreams and when they hit the chorus they turn from the mikes and crack their arms to a rimshot from the drums before they turn back to ponder the abiding pull of their imaginations, their arms circling like they're each winding in a hose. They are palms up on the chorus, arms raised then moving downwards as if chastely admiring a woman passing by. Tenor Ron Tyson sings lead in a restrained falsetto, and if the song isn't poignant enough, a love song from a guy who imagines marriage and kids with a girl he later reveals he hasn't even met, there's an added gulp in watching it led by a sixty-eight-year-old gent with mournful eyes.

When *Later...* goes live that night, the Temptations are suited and booted, resplendent amidst a circle of mostly indie artists in their

thirties or younger. They are wearing dinner jackets with white shirts and black tie, each with a red handkerchief poking out of their top pocket. They are preceded by art school teenagers Let's Eat Grandma who are also choreographed, albeit weirdly. They start with their heads bowed and their waist-length curly hair falling downwards, like robots who've been turned off. Then they stand up and start harmonising to a dolorous keyboard playing sustained chords. Halfway through, a saxophone comes out and the pace seems to further slacken. Both girls stare blankly at the camera, either with indifference or contempt. Ten days before Halloween the whole performance of 'Deep Six Textbook' is oddly unsettling, almost scary, amateur yet compelling, almost inviting you to dismiss it. Then the crane arm rises high and sweeps up and over the floor towards the Temptations' stage which comes alive as lights beam upwards. The crane descends gently towards the Temptations who are spread across their stage like gunfighters. The segue is pure cheek, the age gap between Let's Eat Grandma who are still at school and the Temptations is decades wide, but they are nothing if not a contrast. The minute the Temps start swaying and going through their moves it's as if they've turned back time. They aren't trying to be young or mimic their younger selves, but they sing 'Just My Imagination' tenderly and with utter conviction. They stand erect throughout, but as the last harmonised note rings out, they raise their arms, link hands, and bow together as one. There's something covertly political in the vocal group tradition and in vocal choreography and the five Temptations' synchronised moves are demonstrable proof that Black Lives Matter. They don't feel like a tribute act but like living legends. We won't see their like again.

Alicia Keys

My debut album *Songs in A Minor* came out in June 2001 in the US, and I came over to Europe to promote it in the fall. I was new to the music business and overwhelmed by so many things. It was a whole new world to me; I was twenty and just trying to make sense of what was going on. I did a lot of television in Europe, but we couldn't play live; the band had to mime, I couldn't play piano and I had sing to backing track. People kept talking to me about the Jools Holland show; it sounded like something, but I didn't really know what. When I walked in the studio at the BBC, I felt I was in the best place of my life. It was like this musical wonderland, this encouraging, magical, musical place. At Jools', there was so much different music, and it was an invitation for me and the band to let loose and be ourselves.

That first night was one of the great musical moments of my life and it left such a huge impression on me. Oh my God, I sat watching the whole show unfold in awe; this circular formation, the music weaving around the room, sometimes building a mood, sometimes breaking away and moving on. Everyone played together and jammed which was neat at the start and I couldn't believe it could work. Sometimes you'd toss to the artist next to you or sometimes across the room or Jools would move the show along like you're tossing a ball around.

It was a crazy mix of artists in one space, this interesting mosh pit of people. I was playing across from such different artists like Mercury Rev or Kosheen or Doudou Cissoko the kora player in the middle of the floor. The contrasts are the point. No one was the same as you, but you felt very comfortable being yourself. I was never in a scenario like that. There's this lounge circle, campfire vibe, the circle raises your

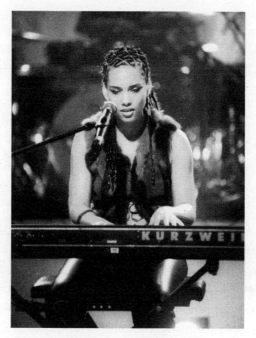

Alicia at the keys, series 18,
episode 4, November 2001.

game. You walk into the studio different, knowing you're going to be amongst musicians who are being themselves and not trying to do what somebody else is doing. Everybody's in their own lane. It opened my eyes and inspired me musically, how to phrase different songs and different notes, how to think about my music.

There's a level of respect for Jools in the studio already because of what he can do as a musician and then there's a light-heartedness and a real joy in him that brings everybody together. Every time you perform in a gathering like that, you're nervous, but there's a levity and an openness in Jools that fills the room and takes the pressure off. He encourages you to have fun and take risks. We did 'Fallin'' and then Jools joined me on Prince's 'How Come You Don't Call Me?'. We rehearsed a little in his dressing room and then on the floor. Jools is so able and super warm and encouraging. He was so confident, it was like 'How can I keep up with him?' Some people want to show off a bit, some people want to show you that they are better than you, but with Jools, it was how do we get the best out of this moment? When we finished, the camera swung over to Mercury Rev doing this

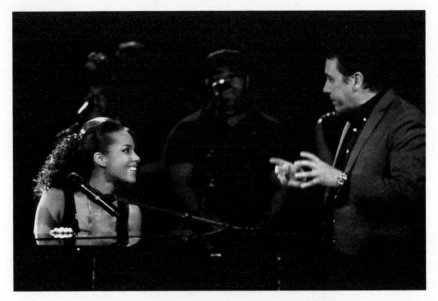

Alicia and Jools bonding, series 36, episode 6, May 2010.

spooky, atmospheric song, 'The Dark is Rising', and it was like 'Who Is This?!'

I remember the second time better because it was a few years on, and I wasn't so confused. The world of music was so foreign to me when I came the first time. I remember Rufus Wainwright, Snow Patrol, we were so impressed that Alanis Morissette was there and then there was Robert Randolph and the Family Band, my favourite pedal steel player who is American but who I'd never come across in America. That show introduced Robert to me; we've met since at the Grammys and other places and we keep talking about doing something together. You are playing across from legends, hot artists, brand new artists, and ones you've never heard of and that gets you to open your ears, to look and listen differently. The third time I came on, in 2010, there was this choir [Creole Choir of Cuba] and I remember them because I was so shocked, they just made me keep saying 'Who Is This?!' I hadn't seen or heard anything like them before. That's the point of it all, it's the ultimate place to discover artists. I just wish there was a show like *Later...* in the US.

Radio is still very separate and genre-based in the States but now there's a whole new festival culture that breaks down barriers like in

the 1960s. Now with streaming we can put together our own playlists, we can follow our imaginations and travel across genres and put music together in our own way. There are no boundaries in music. It's all good, that's the vibe. Now we're more into total discovery – 'What Is This?!' – so it's like the world has come round to the mix and the sense of discovery that's always been there with Jools. The world's come round and the show's still on point. It was even more of a shock back then and such a shock to me in 2001!

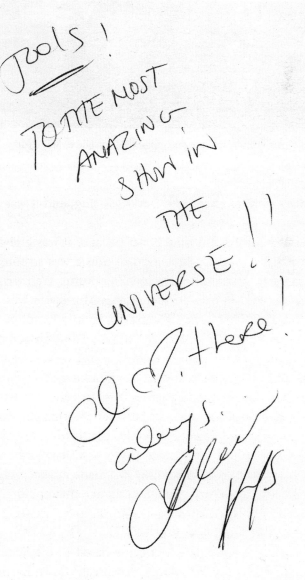

Jools!
TO THE MOST
AMAZING
SHOW IN
THE
UNIVERSE !!
I ♡. there.
always.
Jx

KT Tunstall, pedal to the metal, series 24,
episode 2, October 2004. (BBC film still)

Will the Circle Be Unbroken?

Drop-ins and Drop-outs

What I loved most about producing *Later...* was filling the room with musicians. But as the show expanded so too did its margin for error. If a band or a camera had technical problems, the whole endeavour ground to a halt. If an artist didn't turn up, the circle was sundered, the magic rent. Janet had conceived *Later...* as a 360-degree, one-shot show; the rewards of that were palpable but so was the jeopardy. Every show was a house of cards, and the early series were nerve shredding as Janet tried to make her vision come to life and the camera crew learned to stay out of each other's shots. We were still establishing our circle, which felt as fragile as a soap bubble. Getting on *Later...* was already a hot ticket but that didn't mean that artists didn't drop out for one reason or another. Breakdowns, drug problems and international visas were all last-minute hurdles that couldn't always be jumped but, as it turned out, one artist's problem was another's opportunity. We learned to have a candidate or two in the back pocket for late drop-outs and the myth of the last-minute replacement was born.

No matter that KT Tunstall, Ed Sheeran or even Adele were all already high on our pending list, in a holding pattern for an imminent spot to emerge, they would all choose to regard their sudden booking as a random occurrence, an obscure roll of the dice by invisible gods. Star-making by chance. In truth on occasion a gap in the schedule and four minutes in the running order would materialise days before a show: we were just booking late. Once the show was established, everyone wanted to be on and what one plugger called 'the *Later...* silence' emerged. We were spoilt for choice as we juggled availabilities and listened over and over to the riches on offer, trying to build magic combinations. It was always a joy to say 'Yes!' and commit, much

harder to say 'No!' and disappoint, especially when we didn't quite know what we were doing, and so, often, we'd say nothing at all. I don't think anyone quite understood our eclectic casting or the method in our madness and so our last-minute Cinderellas put their opportunity down to chance. But if these happy accidents seemed to lack a fairy godmother, there were other sudden gaps that had to be filled while the clock ticked and the tension mounted, like when I had to find the Manic Street Preachers a new bass player, stop Eric Clapton from walking out on Smokey Robinson, or tease Jay-Z out onto the studio floor...

Not every artist understood what we were building at first. I still revered Van Morrison's music and had wanted him to do the show from the beginning. Come our sixth series in 1995 and talk began of Van coming on with Georgie Fame and brass players Guy Barker, Alan Skidmore and Leo Green to perform a few of the songs from the be-bop-flavoured 'How Long Has This Been Going On?' which they'd recorded live at Ronnie Scott's in a few hours. This was Van's twenty-fourth album and I'd got them all. Yet as negotiations proceeded and the date of the last show of the series neared, Van's representatives kept insisting that while he really wanted to do the show, he absolutely didn't want to stay in the studio and watch all the other artists perform – he just wouldn't be comfortable. No matter that the week before David Bowie had happily shared the floor with Oasis, no matter that the bill featured two other Irish artists that he surely knew – Paul Brady and Maura O'Connell – plus the Charlatans, Buju Banton and Tori Amos with the Black Dyke Brass Band, Van would not be comfortable. *Later...* was still in its relative infancy, I desperately wanted Van on board, I'd never imagined that participating in the show should feel compulsory. I was sure that once he was in the room with the other artists, he'd relent...

Van himself didn't sound-check, so he arrived in the studio on the afternoon of the taping, safely hidden behind dark hat and shades. The body language was more than clear – 'Don't come near!' Jools would later befriend Van and often sit in with him when he returned to the show over the years. They shared a love of blues, jazz and of the father-in-law and sometime music television presenter Jools sadly never met, the Scottish botanical artist and Leadbelly enthusiast Rory McEwen. Van greatly admired McEwen, who'd hosted ATV's groundbreaking

folk and blues television show *Hullabaloo* in the early 1960s' where the Rolling Stones once auditioned to be house band, but Rory died in 1982, long before Jools met his future wife Christabel McEwen. However, this friendship had yet to fully blossom, and I am not sure it would have made any difference at this juncture. Van had already been treading the boards for four decades and his spiritual seeking was increasingly juxtaposed with a loathing for the business that he expressed in songs like 'I'm Not Feeling It Anymore'. I'd already seen Van in torment at *The Late Show*, but this was now our dedicated music show, our happy place… surely, we could make him happy this time around?

Janet had conceived *Later…* as essentially a single-shot show with the whole event unfolding in real time within the intimate confines of four walls with Jools as the ringmaster of the circus. The show was pre-recorded and, because bands often wanted another go, she'd devised a method in which artists would repeat the very last section of a song so that she could use a shot or two to cut across to previous or future takes and join them with Jools' trademark links as he walks into shot in front of the band just as they finish. Van had three songs in the show and had to appear in the opening groove, Jools' walkabout introductions and his closing thanks. This seemed to mathematically spiral into innumerable links in which Jools would thank Van in one shot and then appear in front of the artist that followed or preceded him in another shot via an uncomfortable cut that undermined the unity of our single-shot show and required the grinding halt of a recording break at every join. Still, nothing ventured… all artists to the floor, the opening groove, Jools' show introductions and Van's opening song, Mose Allison's 'Don't Worry About a Thing' followed by… a recording break. Then Jools' link off the back of the Charlatans' appropriately titled 'Just When You're Thinking Things Over' into Van's closing songs, 'That's Life' and a jazzy take on 'Moondance', complete with double bass solo. Once all this was in the bag and on tape, we set about recording the rest of the show. Van and party left the room but remained just outside in the holding room by the studio doors having a few drinks. Inevitably this tortured process reduced the whole endeavour to nothing more and nothing less than a television show. Van was still outside when we finally finished and one of the Charlatans was heard to mutter as they stumbled past him out of the studio, 'It's nice to be

Tim Burgess, Tori Amos, Van Morrison, Jools, Maura O'Connell,
Paul Brady, series 6, episode 6, December 1995.

important but it's important to be nice.' I don't know if anybody watching the show when it transmitted would have known what we'd gone through to knit the whole show together and maintain the aesthetic of the single shot, although the studio audience certainly looks a little wearier than usual!

We have never broken up the recording of a show like this again and neither Van nor anyone else has ever asked us to. I stopped dropping in the odd *Late Show* recorded session after the first two series and Scott Walker, Bill Fay and Tom Petty gave the only other separately pre-recorded performances I can recall. Scott and Bill no longer perform in public and verge on the reclusive: both slipped in and out while the studio was all but empty, Scott at lunchtime in 1995 and Bill at teatime in November 2012. Petty and the Heartbreakers recorded a couple of songs on the afternoon of 20 April 1999 before going on to play Shepherd's Bush Empire that evening when the rest of that episode was recorded. I am glad those rare performances exist but *Later...* really has to be about everybody being in the room together, in the circle.

When we began the third series in 1994, the studio team – electricians, riggers, painters, luggers and all – announced that, while they loved

Tim Burgess and Tori Amos have a laugh,
series 6, episode 6, December 1995.

the show, they couldn't carry on turning it round in a single, exhausting eighteen-hour day. After an uncomfortable standoff, our production manager Barry Dixon went off to find the money for a two-day stand and *Later...*'s production schedule was set for years to come. Monday: put in set, rig lighting, bring in monitors and band equipment, sound-check. Tuesday: fine light, camera-rehearse all artists and Jools' links, tape show, go home. The circle now generally consisted of four full bands, a small setup around Jools' piano – the show's de facto 'home' – and a walk-on spot in the middle of the studio for a solo and often acoustic performance that we could set and strike while filming else-where in the room. I'd kept adding as many acts as we could possibly accommodate; there were always more artists to add to the mix.

Later... gradually assumed talismanic status for many artists striving for recognition; a booking loomed high on their bucket list. An appearance didn't always ignite sales, but it quickly became a stamp of validation for breakthrough artists, proof of arrival or at least that they had at least one foot on the ladder. The rest of the British music media and business took note. When the show started, there were

teams of TV pluggers at all the major labels plus a choice of independent pluggers with their own rosters, all determined to get their charges on screen. Already music television opportunities were shrinking but there was still *Top of the Pops, Live and Kicking, The Chart Show* and Jonathan Ross's chat show. Channel 4 had *The Word*, 'shock' TV for the young late-night crowd between 1990 and 1995, and then launched *The White Room* which soon made way for *TFI* between 1996 and 2000 while Saturday mornings on ITV had *CD:UK* between 1998 and 2006. Mostly, labels regarded television as a promotional tool and a commercial boost, while most television shows simply wanted hits. But our proposition wasn't essentially commercial but artistic. Plenty of our bookings had nothing to do with the charts. Perhaps because *Later...*'s sole narrative was music, getting booked on the show became a badge of progress, a moment of recognition, a vindication.

Manic Street Preachers had proclaimed their outsiderdom and their contempt for much of the British pop mainstream since they'd first stumbled out of the South Wales Valleys, spouting headlines and dissatisfaction in their glad rags and eyeliner. Conceptualist and sometime rhythm guitarist Richey Edwards had joined his schoolmates from Oakdale Comprehensive in the Manics in 1989. Despite his self-harming and bouts with depression, Richey's outspoken blend of political disgust, cultural criticism and personal alienation increasingly dominated the band's dynamic. Their 1992 debut album was entitled *Generation Terrorists* and they seemed to be one of those British bands whose primary currency was the music press interview. They didn't only talk a good game, they also performed for the press. Edwards was so determined to convince the *NME*'s Steve Lamacq of the band's sincerity during an interview at Norwich Arts Centre in May 1991, he carved '4Real' into his arm, a wound that required seventeen stitches. Their early albums are arguably all over the place as the band searched for their sound while talking up their passionate, bleak, and often hysterical manifestos.

When *The Holy Bible* came out in the late summer of 1994, Deirdre Moran of Epic's promotions department started campaigning for the Manics to make their *Later...* debut that autumn, urged on by their new manager Martin Hall, who'd replaced his brother Philip who'd sadly died of cancer late in 1993. Post-grunge the American alternative scene was on fire and Deirdre had brought Pearl Jam, Rage Against the Machine

and Screaming Trees to *The Late Show* studio. I liked and trusted Deirdre, who loved the Manics as people and as a band. We were a couple of weeks away from our fourth series when she and I travelled to Cardiff to catch them at the local Astoria. We sat on the balcony and watched a twenty-plus set that began with 'Revol' and ended with 'You Love Us'. The performance was bewildering. Richey had become the band's primary spokesman but seemed barely there, intermittently playing the odd note on his guitar while disappearing into the shadows on far stage right. Nicky Wire was more present, but his bass playing was rudimentary. As a live band, the Manics were all about cousins Sean Moore and frontman James Dean Bradfield. Moore drove the drums and James was a musical powerhouse with that searing high voice, slash-style guitar solos and whirling dervish stage moves that already included his trademark 360-degree spins. Yet for all James' musical command, he didn't quite feel like the band's authentic voice: the voice of the lyrics and the interviews, the voice of Richey and Nicky, the band's conceptualists. It was as if the Manics were split straight down the middle – theory with Edwards and Wire, practice with Bradfield and Moore – and that night in Cardiff, the twain never quite met.

Deidre and I didn't go backstage but headed back to London straight after the gig. A few months before, in June 1994, the Manics had famously gone on *Top of the Pops* to perform *The Holy Bible*'s 'Faster' wearing military fatigues with James in a balaclava. 'Faster' charted at 16 and the BBC received over 25,000 complaints about the balaclava, which many argued aligned the band with the IRA even though James had written his name above the eye slits to reveal his identity, probably at the producer's request. Braziers belched flame in the background, Nicky wore face make-up, Richey swung his guitar with energy and the sheer nihilistic brio of the performance still resonates. The Manics had made their television debut playing 'Motown Junk' on *The Word* back in 1991 and it was as if they'd now brought that same nihilistic energy to *Top of the Pops* where they could genuinely hope to shock on mainstream telly. Suede, Portishead, Elastica and Oasis would all appear on that autumn 1994 series and Blur on that year's *Hootenanny* as Britpop took wing but, I regret to say, I didn't book the Manics. Richey's era and *The Holy Bible* feel ever more important in retrospect but I wasn't yet convinced that the band weren't more mouth than trousers, more hype than substance. There had been something awry about that night in Cardiff and even

the balaclava and the braziers seemed a little try-hard. Richey played his last gig with the band at London's Astoria that December and disappeared the following February.

Eighteen months later, when I first heard 'A Design for Life' and its parent album *Everything Must Go* in the spring of 1996, I was thrilled. The Manics had so palpably found their voice, their tone, and their sound. Everyone loves a comeback and, post-Richey, it was as if the band had suddenly clicked into focus. 'A Design for Life' is one of the great anthems of the Britpop-era of the 1990s, James Dean Bradfield delivering the lyric's mournfully abrasive examination of how socialist ambitions have crashed on the rocks of capitalism in that keening voice that explodes into a mixture of rage and despair when the soaring but cynical chorus arrives. The walking bassline and lush strings heralded the Manics' instant redemption from the slough of despond left by Richey's disappearance. Their politicised anger was intact and at last the band sounded unified and sure.

I booked the Manics for the second show of our seventh series on a bill where they would be in stark contrast to US AOR behemoths Hootie and the Blowfish, nu-soulster Maxwell, witty piano trio Ben Folds Five, the shimmering voice of Mali's Salif Keita and the Who's Pete Townshend. They arrived for soundcheck on the Monday, impressed by their giant backdrop adapted from the single sleeve, and bolstered by a string quartet for those soaring choruses. Their middle song, the acoustic 'Small Black Flowers That Grow in the Sky', featured a Welsh harp with lyrics by Edwards that merged his own alienation with the horror of animals trapped in cages. 'A Design for Life' had almost topped the singles chart at the end of April with the album due out a couple of days after the show was to be broadcast. The band were affable but guarded, curious about the other artists on the show but happy in their own bubble, ready for their close-up. As 'A Design for Life' soared across the studio in soundcheck; it was palpable that here was a band whose time had come.

Around 12.30 the next lunchtime, a distraught Deirdre phoned to tell me that the Manics were pulling out of that evening's recording. Nicky Wire had pulled a muscle in his arm while reaching from his hotel bed to pick up the telephone call announcing the arrival of his taxi to Television Centre. He simply couldn't play his bass, Deirdre explained. Nicky was mortified. The band felt cursed. The soundcheck

had been so good, they were so ready, the album that was going to take their career to another level was about to come out, they didn't want to let the show down but what could they do? They'd already lost Richey – without Nicky that only left James and Sean of the original quartet. Deirdre was gutted, Nicky was gutted, Martin Hall was gutted – but what could they do? I went down to the studio to tell the team, my brain spinning wildly. There was all the Manics' gear, their giant backdrop, the Welsh flag on Nicky's amp, their corner of the studio. It was too late to replace them even if I wanted to. There was no time to track down, book, sound-check and camera rehearse another artist and, besides, the Manics were due to open the show. It was their time, their week, their moment. No one could replace them.

Pete Townshend was due to rehearse a bit later. He was playing three songs – 'Magic Bus' and 'Let My Love Open the Door' solo and 'English Boy' – the opening track of his new concept album *Psychoderelict*, with the Colombian bassist Chucho Merchán. I knew Chucho well from a previous life. I'd joined Virgin Records as a press officer in 1984 just as Working Week released their acclaimed tribute to Victor Jara, 'Venceremos (We Will Win)', with vocals by Robert Wyatt and Tracey Thorn from Everything but the Girl. We hit it off and I started acting as their A&R during the recording of their debut album, *Working Nights*, and as they went on the road with a large live band with pronounced jazz and Latin leanings. Merchán was Working Week's bass player and I had hung out with the band in the studio and at shows. Chucho had emerged as an elite sideman since then, touring and recording with Thomas Dolby, the Pretenders and Eurythmics, but he remained a gregarious and generous character. Slowly it dawned on me that Chucho could be our knight in shining armour. I knew that he could play anything, but Chucho and a lot of other people had to agree and quickly. Pete Townshend obviously had to be happy to lend out his bass player and then the Manics had to be prepared to break the Welsh brotherhood and to play with the kind of accomplished musician that they'd perhaps started out despising when they were planning their punk provocations back in Blackwood in the late 1980s.

Pete was generosity itself, Chucho ready for anything and the Manics understandably wary but ultimately prepared to adopt a bass player

for the night. I think this was more so as not to leave the show in the lurch so late in the day than it was to save their slot. By teatime the band – well, the remaining two – were on the studio floor camera-rehearsing with their support musicians and string quartet. Chucho strutted stage left, sporting his trademark colourful cap, leaning towards James and Sean with the air of a man who wishes to please. He'd learned the parts for 'Everything Must Go' and 'A Design for Life' in his dressing room and now he was pumping out the bass lines with a rhythmic drive that was precisely and funkily on the money. No matter that Chucho's cheerful dexterity was a million miles from Nicky Wire's simple yet angular bass style that's at the heart of the Manics' DNA, that he had nothing to do with the Manics' painful journey to this moment, that he wasn't the man to study Nicky or Richey's provocative lyrics and certainly not to sport a dress on occasion as Nicky has always loved to do; at least he was bloody there.

There's a mid-Nineties exuberance about the show that night, every spare part of the room is packed with audience, bands or gear. Local boy Pete Townshend mugs for the camera and gets down to kiss the floor of his beloved Shepherd's Bush as he is introduced. Jools is at his capricious and playful best, lord of all he surveys. He has the unenviable task of explaining why for one night only the Manic Street Preachers have a Colombian bassist. As he approaches their corner, Jools is handed a mysterious piece of paper. 'The next band that are on,' he begins, 'have an album surging up the charts at the moment but we got a phone call saying "I am sorry, we can't do it, it's not on," that unfortunately one of them, Nicky Wire, the bass player, had strained a muscle in his arm so badly while stretching out to answer the phone, and the phone call – this is completely true – was to tell him that the taxi to take him to the BBC was there to pick him up.' Jools has been gesturing with his arm while clutching a sheet of white paper. 'So, they said, "I'm sorry, that's it, we can't go on." The producer Mark Cooper grovelled, pleaded, "Please come on, we'll do anything!"'

Jools has clearly done the heavy lifting at this point and so concludes 'Which includes borrowing Pete Townshend's bass player,' the latter part delivered almost in a whisper. 'So, ladies and gentlemen, please welcome all the way from Wales opening the show, the Manic Street Preachers!' And there's James, centre stage, giving it his pugnacious best, Sean driving the song forward on the drums, the five string players

And then there were two, Manic Street Preachers with bassist Chucho Merchán, series 7, episode 2, May 1996. (BBC film still)

sawing away on a riser and then, lo, there's Chucho with a reversed and rather glamorous baseball cap, occasionally playing into James and Sean, but somewhat on the periphery stage left with director Janet under instruction not to shoot too much of the depping bass player who does not look anything like a Manic Street Preacher!

When the opening 'Everything Must Go' finishes, Jools pops up, thanks Chucho for standing in, still clutching the piece of white paper he's brandished at the camera while introducing the band. Deirdre had suggested getting Nicky to write a sick note that Jools could read out but while he'd waved the piece of paper about, Jools had never explained its purpose or provenance. During 'You Love Us', I'd rushed down from the gallery and asked him to at least explain what he had in his hands. 'Of course, a lot of people have been wondering what this piece of paper I have been holding up is. It's a note from the bass player, a proper note explaining why he couldn't make it, I just thought that would make it nice and official.' Jools thrusts the note at the camera just long enough so we can see Nicky's handwriting but not long enough so we can read it and then he moves on to Hootie and the Blowfish, whose hobbies the script listed as 'sex and golf' to their obvious dismay. A suitably tortured version of 'Small Black Flowers...' follows in the middle of the show, just James and the harp player, before James, Sean and Chucho return for an epic finale of 'A Design for Life'.

Two days later, 'Everything Must Go' entered the charts at Number 2 and stayed there for most of the rest of the year, going on to sell a million copies. Manic Street Preachers returned riding high in September 1999 to kick off the twelfth series alongside Ian Dury and the Blockheads, eels, Beverley Knight, and Björk. It was the seventy-fifth *Later...* and they opened with 'If You Tolerate This Your Children will be Next' from their imminent fifth album, *This is My Truth, Tell Me Yours*, which would sell over five million copies worldwide. They were in their pomp. Nicky chatted with Jools at the piano and reflected on his non-appearance a couple of years before, explaining how he'd nearly dislocated his shoulder picking up the phone to the tour manager and how 'you lot' had tried to wheel him in in his hospital bed to play. He smiles at the band's early absolutist pronouncements – that they would sell millions of copies of their debut album and promptly split up – grinning that while a lot of bands can look back on their careers and blame the drugs, they'd been totally sober. 'A lot of that came from Richey because he took it to the edge.' Nicky regretfully acknowledges that the band have only finally become successful since his disappearance. 'We'd have loved to have Richey here with us tonight, I think he would have enjoyed it a lot. But it wasn't meant to be.'

Manic Street Preachers returned to *Later...* many times after this. We'd always find ourselves chatting about the first time. The last time the Manics played *Later...* when I was there was at Maidstone Studios on a Tuesday in May 2018. Fellow Welsh artists Boy Azooga and Gwenno were also on the show along with Mélissa Laveaux, Ben Howard and Ray LaMontagne. Nicky's mother was dying of cancer, and after attending soundcheck on the Monday he rushed back to Wales before returning for the show. The Manics played songs from their thirteenth studio album, *Resistance Is Futile*, but as we often finished those live shows with a classic, I asked them to reprise 'A Design for Life'. The label and management weren't sure, but the band were happy to oblige, and they sent everybody home buzzing to those poignant lyrics and that soaring chorus. It was a mere twenty-one years since the band had first performed it on *Later...* but Nicky's first and he enjoyed it.

If Nicky Wire pulling a muscle on the day of the show was tricky, it wasn't the trickiest. The second time Jill Scott came to *Later...* in

Manic Street Preachers all present and correct,
series 52, episode 2, May 2018.

December 2007, we were welcoming back a true queen of nu soul. Jill and her crack band were playing Shepherd's Bush Empire on the Monday night but her label hired a second set of gear and the band sound-checked early that afternoon before they headed down Wood Lane to the gig. KT Tunstall, Band of Horses, the Ting Tings and Gabriella Cilmi were also on the bill in what was our last studio show before Christmas. Scott was born and raised in Philadelphia, a poet and a powerhouse vocalist with jazz phrasing who'd made her *Later...* debut alongside Dido back in 2000 when she released her first album, *Who is Jill Scott: Words and Sounds Volume 1*. Now Jill was back with Volume 3, *The Real Thing*, and she sounded as mellifluous as ever in soundcheck, taking out her online critics in sassy style on 'Hate On Me'. Scott was scheduled for a camera rehearsal soon after lunch the following day and her band started assembling outside the studio around 1 p.m. Half an hour later, we got a call that Jill would not be joining them. Whatever had happened last night at the show or after, she'd lost her voice and couldn't perform even the couple of songs we had lined up. We offered to move her camera rehearsal to early

evening or even go without, but Jill was silently adamant. She wasn't coming.

All Jill's band were present and correct, her gear all sound-checked... It was too late to strip out the gear and start afresh but what if we could find another singer to front Jill's crack musicians who could surely learn to play most anything in a matter of moments? Jill's label knew the show was in a hole and were happy for us to try and find a replacement. Enter Mutya Buena who'd left Sugababes back in 2005 and released her debut album on Island earlier that summer. Mutya had come on both *Later...* and the *Hootenanny* with Sugababes back in 2003 and while her solo album wasn't exactly setting the world alight, the title track, 'Real Girl', had been a substantial hit, she had a pop star's doe-eyed charisma and a soulful voice and, best of all, she was up for it. Scott's band and backing vocalists went back to their dressing rooms to work on Mutya's songs and by the time she arrived to run the songs for cameras around 6 p.m., they had them down pat. I think Mutya thought they played them better than her own live band that night, horns and backing vocalists loose, funky, and yet on the money. She was only twenty-two, barely looking at the band when her time came to sing, either because she was fearless or because she was too terrified she'd break their concentration. But they had her back and Mutya's vocal was very much on Jill Scott's tip. As one comment on the performance has it on YouTube, 'That tone, sultry, husky yet pure as dripping honey straight from the hive! Like a Nun with a kinky past.'

Mutya was an apt stand-in for Jill Scott but some of our subs were frankly altogether random. In November 2007 we'd booked a returning Babyshambles around their second album, *Shotter's Nation*. We'd hosted the Libertines for their memorable television debut back in 2002 when they'd brought a smattering of their own fans to pogo side of stage during 'Up the Bracket' and 'Boys in the Band'. The band were rock 'n' roll to their stained fingertips in the era of what critics would coin 'landfill indie', dominated by characterless guitar anthems, but they were already threatening to implode around Pete Doherty's wayward trajectory. Pete had managed to keep a tight grip on his titfer during camera rehearsal but then dismayed the make-up team by getting out the wraps stuffed inside his hatband. All the artists had gathered on the floor for photos and the recording while Pete couldn't

be extracted from the powder room. We had to ask Jools to knock on the door and usher him to the studio. Yet, despite his much-publicised drug issues, Pete Doherty had returned with his new band Babyshambles in November 2005 for a wasted and elegiac 'Albion' and a delightfully abandoned 'Fuck Forever', channelling Neil Young's ramshackle and druggy epic, 'Tonight's the Night'.

Two years later, Doherty was supposed to be clean. Soundcheck flew by on the Monday with the band's louche garage swagger present and correct. Babyshambles had just completed a small arena tour, 'Delivery', the first single from the album had gone Top 10, they seemed to be on a roll. The band left Television Centre with a smile and a wave but the next morning all hell broke loose as a tabloid published photos of Doherty apparently smoking crack. His relationships with Kate Moss and Amy Winehouse had sent the papers into a feeding frenzy, aided and abetted by Pete's frequent run-ins with the police for drugs, drink and driving under the influence; now here he was all over the front cover in murky black and white, caught in the act. Pete's immediate response was to go missing; neither his new record company Parlophone, the papers nor the police could find him. By late lunchtime it was clear that Pete had gone to ground and that Babyshambles would not be appearing on *Later...* that night.

The bases were no longer loaded but the *Later...* schedule could not be derailed. Babyshambles' camera rehearsal had been set for around 4 p.m. and every ten minutes Alison and I were being asked who was going to replace them, what time they'd be arriving and whether they'd be ready for that rehearsal slot. Babyshambles' gear was broken down and soon we had a large empty space where they had sound-checked the afternoon before. No matter that Manu Chao, Duffy, Orchestra Baobab, Dion and Kano, accompanied by Damon Albarn, were all still present and correct, the ship was listing, and we had to right it. Fast. While our cast was still strong, it clearly lacked form – a name with some sales, some fame, some following. This, after all, was Duffy's television debut, and although 'Mercy' was already taking off and she would go on to become the bestselling artist of 2008, she was our wild card, not our opening gambit. Neither Kano nor New York 1950s legend Dion had a band, both performing stripped down around the piano. We desperately needed further firepower and Alison was chasing leads on the phone.

New Mexico's the Shins had broken through with their third album, *Wincing the Night Away*, and they were in town! Phone call followed phone call. The Shins were on a day off around town and couldn't be found! There were a couple of tentative offers of artists who didn't quite fit, but the afternoon was slipping by. We'd shifted the rest of the bill forward to fully use that afternoon's rehearsals and give Alison and I more time but by 6 p.m. we still hadn't found Babyshambles' replacement. We decided to move on from pluggers to rehearsal spaces on the grounds that if a band was rehearsing, then they and their gear would be all in one place and therefore ready to go. So it was that we called John Henry's in North London who have always provided the house PA and the monitor systems for many of the acts who play the show... Who should be there in full band rehearsal but the man who was well on his way to becoming the biggest-selling artist of the 2000s, Sir James of Blunt?

The fact that James Blunt was Pete's polar opposite tickled us, as did his immediate availability. We had history with James who'd made his auspicious debut on *Later...* playing 'Goodbye My Lover' solo at the piano just as 'You're Beautiful' finally took wing. While much of James' debut album seemed simply too MOR for *Later...*, the edge of his confessional talent shone out in that address to a lost lover. Once 'You're Beautiful' took off in that summer of 2005, there'd been no stopping Blunt. The album *Back to Bedlam* went on to top the charts in sixteen countries and sell nearly twelve million copies. 'You're Beautiful' became the first British Number 1 in the US for nearly a decade. In a matter of months, Blunt had become the new mainstream everywhere; ubiquitous, adored and loathed in equal measure. He'd released his second album, *All the Lost Souls*, that September and while his promotions team were just as keen for us to book him as they had been back in 2005, we'd decided to pass. We couldn't find that personal, more intimate connection that we'd found in 'Goodbye My Lover' and James was now too popular – and too unpopular! – for us as a tastemaker show. At least that's what we'd reasoned in October, but now at 6.15 on Tuesday, 20 November 2007, with a gaping hole on our studio floor and in our running order, James Blunt seemed like our perfect 'Get out of jail' card.

Pete had gone AWOL, but James was ready, willing and able – happy to pack up his band's gear, load up the van and drive from King's Cross

to Shepherd's Bush post-haste. At 7.30, when the studio's vast screen dock doors opened to admit band and gear, they were the cavalry coming to our rescue. James, after all, is a former captain of the Lifeguards. The band set up, sound-checked and ran straight into a short camera rehearsal of their two songs, '1973' and 'I'll Take Everything'. The studio audience were gathered at the doors when James finished his run-throughs, we'd rehearsed Jools' links earlier that evening and we were ready to go. Manu Chao opened the show with a rabble-rousing and rocking 'Rainin in Paradize', swiftly followed by the poignant but driving '1973', Blunt's tribute to another lost lover and a lost era. Later in the show, Jools sat and chatted with James. He explained James' rescue act to the viewers and asked him if he had a message for Pete. 'Um,' Blunt answered politely. 'Thanks very much!'

When Television Centre was sold and the studios closed for refurbishment in 2013, we moved to Maidstone Studios in deepest Kent, whose previous productions included *Ministry of Mayhem*, *The Basil Brush Show* and *Dale's Supermarket Sweep*. There was but one serious drawback; were we not too far from town if an artist went missing on the day of the show? In spring 2017 Jamiroquai was scheduled to return to *Later...* to promote his eighth studio album and his first in seven years, *Automaton*. We'd agreed that Jay and the band didn't have to come in on the Monday but all their equipment should. Mountains of gear duly appeared, including two of the largest percussion and drum setups I have ever seen, in front of which perched a couple of elongated and mounted keyboard stacks, ready to bring the funk and do justice to *Automaton*'s themes, the increasing impact of technology and artificial intelligence on human behaviour.

Unfortunately, Jay was now struggling with more personal concerns as the band's co-founder and co-writer of their first five albums, forty-six-year-old former keyboardist Toby Smith, had died of cancer a couple of weeks earlier. Jay's record company and his management team were trying to get him to press ahead with promoting the new album but Jay himself was heartbroken. 'He has been a huge part of my life,' he'd posted on the band's Facebook page, shortly after Toby's death. 'Without him, there would be no JAMIROQUAI, and as I write this, the moon is clear and bright in the sky, and I think of him how it should be, riding his white horse across it, leaving a trail of stars behind him.'

When Tuesday dawned, although many of the band had made their way to Maidstone, it gradually became apparent that Jay himself would not be joining them. By early afternoon, Jamiroquai's substantial equipment was being stripped down and put back in an artic lorry and a long wall of the rectangular studio was looking bereft.

Sure, we had Robert Cray and the Hi Band, Beth Ditto and Eivør from the Faroe Islands, but something – or should I say someone – was missing. Alison was hitting the phones again but this time the word was out. She was calling pluggers and pluggers were calling her. Who was available and in town with their gear and their band members in one place, and could they leave in time to beat the rush-hour traffic that bedevilled Kent's labyrinth of motorways? The week before, Alison had happened to see a largely unknown artist performing out on the piazza in front of BBC Broadcasting House on *The One Show*. Laura Pergolizzi, aka LP, had already made a few solo records and written songs for everybody from Cher to Rhianna, and now she was finally having her own breakout song, 'Lost on You', a mid-tempo torch ballad with a Western rhythm and a street whistle hook straight out of Morricone, which was fast becoming a global radio hit and would go on to top the charts in thirteen countries. Alison caught a charismatic and androgynous performer with the skinny, curly look of Bob Dylan 1965 or John Cooper Clarke 1981.

LP just happened to still be in London and be free and within minutes she was booked and on the bus. The band were with us by 7.30 p.m., gear was hurriedly set up, soundcheck and camera rehearsal rolled into one, and despite a couple of technical hitches with incompatible electrics, we began taping our pre-recorded show right on time at 8.35 p.m. LP was magnetic, stalking the floor, delivering her street whistle like a proper urchin while staring down the lens, and live, 'Lost on You', has an overwrought, almost operatic power, particularly in its extraordinary final section when LP is simply keening wordlessly from behind her mop of curls. 'Lost on You' took her around the world and helped her conquer countries as far apart as Poland and Mexico. Her 2018 album, *Heart to Mouth*, didn't match its predecessor's success but had the same emotional intensity, enabling LP to feel 'that direct line from my heart to my mouth'. Who knows if she'll ever come up with another 'Lost on You' but in April 2017 in Maidstone she was both the cavalry and the star of the show.

LP was reaping the fruits of one of the key *Later...* myths in which the success of a debut appearance on *Later...* is directly linked to the lateness and apparent randomness of the booking. It's a charming legend because it endorses the idea that anyone can be on *Later...* and that a multitude of aspiring artists are but one lightning strike away from lift-off. The wide musical remit of the show and the fact that a significant proportion of those who perform on it aren't too well known, save by their family, friends and perhaps a few industry insiders – inevitably suggests the notion that anyone can be on because, well, where in hell did this person come from? KT Tunstall's 2004 *Later...* debut is but one of the best versions of this archetypal fairy tale. This is the 'Opportunity Knocks' version of *Later...* and, in KT's case, it goes something like this. We'd assembled a strong line-up for episode 3 of our twenty-fourth series back in autumn 2004 including the Cure, Anita Baker and Jackson Browne. As a moment of additional spice, we'd also booked a stripped-down performance from rapper Nas and his father Charles Jones III, better known by his Yoruba name, Olu Dara. Nas is a hip-hop icon thanks to his 1994 album, *Illmatic*. Dara played guitar and cornet and hailed from Natchez, Mississippi, but had long been a staple on the New York avant-garde jazz scene playing with the likes of James Blood Ulmer and Cassandra Wilson. Nas and Olu had collaborated on 'Bridging the Gap', a track from Nas' double album, *Street's Disciple*.

The Sunday before the show, we got the call that Olu was ill and father and son weren't coming. Alison had been to see KT Tunstall in rehearsal shortly before the start of the series, watching her run through three or four songs from her Restless Records debut album, *Eye to the Telescope*, with her band. When they finished, Shabs from Restless cannily suggested she play something on her own. Before the label helped finance the band, KT had been gigging solo as a one-woman band, performing a mutant folk song with a Bo Diddley beat with loops, tambourine and guitar, entitled 'Black Horse and the Cherry Tree'. Alison was impressed with both line-ups, and the band songs she saw, including 'Suddenly I See', would eventually help *Eye to the Telescope* sell over four million copies worldwide. But we struggled to devote a whole band space to a debut solo artist back then and we hadn't yet found a space when Nas and his dad dropped out. KT had rather been burning a hole in Alison's pocket since that rehearsal; this sudden vacancy seemed like the ideal

LP gives a little whistle, series 50, episode 3, April 2017.

opportunity to get her on – solo with loops etc – before the series ran away with us.

A day or two later, there was KT, bright-eyed and ready to give her all, six weeks before album release and almost unknown and un-heralded. She was then twenty-nine and had been knocking around the Scottish indie and folk scenes throughout her twenties, even collab-orating with the modernist klezmer band Oi Va Voi. KT's floor spot was late in the running order, long after all the other artists had performed at least once. We imagined her as the sting in the tail of the show, coming out of nowhere. This must have meant she had most of the show in which to stew. KT herself has said that 'girls with backing bands are boring' and there was something rivetingly brave about her stepping out alone off the back of Anita Baker's iconic 'Sweet Love' that only added to the plucky charm of her performance. To all intents and purposes, she might as well have been a busker. Here was this unknown tiny girl in a pink mini skirt, T-shirt and ankle warmers in a corner of a room giving her all in front of Baker, Robert Smith and Jackson Browne. The camera closely follows every step as she begins to build a rhythm track from handclaps, percussive slaps and dampened strokes on her guitar, and then her tambourine. Then she starts to loop those call-and-response 'whoo-hoos' against which she frames her lead vocal

Bo Diddley, Jools and Nigel Kennedy, 1996

Erykah Badu and Jools, 1997

Howlin' Pelle Almqvist of the Hives and Paloma Faith, 2012

Ed Sheeran and Christine McVie, 2017

Paul Weller and Jools, 1996

Neneh Cherry, Johnny Marr and Bernard Sumner, 1996

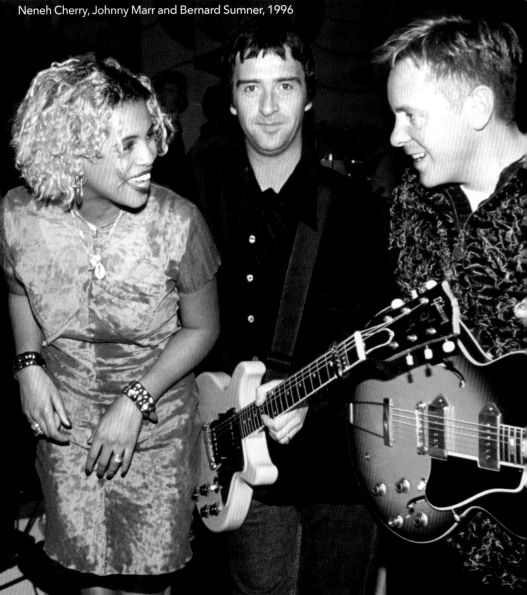

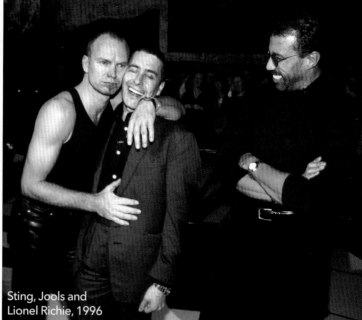

Sting, Jools and
Lionel Richie, 1996

Little Simz, 2015

Bruce Johnston and John Lydon, 2012

Duane Eddy, Jarvis Cocker
and Richard Hawley, 2010

Sheryl Crow and PJ Harvey, 1995

Charlie Watts and Jools, 1996

Wayne Coyne, Flaming Lips, 2006

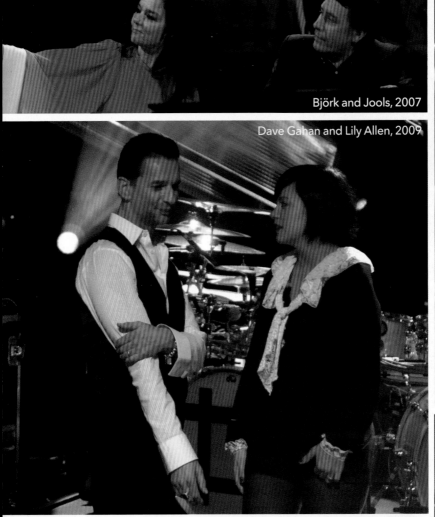

Björk and Jools, 2007

Dave Gahan and Lily Allen, 2009

Jools, Ms Dynamite and David Bowie, 2002

Red Hot Chili Peppers and Jools, 2006

Empire of the Sun, 2016

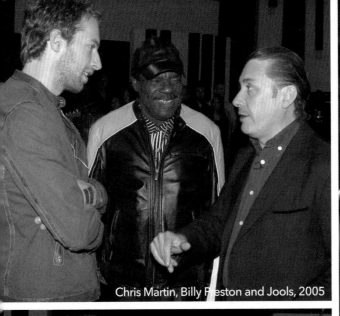
Chris Martin, Billy Preston and Jools, 2005

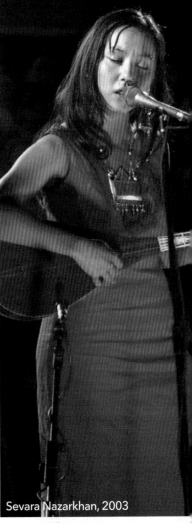
Sevara Nazarkhan, 2003

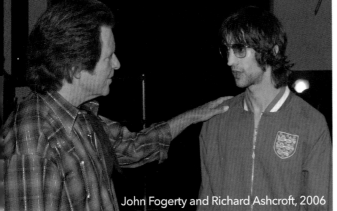
John Fogerty and Richard Ashcroft, 2006

Mariza, 2005

Petula Clark with Timothy B. Schmit and Joe Walsh of the Eagles, 2013

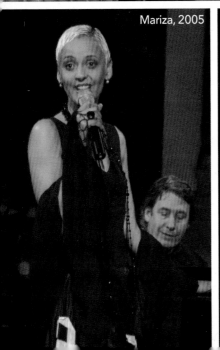

with its stark title image and determined chorus of 'You're not the one for me'. There's a folk tale quality to the lyric, she's been forsaken by all including her own heart for rejecting the big black horse's marriage proposal. KT's voice has the grain of a Scottish R&B singer like Maggie Bell and there's fire and drive in her performance. The rest of the studio watches agog, the Cure to her stage right riveted, Anita Baker clapping along, the room humming. It's a pure *Hootenanny* moment and it launched KT's career. No matter that the performance must have broadcast well after midnight and long before the BBC shared performances from the show on YouTube, it made her name almost overnight. 'Black Horse and the Cherry Tree' wasn't even in the track listing for the December release of the album but Relentless promptly licensed this performance and added it as a final track before re-releasing the album early in 2005 with a re-recorded version four tracks in. Gradually the album took off on radio and both 'Other Side of the World' and 'Suddenly I See' nearly made the Top 10. 'Black Horse and the Cherry Tree' would also launch KT in the US when a contestant on *American Idol* chose to cover it and KT's version took off as a result, reaching the US Top 20. KT regularly returned to *Later...* and she's continued to tour with Jools over the years. She's one of *Later...*'s greatest success stories and there she was at *Later 25* at the Albert Hall in 2017, alone again onstage with her pedals. This time she appeared early in the first half of the show. In rehearsal, I asked her not just to perform the song but to engage the room, to invite the Albert Hall to clap along just as the studio audience had so spontaneously done over a decade before. From that moment there was the warmth of a proper *Hootenanny* in that august hall, and it never went away.

Of course, to be part of *Later...*'s circle of dreams, you had to make it to the studio and stay till the show was in the bag. This wasn't always quite as easy or as obvious to some artists as you might expect. When Ian Ashbridge offered us Smokey Robinson in 2009, we were over the moon. Ian and his wife Jo's independent Wrasse Records has long specialised in picking up and then marketing albums that a parent label has declined to release in the UK. Ian and Jo had had major success with one of their first releases, Ladysmith Black Mambazo's Best of... collection, *The Star and The Wiseman*, and now they had picked up Robinson's latest, an album in his 1970s *Quiet Storm* vein, *Time Flies*

When You're Having Fun. The title would turn out to be prophetic in ways we couldn't yet imagine. Smokey was nearing seventy and in town to close the Electric Proms that Saturday at the Roundhouse. He didn't have a band, but he was free on Tuesday and, as Ian explained, would be delighted to sing a track from the album with Jools at the piano. I am still not entirely clear whether Ian had asked Smokey this himself but then, as I'd later learn, Ian was rather struggling to communicate with Team Smokey and certainly with Smokey himself.

Nevertheless, Ian assured us that Smokey would be happy to sing his version of Norah Jones' 'Don't Know Why' on the show and would welcome Jools accompanying him with his regular rhythm section from his Rhythm & Blues Orchestra. It then transpired that his guitarist Mark Flanagan had an unbreakable prior commitment in Ipswich and couldn't possibly be at Television Centre that Tuesday. Before my fellow producer Alison Howe and I knew it, Jools announced that he'd sorted the problem with a swift phone call to his friend Eric Clapton. Eric had dropped by the *Later...* studio to see Bonnie Raitt and Jimmie Vaughan in the early 1990s, he'd sat in with Dr John on the third *Hootenanny* and, in 2000, he'd come and played 'Bell Bottom Blues' with Bobby Whitlock, his old partner-in-crime from Derek and the Dominoes, even though Bobby clearly threatened Eric's hard-won sobriety. Jools explained that Eric had never met or played with Smokey and was free that Tuesday and keen to do so. We couldn't quite believe this gold-plated collaboration had fallen so easily into place amongst a line-up that already featured Basement Jaxx with Yoko Ono, Jack White's the Dead Weather and Bassekou Kouyate's Ngoni Ba.

Soundcheck was scheduled for 5.30 p.m., with a camera rehearsal right after the crew's dinner break at 6.30 p.m., the favoured slot for hastily convened sessions involving Jools and visiting legends with busy diaries. Eric turned up on his own, bar his long-serving guitar tech, chatted away amiably with Jools and revealed he'd brought a cheese and pickle sandwich to keep the wolf from the door while hanging around. Jools, Gilson, bassist Dave Swift and Eric sound-checked, looked at their watches and ran 'Don't Know Why' a couple of times to get ready for Smokey, who'd been called for 6 p.m. to avoid unnecessary hanging around. Come 6.30 and camera rehearsal, there was still no sign of Smokey. Ian Ashbridge was getting a tad nervous as,

Smokey Robinson with Eric Clapton – 'Don't Know Why', series 35,
episode 6, October 2009.

frankly, was I. We decided to postpone Smokey's camera rehearsal,
rehearse Jools' links for the live and pre-recorded shows and try not
to fret. Eric seemed philosophical enough about Smokey's tardiness
and went off to Jools' dressing room to have his sandwich. Meanwhile
Ian was pacing up and down outside Television Centre's stage door in
front of the statue of Helios, ear bent to his mobile, looking increasingly
desperate. He'd assured us Smokey would be with us by 7.45 but this
latest call time came and quickly went; all Ian could tell us was that
Smokey still hadn't left his hotel room. Of course, Smokey Robinson
– the man Bob Dylan once called 'America's greatest living poet' – had
been doing television shows since the early 1960s, clearly wasn't too
keen on camera rehearsals and probably didn't even know that Eric
Clapton was his guitar player for the night.

I say 'Of course' but, frankly, we had no grip on Smokey at this
point. I hadn't met him or seen him since he'd popped in for an inter-
view on our third ever show back in 1992. We knew nothing of the
management team who were sequestered with the Motown legend in
some West End hotel. *Later... Live* had started the year before so our

evening's schedule was set in stone. We were due to assemble our audience and the artists from shortly after 8 p.m. with a view to starting to tape our traditional hour-long show soon after 8.30 so that there'd be time for any retakes and a short break somewhere around 9.40 before broadcasting live at 10. Given the scale of the endeavour, the number of artists in the room and the relatively recent practice of delivering two shows in an evening, we were feeling a touch vulnerable at this juncture. By now, we'd given up any hope of rehearsing 'Don't Know Why' with Smokey. Eric was looking increasingly disgruntled and muttered something about getting his coat, but Jools and I begged him to stay. A haunted Ian Ashbridge was still pacing up and down under the pillars by Stage Door where Jools arrives in those first opening titles and kept telling us that he'd been assured that Smokey was on his way, had just left the hotel etc etc.

Our original running order had Smokey appearing early in the first show, but we now moved him to the penultimate slot and pressed ahead with the recording, gambling that he would surely turn up by 9.15 latest. Every fifteen minutes or so I would rush out of the gallery while the show unfolded on the studio floor below and down to the Horseshoe to see if Ian had any news or Smokey was in sight. But he didn't. And he wasn't. 9.15 came and went, the show sped relentlessly towards the end, Ian paced the ground, mobile to his ear, while I ran down yet again from the gallery – pleading for news, for reassurance, for Smokey. Finally, shortly after 9.30, word came up from one of our floor assistants who'd now been detailed to wait outside that Smokey's car was arriving. I rushed down to join Ian and together we virtually frogmarched the affable and entirely unapologetic Smokey into the studio, through the back of the set and a tangle of cables up to his spot by the piano, pausing only to triumphantly introduce him to Eric and Jools' rhythm section.

Less than five minutes later, the taping reaches Smokey's turn in the pre-recorded show, and more for continuity than with any expectation of much of a take, Jools plays the opening chords of the song. Smokey's unmistakable voice fills the studio, and we are off. During the short guitar solo, Smokey turns round and beams at Eric, and all the sphincter-tightening hours of waiting are almost forgotten. Ian still looked white as a sheet, but as the poet says, they also serve who only stand and wait. The hour-long show was in the can, some twenty

minutes before 10 p.m. Smokey and band quickly sound-checked 'Don't Know Why' – this time without cameras – and we are live. Twenty minutes later, Jools has a quick word with Smokey and then he, his rhythm section and Eric sail effortlessly through 'Don't Know Why' before Basement Jaxx bring out Yoko Ono for the finale.

Yoko proceeds to go into full hiccup and scream, Plastic Ono Band mode for 'Day of the Sunflowers (We March On)'. A dancer dressed in a sunflower headdress cavorts round the band while the seventy-six-year-old Yoko dressed all in black raises her right arm and sings along with the anthem. I don't know how many times Eric had seen Yoko since he and John Lennon accompanied her on 'Don't Worry Kyoto (Mummy's Only Looking for Her Hand in the Snow)' at the 1969 Toronto Rock and Roll Revival Festival forty years earlier, but now they are mere yards apart once again. As for Smokey, I like to think he was glad he'd made it in the end and filled the gap in our unbroken chain.

Only a couple of weeks later, I am squatting close to the floor of Jay-Z's dressing room in Television Centre shortly after eight in the evening, November 3 2009. It's close to showtime, the other bands and the audience are being ushered into the studio but the six-foot-plus Shawn Carter is towering across from me looking impatient. Look at it from his point of view, he's signed up to do this BBC TV show, *Later… with Jools Holland*, but the ratings aren't huge, he's been rushing around looking after his business interests on a quick trip to London and he's just found out he's expected to spend his whole evening and nearly two and a half hours in a television studio with a bunch of other artists. Those other artists are surprisingly famous – Foo Fighters, Norah Jones and Sting are also on the bill – but Jay doesn't seem that interested in the company he's being invited to keep. He's a busy man and a businessman; naturally, he is time poor. Although Mr Carter's team back in the US have been sent tapes of *Later…* and signed him up for it, I am discovering that he has never actually watched the show himself or, if he has, he has never really digested the suddenly awful implications of its single-shot camera style and its circular studio. The famously persuasive Atlantic plugger Damian Christian put him forward for *Later…* from the UK end and he has been trying to explain how the show works since Jay arrived a few minutes ago. Damian isn't

Yoko Ono feeling a little under dressed alongside Basement Jaxx,
series 35, episode 6, October 2009.

really saying what Mr Carter wants to hear and now he's called me in
to have a go myself. 'Why can't I just do all my songs and leave?' Jay
asks me bluntly.

This is probably the starriest bill of *Later...* ever assembled and
tonight Jay is the jewel in the crown. A year ago, he'd married
Beyoncé months before headlining Glastonbury 2008 with an incen-
diary set that wiped the floor with those who preferred to see the
festival as a bastion of rock 'n' roll. The same year he'd founded
entertainment company Roc Nation to add to his portfolio of busi-
ness interests which already included Ace of Spades champagne, his
40/40 sports bars and Rocawear clothing brand. In a decade he will
become the first hip-hop billionaire and America's wealthiest musi-
cian. He is the greatest of rappers, he is crossing over on his own
terms and everybody wants a piece of him. Foo Fighters, Norah and
Sting are all *Later...* veterans and have long since embraced it. Foo
Fighters have previously played opposite both Radiohead and
Coldplay and they positively relish a challenge. They have also been
doing *Later...* long enough to know that the gauntlet isn't necessarily
thrown down by the biggest or most famous name in the room.
They've already seen their share of surprises and they know that it

is often the unknown acts that come out of nowhere that get everybody talking and steal the show. They don't see that as a threat, they love the music.

Later... always tries to balance new talent and star power but this week the stars have aligned so that the scales are weighted with big names. Yes, we will be throwing to the lions possibly the first ever unsigned band to appear on the show, Oxford's Stornoway, whose propulsive and very English debut single 'Zorbing' shares the folkie harmonies of the Bluebells and recent success story Fleet Foxes. There's also a spot in the hour-long pre-recorded show for Canadian acoustic guitarist extraordinaire Erik Mongrain who happens to be touring Britain that week and whom I'd found on YouTube where his 'Airtap!' instrumental already has millions of views. Mongrain has developed a boggling guitar style in which he plays his acoustic like a keyboard on his lap, tapping and slapping the strings and conjuring tinkling harmonics like raindrops pattering on a window. He's probably not going to be a household name but he's an original musician and a fascinating watch...

Jay-Z doesn't care about the bill. He just wants to do his thing and leave. The pre-recorded show is due to begin in fifteen minutes and, at this point, he hasn't even been on the studio floor. Jay has come from playing his eleventh Number 1 album, *The Blueprint 3*, across Canada. The night after this he plays the MTV Awards in Berlin then heads straight back to Fresno to pick up the US leg of his arena tour. Jay already has plenty going on, which perhaps explains why he hasn't made it to the studio for camera-blocking, letting his band and guest vocalist Bridget Kelly, who is depping for Alicia Keys on the New York anthem 'Empire State of Mind', take care of business.

Jay has a tall and rather intimidating tour manager who has bossed the floor and the band in the hour in the afternoon allotted to his tunes while encouraging the impression that Jay himself would arrive at any moment. We have just camera-rehearsed Erik Mongrain and Jools' links, the other artists are filtering excitedly into the studio and I am squatting down on my knees so that I am looking up at Jay in the hope that he won't think I am on any kind of power trip. I am trying to explain to him that this show is all about the sum of its parts, its collective energy, that artists love it because they feel part of something larger than themselves, because they get to see great artists up close

and personal with the best seat in the house, right across the floor, that *Later...* is an experience not just a television show and that he will see what I mean if he will just surrender himself to the moment and walk through the doors of TC1.

I am pitching Jay the show although I haven't had to pitch it to anyone in a decade because *Later...* has long since become an institution which everybody wants to play. But Jay moves in different circles, and I am not sure he can see what I am trying to describe because I am trying to tell him not only what the show is but how I hope it will make him feel. I am absurdly conscious of who he is and where's he from – his old gangster life, his wealth, his power, and his extraordinary gifts as a rapper. I know he is the Man and I feel absurdly British and comically BBC. There is added pressure for me. Our first two sons were born in the late 1980s and Jay-Z is their favourite artist. They know all Jay-Z's lyrics and can deliver his catalogue of albums word for word. Jay-Z is their guy like Leonard Cohen is mine. They are waiting excitedly in the studio, and they can't believe that Jay-Z is about to walk through the door. Except I am still not quite sure that he is. I have finished my speech and given Jay my best shot. I have told him he will 'get' the show the moment he walks through the studio door, and I have stood up and left him with Damian in the dressing room.

Ten minutes later, Jay-Z walks into the studio and the room erupts. He arrives like a conquering hero. Even the other artists clap him while eyeing him up during the cast photo. Jay is instantly charming and ambassadorial, introducing himself to each artist round the piano individually with a hi-five and a 'Hi, I'm Jay.' Moments later he's watching Foo Fighters kick off the first pre-recorded show of the evening with 'The Pretender'. They are right across the studio floor from his band, almost in his face, and moments later he and Kelly will come right back with an epic 'Empire State of Mind'. We have dovetailed the Foos and Jay-Z's numbers throughout both the evening's shows so they can trade punches and enjoy equal ownership, equal status. Jay closes both shows with '99 Problems'. As soon as the live show finishes at 10.30, my son Cian who is a month short of his twenty-first birthday rushes on to the floor and manages to get our resident photographer Andre Csillag to take his photo with Jay. His older brother Luke is close behind but doesn't quite get to greet him

before Jay-Z is engulfed and then marched quickly off the floor. We get the photos developed and put Cian's on a mug for his birthday a month later so he can drink tea out of it. Sometimes I even use the mug myself.

The author's eldest sons, Luke and Cian, with Mr Carter on the *Later...* floor, series 35, episode 8, November 2009.

Nick Cave

I didn't feel the love and the connection other artists seemed to experience with *Later...* but I think that's to do with me personally. There was obviously an attempt to connect musicians with each other... but I found it alienating in its way because I always feel like an outsider and *Later...* made me feel even more so. I never felt so much out of time, out of touch, as I did when I went to *Later...* because you were confronted with other music.

I am not saying it's a bad thing. It's a thing. Suddenly your music had this completely different context, it had a context that lived inside of other music rather than just the little bubble of music in which you operate.

There's a different context when you're playing with a whole lot of other groups, particularly when they are as diverse as the group of artists which *Later...* brings into play. I remember playing next to the Darkness. Warren Ellis and I were there on our own to play this delicate little flower of a song, 'He Wants You'. The Darkness came out before us, full of all the piss and vinegar of a band having their moment; they had spandex, hair spray, the amplifiers. I am not a fan of that kind of music, but they were inside their performance. It was transcendent. They were fundamentally giving everything they possibly could.

We had to follow them, and there was no way our little song could survive that onslaught. After we'd played, they asked us to go again because the pickup on Warren's violin had malfunctioned, I'm like 'Fuck that! We're done!' I actually think the version of 'He Wants You' we did was quite good. The singer was changing into a new leotard behind Warren's amp, which was also distracting... It was a song played under a certain amount of duress and that was affecting too.

But then, on the other hand, it works the other way round. We came

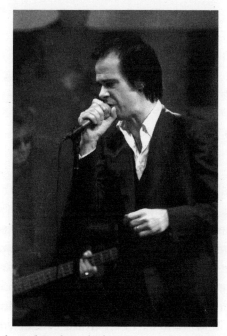

Nick Cave and the Bad Seeds in the house, series 24, episode 3, October 2004.

early on with Grinderman, and we played 'No Pussy Blues' and 'Honey Bee (Let's Fly to Mars)'; we were just starting up and we were on fire that day. We had the wind in our sails, we did a pretty fucked-up, subversive, insane performance and they kept cutting over to Travis sitting in their corner with their jaws open. Every time the camera cut back to them, they seemed that little bit more diminished. So, it can work either way. You never knew what you were going to be confronted with when you went to *Later...* and I guess that was the beauty and the horror of it.

When I go on other TV shows, those American late-night talk shows, it's very difficult to do the performance you want to do, the environment doesn't lend itself to that, you have this one moment and it's usually disappointing. At *Later...* there was something about the hanging round, the sitting there and loving or enduring the other bands that were on, that allowed you to get into the performance a little bit more than when you get to play one song at the end of *Letterman...* There's something inclusive about *Later...* too, in the sense that everyone's dealing with playing music on TV, they're not at their gig, everyone's a fish out of water in their own way and that's a common bond. It's a beautiful show, you know.

I was moved by the performance of 'Wonderful World' that I did with Shane MacGowan in the first series. I love Shane in that performance; it was almost heroic, this epic battle he was having just to be able to stay sitting on his stool, I know he was having immense problems with that, the way he battled to stay on, it was beautiful. There are moments like that on TV, if it's good, that you don't get with a live concert, you can go in close with the cameras and you can see what's going with the performer, that's one of its advantages, you can see the terror. There's an intimacy to it. Television's good at personality.

'God is in the House' was the performance I like the most. We had everyone leaning against the piano, Dean Martin-style, Warren was sitting on the piano playing the violin, a beautiful relaxed and measured version of the song. I found it really moving. It felt natural and casual at the same time. Neil Finn came up and said that's a really good song and that was nice too. I wouldn't normally come across a guy like Neil so for him to come up and say that, means something. I saw Joanna Newsome there, Morphine I'd never heard of them, Beth Orton, the Raconteurs who are friends, occasionally some kindred spirits.

The first time I met Jools was at Paula Yates' house. Michael Hutchence was there and Kylie. I walked into this room and Jools was there, leaning up against the mantlepiece and regaling this captive audience with stories. He's always been this incredible raconteur. He was explaining that when he was 11 he thought he'd discovered masturbation. He tried to put a patent on it. I remember hearing that and thinking that this is one of the good ones – I really like this guy!

It's an arena, right, it's almost deliberately set up in that way; everyone's looking at each other, facing each other off in a gladiatorial setting, but it was so diverse, I didn't find it competitive. I am not going to have a problem with Natalie Imbruglia or Shaggy, they're just doing their thing and we're doing ours. Sometimes I felt out of place, out of time, other times I felt ahead of time. I've had a long career. Sometimes I felt ahead of the moment and sometimes behind it; we are just our own thing; I'm used to that. In the grunge period, we did the Lollapalooza tour in arenas of 80,000; we were literally the only band and the only people who had long trousers on.

I have always felt an imposter in music to a certain degree. I am just not a muso in the way that other musicians are and *Later...* was obviously very much about what music is in its essence. I have always felt

outside of that, just because I operate in a different way with different strengths and musicality isn't necessarily one of them. I never felt that confident about what I do to present it to a bunch of musicians and say 'Hey, check this out, here I come!' I never had that. I know musicians who did, and it was mystifying to me. There's always a sense of remove in that respect but the concept of *Later...* was inclusive. It is a broad church as a concept. When you found your spot, you could really find yourself at the same time. There you were. That's the beautiful thing about the show.

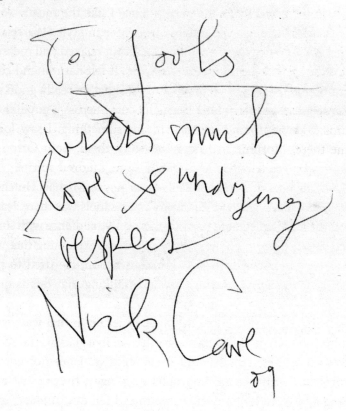

To Jools
with much
love & undying
respect
Nick Cave
'09

Elton John and Jools Holland – only one of these two pianomen arrived at the studio by helicopter... Series 48, episode 4, May 2016.

6

Boogie-Woogie Man

Jools' Piano

Even when there wasn't much or even any set, there was always the piano. The piano was Jools' home, his interview base, *Later...*'s black and visible heart, our talisman. Every Monday morning a Yamaha Grand would be wheeled into the empty studio on its side, clad in protective brown sackcloth, and given pride of place in the room while that week's bands' gear piled up in different corners, the set and lights were hung, and we slowly built towards soundcheck. A grand piano with a shiny black surface which presided over the room like the prime minister's desk in Number 10 Downing Street. The black body required regular polishing and a visit from the piano tuner in the quiet of supper break before the taping. The piano has always been a constant and so its black and white keys became our graphic icon, winding across the floor like a snail trail and, for a time, climbing up the set behind the grand to distinguish its own designated area, a private club of sorts.

Jools' piano has always been the very emblem of *Later...*; there to be played, to be sat at and stood around, a gathering place and a sleeping giant, waiting for hands to bring it alive, in pride of place as pianos once were in Victorian living rooms. At first, the piano was placed in the middle of one of the side walls at TVC. Once, we put it in the middle of the floor for Jimmy Webb to play 'The Highwayman' while the cameras swam around it like a shoal to reach Spiritualised and Lynden David Hall; for a time, the piano would move around the room as we tried to unsettle the fixed geography of the circular studio layout. The first week we moved it, a disoriented Jools banged his shin on a lurking monitor after the lights had been dropped in the studio for adjustment. Then it had its own dedicated corner stage on a raised platform with tables and chairs behind it, our own piano bar. Latterly,

in Maidstone, the piano became a moveable feast, placed according to what and who else was in the room, but always ever present.

Jools and the piano go hand in hand; if the show and the host are all about the music, what better icon can they share than the instrument on which so much popular music has been conceived and played? What melody can't be played on the piano? It's the roll call of popular music at your fingertips. Think of who has sat at that piano, from Johnny Cash to Odetta, from Joe Strummer to Gladys Knight, think of the artists who've played it, from Nick Cave to Norah Jones, from Herbie Hancock to Diana Krall. The presence of the piano means we are primed for business, there to make music. Most of the guests that roll into the studio are on tour or fresh from rehearsal, prepped and practised, well oiled and ready. But the performances around the piano are thrown together a couple of hours before showtime, cooked up on the spot. When Jools is formally accompanying a guest or sitting in, he'll rehearse thoroughly at home, but there's also plenty of spontaneous fragments that pop up during his chats. Much of what he creates at the piano is fresh off the griddle and not overly refined; it's not a studio recital but thrives on the one-take immediacy of the stage.

Jools' piano skills often bring an impromptu, *Hootenanny* quality to *Later...* There's a sense of shared tradition, a common love of the pop songbook, in so many of his collaborations. *Later...* has always been primarily devoted to new music and there have been plenty of debuts at the piano, from singer-songwriters Tori Amos or Benjamin Clementine, but who doesn't also like a deep dive into buried treasure, a classic song dusted off and celebrated round the Joanna? The piano puts that shared long tail of popular music at Jools' disposal like an inexhaustible jukebox. Where else would Annie Clark aka St. Vincent reveal that she'd grown up in Texas on old-school country and promptly share a verse or two of Patsy Cline's 'Crazy', all while dressed in a leopard-spotted hooded jumpsuit? Or Colombian global superstar Shakira take a breather from demonstrating that her hips don't lie to serenade Jools with her take on the jazz classic 'All of Me', written in 1931 and a favourite of both Billie Holiday and Frank Sinatra?

The piano has always been where all the artists gather before the show for a cast photo. After two days' preparation and individual camera rehearsals, suddenly the studio would teem with artists, crew and audience and the whole elaborate edifice of the show would teeter

into life. Although a couple of the artists might cross paths at sound-check or bump into one another in the labyrinth of dressing rooms, it was only in these last few minutes as the audience settled and the warm-up began that the solo artists and bandleaders would leave their band areas and gather in an awkward huddle around the piano for the group photo. A few bands insisted that they all had to be in the shot, most were happy just to send the lead singer, the Face. The group photo emphasised to the studio audience and the assembled artists that we were embarking on a joint venture, launched around the piano. This brief gathering was always an odd blend of first date and the moment after the ring walk when boxers square up before a bout: the moment when Noel Gallagher met Dua Lipa, Amy Winehouse maybe had a chat with Matt Bellamy or Jay-Z encountered Dave Grohl. Think of the muttered conversations between unlikely bedfellows that have taken place in those few minutes while the studio audience stares around the room, the camera crew make last-minute adjustments to their shot lists and the cracked oil diffuses under the lights. If only the piano had ears! If *Later...* is the music show 'where all the artists play together live in the round', Jools is the conductor and the piano both blue touchpaper and spark, meeting place and emblem.

Jools would usually arrive in the studio before teatime on the day of the show. For many years Jools declined to get a mobile phone and I think he enjoyed these snatched minutes of solitude before the madness of showtime, especially when he was in the thick of a Rhythm & Blues Orchestra tour. If he was accompanying someone, I or one of the floor assistants would escort them round to his dressing room as soon as he was settled. As you walked down the dressing-room corridor, you'd usually hear a bit of boogie-woogie coming through the door as Jools warmed up on his rehearsal piano. The dressing rooms were always sparse, particularly at Television Centre, where the ambience wasn't too far from a prison cell, with a single small window that wouldn't open but looked out to the rotunda and T.B. Huxley-Jones' bronze statue of Helios. Often that week's collaborator would be accompanied by a tour manager or a plugger and we'd all chit-chat for a minute or two before leaving Jools and his new friend to business. You couldn't hear very much through the dressing-room door, but Jools had the gift of putting his guests at ease and making them comfortable. No one stayed too long, everyone came out happy. There was never

Jools squeezed into his dressing room with Candi Stanton and the London
Community Gospel Choir, series 13, episode 1, April 1999.

any shouting and sometimes there were cakes. Many of the artists that
Jools played with either knew him already from past encounters or
were immediately charmed, first by his olde worlde English manners
and then by his piano playing. There's something intimate about voice
and piano and although Jools is first and foremost a soloist, he's always
fully embraced his role as accompanist.

Jools' accomplished presence meant anyone could drop by and
perform, even if they didn't have a band in tow. When Luther Vandross
came to town in November 1995 he must have been promoting that
year's Christmas album. I was a huge fan and had interviewed him
several times during the 1980s as a journalist, and then filming him
for a *Late Show* feature on the Soul Man. Luther absolutely dominated
American R&B in the 1980s. His vocal finessing threw back to his
female heroines of the sixties, Dionne Warwick et al., and he played
the matinee idol for the rising Black middle classes. I was always smitten
by his silken vocal genius and arranging skills but each time I inter-
viewed Luther I was struck by what he called his 'sensitivity'. Luther
was a troubled male lead, constantly struggling with depression, his

size, and music biz mutterings about his sexuality. When I talked to him backstage at Atlanta's Omni Arena in November 1988, Luther was once again heavily overweight, even though he'd manged to slim down for the cover of his sixth album, *Any Love*, which had only come out a few months before. Now he was out on the Southern leg of the Summit tour with Anita Baker. If Luther was king of what Nelson George had dubbed 'retronuevo soul', Baker was the queen, but all the talk backstage was of how the two divas had fallen out. I described Luther then as having 'the sad eyes of Buster Keaton trapped in the body of W.C. Fields'. 'Some people can't express their emotions,' he told me as he sat forlornly in his tracksuit in an empty room a couple of hours before the show. 'Maybe my way of expressing them is through song. It's not like I'm the happiest, most emotionally stable person I know but I wouldn't tell you that as readily sitting here as I might through a song.'

The American charts and radio were still profoundly if tacitly segregated throughout the 1980s and Luther wouldn't begin to cross over to white audiences until his music lost the finger-poppin' swing it maintained throughout that decade and got a touch schlocky. But Luther had been a soul icon in the UK since 1981's calling-card single, 'Never Too Much' and his live debut at London's Dominion, Valentine's Day 1983. In 1989, he'd played ten nights at Wembley Arena in the round. It's safe to say that Luther won't most be treasured for his 1995 *This is Christmas* album but his plugger Deirdre Moran somehow convinced him that he should set aside a few hours from promoting his seasonal celebration, come on *Later...* and sing a song with Jools. I was used to seeing him in arenas, dressed up in diamanté flanked by his vocal troupe. Dressing down wasn't a Luther thing so I knew he was asking a lot of himself to come on British television and sing solo, accompanied only by a man he'd never met in front of a strong cast led by Pulp in their imperial moment, the week that the *Different Class* album debuted at Number 1. I couldn't believe he'd also agreed to sing 'Any Love' which I regarded as his cri de coeur, Luther at his most candidly personal, longing for love. 'People tend to want to see me happy, to be everything they can't be,' Luther had told me in 1991. 'The idea that I don't need anything is the farthest from the truth; it's the biggest paradox of my whole career. I've stood on stage and seen couples hugging and just spiritually bonding to my music. Then

Jools, Luther Vandross and Randy Newman gather at the piano,
series 6, episode 2, November 1995.

I go back to my hotel room and the red messages light on my hotel
phone? Nothing.'

Jools' stint with Luther's producer, bassist Marcus Miller, on the
Sunday Night show in New York meant Jools also knew what was being
asked of him. The *Sunday Night* house band were all crack players, the
crème de la crème of the American session scene, and Marcus Miller
was all over Luther's 1980s albums which are a kind of uptown who's
who of jazz-inflected R&B. Jools knew he was playing with the best of
the best. He wasn't always that comfortable carrying a performance
solo and would bring in drummer Gilson Lavis, bassist Dave Swift or
both to lock down the tempo. On this occasion, Gilson came in on
congas while Jools faced up to the challenge of 'Any Love' like a grad-
uation exam. Co-written with Miller, 'Any Love' is a ballad but with
that familiar Luther swing, a sophisticated melody with plenty of chord
changes and a subtlety of expression that drips intimacy. It's not the
blues or boogie-woogie and it's certainly not a chance to shine as a
soloist. Jools told me he'd spent hours at home working out a solo piano
arrangement without the help of Luther's brilliant musical arranger,

Nat Adderley Jr. Jools has a brilliant ear and he'd written out the song in his own musical code. He charmed Luther in the half-hour or so they spent running the tune on the studio floor at teatime while the odd roadie tinkered with Pulp's gear, James Campbell adjusted his lights and the massed gear of the various bands loomed across the floor.

I think it was after his camera rehearsal that Luther began to get stage fright as the clock ticked towards the taping. Suddenly he began to feel the full extent of his exposure. All the bands had one another, Randy Newman had always been self-accompanied. Luther's dressing room was down in the basement where he complained bitterly to Deidre about what she had gotten him into. Why was he alone like an amateur, where was his band, his singers, his show? If Luther could have bolted, I am sure he would have.

Luther was in one of his slim phases in 1995 and, at showtime, he came out as if to the manner born, resplendent in an azure jacket and a silvery silken shirt. He didn't appear until two-thirds of the way through the show, after all the other guests had already performed at least once. Across the studio floor, German electro-soul singer Billie Ray Martin had just concluded the torchy, pedal-steel drenched 'I Don't Believe' from her *Deadline for My Memories* debut solo album with an extended dance routine with her three backing vocalists. Luther sat waiting his turn, no doubt wishing his backing singers and band were there beside him. I don't think he'd ever sung solo on television before and here he was, surrounded by a roomful of musicians, the only Black artist in the studio. He'd elected to sit on a stool in the well of the piano while Gilson and Jools remained half lit in front of the audience gathered around the piano.

As the studio lights drop, Luther's bright blue jacket and his confiding doe eyes take centre stage. The moment 'Any Love' begins he's Luther the artist, completely in command of his story and what he wants to share. When he sings, he's all expressiveness, his face an open but theatrical book. Janet's cameras barely leave his face. He's appropriately tentative at first as he begins his confession and so is Jools, but as the song progresses, they both gather in confidence. Jools begins to swing into the melody and slam into the choruses with a few of his trademark gospel slurs, the steady conga pulse gathers and the stakes mount. A couple of minutes in and Luther is enjoying himself, clicking his fingers as the rhythm asserts itself with that

trademark bounce. When the middle eight finally appears, it's over three minutes in and it's the song's crescendo. As Luther confronts his isolation and his longing, he rises from his stool and hits the big notes. Westlife would turn this gesture into a career in the new millennium but here it's the sweet spot where showbiz and soul combine; there's a kind of redemptive epiphany as Luther stiffens his resolve and outfaces his loneliness. He's in complete command now and the three of them climb back into the chorus once more before the conga drops out and the tempo slows, leaving Luther's vocal almost unaccompanied as he teases out every melodic nuance of the final line, relishing his vocal skill even as once again he returns to his recurring and heart-breaking search, his longing for a love of his own, his longing to be loved. At the end of his promo trip, Luther told Deirdre this was the best thing he'd done and the highlight of his stay.

'Any Love' illustrates the breadth of what Jools has always brought to *Later...* as a musical resource. Sometimes he would accompany legends on one of their signature songs – Eartha Kitt and 'Ain't Misbehavin'', the Beach Boys and 'Barbara Ann', Jimmy Cliff and 'Many Rivers to Cross' – occasionally he'd back a new artist with whom I felt he had an obvious kinship, especially when they came with an introductory song that suited, say Gregory Porter's piano ballad 'Illusion' in 2011 or Rag'n'Bone Man's 'Human' in 2016. Often artists who'd grown with the show and who had befriended Jools would volunteer a song they could do together, Adele's cover of Dylan's 'To Make You Feel My Love' or Ed Sheeran and his own 'Thinking Out Loud'. Jools would often guest with artists with whom he is simpatico, especially when they share a common love of blues, country or jazz. You can follow his growing musical friendship with Bonnie Raitt down the years, jamming on Wilson Pickett's 'Three Time Loser' with Jimmie Vaughan in 1994, flanked by Bonnie and Trisha Yearwood on Charlie Rich's '(Feels Like) Going Home' in 1998 or playing a verse and chorus of Allen Toussaint's 'What Do You Want the Boy to Do?' in 2017.

But the role of the piano isn't solely to be played. Most of Jools' most informative chats have always taken place at the keys where he and his guest can sit close on adjacent stools, where Jools can throw in the odd musical quote and where a monitor waits close by so he can take his

subject and the audience 'down the time tunnel', with archive from way back when. The piano made immediate sense of Jools' opening question, 'What was the first music you heard?' The interview and archive series during lockdown in 2020/2021 showed what a thoughtful interviewer Jools could be in the quieter, more intimate environment of his own Helicon Mountain studio, whether on Zoom or in person, with his piano standing close by. The warmth that the likes of Michael Kiwanuka, Héloïse Letissier or Dizzee Rascal clearly feel for Jools was evidence of the trust he'd built with them over their visits to *Later...* and the *Hootenanny*. Their shared interest in the show's archive offered musical sustenance in dark times.

But in the bearpit of the studio with the clock ticking and a roomful of musicians, Jools' chats could be hit or miss. My journalistic approach and Jools' desire to put his guests at ease were mutually exclusive. Jools couldn't be the musicians' champion and ask them tough questions at the same time. His own experience with the press had already made him sceptical of prying journalists and their basic command of facts, a scepticism which would only mushroom as his star rose. When Alexander O'Neal came on the show in 1996, I insisted that Jools simply had to ask him about his much-publicised drug issues. O'Neal had frequently commented in print about his cocaine use which had rather derailed his career in the early 1990s. While O'Neal was happy to admit that he'd argued with Prince, who had prevented him from being the lead singer of the Time, and to discuss whether the four-poster bed that had been the key stage prop of his many UK tours should be retained for his forthcoming jaunt, he reeled back as if stung when Jools haltingly asked him about his relationship with drugs. Jools felt that he had been ungentlemanly at my instigation and increasingly resisted research-based questions putting his interviewees 'on the spot'. We would discuss questions for each chat at length, but Jools preferred to rewrite the interviews to his own specifications and to avoid questions that might unsettle his subject. As a result, Jools' chats were always amiable, frequently flirtatious, but sometimes inconsequential, particularly with younger or newer artists who had less history to draw upon. Jools became more easily sidetracked because he preferred bonhomie to probing. He felt it was his primary job to welcome the guests and put them at ease so that they would share their musical DNA with him as a fellow

musician and fan. Women have always been particularly comfortable with Jools, and I can still see Courtney Love or Angie Stone putting their heads on his shoulder, mid-chat.

When Jools admires his subject, he's a warm and witty confidante. He was fascinated with Brian Eno's 'Oblique Strategies', cards bearing surprise advice for stalled producers. When Brian sat at the piano in 2001, he explained the deck's liberating potential. 'I noticed when I first started working in studios, you get a kind of tunnel vision and forget the most obvious things. You come out of the studio and think – why didn't we remember to do this or that? These cards and their instructions are really just ways of throwing you out of the frame, of breaking the context a little bit... it's a way of breaking the tendency to get the screwdriver out.' 'So, they'd work for any artistic endeavour, I suppose?' Jools muses. 'Yes, I even met a brain surgeon who told me he used them frequently,' answers Brian with a smile. Jools is thrilled by this and immediately wants to give it a go, imagining we are the patient mid-operation. 'Could be any of us here!' Jools warns, gesturing to the studio audience. He pulls out a card which poses the question, 'Is there something missing?' Brian, Jools and the audience around the piano dissolve. It's a quintessential Jools' moment – quirky, a tad cheeky, spontaneous.

Jools' own lines of enquiry are rather more predictable than those cards would approve. Jools' piano interviews have always revolved around the perennial questions: what was the first music you heard and what was the first thing you heard that made you want to be a musician? He's always looking for his subject's musical origins as the key to their identity. As a producer, Jools' refusal to probe our guests could sometimes be frustrating. But that's why musicians are so comfortable in his presence and it's part of the ambience of the show, the sense that the musicians come first. He doesn't want to tittle-tattle; he wants to entertain and talk about music. Sometimes that can make his chats seem almost incoherent, particularly when he's rushed or we hadn't set enough time aside for him to let the conversation develop, and then Jools would settle for being playful. Flighty, even. 'What do you take on tour with you?' became a standard question in the 2000s. Jools often jumped from question to question, preferring to banter with rather than draw out his guests. I don't think we ever cracked how to involve Jools' interviews in the live half-hour shows. We usually had

six artists in the studio, at least one of whom would do a couple of songs, the shows rushed along and there was less and less time for Jools to relax with his subjects.

In 2010 Jools and the Orchestra had the *Rockinghorse* album coming out, and I encouraged him to do an interview with my old editor at *Q*, *Mojo* and *The Word*, Mark Ellen. What Mark didn't tell me was that he intended to quiz Jools about his interviewing technique because his readers regarded Jools' chats with something approaching horror. Mark and fellow journalist and editor David Hepworth had presented the *Whistle Test* in the 1980s on BBC2 when Jools and Paula Yates had been riding high on *The Tube* over on Channel 4. Jools shocked Mark by claiming that he didn't really prepare his interviews and that his approach was inspired by Commander Burt of Scotland Yard, former head of the Special Branch in the 1950s, who elicited confessions simply by listening. '… I think you should get people relaxed and then listen carefully to the answers they give… so yes my technique is like Commander Burt's – less is more.' When Mark pressed Jools as to why he constantly returned to the same few questions, Jools compared music interviews to comedy. 'There's probably only two jokes. There's only eight notes in the scale.' Mark proposed that such general and predictable questions suggested a lack of knowledge or prior research of his subjects. A flustered Jools then revealed how totally he'd come to distrust the facts and opinions on which journalism feeds. 'But if somebody tells you something about someone, I never believe it's true. You can never make an assumption. You say "research" – OK, that's a very good point – but Wikipedia is all rubbish, encyclopaedias can be wrong, press cuttings can be wrong, and they're just repeating things that were in before.'

Jools invoked his hero Duke Ellington's autobiography *Music is My Mistress* in his defence. 'He [Duke] says that music itself is the thing that explains it. And a lot of musicians express themselves better in song. You don't want to talk too much about it. If you try and explain it, you will trip yourself up. So, I wouldn't want to say too much or I might start falling over.' Jools was discomfited by this encounter but sanguine enough to welcome Mark onto *Later…* in 2014 to promote his memoir, *Rock Stars Stole My Life!* Meanwhile Mark came round to Jools' approach. 'You have to ask friendly things with no wrong answer,' he reflected in 2021. 'You have to find out what made them want to

write songs and to perform. And if you're slightly critical people just clam up, especially on TV. Jools does a brilliant job and he has to stay onside with all musicians as they're all in the same business and should support each other.'

I think Jools has always believed that musicians reveal themselves in their music rather than what they have to say. Jools would often sit and talk with an artist he was initially just going to interview during the show and together they'd cook up a snatch of an appropriate cover to drop into their chat. Tony Bennett came with his own venerable trio in 1997 but when he and Jools chatted at the piano, they played a snatch of 'Fly Me to the Moon', Tony's voice ringing out powerfully across the studio while Jools played the chords, surrounded by a gaggle of young audience members, collectively holding their breath. When k.d. lang returned to *Later...* in 2000 with the *Invincible Summer* album, she and Jools bantered away opposite the Webb Brothers, the band formed by Jimmy Webb's three sons, Christiaan, Justin and James. Inevitably their chat turns to Jimmy's august songbook and although k.d. keeps apologising to the Brothers for harping on about their dad, when Jools begins fingering the chords to 'MacArthur's Park', k.d. goes all operatic, arms in the air, soprano-style, comically relishing the 'R' of 'recipe' in that famous line as Jimmy Webb explores the terror of forgotten inspiration, scaling the heights for the crescendo, bringing the house down. When Mickey Dolenz and Peter Tork of the Monkees sat at the piano to promote a tour in May 2011, Peter and Jools shared piano duties while Mickey stood up in his homburg for an unguarded supper-club version of 'I'm A Believer'. Something of the sweetness and glee of their characters in those classic 1960s television shows was suddenly on display, more so in this impromptu performance than anything either of them revealed in interview. Peter and Mickey clearly still simply loved to entertain.

Jools likes to welcome the guests as if they are coming round to his house and he works hard to let them know that he only wishes the best for them. He loves to play, and I think he's always felt that he could get further under his interviewees' skin and get them to reveal more of themselves if they were to make music together. But, above all, Jools has always enjoyed the show more if he has something musical to get his teeth into and quicken his interest. I figured early on that the more involved Jools is as a musician, the better the show comes over because

it isn't just Jools' piano that is the heart of the show; it is, of course, Jools himself.

Jools had naturally taken to Amy Winehouse's jazz sensibility and London girl charm when she first appeared with her debut album, *Frank*, in 2003 and we'd brought her back a year later for the twelfth *Hootenanny* where she sang Dinah Washington's 'Teach Me Tonight' with the Rhythm & Blues Orchestra. When Amy released *Back to Black* in autumn 2006 she returned transformed with her beehive, her tattoos and her print dress, thinner but still healthy enough. She sat in Jools' dressing room where they chatted about singers they both loved before alighting on a shared affection for Sarah Vaughan's 'Tenderly'. Amy would sing a line or two and Jools would cock his head and feel for the chords on the keys, feeling his way towards the melody and the spaces between. During Jools' links rehearsals Amy popped out to the empty studio floor so they could play a snatch of 'Tenderly' on the show piano and balance her voice in the monitor.

Come showtime, they chat about the Motown girl group inspiration behind *Back to Black* and the moment Amy inspired Mark Ronson by singing him a line or two of what would become 'Rehab' while walking along a New York street. Then Jools enquires mildly after the music Amy first listened to, the perennial question. 'A lot of jazz,' she answers. 'One of my first musical memories is listening to my grandad play "Tenderly" on the record player.' Amy is sitting next to Jools and a microphone just happens to have been left on top of the piano. He asks her if she's up for singing a bit of it and then decides to get a bit of tempo from the audience surrounding them. He claps out a beat, they join in with gusto and Amy and Jools swing into action. It's a driving version but Amy doesn't hurry the beat and her phrasing's pure jazz from the get-go. She's obviously schooled in the greats – Vaughan, Washington, Holiday et al. – and she's paying tribute, almost karaoke style, as the standard recalls a lovers' walk kissed by an evening breeze. John Legend and Jack White and Brendan Benson's Raconteurs are watching from across the room, halfway through there's a brief cutaway of Muse clapping along from their stage. 'Tenderly' barely lasts a minute; if only there were more!

Amy giggles at the end as she puts the mike back on the piano. She and the band are utterly styled this time around, from the beehive and the dress to the grey zoot suits and routined dance steps. They've only

played a couple of gigs together so far, the album's only been out a couple of weeks and Amy's debuting 'Rehab' and 'Tears Dry on Their Own'. All the madness lies a little further down the line but for all the studied delivery of the *Back to Black* songs, with the band, there's something particularly revealing in this brief and barely rehearsed duet with Jools at the piano which allows the studio audience to lean in and warm to Amy the person.

Although Jools has featured most commonly as an accompanist with a guest singer joining him at his piano – not to mention the odd piano duet with Herbie Hancock, Hiromi or Jamie Cullum – he's also always sat in with his share of visiting bands. Take Jools guesting with the White Stripes in 2007, albeit not at his own piano. Jack and Meg had first appeared in 2001 with 'Hotel Yorba' from the *White Blood Cells* album. Back then, ever keen to maximise our use of studio space, we'd squeezed in the breaking duo as a fifth band alongside Jamiroquai, US3, Super Furry Animals and Muse. I don't think they were too impressed at being boxed into a metaphorical cupboard, but six years later Jack requested that Jools sit in on 'My Doorbell' from the *Icky Thump* album on Wurlitzer while he played fuzz bass. In 2001 the White Stripes were a jug band swamped by the show, but by 2007 they inhabit their own art-garage world, flanked by a team of quietly spoken and almost sinister minders in matching homburgs dressed uniformly in black ties, shirts and suits with red handkerchiefs peeping neatly out of their breast pockets. Their stage set and lighting is all red and white while the floor beneath them is bedecked in red and white spirals like a Japanese flag. This time around, we are fully in the White Stripes' world as those dark locks fall across Jack's face while he squeals like Robert Plant's love child, panting for his doorbell to ring. Jools faces away from the band and either uses the mirror on the band's keyboard or glances back over his shoulder to check on the groove. I am not sure he received any advance warning on the band's dress code because there he is in smart striped shirt and a tidy jacket, every inch the casual British gentleman, adrift in a red, white and black world. Jack goes over to Meg to sing the last chorus and then he comes over to Jools and gives him a big hug. Jack would return with the Raconteurs, the Dead Weather and as a solo artist, but this was surely the moment he fully bonded with Jools and the show.

Jools has always had a sideline in garage rock. After all, he came of age with punk and his first session was providing a piano part on

Amy Winehouse and Jools play tenderly together,
series 28, episode 1, November 2006.

Wayne County and the Electric Chairs' 'Fuck Off'. When the Jon
Spencer Blues Explosion came to *Later...* in 2002 the trio had already
been going over a decade, but they retained the chaotic but celebratory
take on primal rock 'n' roll which had first got their juices flowing in
1991. Frontman Spencer had come out of the underground East Coast
punk scene and bands with names like Shithaus and Pussy Galore.
Daniel Miller's Mute Records had just released their ninth studio album,
Plastic Fang, produced by Steve Jordan, now the Stones' drummer who
had streamlined their sound without filing off any rough edges.

Jon strode out into the studio dressed in black leathers like the
reincarnation of Jim Morrison, boasting the kind of sideburns that a
werewolf might envy, determined to shake up the joint and impress
fellow guests Patti Smith, Angélique Kidjo, Gomez and Tweet. Jools
sat in on 'Sweet 'n' Sour', the penultimate song in the show and an
invocation to the off-the-hook joys of rock 'n' roll, guitars distorting
on overdrive. The Blues Explosion came screaming out of the blocks
with Jools pounding away on the piano on the other side of the studio,
giving it his very best Jerry Lee Lewis. A vertical array of metal trusses
and a barrage of flashing lights surrounded Spencer while he prowled

The White Stripes ring Jools' doorbell,
series 29, episode 5, June 2007.

in the semi-darkness of his own demonic disco. Jools remains the English gentleman in a sensible sports jacket but he too is keen to get gone, twinkling away on his trebly solo while Jon spurs him along, 'Aw, come on, Jools, get it!' Jon isn't the kind of showman who's going to stay caged in his tidy corner, and before you know it, he's taken his mike off the stand, yelled 'Rock 'n' roll!' and dropped to his knees before legging it across the floor to bellow in Jools' ear. Suddenly he's up on the piano itself. Jools' camera gazes up at Jon as he towers towards the studio roof and then he drops to his knees again, his guitar slung round his back, yelling out 'Rock 'n' roll!' like a call to arms before leaping high off the piano to the floor and stumbling back to the band just as 'Sweet 'n' Sour' lurches to a halt. The audience roars their approval as Jon then sashays back over to Jools and raises his arm aloft like a prize fighter. He's rocked the joint and Jools has played his part.

Jon Spencer isn't the only artist to mount Jools' piano. Kylie and Michael Hutchence have both sprawled across it – not at the same time – and the Bad Seeds have encircled it like a prayer meeting while Nick Cave played 'God Is in the House'. But Justin Hawkins clearly had his

The Darkness' Justin Hawkins traps Sam Brown at the piano,
series 21, episode 6, June 2003.

eye on the piano from the moment the Darkness entered the studio
in June 2003, a year or so after Jon Spencer's visit and shortly before
their debut album, *Permission to Land*, topped the charts. Dido, Norah
Jones and Beyoncé ruled the airwaves, and, straight out of Lowestoft,
brothers Justin and Dan Hawkins were primped and poised to bring
back 1970s rock excess, both musically and personally.

At the end of the show, with Moloko, Nick Cave and chat guest Tony
Benn looking on, the Darkness return for their second song and future
Number 2 single, 'I Believe in a Thing Called Love'. Justin parades up
and down in front of the band in his zebra-striped bodysuit slashed
to just below the belly button. He fingertaps an impressive bit of guitar
wigging by way of intro and nods to bandana-sporting bass player
Franke Poullain to get the studio audience to clap along, even before
he's started singing. It's Thin Lizzy, Queen and Glam Rock long after
their 70s heyday, vain and innocent all at once, and Justin sings most
of his touching celebration of falling in love in a piercing falsetto that's
seriously silly but expertly delivered.

Justin and brother guitarist Dan stomp back and forth across the

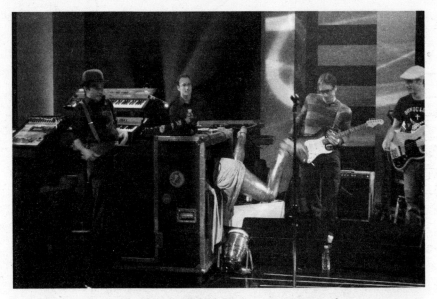

Róisín Murphy of Moloko loses an earring in a speaker,
series 21, episode 6, June 2003.

stage as if they were still kids in front of the bedroom mirror before Justin suddenly sets off unscripted across the studio floor. It's the penultimate song in the show, Moloko are scheduled to finish, and the Darkness have segued off the back of Sam Brown and Jools' blues ballad, 'I Told the Truth', just a little further along the studio wall. Poor Sam has been asked to linger at the piano in preparation for Jools' closing link when he will circle the studio to thank all the guests before handing over to Moloko. Sam's doing her best to lean nonchalantly in place in the well of the piano but now Justin is almost upon her. Suddenly he's standing on top of the piano, soloing away, while Sam grins up at him, clearly wishing the floor would open up and swallow her. As Justin continues to shred away, Sam senses what's coming and shrinks beneath the piano just as Justin jumps off, legs akimbo, and rejoins the band, brandishing his, ahem, axe aloft in triumph as the Darkness finish. Moments later, Jools sidles into shot and congratulates Justin. 'Bloody brilliant!' he beams, shaking his hand. Not to be outdone, Moloko's Róisín Murphy finishes 'Sing It Back' by clambering inside keyboard partner Mark Brydon's Leslie speaker until all we can see is her silver leggings waving rhythmically in the air. We will never know what the piano made of it all.

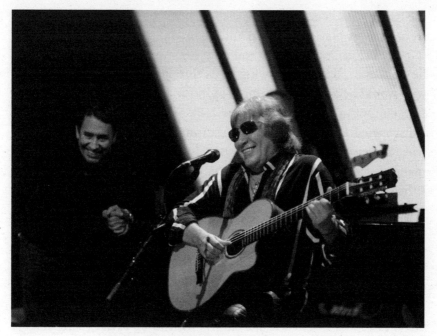

Jools and José light each other's fire, series 49,
episode 8, November 2016.

I was always looking for artists for Jools to accompany, artists with
whom he'd share a musical grammar, artists with character who sounded
like they knew who they were, whether young or old. Jools and I both
grew up in South London, not too many years apart, and we share
common musical enthusiasms, past and present – blues, jazz, country,
Motown, the roots of popular music. I always loved coming up with
artists we both revered and sharing them on *Later...* with Jools'
passionate endorsement and accompaniment. I spent years trying to
contact the blind Puerto Rican singer and guitarist José Feliciano who'd
emerged out of the Greenwich Village folk scene of the early 1960s to
become an international star and who'd so shocked older white
American audiences with his Latin-tinged solo performance of 'The
Star-Spangled Banner' at the 1968 World Series in Detroit. Feliciano
had come to London in 1967 despite the border authorities refusing
entry to his guide dog Trudy, appeared on Dusty Springfield's television
show and had his unique guitar style admired by none other than Jimi
Hendrix. José had even recorded the album *Alive Alive-O* at the London
Palladium in 1968 but he'd pretty much stopped coming to the UK in

the twenty-first century and on the rare occasions he did, he'd pop over from Europe, play small clubs and fly in and out on a shoestring.

Most British music fans who'd even heard of José probably assumed he was dead. I'd been following leads through local British promoters who would be looking to bring José in for a random London date but turn out not to have the venue, the cash, or the connection. Eventually I discovered that José's key European market was Austria where he'd had a massive hit in the early 2000s and where he now had an Austrian manager Helmuth Schaerf, who was prepared to heed my invitation. When José played Austria in November 2016, he and Helmuth flew over to Gatwick and came to Maidstone for the last show of our forty-ninth series. The BBC put them up for a night in the local Hilton and Jools was as thrilled as I was that this unique soul-jazz vocalist and guitarist whose records we'd both adored as kids in the 1960s would finally be seen again in the UK. Jools brought in a bassist and a conga player and together they played 'Light My Fire' and 'California Dreaming', José's signature hit covers, with José's nylon string finger-picking to the fore and that syncopated groove that reminded Jools of Ray Charles. José himself was charming with a delightfully lewd sense of humour and he and Jools hit it off, musically and personally. 'His style of piano playing is my style of guitar playing,' José would later explain. The following year they recorded the album *As You See Me Now* with the Rhythm & Blues Orchestra and toured together, winding up at the *Hootenanny*. Jools had made a new friend.

However, not quite everyone who has appeared on *Later...* or who watches it wants Jools as a friend. As the only live music show on British television since the mid-1990s, *Later...* has a singular responsibility and, inevitably, our host's idiosyncratic persona and musical convictions have proved somewhat Marmite with some viewers. Believe it or not, there are those who watch *Later...* as a musical showcase, who are curious about many of the acts on view but could do with a little less Jools Holland. Jools is a piano stylist and if you don't like his distinctive style, you might well wish he'd leave it alone. That's what being British television's foremost music presenter while also being Britain's foremost big band leader will do for you. As the internet reminds us daily, we all have our detractors. But only one of our guest artists has publicly expressed such reservations...

My fellow producer Alison Howe had frequently dealt with the Fall

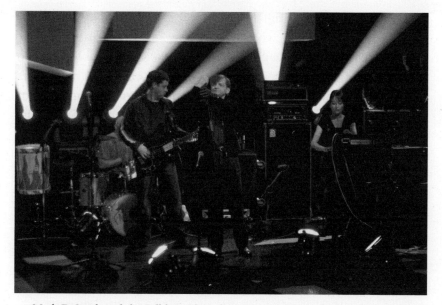

Mark E. Smith and the Fall keep their distance, series 25, episode 2, May 2005.

while producing *The John Peel Show* in the mid-1990s before joining me on *Later...* in 1998. Alison had overseen the BBC Four documentary, *The Fall: The Wonderful and Frightening World of Mark E. Smith* which aired in January 2005, not long after John's death. As Peel once said of this most idiosyncratic of British bands, 'With the Fall, you can never be absolutely certain what you're going to get. Sometimes it may not be what you want, but still – they're the Fall, that's all you need.' A few months after the documentary aired, the Fall released their twenty-fourth studio album, *Fall Heads Roll*. They were an iconoclastic institution, they'd never been on *Later...* thirteen years in, and that seemed like a wrong it was time to right. Alison conducted all the negotiations with Mark on the phone and when he'd asked if the Fall would be required to participate in the groove or whether Jools would expect to accompany them. 'Of course not!', Alison readily assured him; we'd never required participation or expected collaboration from any artist.

A week or two later, the Fall arrived in the studio alongside Athlete, Robert Plant, the Go! Team, Mose Allison and Lhasa. Mark seemed profoundly indifferent to his surroundings, which he tolerated at best. Normally we'd suggest a duration for a band's songs but, wisely, Alison

wasn't about to tell the Fall what to do and agreed with Mark that she'd edit them to length after they'd gone. The Fall ignored the opening groove and pulsated through their two songs, a Krautrock-style take on the Move's 'I Can Hear the Grass Grow' and the chaotic drone of 'Blindness' featuring Mark sporting a leather glove on his left hand, intervening with his third wife Elena Poulou's keyboards and narrating his blackly comic account of an encounter with a blind man through a heavily distorted microphone. 'We are the Fall!' he announced proudly some six minutes in. When 'Blindness' finally tailed off, Mark put down his mike, keyed a single whining note on the keyboard and nodded to the rest of the band, who downed tools and walked out of the studio past the bemused but applauding adjacent audience riser. Eventually one of our sound crew had to unplug the keyboard to stop the whine. They came, they played, they left. Mark and the Fall hadn't sullied themselves or participated in any way. They didn't look or sound like any other band and somehow they managed to make all the others seem, well, a bit cosy. Like they'd jammed the circuit. The Fall had punked *Later...*

Yet while the Fall had confronted *Later...*'s broad church on their own terms, refusing to be absorbed, Mark hadn't quite had his say. Soon after their appearance, he managed to put it about that he was 'the only artist in history to have a clause in his contract banning Jools from playing boogie-woogie over any of his songs'. Or anywhere near the Fall, depending on who he was talking to. Of course, none of this was true. For starters, the contracts department was always too swamped with work to ever discuss or issue any paperwork until weeks after an appearance. But Mark E. Smith had come up with a canard that speared the show's blurring of any distinction between Jools the presenter and Jools the piano player. Jools' recording career was thriving at this point after the three 'Friends' albums and *Small World Big Band*, he toured constantly, and his Rhythm & Blues Orchestra appeared not only on the *Hootenanny* but intermittently on *Later...* itself. While Jools didn't always play with somebody on the show, he very often did. There will always be those who wish Jools wouldn't, who think he sticks his oar in too much and makes the show too much about himself. Mark E. Smith had made himself their cheerleader with a simple but telling fib. There are those who watch *Later...* precisely because Jools is their trusted musical guide and then there are those who watch it for the

music, for whom Jools is a distraction at best. As producers we've always loved what Jools the pianist can bring to the table, the authority he brings to the show as a musician of distinction. Pretty much all of Jools' collaborations have either been suggested by us or by the artists themselves. He would be mortified if he thought he'd thrust himself on anybody. *Later…* is designed to showcase a broad variety of musical styles but its host primarily champions one. Boogie-woogie is distinctive, flash and fun, and Jools plays it brilliantly, but there are those for whom boogie-woogie can sound as relentless as… er, the Fall. And the Fall never had their own television show.

But then as I have already stated Jools doesn't just play boogie-woogie. Fast-forward to March 2021, Britain in the second lockdown. Jools' old friend Sir Tom Jones is on one of the *Later…* interview shows, chatting about his life and rummaging through the archive. Tom's been working on a brave new album with producer Ethan Johns and his son and manager Mark Woodward. He's eighty, his hair has long been allowed to stay grey and he's determined to sing songs that speak to who he's now become. When it's released a month later, Tom's called his forty-first album *Surrounded by Time* and it is his first Number 1 album since *Reload* twenty years previously. The first song Tom suggested for recording was the arranger and jazz vocalist Bobby Cole's 'I'm Growing Old', a song he's been waiting to sing since the 1970s when he first came across Bobby in Las Vegas. Now he's old enough to sing it. He's facing Jools across the studio, socially distanced, legs apart, and he looks grey and weary. Like the rest of us, he hasn't been out much. Tom sings 'I'm Growing Old' like a confession. It's an admission of weakness from a titan and all the stronger for that. Tom isn't sugaring the pill; he's looking straight in the mirror and down the lens, mourning the years that are gone. Jools sticks simply to a supporting role, playing the chords, keeping it minimal, sparse. The notes linger in the air while Tom looks inward, confronting his mortality. He's Tom the artist, not Tom the entertainer, and Jools is right there, growing older with him. It's a timely reminder why *Later…* and Jools and the piano are indivisible.

John Grant

My old band the Czars had just come to England for the first time in 2000, we were soaking everything up. We saw *Later... with Jools Holland* on TV one night and I was blown away that such a programme existed; it was so beautifully presented – the lights, the stage, Jools himself – and the fact that it was only about music, there's wasn't any other toing and froing, it didn't have to be a variety show. It was unique, there was nothing like that in the States. I saw Broadcast on there doing 'Come On Let's Go' and that stopped me in my tracks; I was like – 'What is that?' Who is that? That's what I want!' Then it would be another ten years until I was asked to be on the show myself...

I was in my forties and it was a dream come true for me; although I kept screaming and clawing, I was still putting myself out there but almost never believing I would get there. It was a huge thing for me, and I was scared shitless. I bought a suit; I had this weird idea of dressing up like I was going to church and in a weird way going on the Jools show was more like going to church than any church I'd ever attended. All I can see is this little boy trying to dress up for the grown-ups. In his Sunday best. Scissor Sisters, Brandon Flowers, Rumer and Nick Cave were on, so I was shaking in my boots, and it was tough to sing. I was in heaven every moment I was there.

So much happened for me that first night. Jake Shears and I became friends after we met there and he introduced my music to Elton. Brandon and Jake both came up to me that night and told me they liked my song, Nick Cave told me it was a beautiful song I did. You don't forget stuff like that. That's where I met Rumer too and later Richard Hawley and they both became friends. It's a very emotional thing, actually. *Later...*'s like a wormhole that opens up that can only

John Grant, GMF, series 42, episode 6, May 2013.

happen at this particular time in this particular place with these particular people; you could feel that going through the entire team as well. You could feel that all the people loved their jobs and that they wanted to be there. For me, it was like the holy grail. All the bands and singers were being given a space and being told, 'We applaud your trajectory in this world and what you've chosen to do and we're going to give you the space to do exactly what you want to do, and we are going to present you as beautifully as we can.'

Then it's Jools and the way he presents the show; it isn't a business. This is a man who has a deep, deep love for music on so many different levels. You can see that he's excited that he gets to present this music, share music with you. The last time I was on I got to sit and chat with Jools at the piano, and you could feel the warmth coming from him. He gets this little grin that says, 'I am amused by this creature sitting in front of me. He's an individual and I like individuals!' You can never know how much that means to somebody who can never quite fit in or find their place.

I didn't feel ashamed or embarrassed of who I was. For me, that's fucking huge. I can't understate that. One night I was on with Tom

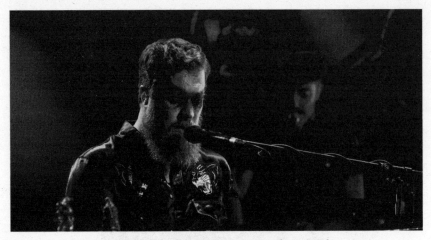

John Grant gets his freak on, series 53, episode 2, October 2018.
(Andy Heathcote)

Jones, and I was like, 'Are you sure I am allowed to be on with Tom?' Surely someone will come along with a cane and jerk me off the stage and tell me, 'Mr Jones has become aware of an unflattering scent here in the room and you must leave!' But Jools made me feel I had the same right to be there as Tom Jones or Nick Cave.

Jools is interested in sounds, all the combinations that are possible, different ways of putting sound together, all the different stories; he's fascinated, he's a little boy, his spirit has been kept young by this. I like melody and I like dissonance. I like industrial music, Skinny Puppy, Ministry and Throbbing Gristle, but I also loved Abba, the Carpenters, and the country music my mother loved but which often went against her principles, tunes about carousing like Loretta Lynn's 'Your Squaw is on the Warpath'. People are always saying you couldn't possibly like all that shit you're listening to, Patsy Cline and Skinny Puppy, you're just trying to look interesting, and Jools is saying 'No, no, no, you can!' He makes you feel seen by somebody.

The last time I was on was in Maidstone in 2018. 'Love Is Magic' had come out and I wore make-up, and the band wore pig masks during 'He's Got His Mother's Hips'. I loved the theatrics of the 1970s – Elton, David Bowie – and it's taken me so long to be able to put these elements together. That was me saying I want to play dress-up for once; I want to have fun. I can wear make-up if I want to because I love the way that looks. If I look like an awkward little boy playing dress-up, then

so be it, because I am going to have fun; I have been waiting for this moment my whole life.

I didn't come to this arena to be pigeonholed, to be told you must do 'Queen of Denmark' again because that's what we expect you to do. I am asked to come on the *Later...* show to be myself; that's such a precious thing; for someone like me and I'm sure for so many of the people that come on there, that makes all the difference because it is not that way out there in the world. I am trying to filter all these influences and all this beauty that I am so excited about. That first time I saw Broadcast on the show was electrifying to me. It opened a door, and I am still going through it.

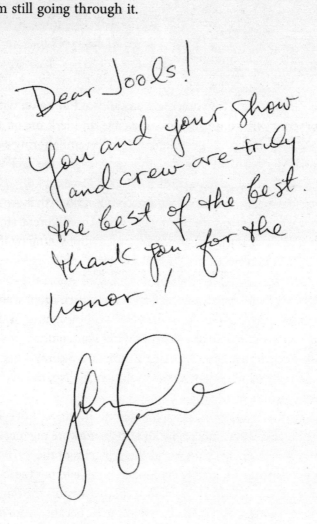

Dear Jools!
You and your show
and crew are truly
the best of the best.
Thank you for the
honor!

The piano's more my thing, you know... Jools with the Yamato Drummers of Japan, series 32, episode 4, April 2008.

7

Chan Chan

Music from Out There Over Here

It is May 1994, the third programme of our third series. The Pretenders have opened the show with 'Night in My Veins' and now it's Benin's Angélique Kpasseloko Hinto Hounsinou Kandjo Manto Zogbin Kidjo's turn. Kidjo is thirty-three and has been singing since she was a child, fronting Euro-African band Pili Pili in Paris in the 1980s before signing to Island in 1991. Angélique is a pocket-sized figure with cropped hair and fearless eyes. She's dressed in a black bodystocking topped with a gold-patterned blouse from which hang tassels that look like a grass skirt as she kneels, head bowed, on the studio floor. She's framed against a set of three giant gold circles and surrounded by her French band with keyboards and percussion to the fore. During an opening fanfare, Kidjo rises slowly from her crouch and the camera elevates with her as she stands upright at the mike. Moments later, she and her two backing singers are swaying from side to side as her powerful voice rings out across the studio, driving the slip funk anthem, 'Agolo' from *Ayé*, her second album for Chris Blackwell's Island, recorded at Prince's Paisley Park. Producer David Z was a member of Lipps Inc. who scored a worldwide Number 1 with 'Funktyown' in 1979, and a decade later he produced Fine Young Cannibals' 'She Drives Me Crazy'. 'Agolo' is a funk hymn in praise of Mother Earth and it will help build Kidjo's global reputation. She will become an activist for young African women and perform everywhere from the White House to the Arc de Triomphe. Fifteen years later she will sing 'Agolo' again at the final FIFA draw for the FIFA World Cup 2010 in Cape Town, South Africa. In September 2021, *Time* magazine will list Angélique as one of the 100 most influential people in the world.

Angélique Kidjo says 'Ayé!', series 3, episode 3, May 1994. (BBC film still)

But despite the chic power of Kidjo's performance that night, 'Agolo' didn't break commercially in the UK or anywhere else, although it did go Top Ten in Norway. She's palpably brilliant, a human dynamo with a belter of a voice who has frequently returned to *Later...* and always punched high above her weight, but she has struggled to sell records back home and in the West. Kidjo remains a powerful ambassador for African culture but she has also pursued a fusion between African and funk styles that has never quite found a broad audience. Blackwell was trying to repeat his 1970s success in internationalising Jamaica's Bob Marley with an African artist, signing Kidjo, Baaba Maal and Salif Keita in the 1980s after launching Nigeria's King Sunny Ade and his 'Juju Music' a decade earlier. Despite Blackwell's investment and perhaps partly because of the sophisticated 'fusion' aspects of the albums Island produced, this new Euro-African pop music never quite found its market. Not that this mattered when Kidjo commanded the studio that night. She looked and sounded like a superstar, the match for any act in the room. She looked and sounded like the future.

In the late 1980s, post-Paul Simon's *Graceland*, African music was everywhere and plenty of pundits argued that pop music was going to transcend its Anglocentric past and become a multi-tongued global

village. Channel 4 launched the series *Big World Café*, mixing British bands with the artists Andy Kershaw was championing, the BBC had the documentary and performance series *Rhythms of the World*. But the commercial dream of a 'world music' that would blend indigenous styles, melodies and language with Western pop has rarely struck paydirt until the recent arrival of Afrobeat. Global or 'world music' can sometimes belong everywhere and nowhere. Angélique Kidjo's commanding performance of 'Agolo' suggested the long and adventurous career ahead of her, including idiosyncratic albums responding to Talking Heads' *Remain in Light* and the legacy of salsa queen Celia Cruz. But also signalled that the fusion concept of 'world music' in which African artists with European producers experimented with synths and Western beats was commercially more of a side alley than the international future of pop. I last saw her willing a small but growing crowd to dance at the West Holts stage on the closing Sunday of Glastonbury 2022. Most of the 'world music' albums that have been successful in the UK have tended to the nostalgic, the acoustic and the folkie rather than to fusion or the dancefloor. Think Gipsy Kings, Ladysmith Black Mambazo, Le Mystère des Voix Bulgares or Buena Vista Social Club.

When *Later...* started, the term 'World Music' was only five years old, having been coined in a London pub in 1987 by a group of music enthusiasts who simply wanted to market and rack the African, Latin and even Eastern European 'folk' music they championed more successfully. I loved the artists I'd been discovering through John Peel and Andy Kershaw, the Womad Festival and eclectic record labels like Globestyle and Real World. I'd seen stunning London shows by Youssou N'Dour and Algeria's Khaled, inspirational nights of discovery during which the range and intensity of their voices and the flair and drive of their bands felt like a whole new world of music sweeping me to my feet. But, like Joe Boyd, Charlie Gillett and the other enthusiasts who wanted to promote the music they were discovering abroad, I don't much like the term 'world music'. It suggests a club and it tells you more about Western perceptions than the music itself. I don't know that it makes much sense to lump Taraf de Haïdouks, the Romanian gypsy band championed by Johnny Depp, in the same category as Brazil's Bebel Gilberto with her subtle reinvention of bossa nova and samba.

Angélique Kidjo is a global citizen building on her West African

'There Will Be Time', Baaba Maal with The Very Best, Beatenberg and
Mumford & Sons, series 48, episode 2, April 2016.

roots, but many of the artists lumped under the banner are folk musicians, championing and developing the traditions in which they grew up. But whether traditionalists or pioneers, they come from afar and they open our ears. Foreign language music may not have been played on Radio 2 but there was real momentum behind 'World Music' and behind the artists and styles that this new catch-all term was promoting when *Later...* began, as if the future of popular music might truly be global. I loved the idea that artists from all over the world could perform in front of each other on an equal footing in our studio, where everyone could share the same language of music but sing in their own voice. I was curious to see and hear musicians from around the planet, and I admired their skills. 'World Music' to me was all about inclusion and difference – difference of instrumentation, rhythm, costume and colour. On our third ever show, Baaba Maal from Senegal first encountered Oumou Sangaré from Mali in our studio in White City. Baaba Maal came with a kora player while Oumou and her backing singers matched the rhythm of her songs by tossing calabash in the air and catching them on the beat. Baaba primarily sings in the Pulaar language of the

Futa Tooro kingdom by the Senegal River while Oumou sings in
Wassoulou, from south of the Niger River. As Oumou remarked
recently, 'People don't need to speak your language to understand what
you're trying to say.' They sang Maal's mesmeric 'Sy Sawande' together,
clad in gorgeous robes, watched admiringly by Was Not Was, Tasmin
Archer and Smokey Robinson.

From the beginning, so-called World Music was much more than an
occasional treat in *Later...*'s circle of dreams. Indeed, this celebration
and demonstration of difference has remained at the heart of the show's
DNA even as its commercial star has waxed and waned. Ali Farka Touré,
Youssou N'Dour, Le Mystères Des Voix Bulgares and Bahia's Olodum
all featured on the first few series; they each played and sang with
virtuosic skill, they had a strong relationship with their indigenous folk
traditions, and they all came from somewhere else; some came with
major label support and several from the small independent label World
Circuit run by producer Nick Gold. Gold had a genius for spotting
talent, for encouraging artists to sound like themselves and for packaging
them for Western eyes and ears. World Circuit didn't just introduce
artists from Africa, Cuba and beyond; their beautifully rendered artwork
always underlined the gravitas and authenticity of the music to be found
within while also hinting at something else, another kind of lifestyle
perhaps. The look was far more Blue Note than field recording, and the
sound aesthetic was similarly dignified and unfussy.

I am not sure I'd seen what would become the cover photo of the
Buena Vista Social Club album when Nick and his team began talking
up the musicians and the music they'd recorded in Havana in March
1996. That image's blend of sunshine and shadow in a narrow street
in Havana with its 1950s automobiles, children playing and the fore-
grounded figure of the slim, natty Ibrahim Ferrer on his way to the
studio in white beret and shoes showed the impoverished iconography
of old Cuba now magically transformed. This Havana, here beautifully
revisited in colour, its pre-communist culture charmingly preserved
in aspic by years of isolation from the West, perfectly captures the
rare warmth of the Buena Vista Social Club. Nick had recorded the
1994 Ali Farka Touré album, *Talking Timbuktu*, with Ry Cooder, and
the pair had initially intended to underline the links between West
Africa and Cuba by taking a group of musicians from Mali to record

with their peers in Cuba. When the Malians' passports failed to return from Burkina-Faso where they'd been sent for their visas, Cooder and Gold were left with studio time in Havana and a bunch of veteran musicians assembled by bandleader Juan de Marcos González standing by. They decided to press ahead and record these old-timers from the 1940s and 1950s. Ibrahim Ferrer, the veteran bolero singer, was sixty-nine, shining shoes and selling lottery tickets to keep the wolf from his door while pianist Rubén González was rumoured to be dead, his piano destroyed years ago by the tropical climate and wood-worm. Juan González had found both and placed them alongside fellow singers Compay Segundo and Omara Portuondo and sophis-ticated roots players like double bassist Cachaito López, percussionist Angá Díaz and guitarist Manuel Galbano. While some were still performing, the recordings and the styles with which they'd made their names were all but forgotten, swept aside by the ambitions and constrictions of the Cuban Revolution.

Even without the photo imagery the narrative of the Buena Vista Social Club was bewitching. The very first *Later...* featured the Neville Brothers, those New Orleans veterans of the early 1960s who'd finally crossed over in the 1980s thanks to Daniel Lanois' production of *Yellow Moon*. Jools and I shared a common love of the roots of popular music and always actively pursued the oldies we regarded as legends whether they were still making new music, working the cruise ships or long forgotten. We knew how restlessly commercial pop music moved on and how much it discarded on the way; we didn't find it hard to believe there was buried gold out there. The *Buena Vista Social Club* album had been recorded in a week at the vintage Egrem studio in Havana and crystallised a cohesive sound and style from musicians who'd either never played together or hadn't done so for decades. 'In my experience,' Cooder would later reminisce, 'Cuban musicians are unique. The organisation of the musical group is perfectly understood. There is no ego, no jockeying for position, so they have evolved the perfect ensemble concept.' Recording went so well, Cooder and Gold recorded another couple of albums including a solo outing with Rubén González, who was so excited to play the piano again that he was waiting outside the studio when they opened up every morning.

World Circuit was a tiny independent company however and once

again Nick found himself struggling with visas and work permits when he attempted to bring most of Buena Vista to London in the spring of 1997 to set up a September release. The BBC's rights department would always insist that all musicians who played on *Later...* had work permits and the correct paperwork. Frantic phone call followed frantic phone call in early May as it transpired that Nick was struggling to get all the necessary permits through in time. Rubén González was already in town and appeared on the first show of that ninth series, performing the nostalgic Cuban standard, 'Siboney', written in 1927 and once covered by Connie Francis, with double bassist Cachaito and percussionist Angá Díaz at Jools' piano. Ruben was a week or so short of his 78th birthday, his fingers were long and spidery, and his silver hair and moustache emphasised his courteous demeanour. His 'Siboney' is a sprightly bolero in cut-time with stops and starts and descending melodic runs that tease and insist that you sway along. Jools was captivated, as was the rest of the studio, including David Byrne, Beck, Dru Hill and Henry Rollins.

Yet by the end of that week, Nick still didn't have the necessary paperwork for the whole Buena Vista Social Club posse who were booked to appear on the second show, squeezed in alongside heritage artists Steve Winwood and James Taylor, the buoyant Counting Crows and TV debutants Stereophonics and Finley Quaye. While the BBC's contracts department continued to suggest that any appearance minus the correct permits was a non-starter, they also made clear that while there might be dire consequences in an imponderable future, no one would physically stop the Cubans entering the studio or being broadcast. There was some soul searching as neither Nick nor I wanted to get the Cubans banned or their visas revoked but here was a once-in-a-lifetime opportunity to capture these veterans in Shepherd's Bush and we went ahead. Fortunately, the visas arrived before Friday's transmission and Ibrahim Ferrer and Compay Segundo weren't prevented from touring the UK in their ripe old age when Buena Vista took off as the millennium approached.

Tuesday teatime 13 May 1997, the Cuban veterans began to assemble on the studio floor around the piano area which was the only remaining performance space, joined by a positively grumpy Ry Cooder wrangling as musical director despite a heavy cold. I'd admired Cooder since his 1970s ensemble albums, loved his film soundtrack for *Paris,*

Texas and interviewed him when, despite competition from Van Halen and the digital age, he threatened to make a comeback with the *Get Rhythm* album in the late 1980s. 'That's what triumphed,' he'd complained then. 'Speed and accuracy made possible by more sophisticated hardware and what you could do on the guitar to really put that aggression and that massive ego out there. What I do is not the thing, it's too old and slow. Me, I like to play that space; what these other guys want is to fill it all up with themselves and I think that's a cheap shot.' I'd even filmed with Ry once before, at the Sweetwater Club in the Bay Area in 1992, when John Lee Hooker's manager Mike Kappus and I had convened the likes of Bonnie Raitt, Albert Collins and Johnnie Johnson to play with the great bluesman after *The Healer* album took off. Kappus' Rosebud Agency was perhaps the leading roots agency in the US and Mike was passionately committed to rebuilding the careers of veterans who had fallen by the wayside during the brash onward march of the 1980s.

Pianist Johnnie Johnson was a large, jolly man in a sailor's cap. Chuck Berry started out in Johnson's band in St Louis before they swapped lead billing. Johnson was reportedly the inspiration for 'Johnny B. Goode' and an intimate collaborator on many of Chuck Berry's other era-defining hits which leaned heavily on Johnnie's piano licks transposed to guitar. Ry Cooder, who'd arrived early in the afternoon from LA was appalled that Johnson's manager had requested an electric keyboard for his artist. It didn't take much head-shaking and dark mutterings about fellers who 'wouldn't know the real deal if it hit them in the eye' from Cooder for me to send to a local supplier for a proper Joanna. 'The sound of John Lee's voice is ultimately the real deal,' Ry would tell me later. 'It's this deep, well-like sound and when he's talking or singing, he's painting a picture for you. He's not arthritic or doubled up. He's not weak. We're blessed, I would say, to be in a time when he's still around doing a good job for us.'

All the artists brought their love of Hooker, who was already in his seventies and arrived last in one of his trademark suits. Ry and John Lee got intimately swampy on 'Black Snake Moan' while Bonnie answered John Lee's throaty chuckle with 'I hear you call!' as they dripped sex on 'I'm in the Mood'. We'd planned all manner of collaborations, but John Lee got tired after forty-five minutes or so and launched into the communal jam of an all-star 'Boogie Chillen',

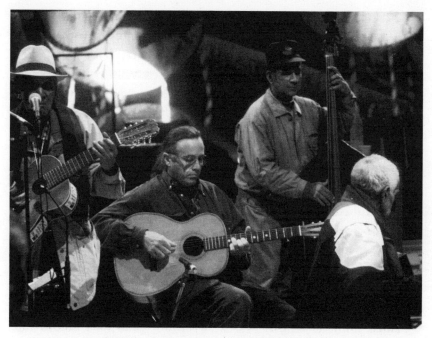

Compay, Ry, Orlando 'Cachaito' Lopez and Rubén González in rehearsal, series 9, episode 2, May 1997.

Ry Cooder, Jools, Ibrahim Ferrer, Compay Segundo, Buena Vista Social Club, series 9, episode 2, May 1997.

marshalling his collaborators and sharing out the solos with a nod to each musician in turn. A day after the show I drove south of San Francisco to one of John Lee's houses to interview him for Q magazine. There was extended family and friends, of friends all over the house while John Lee hid in his bedroom watching his beloved baseball. Hooker had extraordinarily long fingers which helped explain his extraordinary guitar style; when we shook hands, it was like holding ancient papyrus, so soft was the skin.

Ry Cooder had given me sage advice at Sweetwater and declined to join the boogie, confiding he'd long since concluded that nothing meaningful could emerge from an all-star jam. I'd sorted out Johnnie Johnson's piano, but I was still mortified that Ry had lumped me in with the manager as a typical music biz slicker, ignorant of the well-springs of the music. On the *Later...* studio floor with Ry and the veteran Buena Vista Social Club, a disturbingly similar scenario began to unfold. Ry insisted that Ruben form the musical centrepiece of the ensemble with the singers seated behind him and the other accompanying musicians fanning out on either side. Ibrahim and Compay were to sing together with three percussionists, Cachaito on bass and Ry on guitar. More time had been spent on visa application than rehearsal, Buena Vista Social Club wasn't exactly a band and this combination of players in such a configuration had never played together before. There'd been sixteen players in the studio in Havana. When this ensemble ran 'Chan Chan' for the cameras for the first time, it lasted eleven minutes. Head cameraman Gerry Tivers muttered something over talkback about having time to go on holiday and I descended from the gallery to ask for a three-and-a-half-minute version while Cooder muttered darkly to himself, as if all his worst expectations of a television studio were being realised.

Singers Compay Segundo and Ibrahim Ferrer were in their 90th and 70th year respectively and looked delighted to be there in a room full of music. The ensemble rehearsed their two songs – Compay's 'Chan Chan' and '¿Y Tú Qué Has Hecho?' – a couple of times each and brought them down to a TV length. Towards the end of the show, the ensemble performed creditably enough when their slot finally arrived. Ibrahim wore a white beret as if foreshadowing the cover of the album that would come out a few months later while he and Compay struggled to blend their voices. The configuration of players

and the dominance of the piano ensured a sound mix that probably simply frustrated Nick and our resident sound engineer Mike Felton. What is languid but anchored in rhythm on the album sounded swimmy and a tad perfunctory in the studio, as if the Buena Vista Social Club's ability to suspend time has been defeated by TV's stop-watch. Meanwhile the camerawork rather suggests that Cooder is the star of the show. He sticks out from the Cubans in an orange shirt and ponytail, sitting on a chair with his slide guitar and a professorial air, glancing proudly but uncertainly over to Ruben and the percussionists as if he too isn't quite sure about what's going down. Ry's certainly a lot easier for Janet's cameras to find than vocalists Compay and Ibrahim, tucked away behind Ruben and the piano.

When the *Buena Vista Social Club* album came out that September, it slowly but steadily took the world by storm, going on to sell some eight million copies. Wim Wenders made his film celebrating these Danzón veterans of the Big Band era, capturing their shy charm as they delighted in their vindication and reflected on the dark years of seclusion and neglect while performing triumphant concerts in Europe and at Carnegie Hall. Ibrahim Ferrer, Cachaito and Omara Portuondo – who didn't make that first *Later...* appearance in 1997 – would all individually come to Television Centre in the next few years as Nick Gold continued to record this golden cache of musicians and bring them individually into the spotlight, but that first ensemble session failed to capture their magic. No matter, as the *Buena Vista Social Club* album soundtracked the rise of coffee chains in the late 1990s, its relaxed charms suiting their emerging boutique sensibilities as these lifestyle franchises captured the high street. I don't think they ever gave another television performance as Buena Vista Social Club, surely not with Ry in attendance and certainly not in the UK.

Later... grew out of *The Late Show* and so it was always a Music & Arts proposition with the BBC ideal of public service at its heart. Plenty of stadium-filling and festival-headlining artists have appeared on *Later...* and quite a few of them made their television debuts in our circle of dreams. But, ultimately, the ideal of music as a global community rather than as a commercial proposition drives the show, which isn't about being big, successful or British but about being open-minded. The booking policy was forged by curiosity; we wanted to entertain but we

also wanted to report what was happening across multiple genres and beyond genre itself. All that binds together the artists on each show is their music and their commitment to it. The artists that come from beyond the West, many from Africa but also from India, Russia, Brazil, Colombia, Albania and elsewhere, are the clear signifier of this ideal. The diverse singers and players who have travelled from the musical goldmine that is Mali in West Africa for example have brought their talent, their traditions and their love of performance. Bassekou Kouyate, Toumani Diabaté, Oumou Sangaré, Ali Farka Touré, Tinariwen, Rokia Traoré, Salif Keita, Amadou & Mariam and Fatoumata Diawara have all enriched the studio with their thrilling voices, their brightly coloured robes, the kora, the ngoni, the djembe, the calabash, the talking drum, their profound sense of the past and their take on the present. Their performances have always been intrinsically theatrical, they dress to kill and their musicianship is breathtaking. Every artist from Mali gets lost in the music and puts on a show.

fRoots magazine would characterise world music as music from 'out there over here' and it is the very difference, the variety, both rhythmically and vocally, that makes world music intrinsic to the *Later...* DNA. Jazz, blues and folk all feature consistently in the show's mix but here are music and musicians you can't see anywhere else with palpable performance skills. You could call this a 'muso' aesthetic but there's nothing smug or self-obsessed about the artists we featured from round the world, just their delight in the music and our pleasure in their passion and skill. Yet so-called 'world music' undoubtedly drew more criticism than any other genre on the show; some of its detractors regarding such music as fatally worthy, uncommercial and the product of Western patronage. Jonathan Ross would sneer about 'Mongolian nose flutes' and tease Jools about 'the rubbish' we had on, Chris Evans would roll his eyes and look similarly aghast, as if all non-western music were a kind of unpalatable medicine. Jools neither proselytised nor argued for world music, he just delighted in the artists' musicianship and their joy in performance. Which isn't to say he wouldn't occasionally struggle with pronouncing their names even though they would be written phonetically on the so-called 'idiot boards'. 'Buena Vista' may have come out as 'Boona Vista' but Jools' enthusiasm was palpably on point.

Each *Later...* show is designed as a unique collection of talent arrayed

around the studio floor according to size and space and unleashed in turn as a matter of contrast, or should I say variety? Like a DJ prepping their set or a student sitting an exam, we'd agonise over every running order, searching for the best dynamic. Our global bookings always remained the artists you wouldn't see anywhere else on television, the twist in our tale. The running orders were our hand, our deck of cards; like all good poker players, we knew it wasn't the hand you've been dealt but how you play that hand that makes you a contender. Of course, we developed favoured strategies: we'd start with the 'headliner', the biggest artist in the room playing their song of the moment, something commanding or even epic but preferably with tempo. Let's get this party started! Then something else commanding and rocking before changing direction, moving away from that four to the floor beat to something with a groove, preferably with horns; something funky to change the dial and move us further afield, away from planet rock. First three songs to get the pulse racing and the show properly launched and we were off on our way. Hip-hop, grime, oldies, singer-songwriters, brand-new artists not yet on the radio, solo spots, Japanese drummers or Bulgarian choirs, trip hop or country, we'd set sail on a voyage of discovery.

Perhaps this sounds formulaic, but I am not sure that the show ever sat down quite so predictably because ultimately the running order was always driven by the cast of that week's circle, and we always booked the richest combination of artists available to us. Combination is the keyword because we chased variety and difference. Difference was what we came to celebrate, which is why we loved a sound or genre clash in the mix, a moment of tenderness followed by a wall of sound or vice-versa: Alicia Keys into Mercury Rev, U2 into Slaves, Sevara Nazarkhan from Uzbekistan into the Dandy Warhols. If the bill was too predictable or too star-driven, we'd actively look for a surprise, something to shake things up, an artist you wouldn't see anywhere else doing something you wouldn't necessarily have encountered before. That might be a New Orleans brass band like the Soul Rebels, Ukrainian folk punks DakhaBrakha or Irish folk band Lynched (now Lankum). Or it might be a punky twin sax outfit like Moon Hooch, post-bluegrass quintet Punch Brothers or kora and cello duo Ballaké Sissoko and Vincent Segal. Some of these artists are what gets called 'world music', some certainly aren't, but they all bring something from 'out there' over

here. There's a freshness and a curiosity in their playing and performing; they invite you to look and listen anew.

Take Mariza, the new-look fado singer who debuted on *Later...* back in November 2001. What did we need to spice up a show with the Charlatans, Mull Historical Society, Dreadzone and Jools' very own Rhythm & Blues Orchestra featuring guests David Gilmour, Mica Paris and Suggs? This line-up begged for a wild card, something extra, a coup de théâtre. A former colleague of mine at *City Limits*, folk and roots PR John Crosby, had recently taken on an unknown young singer from Portugal with striking eyes and a braided bleached blonde crop. Mariza was born in Africa to a Portuguese father and a Mozambican mother but raised in the Alfama neighbourhood of Lisbon where she'd absorbed the fado tradition of Portuguese blues which while still practised in local bars, was rapidly becoming a relic of a vanishing era. Fado originated in the port towns of Portugal as early as the 1820s and suggests the sailor's longing to return to port, a yearning for a homecoming that may never arrive. The tone's often resigned and melancholic, and yet rails at the harshness of fate, although there are also plenty of dance tunes with a spring in their step. The word 'fado' derives from the Latin 'fatum' which translates as 'fate', 'death' or 'utterance'. Or perhaps all three at once. When Amália Rodrigues, fado's greatest and most adored interpreter, died in 1999, fado enjoyed a revival during a period of national mourning. The twenty-six-year-old Mariza appeared in a broadcast tribute which led to her recording her debut album, *Fado em Mim*, when such genre albums generally sold less than 4,000 copies at home and rarely travelled abroad. Portuguese record labels wouldn't take a risk on an unknown artist and passed, but World Connection, a small and adventurous indie label from Holland, picked up the album for distribution and hired Crosby to see if he could get some traction for it in the UK media.

I am not sure Mariza's debut on this tiny imprint had even been released in the UK when John sent me the album. I remember sitting in my office in the Design Block at Television Centre and being instantly smitten, as much by the cover as by the music; Mariza smiling secretly to herself, cornrows of cropped hair, a diaphanous black gown, a confident and contemporary air of self-possession. She looked like a peer of Björk, Tori Amos and PJ Harvey rather than a throwback. Mariza was very now, but fado was old-school authentic. As the new

Cape Verde's barefoot diva, Cesária Évora – Mindelo Airport now bears her name –
series 17, episode 5, May 2001.

millennium approached, world music marketeers became less obsessed
with crossover and global success and more taken with the local, with
what appeared to be lost or vanishing, as globalism enveloped the
world. Hence the success of Cuba's Buena Vista Social Club, Orchestra
Baobab from Senegal, and Cape Verde's Cesária Évora, all of whom
had roots in a previous era. World music had perhaps passed the 1980s
fusion stage and the obsession with the Western dancefloor. Suddenly
authenticity seemed to be what mattered. Something old, untouched,
and still vibrant, like stumbling on an undiscovered beach in the
Mediterranean where there are no high-rise hotels, only cypress trees,
long sands and a sparkling sea. Mariza's fado had exactly this appeal.
The music was as stark as flamenco, just guitar and lute, and the vocal
was intimate and upfront in the mix, in the manner that would drive
Norah Jones' debut 'Come Away with Me' a year or so later. Norah's
roots were in jazz, country and folk, but Mariza's fado was altogether
fiercer and unrestrained.

While there were jaunty songs on the album, the haunting 'Ó Gente
Da Minha Terra' with lyrics by Amália Rodrigues, the queen of fado

herself, was utterly bewitching and infused with 'saudade', that painful yearning for a vanished past, that haunts this most nation-defining of genres. There seemed to be something almost Celtic in Mariza's intense but ornamental delivery that recalls the sean-nos Gaelic unaccompanied vocal tradition drawn on by the likes of Clannad's Máire Brennan and Afro Celt Sound Systems's Iarla Ó Lionáird. Fado is an essentially working-class music and Rodrigues in her heyday was variously accused of being both a Communist agent and a police informer. Salazar, the prime minister/dictator who did much to modernise Portugal from the 1930s through to the late 1960s, regarded fado as essentially anti-modern with a debilitating effect on the nation that 'sapped all energy from the soul and led to inertia'. His 'Estada Novo' or Second Republic was a police state which supported religious conservatism and the rich; yet fado could also chime with his government's repressive celebration of the simple life of the rural and urban poor. Salazar dismissed Rodrigues even though she once brought a tear to his eye, while she seems to have had a sneaking admiration for him despite her own leftist leanings. I knew little of fado's complex backstory back then, sitting in White City staring at Mariza's CD and listening to 'Ó Gente Da Minha Terra'. Salazar's dictatorship had collapsed in 1974, Mariza was reclaiming fado for a new generation and saudade isn't hard to fathom or to feel.

Mariza was unknown and unheralded, but she had a precursor in Cesária Évora – *La Diva Aux Pieds Nus*, as her 1988 debut album put it – who'd performed 'Petit Pays' barefoot on *Later...* back in 1996 in front of Baby 'You're Gorgeous' Bird, Luciano, PJ Harvey and Christy Moore. Évora was in her mid-fifties when her career began to take off in Europe, aided by her signature song, 'Sodade'. She was short with a lazy eye and a world-weary, long-suffering air; she had clearly seen hard times. Like Mozambique, Cape Verde's islands in the middle of the Atlantic remain part of the Lusophone diaspora in a permanent imprint of their colonial past, although many islanders speak and sing in Cape Verdean Creole or 'Kriolu' as the locals have it. Cape Verde's Morna tradition is close to fado – as if the Senegalese balladry of Dakar some 400 miles east, the drama of flamenco and the Afro-American blues tradition had entwined in the taverns of the port city of Mindelo where Évora grew up and started singing in the 1960s. Évora's international success in the mid-1990s enabled this

local music that had been culturally and geographically isolated to find its moment in a Western marketplace longing for something earthy; music that palpably came from somewhere that wasn't like everywhere else, music with tangible emotion, simple acoustic settings in an exotic tongue.

Cesária Évora had returned to *Later...* in the spring of 2001 to sing 'Tiempo y silencio', looking as weary and singing as beautifully as ever. Mariza clearly had something of Évora's emotional pull but with the looks and style of a striking young urbanite, or so her album cover suggested. I'd come across Portuguese forerunners like Dulce Pontes, a singer with fado leanings and contemporary, even pop, arrangements, while visiting the Café Ingles in Silves on holiday in the Algarve in 1999. But there was nothing crossover or pop about Mariza, who seemed to present fado at its starkest. Generally, I made it a rule of thumb to see the performers we booked on the show in person. But we were in the middle of our autumn series and there was no time or budget for a recce trip to Portugal. Sometimes you just have to go with your gut.

The first time I asked Mariza and her musicians to come over in November 2001, she was playing for Duarte Pio, the Duke of Braganza and heir to the defunct Portuguese monarchy, in Lisbon. I was disappointed but determined. A week or two later, Björk had been lined up for a simple acoustic performance, but she'd had to drop out. We had the bands for each corner of the studio but there was still space for one of our middle-of-the-floor spots which we would rehearse, strike, and then set up during the show itself. The floor team and sound crew had become expert at setting up these largely acoustic spots which enabled us to drop a performer onto the floor as if out of nowhere. Adele, Laura Marling, Seasick Steve on the *Hootenanny*, and many others would be staged in this way over the years; all of them benefited from the unprotected and 'unplugged' simplicity of their staging. The bands round the studio walls had strength in numbers, equipment and volume but, in the middle of the floor, you were utterly exposed. The studio audience and the viewers at home could only marvel at the chutzpah of some unknown and solitary figure, stranded and alone but the centre of attention, and were often instantly beguiled. Mariza and her two musicians were particularly suited to such staging because her act was small,

acoustic and, as it turned out, utterly dramatic. At the second time of asking, Mariza was available, and John Crosby persuaded the label to fly her into London on the day of the filming. We taped on Tuesdays, I called the Friday before and the flights were booked within twenty-four hours.

Mariza and her young manager were chatty and charming when they arrived on the studio floor in the tea break to sound-check and rehearse, only a couple of hours before showtime. *Later...* screened in Portugal in those days and they seemed to know about the show and to embrace the opportunity with open arms. Mariza's emotive voice echoed around the empty studio while her guitarist and cavaquista or Portuguese lutist plucked emotively away and the piano tuner waited his turn, watching open-mouthed. A striking six feet tall, she was casually but fashionably dressed yet the rehearsal barely hinted at Mariza in show mode. Her performance came off the back of Jools' Rhythm & Blues Orchestra and Mica Paris and David Gilmour's bluesy take on Screaming Jay Hawkins' 'I Put a Spell on You'. Drama and anguish were already in the air when Mariza suddenly appeared on the studio floor, utterly transformed from the modish young woman we'd met an hour or two earlier. She wore the black lace shawl of her album cover which soon dropped to reveal bare shoulders, her throat was covered in a necklace of beads and her flounced and floor-length crimson ball gown hailed from another century. Her two musicians were staged in a semicircle behind her and, as the lights dimmed and the room hushed, the jib camera glided towards them across the now seemingly empty studio, she towered above them, already wracked by emotion. There's something of the opera house in Mariza's melodramatic performance as she offers her profile to the camera then turns head-on to stare it down, pulling her dropped shawl tighter around her waist, her long arms clutching it for warmth and safety. The cameras cut between close-up and wider, establishing shots revealing all Mariza's movements. Her left arm continually reaches out imploringly as though pleading with an invisible tormentor and then she is hunched over, almost beaten. Her phrasing is sometimes guttural, even choked, and yet how she sails on the big notes as she inhabits the cocktail of anguish and celebration that is 'Ó Gente Da Minha Terra', Amália Rodrigues' lyrical evocation of the mournful bond fado creates between listener and performer.

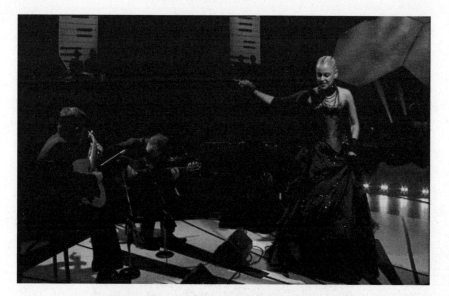

Mariza dos Reis Nunes, that voice, that dress, series 18, episode 7,
November 2001. (BBC film still)

The high theatre of Mariza's performance somehow increases the
almost shocking intimacy of her delivery. Her tall frame crouches
forward while singing, as if bending beneath the weight of her emotion;
she stalks the floor, twisting and turning during the instrumental break,
shying away from the cameras. She's suddenly transformed into a
tragedienne confronting her own anguish, before she raises her left
arm aloft, black shawl threading through her fingers, and throws her
head back for the soaring defiance of her final note. There is something
ripe and overwrought, Moorish even, about the embattled eloquence
of Mariza's performance. She had come out of nowhere and cast her
theatrical spell; the bands and the audience in the studio were stunned,
and so too were many watching at home. That first album took off
globally the following year as Mariza toured the world, playing pres-
tigious concert venues like Carnegie Hall and Sydney Opera House,
eventually signing to Parlophone. I saw her again when we filmed the
Radio 3 Awards for World Music at Ocean in Hackney in March 2003;
she'd won the European category and she seemed radiant with her
blooming success. We filmed a concert with her at Union Chapel in
2005 for BBC Four, and when she came back to *Later...* for the third
time in 2011, she revealed her cheeky grasp of a show tune with an

Rosalía Flamenco meets Burberry,
series 53, episode 4, October 2018.

impromptu take on 'Fly Me to the Moon' with Jools at the piano. Much as Diana Krall had reignited the saloon approach to the Great American Songbook, Mariza has brought fado back and made it contemporary while always honouring its direct emotional appeal.

World music never quite arrived, as the new dawn of international pop music and the financial crash of 2008 along with the rise of the global internet marked a gradual narrowing of investment in music from out there over here. Radio 3's Awards for World Music were cut the following year, and although Womad continued to thrive and established artists like Oumou Sangaré and Orchestra Baobab continued to record and tour, horizons narrowed, and fewer new non-Western artists were launched internationally. After 2005's Live 8 with its line-up of solely Western artists bent on helping Africa, Damon Albarn's Africa Express questioned the whole 'world music' narrative as a Western Colonial construct driven by Western producers and consumers while championing multi-artist collaborations between African musicians and Western bands. Damon's Gorillaz collaborated

with Malian guitarist and singer Fatoumata Diawara while Africa Express helped launch Songhoy Blues, the young rock-based band from Timbuktu, who've toured the world since 2015's *Music in Exile* debut album, a response to Mali's civil war and the rise of Islamist repression. Rediscoveries of lost or forgotten styles like Mariza's fado or Buena Vista's son grew rarer. Joe Boyd and Andrea Goertler's 2017 Saz'iso collaboration with Southern Albanian folk musicians resulted in the *At Least Wave Your Handkerchief at Me* album of Saze, iso-polyphonic songs and haunting instrumental pieces unheard outside an isolated Albania for many years. Eight members of Saz'iso came to Maidstone that autumn, for a chance encounter with two fellow Albanians, Dua Lipa and Rita Wilson, who was singing with Jools and José Feliciano. Rita's husband, Tom Hanks, looked on in wonder as the middle-aged veterans of Saz'iso played and sang their hearts out, staring proudly across the studio at Noel Gallagher's High Flying Birds.

If Mariza or Saz'iso honour the past and the nostalgic pull of songs of yearning, Spain's Rosalía blends cante or vocal flamenco with a hip-hop sensibility. Like Nigeria's Burna Boy or the British-based Afroswing or Afrobashment style forged by J Hus, Rosalía sounds contemporary. She's a trained dancer who, like FKA Twigs, moved into music, and while she sees herself firmly in the flamenco tradition of Rita la Cantaora and other emotive Andalusian singers, she has global ambitions and a record deal with Columbia in New York who are marketing her internationally like a Beyoncé or a JeLo. Traditionally, 'cantaora' sing sitting down, but Rosalía is a hip-hop girl with a large troupe of dancers and inventive visuals projected behind her onstage. Her record label talked her up as Spain's answer to Christine and the Queens, emphasising her stunning dance routines. After Christine's success in bringing her unique choreography and sense of theatrics to the show, we were tempted although we already had a full floor including Paul Weller with a string quartet, Sigrid, and Joe Bonamassa. With less than a week to showtime in November 2018, we discovered that the dancers weren't available, couldn't travel from Spain – someone must have seen the budget! – and might we accommodate Rosalía as a semi-acoustic performance? By this point, we were committed: we'd even already announced Rosalía on our crowded bill. Rosalía's lead track, 'Malamente', is flamenco through a hip-hop lens with a surfeit of flouncing attitude. Without her dancers, Rosalía

put together an almost unplugged performance, as though specially convened for *Later...*'s gladiatorial floor and the premium it places upon musicianship. Yet she displayed not only her flamenco schooling but also her hip-hop gift for taking centre stage and facing down the viewer.

The beats came from the flamenco handclaps of her four backing singers, two male, two female, and the snare drum placed beside the keyboard of her musical director. I guess we'd learned from Christine's adoption of Kanye West's empty black background and perhaps so too had Rosalía. As the ends and side walls of the studio were already chocker with bands, we could only stage Rosalía in the middle of the floor, sometimes the greatest stage of all. Lighting director Chris Rigby turned off all the lights on the set, the other artists disappeared into darkness and Rosalía was framed in the beams of several follow-spots, allowing her to own the floor and perform directly to camera. Over the years, we'd often staged rappers and grime artists like this, handing them the studio as their playground. But we'd also staged plenty of singer-songwriters and solo voices like this – not least Mariza.

Yet while Mariza's take on fado was remarkably traditional and her striking dress theatrically vintage, Rosalía sported a Burberry jumpsuit and huge trainers: contemporary street chic. Mariza wrestled with her demons while we rubbernecked, Rosalía stands silhouetted, legs defiantly akimbo, before coming out of the shadows to face down the camera while frequently dismissing a disappointing lover with a throwaway toss of her arm, her hands covered in rings. The backing singers stay rooted to their microphone stands, singing and handclapping, while Rosalía walks back and forth on the floor, commanding the space. On her second song, 'Pienso En Tu Mirá', the chorus is more plaintive and the melody more lovelorn but still she stalks the floor, taking no prisoners. She's singing in Spanish about a lover; she's in thrall but she's also confronting her fears, confessing but not succumbing. Like fado, flamenco is habitually full of anguish, but while the handclaps place Rosalía firmly in the tradition, her Burberry is contemporary global, and she refuses to play the victim. As she often tells journalists, she's concerned to always represent women as strong. Björk, Buika and Ojos de Brujo had all previously brought a flamenco vibe to *Later...* but for all

Rosalía's knowledge of the flamenco tradition, there's nothing rootsy or nostalgic about her, which perhaps explains why she speaks to younger audiences so effortlessly and why her *Later...* performance thrives on YouTube. Hip-hop's a global culture because everyone who steps up to the mike with something to say and the skills to deliver it can seize a platform. First-hand, right here, right now.

Baaba Maal

I remember the first time I came to the studio in 1992, I remember that exactly like it was today. We played 'Yela' and we were in our traditional robes, my dancers Ndongo and Zig were with me, and dancing, dancing. That was the first time I ever met Oumou Sangaré and we sang together. I am from Senegal, and she is from Mali, but our culture is similar and since then we have met many times and played together many times for Africa Express. But we met the first time in the UK! Now I have played *Later...* six times, three times with my band, once acoustic, once with 1 Giant Leap and once with Mumford & Sons in 2017.

The great thing about the *Later...* show is that you are all sharing the stage; you and the other bands are very close together and you are all equal. The way the room is set up, I never saw something like that before. It is unique and there is the opportunity to see great bands that you have never heard before and great musicians that you never thought you would meet. I come from African music and the other bands are discovering that and I am discovering other styles that are far away from what we are doing. But the music still speaks to you so directly. That is the ambience in the room; it is like a big family that grows and comes together during the evening, during the show. The diversity, the difference between the musicians, inspires you and captures your imagination; it feels like one big programme, a whole.

When we came back in the mid-1990s after the first time, the show had grown, it was more fluent and there was audience everywhere. Paul Weller was there, and Supergrass, and we did 'African Woman' with our traditional Fula hats and our robes and so much energy. In a way it helped me to see the reaction of the audience and the other

Baaba Maal sings 'Dakar Moon',
series 34, episode 7, May 2009.

musicians that night, to grow the music for the big concert stage. A few months later we played Africa '95 at the Albert Hall. But *Later...* was like the test because 'African Woman' has a big Cuban rhythm and I was wondering if people would get that from a band from Senegal. But there was so much energy coming from the band and the whole room was dancing, vibing with me and my band. It was a good night.

Jools has the kind of character that makes you want to give more than you know you have in your chest. Musicians need not be far away from each other and when they get the opportunity to be with each other in the same room and the same project, they shine. Jools makes everybody feel like they belong; they are in the same show, and he makes everyone feel happy, not to be alone, just off on your own in your corner but together in the middle of a big family that is called 'Musician'! Jools does that but there is also a fantastic group of people who make the show and from the moment you arrive for rehearsal, you feel welcomed by the technicians, the people on the lights, the people placing the mikes, it's like a big family.

I came just with my acoustic guitar and three backing vocalists to sing 'Jamma – Jenngii' in 2001. That was a 'Wow!' I was a little bit... not frightened, but worried, 'Maybe this is too naked, just me and my acoustic guitar in that room full of bands, in the middle of all of that, how is this going to sound?' But, in the middle of the show, it was strong and exceptionally good. I had a wonderful response, and I was there in front of R.E.M. and Orbital and others.

You never know who you are going to meet on the show or who you might discover. There are artists who are famous and artists who are going to be famous. One of the times I was on the show in the early 2000s, there was Robbie Williams and Maxi from Faithless, Mahotella Queens and me, we were all with 1 Giant Leap, and this band Coldplay were on. They weren't very well known, no one had really heard them, and then, a few months later, they were everywhere and one of the most talked-about bands in the world. It was the same with India Arie in 2001; we were hearing her music on the radio in Senegal and suddenly we are standing just two metres from her. That makes us proud; *Later...* is a meeting place for musicians from all over the world and for those people who love music. Sometimes you see these artists with you in the room on *Later...* and you can just feel they are going to go on and on and be really, really great. It was the same with Christine and the Queens in 2017.

I am not going to call it like a competition but when you come so far to be there, you appreciate it, and you want to show people where you come from and play well because the programme is like a whole package; you don't want to be the one that drags or lets the show down. I think it maybe helps a lot of groups to play well, to play more than they usually play, you know. But, also, it is very challenging. Why? Because you are in a small place, and you must play like you are on a big stage with that same energy as a big concert.

When you come to England to tour or to London as an African group, we never expected to have this kind of platform or this kind of stage or a TV show like that. The *Later...* show, there's nothing like it in the world, it's unique to the UK. And it becomes a link between you and the other artists who you shared the show with. After I performed there with the Mahotella Queens, we all ended up as friends. We had started something together there and we had to go on.

I love collaborating; it is always an opportunity to challenge yourself

and see what happens. I was on a new journey with Mumford & Sons and some of their friends; we'd toured together in South Africa and then we came back together for *Later...* in 2017. We were rehearsing in a small studio next to the show. Then at the end the whole room sang 'Purple Rain' for Prince. We were all happy to be together and to try and do something great. I had the same feeling at Island 50 singing 'One' and Bob Marley's 'One Love' with U2 in 2009 at Shepherd's Bush Empire. It is always good when people share a piece of music to celebrate someone they all love together.

Always
Nice To
be here

Peace
Love
& Respect
From Senegal
BAABA MAAL

Rehearsing the Midnight Moment with the pipes and drums of the
1st Battalion Scots Guards in TVC, Jools' 16th *Annual Hootenanny*, December 2008.

8

Enjoy Yourself
(It's Later Than You Think)

Hootenanny!

Part 1: Midnight Moment

'Ladies and gentlemen, welcome to our world! Are you ready to live a lie together?' A besuited Jools is exhorting a bursting studio shortly before kicking off the umpteenth *Hootenanny*. A few paces behind him, an aged druid straight out of Narnia's long winter is wildly brandishing a sickle as if to emphasise the importance of what Jools is saying. Next to Father Time stands a man in a suit with white gloves and a kitchen clock for a head, a Magritte painting come to life. Across the floor, a gorgeous polar bear is stretching out on all fours, elongating its considerable bulk across a giant fob watch with the incoming year writ large in Roman numerals across its clock face. The Rhythm & Blues Orchestra have taken their places, fiddling with their instruments and their charts, nervously checking their arrangements of songs they've run but half a dozen times and only in the last couple of days, signature tunes by global superstars like Michael Bublé or Ed Sheeran, legends like William Bell or Irma Thomas and emerging pop stars like Celeste or Rag'n'Bone Man. The trombonists exchange notes and wave at their partners who have come to egg them on. Ruby Turner, the Queen of the *Hootenanny*, presides amiably over her table and the surrounding mayhem, preparing to take it to church.

Behind the Orchestra is a giant painted cityscape right out of *Mary Poppins* and, standing in front of it, a circular clock with Roman numerals and two large wooden hands that rest at some time after XI. To the Orchestra's right and left, tables and chairs are tightly

packed: tonight's star guests and their entourages are being ushered into place, chatting excitedly, and eyeing up their fellow guest singers whom they first met an hour ago while briefly rehearsing the familiar finale of Prince Buster's version of 'Enjoy Yourself'. Raised high above and behind these corner tables are tiered audience risers, packed with punters who've been randomly selected from the 30,000 odd names in the BBC Audience Services' hat and are gazing curiously down at the stars and the busy floor team below. They are dressed up for an evening out and already looking a bit hot and bothered under the studio lights. There are bands on both long walls of the room and at the other end of the studio from the Rhythm & Blues Orchestra, one surfing huge success this very year, one with an enviable stack of era-defining hits from a few decades ago and perhaps one dark horse of a band that nobody has really ever heard of but who look like they'd show you a good time if you chanced into the right bar on the right night. Each band are in their very own winter wonderland and surrounded by an overflow of punters who will engulf the floor when the party gets properly started.

If you think you keep clocking people you think you know, it's because there are actors, comedians and newsreaders spotted around the tables. There's Vic Reeves and his wife, already on the fizz, and Dawn French and friends waving from another table which is almost certainly hosting a regenerated Doctor Who or a Premier League manager on a rare evening off. Lurking near the curtained entrance to the studio are a group of ragamuffins who look like they've wandered in from a folk festival, nursing their own instruments and hoping for a floor spot. They could be a bearded and venerable bunch from Dublin with banjos and fiddles or an Afro-American brass band who've flown in from their hometown of New Orleans, one of whom is built enough to manhandle the thirty-plus-pound tuba, giant and gleaming, that hangs around his neck like an open-mouthed anaconda. Further back behind this ensemble, hidden in the narrow gangway created by the star cloth that surrounds the studio, are some very smart soldiers in kilts, wrestling with their pipes and drums while discussing what they've rehearsed an hour before in the broadest of Scottish accents.

Our host has been introduced by a warm-up man with a beard who has helped everybody settle into place with some banter with the bands and some slightly edgy jokes. Jools is dressed in one of his smartest

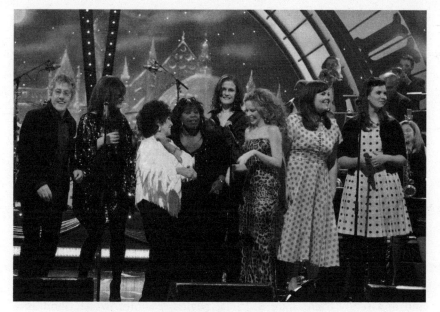

Roger Daltrey, Rumer, Wanda Jackson, Ruby Turner, Alison Moyet,
Kylie Minogue and the Secret Sisters enjoying themselves,
18th *Annual Hootenanny*, December 2010.

suits and he is warming up for the herculean task of fronting the
Hootenanny, both as bandleader and compère, through what has
expanded over the years into a two-and-a-half-hour show, give or take
the odd fifteen minutes. He has been welcomed with a huge round of
applause from bands, singers and audience alike and the floor is now
most certainly his. He is explaining the responsibilities that all 500-plus
people squeezed into the studio must shoulder together. 'Tonight, ladies
and gentlemen, we all have to believe together! It is New Year's Eve
and we are going on a journey from one year into the next and we are
going on it together! Are you ready to frenzy with us? Are you ready
to time travel with us into the most exciting night of the year? Are you
ready to *Hootenanny*?!'

It is only 8.30 in the evening, it is not yet suffocatingly hot on the
audience risers and everyone's itching to get going. A last-minute guest
or two is being rushed to their chairs, which are being coveted by the
odd hopeful who's been lingering close by and hasn't yet been assigned
a seat. '*Hootenanny*!' the room bellows back like an exaggerated echo.
It is a Wednesday in mid-December and Jools has turned the occasion
into a verb, a way of behaving. In a moment, he will make his televised

entry into the room flanked by the pipes and drums of the 1st Battalion Scots Guards, but first he is enlisting the whole of this bubbling and excitable room in a shared mission. If this were a pantomime, he'd be asking the audience to tell him if there's anything behind him but, instead, he is asking for poetic licence, what Samuel Taylor Coleridge once famously defined as 'the willing suspension of disbelief'. 'Ladies and gentlemen, please turn off your mobile phones and please don't tweet or message about where you are or who you're with or what you're doing. Tonight, it's New Year's Eve and another year is just around the corner. Are you ready to live a lie with me? *Hootenanny*!'

Like its parent show, the *Hootenanny* came together as much by opportunity as by design. The second series of *Later...* had finished in July 1993 and there was no sign of a third that autumn. Michael Jackson, our champion while Head of Music & Arts, was now Controller of BBC2, and apparently there were financial challenges. Meanwhile Channel 4 were touting loudly for a new music show. Jools and I even met with the commissioning editor Waldemar Januszczak about migrating *Later...* in case the BBC didn't renew. A bullish Jools told him that there had only ever been two good music shows on British television and that he'd presented them both. It was a shot across Waldemar's bows but I suspect neither party took the other too seriously. Channel 4 would eventually launch *The White Room* with digital stereo, unique duets and retro dancing girls, kicking off with a reggae special in June 1994 and giving us some serious competition until the channel cancelled it in the summer of 1996. Meanwhile what Jools then called his Big Band was starting to take off although the economics of running such a large ensemble were initially proving daunting. Jools needed to get the Big Band on television and BBC2 clearly wanted to keep him on board. *Later...* was on hiatus and wouldn't return until May 1994 when channel and department had finally sorted out their budgets, but why not have a go at a New Year's Eve special in the meantime? Even though we were only two series in and still finding our feet, we set about adapting the weekly show into what would become an annual entertainment institution. At *Later...* the music is the occasion, for the *Hootenanny*, the music would serve the occasion.

The British Broadcasting Corporation is dutybound to orchestrate a national rite of passage like New Year's Eve and BBC2 had a well-established tradition in which topical variety owned the evening

before giving way to rock music post-midnight; the *Whistle Test* team had had a 'Pick of the Year', post-Big Ben slot since the mid-1970s which finally ended as 1989 dawned. BBC2 began the already archive-conscious 1990s with a compilation celebrating the best of its 1980s pop holdings, most of which came from the recently defunct *Whistle Test*. A Rolling Stones' concert from Barcelona followed in 1991 while the rock fan's ultimate inside joke movie, *This Is Spinal Tap*, would provide a stopgap in 1992. When Andy Stewart, the bekilted singer and impersonator who'd formerly hosted BBC Scotland's New Year's Eve 1960s institution, *The White Heather Club*, died in October 1993 it was as if he was drawing attention to the yawning vacancy which had long been his legacy. Stewart had played the Scottish entertainer to the world with hits like 'Donald Where's Your Troosers?', imperson-ations of everyone from Tom Jones to Louis Armstrong(!) and a 'tartanised' bonhomie which began with his welcome, 'Come in, come in, it's nice to see you...' and ended with the regular cast singalong of 'Haste Ye Back' in which the viewers are embraced as lifelong chums and invited to hurry back. Jeremy Paxman may later have cited *The White Heather Club* as conclusive proof that there never was 'a Golden Age of Television', but for those of a certain age, Stewart and his *White Heather Club* remained formative; they weren't a template so much as a reminder that New Year's Eve mattered on the telly.

Jools may not be Scottish and prefer his suits to kilts but, after much campaigning, Michael Jackson decided we should have a go at New Year's Eve and called him on tour in Scotland to share the good news. The Jools Holland Big Band had just been renamed the Rhythm & Blues Orchestra and were as central to our vague prop-osition as the midnight slot. They too had televisual antecedents, offering a contemporary spin on the British dance bands who'd thrived from the 1920s through Ted Heath's 1950s and whose legacy was prolonged by the Cockney bandleader, Billy 'Wakey wake-aaay!' Cotton. Billy had started his first orchestra back in 1924 and his band was noted for its African-American trombonist and tap dancer Ellis Jackson and regular guests like Kathie Kay, Russ Conway and Mrs Mills. Billy's vaudeville patter drove his Saturday evening, 7 p.m. entertainment show on BBC television from 1956 to 1965 and was latterly produced by his son Bill Cotton who would go on to run BBC1 in the late 1970s.

I suggested *Hootenanny* for the show's title and it stuck. I am not sure that any of us fully knew the provenance of the word, but we all liked the ring of it. '*Hootenanny*' sounds like a nonsense word, part Alice in Wonderland, part Tutti Frutti; any word that combines 'hoot' and 'nanny' has got something giddy going for it. I must have first heard the word in folk circles where it had long since been adopted as a loose term for a guitar pull or singalong. I now know that it's an old Appalachian colloquial term that originally referred both to a party and things either forgotten or unknown. Thus, instead of 'Pass me that thingamajig,' mountain folk might have said 'Pass me that hootenanny!' Pete Seeger had come across it in the late 1930s, and by the early 1960s when the American folk revival was in full swing a *Hootenanny* was as popular as work shirts, banjos and Greenwich Village.

The hit ABC television show *Hootenanny* launched in 1963 and featured the first wave of wholesome folk revivalists like the New Christy Minstrels, igniting a nationwide folk fad with one episode of its first season topping eleven million viewers. The British Invasion would sweep it into oblivion less than a year later but not before the BBC had copycatted with *The Hoot'Nanny Show*, a transatlantic knock-off hosted by Scottish folk trio the Corries and filmed at a jazz club in Edinburgh. *The Hoot'Nanny Show* succeeded ATV's rather more eclectic *Hullabaloo*, a folk show that also featured blues and world music artists and was hosted by the Eton-educated, twelve-string guitar-toting Rory McEwen. I am not sure this kind of contextual information was at hand in 1992. We just liked the word's old-fashioned and un-rock 'n' roll aura. It sounded out of time, more like a knees-up than a rave, more silly than serious, like something we could reinvent. Even at the very first show, the studio audience echoed Jools when he yelled out '*Hootenanny!*' like they'd just joined a secret but rather noisy society.

Jools was certain from the first that a military pipe and drum band should play in the New Year in the time-honoured manner. The Scots had long owned New Year and Hogmanay is traditionally celebrated with the spine-chilling call of the pipes. The first *Hootenanny* began with 'Auld Lang Syne', a stirring beginning from a standing start as we only came on air at the midnight hour. The Pipes and Drums of the 1st Battalion Scots Guards would eventually become our regular

midnight escort, returning year after year, bussing down from their barracks in the North and often recently returned from a tour of duty in somewhere life-threatening like Afghanistan. They'd assemble in full uniform and then Janet would choreograph how, on the chosen stroke of midnight, the Guards should march onto the floor and come to attention in a circle in the centre of the studio, keening impassively away amid chaos and cameras.

Latterly, Jools has added a singer to lead 'Auld Lang Syne', first his old pal Eddi Reader and then Louise Marshall from the Orchestra. Robert Burns wrote the words in 1788, they were paired with an old folk melody a decade later and there's something in the sentiment, the melody and the pipes that gets everybody going. Every year the guardsmen enter the room like the cavalry coming over the hill. The effect is always transformative, as if some proud and regal laughing gas is being pumped into the room. From the first skirl of the pipes and the marching tattoo of the drums, hairs stand on end, the eyes moisten and the blood pumps. The Braveheart slumbering in every guest awakens, the studio sways from side to side and Jools rushes around the room like a demented hare, embracing all and sundry, wishing the good, the bad and the ugly a very Happy New Year.

The midnight moment is now a turbo-driven gear change preceded by Jools' mock Churchillian preamble, a trumpet fanfare and the countdown. The room temperature is instantly raised on the stroke of midnight, as are the toasts and the cheers, bands and audience members alike link arms, it's the Midnight Moment and over the years it has evolved into a chaotic ritual that ignites the *Hootenanny*. After a verse and chorus or two of 'Auld Lang Syne' from the Guards, the Rhythm & Blues Orchestra fall in and begin to pick up the beat. No matter that we are still a couple of weeks away from what the Scots call the 'daft days' of Christmas and New Year, and that it's only around 9.30 in the evening, everybody kisses, mugs and hugs for the cameras in a collective hysteria. It shouldn't work and it isn't rehearsed but, like Father Christmas, midnight at the *Hootenanny* only comes once you believe. It is the New Year we all imagine but which all too often fails to arrive – an imaginary party with the best house guests, a great soundtrack and without the unforgiving pressure of New Year's Eve itself.

The *Hootenanny* originally commenced on the dot of midnight as Jools welcomed viewers into the studio and the Pipes and Drums walked out playing 'Auld Lang Syne'. In the late 1990s the start time shifted to five to midnight but it wasn't until 2002 that BBC2 declared that the tenth *Hootenanny* should start at eleven, to build an audience as the New Year approached. An hour to the transformative Midnight Moment could seem like rather too much anticipation, but it allowed the atmosphere in the studio to build while we'd save the biggest hits for post-midnight, obsessing about selecting the right song and performer to lead off immediately after 'Auld Lang Syne'. Eventually, in the 2010s, the pre-midnight hour was reduced because the schedulers discovered that the television audience peaked in the half-hour to midnight and when the fireworks had finished over on BBC1 around twelve fifteen. Post-midnight the show's tail grew longer and longer as we added more songs and more artists. Two million viewers would still be watching at one a.m. and although we'd have peaked with three million plus at twelve thirty or so, we'd often run until nearly one thirty. Gerry Tivers, our first camera supervisor, decided to retire when the 2007 *Hootenanny* ran for over two and a half hours. Some of the Orchestra looked like they wanted to follow him but the extra showtime allowed us to trade with the singing guests for more hits in the first ninety minutes.

Jools recognised from the get-go that the *Hootenanny*'s task was to play with Time and so we set about designing a backdrop for the Rhythm & Blues Orchestra that would reflect the moment at hand. For that first *Hootenanny* in December 1993, the designer delivered a vast backcloth boasting a giant melting pocket watch in the style of Salvador Dalí's 1931 masterwork, *The Persistence of Memory*. Jools had pulled out a fob watch on his way to the studio in our *Later...* titles and here was a soft clock melting across the stage behind the orchestra, its circle dripping and elongating into a tongue shape. A surrealist by nature, Jools loves illusions, coup de théâtres, the world made wonky. Indeed, his charm and enthusiasm have always had much of the Willy Wonkas, about them and so for that first *Hootenanny* he propositioned the BBC to buy him some *Hootenanny* glad rags, a new frock coat with piano keys curling upwards on both sides of its purple lining. He knew that this was a show that required dressing up...

Ronnie Spector and Jools, 'Be My Baby',
22nd *Annual Hootenanny*, December 2014.

The piano keys and the timepieces have never gone away. The Orchestra would soon be framed against a giant clockface that appears to disappear into the studio floor like a setting sun with the hour of twelve in roman numerals at its very centre, right above Gilson's head. This clock has two huge hands that begin the show at something approaching half-mast. During the last song before the Midnight Moment, a reluctant pair of moonlighting studio electricians convene beneath the hands and wait for Jools to begin the vital countdown. As the whole room joins in, chanting down from '10!', they do their best to keep pace with the count, manhandling the heavy arms towards XII. The giant clock hands inevitably lurch about, sometimes momentarily sticking, sometimes lunging a few seconds forwards, heading haphazardly for the hour while the pressganged stagehands heave and their colleagues smirk. Every year it's like watching a scene from Eric Sykes' homage to vaudeville and silent cinema, *The Plank*.

Early on, another clockface was stencilled to the centre of the floor, a giant pocket watch with the incoming year inscribed underneath, providing a mark for the Guards at midnight and later foregrounding

Jools' farewell sign off as a final reminder that we have entered a new year. When the *Hootenanny* first began, Public Enemy's Flavor Flav was famous for clowning around with a watch around his neck asking searchingly, 'What time is it?' I think it was the second *Annual Hootenanny* that we had a cardboard Big Ben built that one of our young runners wore throughout the show while stumbling around the studio trying to guess where he or she was heading. The *Hootenanny* still does much the same job as Mr Flav while over in the real world, on BBC1, Big Ben marks the hour live by the Thames and the Houses of Parliament where the New Year is proper news.

If the *Hootenanny* is a make-believe New Year's house party with a stellar guest list, Jools' Rhythm & Blues Orchestra is the driving wheel of the whole endeavour. Jools and the Orchestra have toured all over Britain twice a year since the first *Hootenanny*, building their own distinctive character and a formidable reputation as a good night out. They aren't like the old showbiz big bands, smart and obedient, but mavericks like Jools himself. The members mostly dress down and several of them probably wouldn't fit quite so well in any other outfit. Like all British jazzers of a certain age, they enjoy seeming a bit road weary and, over a quarter of a century in, they're growing older together. Each year Jools and his Rhythm & Blues Orchestra arrive at the *Hootenanny* in the middle of their winter tour, often having just travelled south from Glasgow, where they'd have been arranging and cramming the fourteen or fifteen tunes we've cast for the show. A day's rehearsal at Helicon Mountain, soundcheck at the television studio late the next morning, rehearse with the guest vocalists all that afternoon, stopping only for mince pies around the piano, back in the next day for a couple more guests, reprise a few of the trickier songs, rehearse the Midnight Moment, grab an early dinner, showtime. Whew!

The rhythm section of Gilson, bassist Dave Swift and guitarist Mark Flanagan can play anything with anybody, the brass line-up includes versatile arrangers like saxophonist Phil Veacock and trumpeter Jon Scott to name but two and there's a strong Caribbean influence from the late Rico, Michael 'Bammie' Rose and Winston Rollins. Jools is the quintessential bandleader, making all his guests personally and musically welcome while ready to take off on his own into a furious and finger-flaunting solo at the drop of a hat. The Orchestra's melange of dance

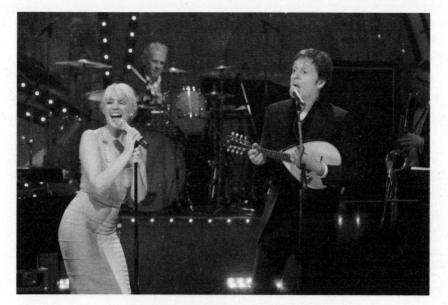

Kylie Minogue and Paul McCartney have a dance,
15th *Annual Hootenanny*, December 2007.

styles takes in jump blues, swing, soul, rhythm and blues, blues, rock
'n' roll, ska and all points in between. They can studiously learn and
deliver Lionel Richie's 'All Night Long' or Róisín Murphy's avant-garde
jazz take on 'Let's Dance' but there are sounds and styles with which
they are undoubtedly most in their element, with jump blues and boogie-
woogie to the fore, and Ruby Turner leading the way.

Each week at *Later...* we'd snatch a quick chat with Jools and talk
through options and ideas for guests for the Orchestra, pitching each
other our contenders, planning our campaign. We'd eye up *Later...*
guests who'd come on as debutants and were now enjoying their glory
days. We'd championed them before they were famous and now they
could return as conquering heroes, as if the *Hootenanny* were *Stars
in Your Eyes* offering their chance to emulate Ella or Frank. Jessie J
debuted 'Price Tag' on *Later...* in November 2010, backed with just
an acoustic guitar and dressed in jeans. Three months later it entered
the British pop charts at Number 1. A year later, Jessie came back in
a glamorous pink evening dress to sing what had become a global
smash with the Orchestra for the 2011 *Hootenanny*. She's not short
of confidence on either occasion but she's almost a seasoned pro the

second time around, climactically sparring with Jools over at the piano as they fire flurries of big notes at each other. More often than not, the young singers would combine a big-band version of their own signature hit with an appropriate cover they'd cooked up with Jools when we'd finally got them together on the phone. Florence took on Nina Simone's 'My Baby Just Cares for Me', Lily Allen assured us that 'The Lady is a Tramp', Christine and the Queens reworked Terence Trent D'Arby's 'Sign Your Name', Hozier channelled his inner Van Morrison for 'Domino' and Michael Kiwanuka delivered Bill Withers' consoling 'Lean on Me.' All with stars in their eyes. Amplified instruments have volume control but there's clearly something about standing in front of twelve brass players hitting a chorus in unison that's like being borne aloft on a roaring wind.

That first *Hootenanny* set the mould even as it also taught us a lot of lessons. Jools managed to recruit his old pal Sting to sing with the Orchestra. Back in the late 1970s they had shared a manager in Miles Copland when the Police and Squeeze had toured together. Jools was also joined by Dina Carroll, flying high on her debut album, *So Close*, with a cover of Barbara Lynn's 'You'll Lose a Good Thing', and Paul Young, who teamed up with Courtney Pine for an epic soul-gospel reading of Randy Newman's 'Sail Away'. Elsewhere in the studio I wanted a combination of current hits and iconoclastic acts that you wouldn't find anywhere else on television. Chaka Demus and Pliers were in town with Jack Radics and the legendary rhythm section of Sly and Robbie, setting up their January 1994 UK Number 1, 'Twist & Shout', Studio One legend Freddie McGregor popped in to join them for 'Carry Go Bring Come' while the Gypsy Kings sat on stools in a semicircle and combined handclaps and four Spanish guitars to rousing flamenco effect on the Christmas standard, 'Navidad'. I managed to persuade the Stetson-sporting Junior Brown and his wife and rhythm guitarist Tanya Mae to fly over from Austin with his invention the guit-steel – pedal steel and guitar on a single twin-necked instrument – and pick their way through droll honky tonk tunes like 'Highway Patrol' with Junior playing both state trooper and drunk driver. I'd seen Brown in residence at the Continental Lounge in Austin, Texas, while on a trip to interview and film Willie Nelson at his legendary studio in nearby Pedernales that spring. I must have

already figured that at least one act on the *Hootenanny* should pop out of nowhere like you've just stumbled into a bar and can't quite believe that the band in the corner rocking the house is not only local atmosphere but pure genius.

Did I say 'bar'? Although the Rhythm & Blues Orchestra and Chaka Demus & Pliers both had the impressive melting cloth backdrop, the first *Hootenanny* looks a little lost in TC1, Television Centre's biggest studio. A smattering of audience is tucked away around the edges of the floor and the few tables and chairs next to the Orchestra are underpopulated. It's awkwardly quiet between songs. There are a few celebrity guests – Stephen Fry, Rowland Rivron and Chris Evans to name but three – and naturally Jools approaches them all for their New Year resolutions. Chris Evans was about to launch *Don't Forget Your Toothbrush* with Jools and the Orchestra as house band and clearly already knew an awful lot more about producing entertainment shows than I did. He points witheringly at the paper cups wilting forlornly on the little round bar table in front of him. 'What kind of a New Year's party is it when you can't get a drink?' he asks Jools with a smirk. The BBC wouldn't permit alcohol 'on set' and anyway we had little or no budget for booze. Jools himself was amused by the sheer hopelessness of a dry New Year's Eve in mid-December and mock-apologised to his guests as if the BBC and East Germany were synonymous, but our balloon had rather been popped. I can still hear the empties rolling off the tables and around the edges of the studio floor as the *Hootenanny* accelerated into the noughties and beyond. I can still see the celebrity guests who had to be assisted from the studio floor by the weary runners who'd ferried them drinks all evening when we finally finished recording. Thanks to Chris Evans, our New Year's Eve was never dry again.

Part 2: Don't Give Up on Me

The *Hootenanny* grew steadily through the 1990s. The sets grew grander and more atmospheric, the shows steadily longer and more ambitious, nearly doubling in duration as the new millennium was welcomed with a near two-hour extravaganza. The fifth *Hootenanny* at the end of 1997 made a quantum leap as the show kicked off at five to midnight, allowing us to briefly set the scene before the midnight mayhem and because

the star of the show was B.B. King. King was already into his seventies and had been recording with producer John Porter over in England for his all-star duets' album, *Deuces Wild*, which came out in November 1997 and included 'Pauly's Birthday Boogie', a collaboration with Jools and the Orchestra. MCA were excited by *Deuces Wild*, as was veteran manager Sidney A. Seidenberg who'd no doubt seen how John Lee Hooker's career had been transformed by *The Healer* back in the early 1990s. The label had already compiled B.B.'s duets with U2, Robert Cray and Stevie Wonder for the 1995 album, *Lucille & Friends*, as they sought to bring in younger fans.

B.B. brought the *Hootenanny* the stamp of authenticity. He turned up at Television Centre with Sid in tow and proceeded to charm all and sundry for the best part of two days. 'The word "gentleman" doesn't really do him justice,' Jools later observed. 'He was always really gentle and always really good-humoured.' When B.B. first stepped out onto the studio floor the whole Rhythm & Blues Orchestra stood up spontaneously and applauded. King got along famously with Jools, of whom he said, 'I didn't think anyone could play like that. Jools has got a left hand that never stops.' Between rehearsals he sat to one side of the Orchestra graciously posing for photos with all who approached while chaos unfolded around him. At the previous *Hootenanny* Eric Clapton had sat in with Dr. John and now David Gilmour took time off from Pink Floyd to back B.B. and deliver a couple of his Albert 'Iceman' Collins-style stinging solos. But the night belonged to B.B. himself, sitting in a low chair in front of Gilson, resplendent in a purple dinner jacket and bow tie. Every solo is eloquent testimony, every vocal as warmly soulful as his old Beale Street buddy Bobby 'Blue' Bland. As Jools later recalled, 'What every musician would want is to have something so they're identifiable – from a hundred yards you know it's them playing. And even somebody who knew nothing about music can recognise it's B.B. King singing and playing.' B.B. is still holding court at the end of the evening, nestling into Jools' piano behind the trio of Gabrielle, Jewel and Sam Brown as they swap verses on the finale of 'If You Really Wanna Cry', answering back with those filigree fills and adding a perfectly formed short solo, happy to be part of it all.

B.B. King kicked open the door for the panoply of legends that would do their best to follow in his footsteps. British rock gods like

Jools, B.B. King, Mark Flanagan and David Gilmour,
5th *Annual Hootenanny*, December 1997.

Paul McCartney, Robert Plant, Ray Davies, Roger Daltrey and Bryan Ferry all took their turn, as did guitarists Eric Clapton, Jeff Beck and Ronnie Wood, Sixties 'girls' like Lulu, Sandie Shaw and Petula Clark and Eighties stars like Annie Lennox or Chrissie Hynde. Alongside the homegrown heritage talent, we began to nurture a guest-of-honour slot for the legends of soul and reggae, most of whom had long since passed the first flush of success and were just getting by with a few of their own gigs or making do with a slot on an oldies' multi-artist package tour, biding their time for a comeback that might never arrive. Desmond Dekker, Eddie Floyd, Sam Moore, Betty Wright, Bettye Lavette and Wanda Jackson, these originals had made their mark a long time ago, everybody still knew and loved their hits but even though they were still working, they'd fallen off the radar. They weren't rich and feted like the rock gods or enjoying their moment in the sun like the young breakthrough acts on the bill, but they were originals, they still had their aura, and you certainly wouldn't see them anywhere else on British television. Jools and the *Hootenanny* started to play the kind of revivalist role

pioneered by John Belushi and Dan Aykroyd in *The Blues Brothers*, shining a light on the forgotten.

Sometimes the comeback was already well under way. Solomon Burke hadn't made a truly considered record since the early 1970s, and while he was busy enough hustling his various businesses and as Archbishop of LA's House of Prayer for All People and World Wide Center for Life and Truth, his musical reputation had stalled since 1960s hits like 'Cry To Me'. When record boss Andy Kaulkin met Burke backstage in 2001 and talked up the Mississippi-based Fat Possum label that had initially championed local blues artists like R.L. Burnside, Burke reportedly believed he was being asked to dress up as a mascot for a sporting event. Producer Joe Henry set about soliciting new songs for Solomon from Bob Dylan, Brian Wilson, Van Morrison, Tom Waits, Elvis Costello and more, constructing the warm, organic sound of 2002's *Don't Give Up on Me*. Henry and Solomon cut the album in four days without charts or rehearsals but with a crack band that knew how to follow Burke as he found his way to the heart of the songs. Dan 'I'm Your Puppet' Penn co-wrote the title track that sets out the album's core narrative as Solomon tries to make belated amends, to plead for forgiveness and find his way back. He'd long been a sleeping giant and here was the proof.

Fat Possum must have loved the reviews and got behind Burke enough to bring him to Europe and offer him for the tenth *Hootenanny*. Neither Jools nor I had ever seen Solomon in the flesh and none of us was prepared for the larger-than-life figure that eventually made his way onto the studio floor in a wheelchair in December 2002. Burke was warm, obese and funny and he knew how to play up to his legend as the king of rock 'n' soul. A large gold throne with red velvet backing had already been placed centre stage and he subsided into it while nodding to the female harpist who was his constant musical companion. He chatted briefly with Jools and then the Rhythm & Blues Orchestra ran their arrangement of 'Cry to Me'. Solomon must have sung it a thousand times before but immediately he was right there in the lyric, the face mobile, the right arm gesturing out to the room offering solace, the voice soaring, vulnerable and undimmed. The Orchestra clapped him when he finished, and Jools and I couldn't stop smiling. Solomon took over from there and owned the whole show.

Jools, Janet, Solomon Burke, the author and Alison Howe gather at the throne,
10th *Annual Hootenanny*, December 2002.

Robert Plant and Tom Jones were both already on the bill and both desperate to sing with Solomon, whom they'd idolised in the 1960s. Tom had befriended Solomon back then and watched him from the side of the stage when he first played London. Come showtime, this trio took on 'Shake, Rattle and Roll', Robert and Tom flanking Solomon on his throne with Jeff Beck on guitar. But it was Solomon's midnight performance of 'Everybody Needs Somebody to Love' that kicked the *Hootenanny* into overdrive. Burke co-wrote the song with Bert Berns and Jerry Wexler in 1964 around a church march from his childhood and scored a minor hit. The Stones covered it in 1965, Ackroyd and Belushi put it at the heart of their 1980 *Blues Brothers* film before Jive Bunny & The Mixmasters used it to bookend their 1990 medley, 'That Sounds Good to Me'.

Right after the Midnight Moment, the Rhythm & Blues Orchestra kick into that irresistible groove and there's Solomon on his throne, dapper with a handkerchief in his breast pocket and a yellow rose in his lapel, arms beseeching everyone to come right on in. He's preaching at first while the backing vocalists yell and banter along. 'I'm so happy to be here tonight, once again I am so glad to be in your wonderful

country, hello England! I have a little message for you and I want to tell every woman and every man tonight that everyone needs somebody to love...' Suddenly the whole room is standing up, Solomon is filling it with his spirit, he's told everyone to clap their hands and he's finally right in the chorus, pointing round the room, as if recruiting each and everyone to his soul-serving army. The joint is jumping and Solomon can't help himself, he's telling us all that he wants us to have everything that we desire, 'This is a brand-new year, oh yeah, and I want you to have the best of everything, Happy New Year and many, many, many more – 2003!'

That was top-drawer first footing, but later, as the show neared its close, Solomon reappears for the title track of his comeback album. The lights are low in the room and the party temporarily stilled, all eyes on Solomon, the throne and the harpist. The gold crown that tops the back of his chair frames his bald head and beseeching eyes, but this soul ballad is a king setting his majesty aside, asking for patience and forgiveness. Solomon's hands are clasped in prayer and then, as he warms to his suit, the glasses come off and he offers up his life, his money, even his wife, as long as his God or whoever he's entreating doesn't give up on him. As the case he is pleading reaches its climax, Solomon's arms flurry up and down, a desperate man offering anything and everything. Suddenly he's up on his feet for the first time that night, his huge bulk raised in supplication, before he subsides back into his chair and stares heavenwards. When Solomon finishes, his close-up fills the camera with the delight of someone who's given it his very best shot. Tom and Robert stand up to applaud and whoever he's been imploring not to leave or trying to win back doesn't have a prayer. Whatever his shortcomings, he's won, and Solomon Burke being Solomon Burke, he knows it.

I'd start worrying about the *Hootenanny* by early spring, tracking the bands and pop stars making waves that year but scouring the press, release schedules and tour dates for signs of any suitable legends who might be out and about and whom we could maybe entice to London. I was on a constant detective hunt for veterans like Betty Wright or Eddie Floyd whom I'd spend hours on the phone tracking down via record label, manager or agent. Recruiting at least one of these legends who'd fallen below the radar became my annual mission and often

took much of the year. There'd be our share of dead ends and red herrings and plenty more we couldn't afford. Mavis Staples came from Chicago in 2004 chaperoned by her sister Yvonne just as she was beginning to rebuild her career with her sixth solo album, *Have a Little Faith in Me*, for Alligator Records, her first since recording *The Voice* with Prince back in 1993. By the time she returned in 2017 she wasn't too far from her eightieth birthday and now as renowned once more as she had been in the Staples Singers at the dawn of the 1970s, thanks to the trio of albums she'd made with Wilco's Jeff Tweedy in the 2010s. Irma Thomas came economy from New Orleans with her long-legged husband Emile Jackson in 2005 even though they'd lost their home and their Lion's Den nightclub in New Orleans to Hurricane Katrina. They must still get along because her first song on that *Hootenanny* was her 1959 hit, 'You Can Have My Husband (But Please Don't Mess with My Man).'

Candi Staton, William Bell, José Feliciano, Wanda Jackson, Bobby Womack, Bettye Lavette, George McRae – the list of legends goes on and on. Some took months to get on board, others just fell into our lap, like Kanye West's vocal foil on the *Yeezus* album's Bound 2 in September 2013. First there was talk of Kanye just rapping in front of a couple of DJs, but I'd argued that he had to bring a vocalist to truly deliver a live performance. When his party arrived in the studio, West was darkly remote while the man his team referred to as Uncle Charlie was immediately the life and soul of the party, a huge and hyper character in dark shades, bouncing around the room and seemingly improvising endless searing vocal lines around Kanye's confrontational raps. Uncle Charlie turned out to be the Charlie Wilson who'd formed soul-funksters the Gap Band with his brothers Ronnie and Robert in their hometown of Tulsa, Oklahoma. They'd started out backing local boy Leon Russell on his 1974 album, *Stop All That Jazz*, and broken big internationally with 'Oops Upside Your Head' in 1980. I didn't know that Charlie had crashed and burned in the early 1990s after going solo. He'd become a cocaine addict and an alcoholic, sleeping rough around Hollywood Boulevard for a couple of years before meeting his social worker and future wife Mahin Tat in rehab. He'd survived prostate cancer in 2008 and now campaigned to raise awareness of the disease amongst Black men, he frequently sang with his good friend Snoop Dogg and first recorded with Kanye

for 2010's *My Beautiful Dark Twisted Fantasy*. Charlie looked like he was in his forties but had just turned sixty and I begged his manager to bring him back to Maidstone for the twenty-first *Hootenanny* a few months later.

If *Later...* is a concert that invites you to listen, the *Hootenanny* is a party where Charlie could come into his own, inspiring those trademark rowing moves from the studio production team as he roams the floor on 'Oops Upside Your Head', delivering those cheeky early hip-hop verses while Sherlock Holmes and Dr Watson dance on stilts in the corner. 'I don't believe that you wanna get up and dance!' sways Charlie, waving his right arm at the audience in the corners while Laura Mvula, Mel C, Dawn Penn and a group of soldiers in redcoats give it up stage left. I'd made 'Outstanding' Single of the Week for *Record Mirror* shortly before I left my staff job there early in 1983. It wasn't a big chart hit in the UK at the time, but it's remained a club favourite and Charlie and the Orchestra turned it into a show-stopper that night, opening it out and working the room. Charlie bust out his moves, dancing around Jools' piano before pitting different sections of the audience against each other... 'Ain't nothing over here, the party's over there! Ain't nothing over there, the party's over here!' Sometimes a party needs an entertainer to really get it going and that's what Uncle Charlie does.

If there's a resident star and entertainer at the *Hootenanny* aside from its host, it must surely be Tom Jones. Now he is a grey-haired Sir, it is hard to remember Tom as the ageing Lothario the critics used to sneer at back at the tail end of the last century. When I first called his manager and son Mark Woodward in 1998, Mark and Tom were on tour in Ireland. Mark sounded nothing if not wary. He and Tom had already enjoyed one triumphant comeback moment by rein-venting Prince's 'Kiss' with digital samplers Art of Noise ten years earlier. Yet the old excesses had left them scrabbling for respect in a sea of ignominy. Tom was still trying to dodge the knickers thrown at him by the female fans he'd once courted a little too readily. He'd come straight out of rock 'n' roll and the Valleys into pop stardom, entertainment television and Las Vegas. He'd sung with everybody on his early 1970s television shows – Aretha, Crosby, Stills, Nash and Young, Stevie Wonder, Janis Joplin – but while the champagne flowed

Héloïs of Christine and the Queens and Imelda May bustin' a move,
24th *Annual Hootenanny*, December 2016.

on, the hits dried up and Tom's overt masculinity and powerful voice
fell out of fashion.

Tom's first manager Gordon Mills had died in 1986 and the son who'd
grown up on the road with his father had taken over. Mark was deter-
mined to bring back Tom the artist but was forced to play the long game
and keep his father famous. In 1996, Tom had played an amiable version
of himself in Tim Burton's camp classic *Mars Attack!* Now he was in the
middle of recording his duets album, *Reload*, with a bunch of hip young
admirers. Tom was more used to being laughed at than admired back
then; he was in the wilderness and *The Voice* or weighty albums like
2010's *Praise & Blame*, were still a long way off. As Tom told Jools on
one of the lockdown *Later...* interview shows in 2021 while meditating
on the fate of INXS' Michael Hutchence, 'At one time if I thought we'd
done a great show somewhere... I'd pick up the paper and they'd have
written "The band struck up, Tom Jones came out, took his tie off, opened
his shirt up, the women screamed." The music wasn't even mentioned.
What did I sing like? What did I sound like? What songs did I do? No.
So it takes over, it takes over from what you originally wanted to do.'

Mark and I bargained back and forth on the phone a few times. He didn't want us to treat Tom just as an oldies' act while I knew we had to have 'It's Not Unusual' at midnight. I'd loved Tom as a boy since that very first chart topper. I loved the adult drama and emotional intensity of those early hits. I wanted to show respect for Tom's musical roots but also bring home the bacon. Mark and I had already settled on 'It's Not Unusual' and Al Green's 'Take Me to The River' when the idea of Tom and Cerys Matthews duetting on the wintery standard 'Baby It's Cold Outside' came up. 'Cool Cymru' was under way, Catatonia were in their pomp with 'Road Rage' and already booked for the *Hootenanny*. I'd thought Cerys was a star since I'd first seen Catatonia opening for Space at London's ULU back in 1996. There was gravel in her voice, and, like all the best lead singers, she seemed fearless. A month later, Catatonia gave their television debut on *Later...* opposite Metallica and the Beautiful South. A couple of years later their second album *International Velvet* was heading triple platinum. Meanwhile Mark and his wife Donna were taking a leaf out of B.B. King's book and making what would become the 1999 album, *Reload*. The stars were aligning, Tom was ripe for a comeback.

I hurried to the studio floor shortly after his soundcheck was scheduled but Tom was already nestled into the belly of the piano, crooning a Willie Nelson ballad accompanied by Jools in the 'slip note' style of Nashville's Floyd Cramer. They were grinning away at each other like childhood friends reunited, chatting excitedly about their mutual love of Jerry Lee Lewis, even as Tom commemorated love lost and time gone by. He'd first recorded 'Funny How Time Slips Away' in 1967 on the *13 Smash Hits* album. Back then the orchestral arrangement was pure supper club and Tom sang it more threateningly than mournfully, as if he were too brash to let a woman win. His voice was simply too big to sound beaten. Now he was fifty-eight and still powerful but he sounded like he knew what sadness felt like. He wasn't boasting any more. I put it straight in the running order along with 'Great Balls of Fire' which they started running right after. We hadn't yet decided on a finale for the taping the next day, and before you could blink, Jools and Tom were tearing up Ray Charles' 'What I'd Say'. Tom's relish for the Great American Roots Songbook poured out of him and Jools more than met him halfway.

The next evening Tom the veteran pop star came out fighting in a beige safari suit. He popped all the classic moves on 'It's Not Unusual' right off the back of the Midnight Moment and it swung more like an evergreen than a guilty pleasure. A few songs further into the show, Tom played the over-insistent and ageing lover on 'Baby It's Cold Outside' while Cerys fluttered coyly beside him in virginal white. They sent themselves and one another up but they also palpably liked each other. Tom had been a household name in Wales since Cerys was a little girl, but now she was a pop star herself and each time she chastely refused him, the twinkle never quite left her eye. Cerys kept Tom at arm's length, but All Saints' Appleton sisters jumped at the chance to flank him for 'What I'd Say', wiggling their hips like teenage girls at a twist party while the dragon roared. Cerys had long since rejoined Catatonia in their corner while the Appletons' band mates Melanie and Shaznay sat it out discreetly. They had their reputations to consider.

Tom has grown older and wiser with the *Hootenanny*, returning four times so far. He likes to sing, he loves Jools, his career has been enacted on television from the first, and where else can he sing live with a big band in front of millions? It's as if he has transferred some of the joy and experience of his classic TV shows to the *Hootenanny*. Television is an opportunity to Tom and Mark, the chance to do something fresh, often with somebody new and interesting. Tom's generous when he duets because he listens to his partners and shapes his tone accordingly. He's a rare kind of saloon singer, there's a vast body of songs at his fingertips and he's always keen to try new singing partners. In 2002, Tom came back to join his old friend Solomon Burke rock 'Be-Bop-a-Lula' with Jeff Beck and get the room swaying almost campily to 'Delilah', minutes into 2003. He and Jools continued to get on famously and they even made an album together in 2004 although Tom wouldn't return to the *Hootenanny* until 2009, delivering a solo 'In the Midnight Hour' and then 'Mama Told Me Not to Come' with Stereophonics' Kelly Jones before offering an intimate, close harmony version of 'Green Grass of Home' in the middle of the floor. Tom had accepted his grey hair by then and there was a new humility and sorrow in his voice which he took into 2010's redefining *Praise & Blame* album and Bob Dylan's opening song of self-excoriation, 'What Good Am I?'

Tom Jones and Cerys Matthews keep warm, *6th Annual Hootenanny*,
December 1998.

Tom and Mark were chasing redemption now, emphasising the artist
over the entertainer, the wayfaring stranger over the unbuttoned shirt.
His career was still a balancing act and even as Tom sought a newfound
artistic credibility he came firmly back into the mainstream when he
joined the panel of *The Voice* in 2012. He was swiftly accepted as the
programme's ultimate vocal authority; his own singing voice was
undimmed and the wariness that had lingered from the years he'd been
scoffed at began to leave him. Although the BBC dropped Tom from
The Voice in 2015, we welcomed him back on the *Hootenanny* that
December. The old muscular voice still had plenty of fire in it and he
tackled both 'Kiss' and 'Sex Bomb' with new brass arrangements redefined
with his touring band – even if the duets with Rhiannon Giddens and
Paul Weller were perhaps what most piqued his interest. Tom was back
yet again with Jools' Rhythm & Blues Orchestra in lockdown year 2020,
taking on Big Joe Turner's 'Flip Flop Fly', duetting with Sound of 2020
winner Celeste on 'Blue Moon' while squeezing in 'Whispering Grass'
with Jools at the piano as if it were 'Funny How Time Slips Away' all
over again. Nobody scoffs at Tom anymore. He's a national treasure.

*

The Jones boys, 17th *Annual Hootnanny*, December 2009.

Mind you, there are those who attend the *Hootenanny* just to raise a drunken laugh or two. There's the impressionists like Jon Culshaw, Rory Bremner and Alistair McGowan, who offer the odd soupçon of political satire which Ronni Ancona and Lewis MacGregor turned into 'psychological farce', parading as Melania and Donald Trump for the 2018 edition. Jools loves sharing the *Hootenanny* with his old alternative comedy friends from *The Tube* who, in addition to offering their predictions and resolutions, have often unleashed their inner rock god on us all. From Vic Reeves and 'Born Free' in 2002 to Jane 'Little Voice' Horrocks enunciating 'Once I Loved' in 2000 to Adrian Edmondson in 2006 channelling his inner Vivian Stanshall for a pert version of the Sex Pistols' 'Anarchy in the UK', the comedians have kept the *Hootenanny* edging into Billy Cotton territory. When Dawn French and Jennifer Saunders decided to become The Poo Stripes and deliver 'Too Tired Armies' in 2003, the studio was already full. So, their drums and amp were set up just prior to the recording commencing with the audience and the bands already in place. Naturally, both Jennifer and Dawn sported red, Jennifer with a fine straggly forelock or two as Jack, Dawn in pigtails as Meg. They both

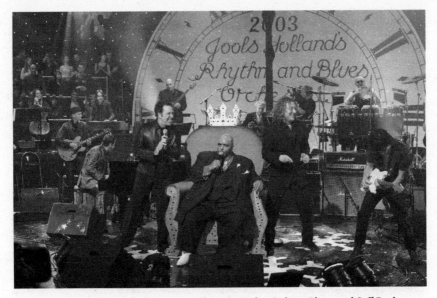

Be Bop a Lula! Jools, Tom Jones, Solomon Burke, Robert Plant and Jeff Beck – the boys are back in town, 10th *Annual Hootenanny*, December 2002.

acted stoned throughout, slipped in an extract of Tammy Wynette's 'D.I.V.O.R.C.E.' and there was the usual hint of a squabble between the two over Meg's unfortunate use of a tambourine. The Poo Stripes were preceded by Steve Coogan's Tony Ferrino back in 1997, a waist-coated 1970s Lothario of dubious sincerity crooning 'The Valley of Our Souls' in the style of 'Windmills of Your Mind'. Ferrino consistently managed to make 'Our souls' sound like 'assholes' while the Electra Strings sawed romantically away behind him as he manspread upon a stool. Perhaps the greatest disappointment was Jools' old friend Robbie Coltrane who'd sung with Jools onstage in Glasgow, and we were geared up to see him deliver his best Sinatra when either cold feet or an actual cold got the better of Hagrid in his pomp.

If Sir Tom and the comedians are the ones that keep coming back, there are plenty who've gone missing, many with only a week or so to go. Elton John was signed for the fourth *Hootenanny* but was suddenly called abroad a few days before the recording. George Harrison had struck up a friendship with Jools when he conducted the interviews for *The Beatles' Anthology* documentary series. George co-wrote 'Horse to the Water' with his son Dani for Jools' 2001 album, *Big Band Small World*, and was up for that year's *Hootenanny*. But it would prove to

be George's last recording and he was already too weak to play guitar. He recorded his vocal early in October and died at the end of the month. I contacted Gene Pitney very early in 2006, determined to get ahead and avoid any disappointment. Gene was happy to commit but died suddenly in April that year.

Then there's Rod Stewart. It felt like I asked Rod every year with Jools' enthusiastic encouragement. One year Rod actually accepted and then pulled out with two weeks to go, claiming to be returning to the US, only to be papped out on the tiles in London the night of the recording. Jools and Rod are fellow model railway enthusiasts and regularly converse on the subject but that hasn't yet enticed Rod to work so close to Christmas for MU rates. All you can do is take it on the chin, turn the other cheek and go again. I am pretty sure that the year Rod pulled out was the year that I chased down Betty Wright in Florida a day or two later. Betty had just made her *Betty Wright – The Movie* album with the Roots. She was thrilled to come, she bought her own plane ticket, mucked in with everybody and brought the house down with her 'Clean Up Woman', complete with extended impressions of Tina Turner and Al Green while Jools added a third guitar to the funk attack. 'A new broom sweeps clean but an old broom sweeps the corner,' adlibbed Betty. She died of cancer in May 2020, and I am so glad she came to the *Hootenanny* in 2011.

Or perhaps it was 2014 when Rod went missing and I quickly managed to track down Ronnie Spector. Ronnie and her husband Jonathan Greenfield were living in Danbury, Connecticut, some fifty miles from where she had grown up in Spanish Harlem. Ronnie had come on *Later...* back in December 1998 when she was already fifty-five and had just signed to Alan McGee's Creation Records. Blondie, Massive Attack and Elliot Smith were on that last show of our twelfth series and so were Neil Hannon's the Divine Comedy, riding high with their jaunty, post-Britpop hit, 'National Express'. Neil shared my love of the Ronettes and kindly agreed that he and his band would accompany Ronnie on Brian Wilson's 'Don't Worry Baby'. Ronnie still had that impish grin and that ripe, yearning voice with the vibrato that had bowled over the Beatles and the Stones in 1963. She was dubbed the 'original bad girl of rock 'n' roll' back then, probably because she never sounded virginal like so many female pop stars of the era. Ronnie dressed in black, Neil sang the high harmonies and Debbie Harry

described Ronnie as her vocal inspiration. Ronnie sat at the piano with Jools and explained that Brian had written 'Don't Worry Baby' for her as the follow-up to 'Be My Baby', but as husband and producer Phil Spector didn't write or publish it, she hadn't been allowed to cut it. Ronnie went on to describe her marriage as 'a prison where the mansion doors were locked from the inside'. 'It was a happy marriage for about a year until I realised I was in a maximum-security lock-up!' she reminisced gamely. She was spunky and used to telling her horror stories, but it was also as if she'd never quite escaped that mansion or those classic songs.

Now Ronnie was seventy-one. She and the Ronettes had been inducted into the Rock & roll Hall of Fame in 2007 despite Phil Spector's objections from jail where he was awaiting trial for the murder of Lana Clarkson in 2003. Ronnie had won a court case for back royalties in the early 2000s, but Phil still dogged her, trying to prevent her performing the songs he owned in her *Beyond the Beehive* show. She wasn't rich, she played small rock clubs and, despite the support of Bruce Springsteen and Joey Ramone, she'd never escaped those 1960s hits or changed the last name that haunted but defined her. Ronnie remembered Jools and agreed to fly over and join a bill that already included Ed Sheeran, Boz Scaggs, Paulo Nutini and three British female pop stars – Ellie Goulding, Jess Glynne and Paloma Faith. She was still tiny and maybe it was the jetlag, but she seemed to have grown fiercer over the years. The Rhythm & Blues Orchestra had arranged three songs, 'Be My Baby', 'Baby I Love You' and 'Walking in the Rain', and Ronnie drilled them over and over in rehearsal.

I had a dream that Paloma, Ellie and Jess would join Ronnie in tribute on one of her songs. Jools' backing singers had the Ronettes' harmonies down to a tee, but while Ellie, Jess and Paloma were all game, they weren't backing singers, they didn't know the parts and I don't think Ronnie knew who they were. One minute they were rehearsing together on the studio floor in front of Jools' piano, the next Ellie shook her head and headed out of the studio, Paloma made herself scarce and Jess was crying in her dressing room. I'd only wanted to pay tribute to Ronnie but now it was apologies all round. But when the studio clock passed midnight that evening, Ronnie stood in front of the Rhythm & Blues Orchestra and Gilson

played those hiccuping drum fills for 'Be My Baby', I couldn't stop smiling. Ronnie still had the moves and the voice, walking up to the mike in a shapely blue blouse and smiling at the room, swooning in rock 'n' roll heaven. A few years later, Ronnie filmed an interview in thoughtful praise of Amy Winehouse, that British bad girl who'd assumed her beehive, for Jeremy Marre's *Classic Album* documentary on *Back to Black*. When the seventy-eight-year-old Ronnie died in January 2022, it was big news. No one else had that voice or those songs. 'Ronnie lived her life with a twinkle in her eye, a spunky attitude, a wicked sense of humour and a smile on her face,' messaged her husband Jonathan who'd worked hard to care for the jetlagged Ronnie in Maidstone, attendant to her every need. 'She was filled with love and gratitude.'

Part 3: Dog House Music

There's another strain of guest that has flourished on the *Hootenanny* ever since Junior Brown and his guit-steel and the Gypsy Kings' flamenco circle popped up on that very first show. Over the years we've regularly made room for what the folk clubs call a floor spot, often a small acoustic ensemble whose playing leans towards the virtuosic, pulling off something homegrown and occasionally a little ironic. A campfire moment in ritzy surroundings without the fame, fuss or fanfare of the bigger bands or more glamorous guests. I imagine them as buskers who've wangled their way into the Savoy. I am thinking of such unique outfits as the Ukulele Orchestra of Great Britain and their po-faced rendition of Nirvana's 'Smells Like Teen Spirit', Finnish harmonica quartet Svang, the Western swing of the Hot Club of Cowtown, Nashville's bluegrass outfit Hayseed Dixie delivering Survivor's 'Eye of the Tiger' with a metal attitude, St. Louis' Pokey LaFarge and the South City Three with some old-time harmonies on 'Drinkin' Whiskey Tonight', New Orleans' Hot 8 Brass Band with a cover of Joy Division's 'Love Will Tear Us Apart', Mexico's flamenco guitar duo Rodrigo y Gabriela and even the sibling harmonies of Joseph, three sisters from Portland, Oregon.

Then in a category all of his own there's Seasick Steve with his three-string 'trance wonder' guitar and his Mississippi drum machine. Broadcaster Charlie Gillett and journalist Mark Ellen had both written

to me about Steve, probably encouraged by his champion, blues DJ Joe Cushley. Steve had been on the fringes of the music business since the late 1960s after a few years hoboing around. He'd worked with both Lightnin' Hopkins and Joni Mitchell, done his fair share of busking in Europe, played bass in the Indian fusion rock band Shanti and fronted disco outfit Crystal Grass before the 1970s were out. A decade later he'd settled in Olympia, Washington, where he'd produced Modest Mouse's debut album, *This is a Long Drive for Someone with Nothing to Think About*, at his Moon Music studio in 1996. Since the early 2000s he'd been based in Notodden in his wife Elisabeth Wold's Norway, playing small clubs and the odd festival in the UK as country bluesman Seasick Steve. He'd just released his first solo album, *Dog House Music*, on the small independent label Bronzerat with the kind of colourful backstory that even Tom Waits might envy.

I don't think Alison and I knew too much of Steve's biography when, one afternoon early in December 2006, we headed to a small basement just off the Euston Road on the edge of the Somers Town Estate. Neither of us had been there before or since. Joe met us outside what seemed like a working man's drinking club, sandwiched between offices and shops. Steve was playing there that evening but neither of us could make the gig, so we'd come to see him sound-check and play a couple of songs. When Steve first appeared fussing over his equipment, he looked like he always has – a combination of dustbowl farmer and Haight-Ashbury street person. I can't remember if he was wearing jeans or overalls, but the cap was there, the beard and the warm but watchful smile. He was in his mid-fifties and had just had his first heart attack. It was an awkward situation, almost like an audition, but Steve was affable and adult as we apologised for any embarrassment, and he showed off his oddball guitars. He told us how his battered red three-string electric guitar had been given to him as a charm in Como, Mississippi, by his mentor, blues aficionado Sherman. He called it a 'piece of shit'. He wasn't much kinder about his one-string diddley bow, a block of wood with a single wire string nailed across it, the kind of rudimental homemade guitar on which generations of rural bluesmen including Buddy Guy had once learned to play.

When Steve sat down to play, that empty room near Euston came alive as the winter afternoon darkened. He had a punk attitude to the

Seasick Steve gets an upgrade,
14th *Annual Hootenanny*, December 2006.

blues which all too often had come to be preserved in aspic and handled with kid gloves by reverential revivalists. Steve sounded like hip-hop as much as the blues as he rode a groove. He was oddly reluctant to do 'Dog House Boogie' which I'd picked from the album as a show stealer but which he'd apparently scarcely played outside the recording studio. He only had a tiny amp and wound up his short recital throwing the trance boogie wonder against a piano left onstage. It was an accident and he was mortified. When Alison and I left Euston, darkness had fallen and we had been both charmed and entertained. Steve had made the blues seem fresh without ever so much as using the term. He'd played dance music, not museum pieces. We didn't really know how Steve might fare on the *Hootenanny*, but we wanted to find out. The next day I called up Joe Cushley and invited Steve to appear. Sam Moore, Paul Weller, Amy Winehouse, James Morrison, the Kooks, Ray LaMontagne, Lily Allen and more were already on the bill; Steve would be the sting in the tail, a wild card playing solo in front of the bands and the Orchestra. We didn't then know that Steve had found the whole exchange mortifying. He'd flown back to Norway the next day and

initially refused to return for the show. He'd never heard of Jools Holland or the *Hootenanny*.

On record day, Steve showed up dressed pretty much as he had been in Euston and we rushed through his soundcheck and camera rehearsal, marking the spot on the edge of the clock where the floor team would set him up while Ray LaMontagne was playing 'Trouble' with the Orchestra. Meantime Steve and Andy had decided that he should play 'Cut My Wings' rather than 'that stupid song', 'Doghouse Boogie'. That's what he told Sam Ribeck when his camera rehearsal came around. As Steve now tells it, he'd spent years shooting himself in the foot and he was about to try to do so again. I came down to the studio floor from the gallery. 'Steve, have you ever been successful?' 'No, I ain't'. 'Do you want to be successful?' 'I guess so.' 'Then play the fucking song, please.' I am quite sure this conversation is utterly apocryphal but it's a good story and both of us remain very glad that he played 'Doghouse'.

A couple of hours later that evening and after 12.30 a.m. in the transmission, Jools strides over and introduces him as 'the brilliant, the unique Seasick Steve!' The lights come down and Steve hits a long slide note. 'I'd like to introduce my band here... on percussion, the Mississippi drum machine,' he drawls, banging his foot on what looks like an empty cigar box with a licence plate attached. Then he introduces Sherman's red trance wonder, observing proper guitars have six strings: 'We're going to get down on some three-string trance boogie,' he promises as he begins to hammer out the kind of groove John Lee Hooker favoured in Detroit when he recorded his 1948 breakout hit, 'Boogie Chillen'. 'It ain't the kind of blues you have for one day, you have it your whole life long,' Steve sings as he recounts running away from home in his early teens, lighting out to escape his stepfather like the ghost of Huckleberry Finn. The boogie is irresistible and there's something approaching shock on the faces of Phill Jupitus, Paul Weller and Amy Winehouse, gawping at this tramp who's bum-rushed that gilded room. Steve's telling his story, years spent bumming around, he might as well be busking now in this glamorous studio full of the famous and he knows it. 'I always did pick on the guitar, put the hat out for the spare change, and now I'm still trying to get your spare change – that's an advertisement!' he smiles. He picks up the tempo, punctuating the boogie with the ringing slide before winding up in a frenzy, waving

the guitar over his amp like he's cooking feedback. It's a smash-and-grab performance, one made even more thrilling by the setting and the occasion.

Steve brought the house down and he clearly touched those watching or those who caught up with the performance on YouTube in the days after the broadcast in much the same way. Suddenly Steve was an instant sensation even if, as he later claimed, he hadn't really been at his best, unable to see much in the studio lights or even hear himself in the monitors. The way Steve tells it, he'd got gradually more furious at his compromised performance and simply wanted it to be over so that he could go and wring label boss Andy Zammit's neck for getting him into this fine mess. Steve's a good actor though, because it doesn't look that way when you watch the clip now. He looks in command, like a man who's been waiting for this moment all his life.

As the applause engulfs Steve in the studio, he looks humbled and dumbfounded. I guess Andy Zammit was forgiven and Steve was reconciled enough to join in 'The Mighty Quinn' finale alongside Weller, Madeleine Peyroux, Marc Almond, Amy Winehouse et al. shortly after. Later in the BBC bar at the after show, he'd get steaming drunk while Amy sat in his lap and the Guards played a few stirring tunes on the pipes and drums. Steve's life changed overnight and the *Hootenanny* too bathed in the halo of his success. He played four stages at Glastonbury the following summer as he rapidly became a major festival draw. We had him back for the very next *Hootenanny* where he returned in overalls with guitar and drum machine but had the showbiz smarts to take his shirt off before launching into 'Cut My Wings'. 'I can't believe it,' he remarked around this time, scratching his head. 'All of a sudden, I'm like the cat's meow!'

Steve's made the most of his overnight success. He's headlined the Royal Albert Hall and the London Palladium, toured with Led Zeppelin's John Paul Jones and drummer Dan as a power trio, recorded at Jack White's Third Rail Studios, duetted with Tom Jones and released a slew of studio albums since *Dog House Music*. He's made new guitars from old hubcaps and written folk songs and plaintive banjo tunes alongside the raucous boogie that remains his calling card. He's even headlined Wembley Arena where I witnessed his triumph and a certain lack of rock 'n' roll excess backstage. He's come on *Later...* plenty of times too and returned to the *Hootenanny* in 2016 to mark the tenth anniversary

of his extraordinary debut, bringing along drummer Dan Magnusson and clog dancer Hannah James to perform 'That's All'. Steve's remained effusively grateful and humble about how the *Hootenanny* changed his life. I reckon he'd have found his audience soon enough, anway, albeit maybe not overnight. He hasn't changed the way he dresses one iota, as if he's still ready to light out the window or jump a train at the hint of a whistle. Steve's seventy now and living the life of Riley but he's still got the blues.

Part 4: Enjoy Yourself – It's Later Than You Think

In the 1990s there was little discussion about whether the *Hootenanny* was live or not. Perhaps people were less sophisticated in the pre-social media age, perhaps the fact that the programme then started on the stroke of midnight drew less attention to the question of what was really going on than the show's hour-long build-up to Midnight in the decade that followed. Jools' private exhortation to the studio audience to 'live a lie' never seemed hard to observe, particularly when the Pipes and Drums struck up 'Auld Lang Syne'. We figured if we could make the show come alive in the studio then it would work in its allotted slot on television. Generally, both punters and the celebrity guests seemed to be thrilled to be in the studio with all that talent. We imagined New Year's Eve as we hoped you would want it to be. I thought we were delighting our viewers, not conning them.

No matter that Jools and the Orchestra used to play New Year's Eve dates when the *Hootenanny* first began and that some of the artists continued to do so, that it wasn't hard to establish that quite a few of the guests could be spotted out and about on the thirty-first of December, the vast majority of viewers clearly believed that the *Hootenanny* was live to air. We were happy that they embraced the occasion and the atmosphere that Jools fronted with such enthusiasm although mostly we supposed that they just didn't think about how 'real' it was. I always thought believing the *Hootenanny* was live to air was a kind of choice, like believing in Father Christmas. Life is more magical when you do, which is why parents like to keep their kids innocent as long as possible. Who wants the wonder to wash away?

I suspect that for the first ten years or so the viewers largely didn't even question what they were seeing, they took it for granted. No matter that the wooden hands of our midnight clock could hardly be said to be 'on time' or that some of the comedians seemed to snigger when asked about their Christmas, the 'lie' endured. The press too was happy to keep shtum and play along. We didn't invite any journalists to the recording and we didn't release any photos of the evening until New Year's Day. Although there were inevitably accidental but public slips from artists and celebrities alike, the *Hootenanny* was still surely live? How else could it hit midnight on the money?

But around the mid-2000s the BBC floundered into major trust issues and the *Hootenanny* would follow suit. In July 2007 the BBC was revealed to have twiddled a variety of its radio competitions. Some six incidents of members of staff passing themselves off as members of the public and even a fictitious winner had been uncovered on various programmes. Later that summer, creative director Alan Yentob was accused of using false 'noddies' or reaction shots in interviews he hadn't attended in his *Imagine* strand. Yentob initially admitted that this might have been the case before discovering that no such 'noddies' had actually been deployed. When that summer's autumn press launch introduced the independently made observational series, *Monarchy: The Royal Family at Work*, the trail included a sequence in which the Queen had apparently stormed off from a shoot with photographer Annie Leibowitz. In fact, the Queen had been walking towards the photoshoot and the shots had been used out of sequence. In the media storm that followed, BBC1 controller Peter Fincham was eventually forced to resign, as was RDF Media's chief creative officer, Stephen Lambert. Even as this row escalated, appalled viewers learned that in a competition to name the new *Blue Peter* cat, the production team had elected to ignore the public vote for 'Cookie' and opted to go with 'Socks' instead. The editor of the show responsible was fired. Meanwhile Mark Thompson, the director general, thundered gravely to his staff over the ring main, 'Nothing matters more than trust and fair dealing with our audiences. We have to regard deception as a very grave breach of discipline which will normally lead to dismissal. If you have a choice between deception and a programme going off air, let the programme go. It is far better to accept a production problem and make a clean breast to the public than to deceive.'

When Russell Brand and Jonathan Ross made prank calls to Andrew Sachs, formerly Manuel of *Fawlty Towers* fame, in a pre-recorded Radio 2 programme in October 2008, the BBC went into meltdown. Brand had had a brief relationship with Sachs' granddaughter Georgina Baillie and, at one point in the broadcast programme, Ross could be heard yelling lewdly behind Brand as they egged each other on like a pair of naughty schoolboys. While no one complained after the initial broadcast, a storm gathered once the *Mail on Sunday* denounced the presenters' behaviour a week later. Complaints now snowballed, Brand and Radio 2 controller Lesley Douglas resigned, and Jonathan Ross was suspended for twelve weeks without pay. This meltdown swiftly resulted in the installing of a detailed compliance culture at the BBC in which every broadcast programme was preceded by a detailed form which the producer in charge had to complete and, more broadly, a jittery and defensive institution. Producers and their ideas had led the BBC creatively. After these errors of judgement, producers were increasingly policed by a compliance culture and a new commissioning bureaucracy that were perpetually wary of production decisions that might endanger the fundamental trust of the audience. The BBC had shot itself in the foot while its political and media enemies grew ever more vocal in challenging its funding and its purpose in a market-led economy.

It was in this darkening climate that mutterings about whether the *Hootenanny* really was live to air had been growing ever louder. Of course, some artists had never recognised that this might be an issue and a few journalists were desperate to spill the secret that their colleagues had been happy to keep. Eric Clapton's website told his fans that he'd just recorded the *Hootenanny* on 16 December 2004. Vicky Allan, a journalist from the Scottish broadsheet the *Herald*, had attended the show that evening and the paper had chosen to publish her fly-on-the wall article on Boxing Day, five days before transmission, under the spoiler by line, 'Shock horror! Jools Holland's much-loved *Hootenanny* is recorded in advance!' Allan's observational piece captures the particular atmosphere of the show recording as seen from the audience risers. There's the couple near her who snog all evening, the plastic cups of lager, the party poppers, the bright studio lights and the sudden surge of bonhomie at Midnight. There's even Kevin, the Man with the Beard, doing the warm-up: 'This is

Jools hurls the nation into the new year,
20th *Annual Hootenanny*, December 2012.

Narnia as we see it. This is the most amazing New Year you will ever have. You are in the company of some wonderful people. So please, ladies and gentlemen, imagine this is New Year's. I'm imagining it already; I always have a shit time on New Year's Eve.'

After the show concludes with the cast finale of 'Night Time is the Right Time', Vicky Allan chats to fellow Scot Alex Kapranos of Franz Ferdinand up in the BBC bar. Alex associates a real New Year's Eve with 'really cold hands and feet', wandering through sleet in the late-night streets of Glasgow. The two Scots can't quite decide whether or not to be sceptical about what they've just experienced. 'Does the *Hootenanny* feel as if it is any more of a pretence than a proper New Year?' muses Allan. 'There's always something faintly absurd about Hogmanay. Most of us have had one of those moments, when, as the corks fly and the fireworks shower, we stand back, half outside ourselves, wondering what it's all about. The *Hootenanny* is perhaps no more of a performance than any other Hogmanay, no more a piece of theatre.'

But it wasn't the odd whistleblowing article or the rising tide of social media that convinced the BBC it was time to come clean. Nor was it the increasingly cheeky *Hootenanny* guests, raising a sardonic

eyebrow at the arguably obvious pretence of the evening. When Jools enquires after Jon Culshaw's holiday season in 2006, 'Well, I've had a fantastic Christmas, Jools, I've had a great time,' comes the knowing reply. Jools: 'What doing?' Culshaw: 'I don't know but it's been great.' No, it was the fall-out from the trust issues engulfing the BBC that made the Press Office insist that I write a clarifying statement when they came to announce the line-up of that year's show towards the end of 2007. 'The *Hootenanny* is an idealised New Year's Eve party with a line-up that would surely be impossible to deliver on 31 December. The stellar cast and audience are, therefore, assembled to record the show in mid-December. The show is recorded "as live", with a midnight countdown led by Jools.'

Fifteen years into the life of the *Hootenanny* this declaration inevitably felt a tad literal to me. I'd already encountered enough fans of the show who seemed disappointed or even devastated when they discovered that the *Hootenanny* was pre-recorded. A few were disgusted, many more ultimately didn't care but the vast majority acted as if they wished they hadn't found out, as if something had been taken away from them. It was the same online even though the internet was then thought to be building a whole new contract with audiences. So why be a spoilsport? Whatever happened to the illusions of showbiz? But the BBC was on the back foot, trust issues were rife and the press were increasingly combative: there were those who felt the public had been misled, viewers who felt cheated; we had to be seen to be transparent.

So it was that on the night we recorded the fifteenth *Annual Hootenanny* in December 2007, we shot a brief opening sequence to reflect and acknowledge the fact that the ensuing show is a trick of the light. Perry, our long-serving editor, had always taken pride in the fact that his hours of post-production would whiz by unnoticed and invisible. The *Hootenanny* had always rolled out 'as live' in the studio with plenty of spontaneous banter, some of it funny, some of it not so much, and so a few minutes of it were later left on the cutting-room floor. Hitting midnight on the nose when it came to the actual broadcast had always proved easy enough with a sensibly programmed first half-hour, a sensitive edit, a patient scheduler and a play-in editor who knew when to press play to the very second. The *Hootenanny* had gradually expanded to over two hours and in those days was broadcast on two tapes with Presentation having to

Ed Sheeran partying with the Beat,
25th *Annual Hootenanny*, December 2017.

sync them seamlessly midway through transmission. But long after midnight in the 2004 broadcast Jamie Cullum had repeated the same extended keyboard phrase at least twice during his version of 'I Could Have Danced All Night' when the tapes 'jumped' in transition. Had no one been sober enough to notice this sure sign that the show was pre-recorded? No, it would seem not...

Jools, Alison, a cameraman and I walked out of the studio and through the back gates of Television Centre to residential Frithville Gardens which eventually runs into the Uxbridge Road. The evening was cold and dark and there was no one around. Kylie Minogue, Sir Paul McCartney, Eddie Floyd, Mika, Lulu and Seasick Steve had just rehearsed that year's finale, Sister Rosetta Tharpe's 'Up Above My Head', led by Ruby Turner. Already the celebrities and the audience were gathering outside the studio and, as always, we were painfully short of time. Fortunately, the street was empty as we set up what purported to be a newsstand bearing the headline, '10 Shopping Days to Christmas' while The Tardis was unloaded in the street. Yes, folks, The Tardis. *Doctor Who* had only been relaunched in 2005 but now

it was a hit all over again with an imminent Christmas Day episode, 'Voyage of the Damned', featuring our shared guest star Kylie. David Tennant, the tenth Doctor, was also coming to the Hoot that evening along with fellow cast member John 'The Master' Simm. The BBC production down in Cardiff had been kind enough to lend us one of their instantly recognisable police boxes and we'd had it transported to West London...

Let me paint the scene. Jools comes staggering up Frithville Gardens bearing a small tinsel Christmas tree, probably purchased from the nearby Shepherd's Bush Market. 'I love Christmas!' says Jools as he approaches a hooded Alison behind the newspaper stand and hands her the tree, 'But now I want to go forward in time to The Land of *Hootenanny*. But how will I do that?' He picks up that day's paper from the stand whose headline and date he doesn't quite manage to show to the camera as blatantly as intended before wondering rhetorically, 'But how will I do that? It seems so difficult sometimes. How will I get to the Land of *Hootenanny*?' At which point Jools moves stagily away from the news stand to reveal the Tardis standing by. 'Got an idea...' he almost winks to camera before entering the Tardis whose lights commence flashing and gears start grinding with that iconic sound effect before vanishing before our eyes and spinning off in familiar fashion through space and time. Actually, that happens later, in the edit. Two stagehands in brown coats who look much as they might have done in 1960 when Television Centre first opened and *Dixon of Dock Green* was the BBC's flagship drama series can now load the heavy wooden police box onto a motorised trolley and drive it back up to the scene dock doors behind TC1.

Once musicians, guests and audience have all squeezed into the studio and been framed on a locked-off camera, the Tardis is wheeled into the middle of the floor in front of this expectant throng and can now manifest itself 'out of nowhere' in a single seamless edit. Out bursts Jools and rushes around the floor telling the audience they are beautiful, gesturing towards a bowing Madness, namechecking Sir Peter Blake, Sir Paul McCartney and Sir Jackie Stewart, the three knights of the realm in attendance. He concludes by 'bigging up' her majesty, Ruby Turner, the queen of boogie-woogie herself, poised to kick off proceedings with the Rhythm & Blues Orchestra and 'Jumpin' at the Jubilee'. It is 20.45 on Wednesday, 12 December. Ruby ignites, Jools tinkles

brightly, Dawn and Lenny are still together at a table and now here's Eddie Floyd in a white suit with his '634-5789 (Soulsville, USA)' which he co-wrote with Steve Cropper for Wilson Pickett back in 1965. Macca and his ukulele will duet with Kylie on 'Dance Tonight' for a pre-midnight singalong, Eddie will 'Knock on Wood' after the Midnight Moment and the drummers of the Scots Guards will join Kaiser Chiefs for '(We Are) The Angry Mob'. There is a Christmas parcel, a box with feet, scurrying around the studio, the late astrologer Jonathan Cainer has some complex props to explain his predictions for the coming year of 2008. It is the Land of *Hootenanny* and everybody in the studio is having a wonderful time. I am not sure our time-travelling opening sequence would have satisfactorily explained that all this was pre-recorded but then it was only a gesture and the press release had been bald enough. We never felt the need to be so literal ever again. Why be a spoilsport?

Gregory Porter

I was quite frankly a nobody in the UK the first time I came on *Later…* in 2011. But when we sat down at the piano to rehearse in his dressing room, Jools was showing deference to me and my musicianship. I was like 'Wow'! He was playing and asking me, Is that good enough? 'Hell, yes, that's good enough!' We were doing my ballad 'Illusion', the opening track on my debut album *Water*, on a small independent label. It's not the most obvious song for a television show. Sometimes I'm even reluctant to play it in my shows for fear of losing people. It's not a pop song, it doesn't really have a singable chorus. Yet it's profoundly important and personal to me, it's my emotions and my personal poetry about being dumped years ago. I am trying to capture personal emotion in melody and that song is probably the one I'm most proud of.

When you go on television, they mostly tell you what they want you to sing. But this was my very first time and the one time they let me do exactly what the hell I wanted to do, and I didn't even choose it, you guys asked for it. I appreciate that because I felt understood. It's the only televised performance of that song that I have, and I really got to be me. Then to sing solo just with the piano that gave me the opportunity for people to just hear my voice, not big booming anything, just my voice.

I didn't realise the impact that first performance of 'Illusion' had at first. You just go on to the next gig and get the hell out of town. The next thing I know I was doing much bigger venues and I was 'What the hell is going on?' The fortunate or unfortunate thing that happened was I went from Pizza Express to the Royal Albert Hall. There was some in between that was supposed to happen that didn't happen and that was down to *Later…* Everybody still references that moment all the time. 'I saw you on Jools and I stopped. I was doing something;

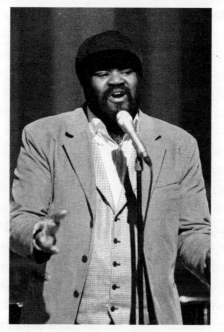

Gregory Porter stops the world,
series 38, episode 2, April 2011.

the television was on, and I stopped.' I keep hearing that still, 'Who is
that? What is that voice?!'

It was a big deal for me, but I try to keep this healthy ignorance about
the importance of things so as not to get anxious. I just told myself to
dive into it and just be me. I'd seen some of the show on YouTube, some
performances, but I hadn't quite figured out that the cameras pan around
from the centre, even though it's central to the show. Until you get there,
you don't really have a perspective on what *Later...*'s like. So, it was
interesting to step inside this well-oiled machine which moves so fast,
to come inside the space and realise that the musical characters that are
there with you are in a way your colleagues, your counterparts. That's
how it feels. It's not like CeeLo Green's the big star here.

I felt just as worthy as CeeLo or Bootsy Collins or Robbie Robertson
or Seun Kuti. There's jazz next to country next to mega pop and it's all
just about the music, you're there just doing your thing. I find that
amazing because that's the way I listen to music. I am a jazz singer but
I'm not just a jazz head; people who love jazz also love Jimi Hendrix.
The show exemplifies how we listen to and enjoy music. If you're a jazz

head and you don't know who Paul McCartney is or what he's about, that's a problem – so the show rectifies that. It was extraordinary to me.

There's been so many great nights since – the Hootenannies, the night we honoured Prince, *Later 25* at the Albert Hall. I do over two hundred shows a year and you're working so much by yourself, so it's a nice little opportunity to sit down and enjoy other artists – Mumfords, Christine, Rag'n'Bone Man, on and on. Over the years, it's always the same with different artists, you find yourself next to colleagues, you are all equals. I have made some real connections and friendships on the show. The show just after Prince died was extraordinary. Mumford & Sons were on and Christine and the Queens, all these powerhouses in the room, and Jools deferred to me to essentially lead the song. It was a big honour to me. Prince is one of my favourite artists; he means a lot from my childhood, he's an original but he's a child of so many R&B, gospel, and blues greats. It was absolutely amazing to feel the whole studio of musicians together, lifting up the spirit of Prince. It takes a show with the equalising factor of *Later...* to create and share a moment like that. The interesting thing about the layout is that the artists are the frontline with the audience in the back watching on so that even in their listening experience, the artists come first, as if they are gathered around a fire pit. That's the vibe. It's not about any one of us, it's about all of us.

I do a lot of television shows around the world and there's nothing like *Later...* The energy and the synergy that's created by artist coming after artist is powerful. Even the section you record that's not live, the energy is kept by filming it like it is live and your life depends on it. The infectious thing that happens, it's in Jools' voice as soon as the red light on the camera goes on. There's a gentle build-up – 'Ladies and gentlemen…' – it's almost like the announcer before a major big heavyweight fight – 'In the centre of the ring, ladies and gentlemen, the moment we've all been waiting for…!' Jools builds it up and then the whole thing just kicks off. That just doesn't happen elsewhere, nothing rolls like *Later...* The energy stays in the room. Sometimes with a television host they are almost distancing themselves from you, like 'Here's Gregory Porter, let's hope he's good, let's see what this is like?' but Jools is your actual cheerleader. He's like 'Hey, watch this badass thing!'

There's always this wonderful camaraderie. That first time, CeeLo came over to me and he said, 'Bless you, brother, you are the real deal. I am honoured to be in your presence.' That same energy coming from Bootsy

Collins who wanted to get my phone number or Marcus Mumford who I sat in with after we met at *Later...* in Texas and then wrote songs with. All this stuff is happening, it's good, and not just for the lesser-known artists; even the older artists connecting with the younger artists, the younger ones connecting with legendary artists, they all feel that camaraderie. Legendary artists – Cyndi Lauper, Chaka Khan, they might not have anything fresh out right now, but frankly who gives a damn? I met Betty Wright at the *Hootenanny* and connected with her again later at the Grammys and ended up going to her studio in Florida and I know she enjoyed that connection as well. I certainly did! It's a very social thing.

The *Hootenanny* is *Later...* heightened, the energy is heightened. Jools, the surroundings, the crew elevate the show, making you feel the occasion. The whole environment has this 'Boom! Let's get it up, let's go!' feel. I remember doing 'Let the Good Times Roll' the first time I did the Hoot and feeling 'Damn, that felt good!' It takes a leader to take people to joy and freedom. It's one of the things that musicians do; you take people to a place. Jools does it in his live performances too. It's called 'going house' in Black culture – getting the audience on their feet, getting them feeling you and feeling the spirit. Jools is a master of that, which is why people are on their feet every night of his tours. They're ready for it. He knows how to take people to the house.

Christine and the Queens tilting together,
series 48, episode 2, April 2016.

9

I Bet You Look Good on the Dancefloor
Debutants

It's a Tuesday night at Camden's Koko in March 2016 and the place is rammed. It's not a regular venue for me anymore; most gigs these days seem to be either East or West, but I have been coming here for years. Ellen Terry opened this ornate local theatre in 1900, the BBC used it as a radio theatre after the Second World War and I first found it in the late 1970s when it became the Music Machine, a punk venue for the likes of the Jam and the Boomtown Rats. The New Romantic scene helped relaunch it as the Camden Palace in 1982. I saw Prince here in 1988 at a late-night private show and again in 2007, three years after it had relaunched as Koko after extensive refurbishment. That same year we filmed My Chemical Romance here for Radio 1. Only a couple of years previously in February 2014 I'd returned yet again to see Prince on the 'Hit and Run' tour for what would sadly turn out to be the last time, backed by rock and funk band 3rdeyegirl as he exhorted the self-congratulatory crowd not to film the show with their phones, brought out local girl Lianne La Havas and sat down at the piano to play 'Purple Rain' solo for an encore. I reckon I've spent as much time queuing to get in here and watching bouncers search for my name on the guest list as I have watching bands.

Tonight, my wife and I are high up on the third or fourth floor of this vertiginous venue, squeezed into a small side balcony from which it's easier to look across at fellow punters while admiring the ornate plasterwork and portentous pillars than catch a glimpse of the band far below. There's ten or twelve people in this tiny space and only five of them can get close enough to the balustrade to then crane their necks and look perilously down at the stage. I have heard a few tracks by tonight's headliner and maybe glanced at an interview or two, but

I don't really know much about Héloïse Letissier, the auteur of Christine and the Queens. I don't know that she's been touring and recording since 2011 or that her label Because have staggered the international release of her 2014 debut album, *Chaleur humaine*, which has already made her a star in her native France. A year later the album came out in the US where Christine and co. have already toured extensively while the English-language version of the same record launched the charge in the UK only a week or two before this launch show. Unusually, and despite the odd recent radio session and a couple of regional shows three years ago, the UK is last to the party. This is actually Christine and the Queens' London debut, which perhaps explains why Koko is full of excited young French 'filles', a strong LGBTQ contingent from East London and a tiny scattering of British scenesters and tastemakers. The word is finally reaching our shores and there's a palpable electricity in the air that heats the blood and pulls you forward like a moth to a flame and that I have come to know over the years as... The Buzz!

When Christine and the Queens finally hit the stage they are like nothing I have ever seen before. You can't take your eyes off Héloïse, whose spellbinding choreography is a startling blend of Michael Jackson and Charlie Chaplin. American R&B has a long and slick tradition of synchronised moves but Christine and the Queens' routines favour the celebratory and individualistic over the uniform, and Héloïse's dance troupe echo and complement her shape throwing, which feels like a bid for freedom. It's hip-hop dance with an arthouse sensibility. Héloïse has called her music 'freakpop' and she owns the Koko stage, her red hair flailing, a small backing band standing unobtrusively behind her in front of a white screen and the dancers falling apart and coming together around her magnetic struggle to express who she is. They are all dressed entirely in black, casual ninjas in slacks. Between songs she's chatty and self-deprecating, as if she's coming out of character and she's Héloïse once again, laughing at the bravura stylistics of Christine and the Queens' routines. There's a brief but stunning workout to Prince's 'I Feel for You' which is a fun-soaked homage to tonight's venue, the petite genius' London theatre of choice, dance tunes aplenty and a sweet melancholy that runs through ballads like 'Paradis Perdus' and 'Sainte Claude' in a long but engrossing set.

Héloïse's debt to the synth-soaked American R&B of the 1980s is everywhere but it's redrafted to soundtrack her quest for selfhood, for

freedom and identity. Yet when she and her dancers plunge into their tightly choreographed narrative routines their ambition and aesthetic feels radically fresh. In their black clothes the dancers are oddly anonymous while Christine herself is strictly gender neutral, as much boyish as girlish, instantly liberated from all the predictable muscular pop dance signalling that so often uses sex as a weapon. In a show of shock and awe, here is star quality that is all about vulnerability with a goofy charm that harks back to Chaplin as much as Janet Jackson. Much of the set suggests a brave quest for confidence and self-belief. She could also only have come from outside the British pop tradition and her song-and-dance routines feel as unmistakably French as the yé-yé style of those 1960s 'jeunes filles' led by Françoise Hardy.

Héloïse has told the French *Elle* that she was influenced by the drag queens at Madame Jojo's in London who befriended her in the 2000s. 'They gave me the idea of creating a character, inventing another silhouette, another way of being in the world. Before it was a musical project, Christine was for me the answer to how to live properly.' Christine is Héloïse's warrior self, a gamine turned Queen who can command the world. Christine has some of Grace Jones' otherness but hers isn't channelled through outfits but in dance moves and she's not an interpreter; these are her own songs, and this is an autobiographical show. It's also timely: the world is beginning to embrace identity and gender politics, and Héloïse is pansexual and genderqueer. A new kind of star is being born on the stage below. There's almost a mosh pit in front of the stage as the crowd pushes forward, shrieking adoringly at every move. I am growing dizzy staring down from the balcony. I can't wait to get Christine on our show. If I could do it the very next day, I would.

This is one of the good nights that every booker lives for. There are other nights when the gig is a long way from home, the band isn't quite what you'd hoped, and the fish don't bite. You aren't going strictly for pleasure anymore, however much you remain a fan, and the journey to and from the gig is mostly a nag. If Charlie Watts spent most of his life hanging around, waiting to play, I have spent a fair bit of mine waiting for the band to come on. The stage times are always vague, your name isn't on the guest list and the gig is miles from the tube. This is what happens when you turn what you love into a job. Mind you, the longer you're in the game, the less likely you are to go out on spec or merely to make a plugger happy. If you're making the journey,

you're already keen. I always liked to see any artist we were thinking of booking on the grounds that our show was all about performance, and recordings don't necessarily tell you what you'll be seeing. I didn't go out looking for stars but artists. If what I saw felt fresh and full of character, that was enough. These days there's always clips of any aspiring artist on YouTube, and you can at least get an idea of what they look like even if you can't quite grasp what they are really like onstage. But *Later...* began long before we all began to migrate online, before Facebook, Myspace, TikTok etc, and anyway, nothing quite matches seeing with your own eyes.

I certainly wouldn't have 'got' Christine and the Queens without going to Koko's. I wouldn't have known that their show is both pop and performance art, I wouldn't have witnessed how goofy and funny Christine could be or how 'Tilted' telescoped the whole project into three delicately anthemic minutes. I wouldn't have seen Christine's shoulders shrug as the beats began or wondered at how her dancers flutter their fingers like wings as that flute-like fanfare sidles in out of nowhere like the key to a magical country. I might even have been sceptical about the French rap in the bridge which mentions 'origamis'...

A month later Héloïse and her team are in Maidstone for her first British television performance. It is 26 April 2016, a matter of days after Prince's death aged fifty-seven from an accidental overdose of fentanyl. Gregory Porter, Son Little, Field Music and Sam Lee are also on the bill, as are Mumford & Sons with Baaba Maal, the Very Best and Beatenberg, who have played together so little since recording in South Africa for their collaborative 'Johannesburg' EP that they have hired another studio in the complex and are busy rehearsing the tunes they will soon run for the cameras then perform. I am trying to find ways for the live show to honour Prince but first there is an intense conversation with Héloïse and her lighting director. Later I will learn that Kanye West's 2013 'Bound 2' is her favourite ever television performance, which helps explain how determined her team is that Christine's performance come out of darkness, that we drop the lights in both corners of the studio so that you can't see the audience and that the lighting frames her and the dancers like a chiaroscuro painting. Not that anyone uses that term. Chris Rigby our lighting director and I initially both want to show that Christine and the Queens are here in our studio and get glimpses of the room looking on. Perhaps in shock. After all, song-and-dance acts always tended to be more

Top of the Pops territory. *Later...* is the musicians' show but the two keyboard players are hidden at the back under the pick-up-sticks set and barely lit. They might as well not be there and when Christine returns at the end of the year for the *Hootenanny*, they won't be, as we'll present perhaps our first ever performance to track like a club PA. But then the art of Christine is all in her voice, the moves, and her mobile face. Why would you look anywhere else? So, we listen to our debutant's vision and then drop the studio lights, shrouding the audience corners in darkness. The set behind her is tinted in blue light but her performance will be lit by a single spotlight from above with a sidelight or two for the close-ups. When the dancers peel off from Christine and head out of shot, they magically disappear into darkness before rejoining her as if from nowhere. The studio floor too is black crossed with a couple of geometric lines and it has never felt more central to a performance as the dancers trip the light fantastic. Christine's vocals ring out powerfully throughout, brimming with jouissance. I am not sure what the term 'Tilted' means exactly but it sounds celebratory, an affirmation of difference.

Meanwhile I am still worrying away about Prince. An unknown Gregory Porter debuted in the UK on the show five years earlier, toured with Jools and the orchestra, and is now a star in his own right. In 2017 he'll present a BBC Four documentary series about popular singers for us. We speak the same language, and he kindly agrees to drop one of his songs in the live show to make room for a Prince homage. Gregory is a great balladeer, and I am mooting the beautiful 'Sometimes It Snows in April' from *Parade*. Clearly, I am being way too literal and too clever for the show's own good. Gregory and Jools decide it has to be 'Purple Rain' and, somehow, we find a moment in the schedule to rehearse it before we let the audience in. We want the lights up in the studio and all the artists' microphones on for the chorus. Gregory and Jools will lead but the chorus has to come from the whole room in communal tribute. Towards the end of Christine's camera rehearsal her team remind me about her dance riff on 'I Feel for You' and offer it up as a segue out of 'Tilted'. I gratefully accept and we add it in to her last rehearsal.

Come showtime Christine's debut comes off the back of Gregory's jazzy 'Don't Lose Your Steam' and is joyful and assured, the dance moves humorously inventive and her voice loud and clear. Later Héloïse would reflect on the moment. 'I didn't know what to expect performing on Jools because why would they ever need a tiny dancing French

singer? I was following Gregory's warm, soulful voice. The pressure was on. I think it was quite joyous to have so much space to perform. You don't feel trapped as a performer, you're free to do what you want to do with the trust you have. But I can see I really wanted it. My eyes have that burning focus that I always have when I really want to nail the thing.' Rather than the athleticism and physicality of so much choreographed pop, here is vulnerability and real dialogue with the dancers. Sudden gestures like the sideways flick of Christine's head or the raising aloft of her right gym shoe keep everybody on the edge of their seats. There is something almost childish, naive, about the routine coupled with an emotional honesty and sense of sheer delight that chimes with 'Tilted's' now English lyrics which are delivered joyfully to camera without any of the customary pop star sang froid. When 'Tilted' finishes in the live show, Héloïse simply yells out 'Prince!', and as the track kicks in and as Grandmaster Melle Mel bigs up 'Chaka Khan, Chaka Khan', Christine goes into full funk mode, her white shirt flapping and her white trainers leading the moves as she vamps on the mike – 'I think I do!' she ad libs after Chaka's sampled voice sings 'I think I love you!' Come the show's finale, Gregory leads off 'Purple Rain' as a gospel-soul ballad at stately tempo. His rich baritone is sorrowful but soothing. All the artists are at their microphones and as the chorus swells, they join in, the lights come gently up and you can see and hear the room reverberate. Janet has orchestrated the cameras so she can cut in every stage. There's a shot of Christine with mike in hand singing along. She has that burning focus again and she looks totally at home.

There's something holy about the whole room's combined attention that reminds me of Leonard Cohen singing 'Dance Me to The End of Love' back on our second series. Once again, the other artists sing and sway along in communion but this time it's for Prince who sadly never played the show. I guess this turned out to be the perfect episode for Christine's debut and she gave the show at least as much as we gave her. Christine took off quickly after that, helped both by another 'Tilted' performance on Graham Norton's BBC1 show and her early-evening slot on the Other Stage at Glastonbury at the end of June, the day after the UK voted for Brexit. Almost overnight, she was the most popular French person in Britain. Héloïse came back to perform on that year's *Hootenanny*, where she reprised 'Tilted' and sang Terence Trent D'Arby's 'Sign Your Name' with Jools' Orchestra. Her hair was cut short, and

she wore a mustard suit. 'She's so sexy it's a joke' commented one viewer on YouTube. A year later she was back again to premier 'Girlfriend' from her second album with a hard-edged funk sound and a playfully masculine look, part ragamuffin, part chimney sweep. This time there was much talk that Christine would feature her live band but the album wasn't out yet and the label didn't want to share more songs, so she and her dancers ended up performing to a backing track. That's probably the closest *Later...* has come to *Top of the Pops* and it's never felt more comfortable! Did I see all this coming that night in Koko's? I did not. But I was there, and I could see she was magic.

The same could be said of Arctic Monkeys at Reading in 2005. I was there and it was magic. Despite the already considerable buzz around the then still teenage Sheffield four-piece, they were scheduled to play the Carling New Band tent in the middle of Saturday afternoon. Reading was evolving into an alternative rock festival with Foo Fighters, Kings of Leon and Razorlight topping the Main Stage that evening but the festival retained a foot in the metal camp with Iron Maiden, Marilyn Manson and Incubus headlining the next day. The year previously I'd taken my eldest son Luke to see his then favourite band the Streets on a Sunday Main Stage bill that included Lostprophets, Placebo and, right before Green Day, 50 Cent. Mike Skinner and co. went down well enough despite the odd friendly missile lobbed in their direction as if for practice. Fiddy got the full treatment however and was bottled offstage having barely opened his mouth. Reading was not having gangster rap just yet and a year later still preferred Goldie Looking Chain to anything American and hip-hop. Most of the bands in 2005 looked like men, but when Arctic Monkeys shuffled onstage, they still had spots. They and the audience that flocked to that tiny tent felt instantly like a generational shift. Although they'd signed to Domino earlier that summer their sole release so far was the two-track EP 'Five Minutes with Arctic Monkeys', only issued in tiny physical quantities and available to download on the fledgling iTunes Music Store. But the internet was growing fast and the band had shared a few of their early songs on Myspace which in 2005 was the biggest social media platform in the world and had just been snapped up by Rupert Murdoch's News International.

When Alison and I ducked in out of the sunshine round the back by the stage PA, Reading's smallest tent was already sweating as we

jostled for a look-see over the scrum of bodies multiplying before our eyes like students piling themselves into a phone box. Except they were mostly too young to be students. The crowd doubled back outside the tent, spilling back into the main arena and towards the nearby Comedy Tent. The likes of Dinosaur Jr. on the Main Stage and Juliette & the Licks over at the *NME* Tent must have wondered where everybody had gone. The word was truly out, and the *NME*'s correspondent could barely contain himself. 'Reading is well-versed in line-up misjudgements (shoving Foo Fighters in a tiny tent in 1995; and, er, just booking 50 Cent in 2004), but today it went one further – putting the most talked-about band in the universe on in a corner of the field in broad daylight. "Don't believe the hype, Reading," winks Arctic Monkeys' Alex Turner. "They haven't hyped us up enough!"'

Sets barely lasted half an hour in the New Band Tent and Arctic Monkeys only played eight songs that afternoon. Their debut album, *Whatever People Say I Am, That's What I'm Not*, would not be released until January 2006 but the entire crowd know all the words already and they sing them with the fervour of true believers. The Monkeys open with 'Fake Tales of San Francisco' as they tear into the bands they already wanted to replace while getting a start at their local club the Boardwalk. Alex sounds both laconic and impatient as the band vamp along on the riff and the words tumble dismissively out. He's demanding greater originality from the indie scene but it's as if Arctic Monkeys themselves are the only answer to his call to arms and the crowd chant along in agreement. There hasn't been anything like it since London's the Libertines arrived with 'Up the Bracket' in 2000 but the Arctics aren't druggie or wasted. They are proudly Northern – stocky, aloof and a bit mod in their aertex shirts. Near the end of the short set the band drop out on 'When the Sun Goes Down' and Alex carries on alone. He's almost swept aloft as the crowd sing along on his grim update of the Police's 'Roxanne'. Alex sounds sad and scathing as he watches a sex worker, the odd 'scummy man' and a Ford Mondeo come and go one night in town, but the crowd are delirious. Almost before the song ends, they are chanting 'Monkeys! Monkeys! Monkeys!' in what is surely a Sheffield accent while their clapping accelerates. It's a frenzy. They've found their band and their voice.

Arctic Monkeys' sudden rise was a gamechanger. They'd grown their fan base through the internet. They owed little or nothing to the established

Arctic Monkeys' Alex Turner showing the southerners a thing or two, series 26, episode 2, October 2005.

media, to Radio 1 or the *NME*. Standing on the flattened grass in the New Band Tent, Alison and I witnessed the band take off in front of us. The sound is old-school garage punk with a wiry edge but the tone is new, the knowing lyrics full of sardonic put-downs and sceptical one-liners, and they can surely write a chorus. When the band come to release their debut single in October the promo video for 'I Bet You Look Good on the Dance Floor' plays with the BBC tradition of rock authenticity. They perform against bare studio walls with minimal lighting in a pastiche of the *Old Grey Whistle Test* circa 1975. 'We're the Arctic Monkeys, don't believe the hype,' mutters Alex by way of introduction. They are dressed in everyday togs as if fashion doesn't exist and the video is anti-style, pro-substance. They turn down *Top of the Pops* whose forty-plus-year run will finally end the following summer and open the second episode of *Later...* series 26, the week the single charts at Number 1. They sound-check the night before, help set up their own gear and keep themselves to themselves as if wary of the studio, the BBC and London itself.

When the show starts Arctic Monkeys are flanked by a young crowd

crammed into tiered risers, lit largely in blue and framed against the set pieces arranged in parallel lines. Alex has something close to a fringe and looks as unimpressed as ever as they launch into 'I Bet You Look Good on the Dancefloor'. The song is fast cut and full of whip pans from the gyrating audience back to the band. He's describing a stop-start flirtation at the disco which is more stop than start, torn between keeping his cool and making a move in a loveless world while quoting 'Romeo and Juliet'. Alex is the smart one in the class and, for once, everybody is listening. The band are taut and their secret weapon is drummer Matt Helder's falsetto backing vocals. The next year they are the penultimate band on the Main Stage at Reading and in 2007 they headline Glastonbury.

In 2013 Arctic Monkeys came to Maidstone to play *Later...* for the fourth time on their fourth album, *AM*, opposite Paul McCartney. They'd already headlined Glastonbury again that summer, but Alex's newly styled sleazy rock god persona was still a shock even if it was as heavily ironic as Bono's transformation into the Fly. He'd been listening to Prince and Queens of the Stone Age and tired of the old truculent authenticity. The new songs were sly, sexy and poised. His hair was greased back with a devilish quiff, his leather jacket stylishly cut, and there was even a hint of vulnerability in 'Are U Mine?' They'd come a long way from the New Band Tent.

It wasn't hard booking Arctic Monkeys or Christine and the Queens. It wasn't hard booking Catatonia in 1996 after catching them supporting Space at ULU or Villagers opening for Tindersticks at Shepherd's Bush Empire in 2010 or Shame headlining the Electric Ballroom in Camden in 2018. It wasn't even hard to book Melody Gardot although her 2007 debut gig at Joe's Pub in New York was so crowded with celebrities that the guest list had closed and I had to listen to the music wafting out of the air vents outside. There's something about seeing and hearing a new artist in their moment taking off in front of an audience that's irresistible. But often we couldn't hope to see artists, especially international ones, before booking and just had to go on instinct. When Deirdre Moran at Epic sent me a cassette with 'I Try' and a couple of other songs in the spring of 1999, I fell instantly in love with the squeaky, soulful vocal, the song's hectic yearning and that swelling chorus. It sounded like an instant classic to me. I hadn't seen a picture of Macy Gray – I didn't

know she was tall and angular with a forthright manner although I could somehow hear that she was completely her own person – and I didn't need to. I just knew that she was a somebody, an artist with her own voice and her own perspective. It transpired that in a week Macy and her band were due in London for a showcase on the Wednesday. I couldn't wait for the Wednesday, we recorded on Tuesdays, and, yes, they were arriving on Monday in time for soundcheck and we still had studio space for another group. So, Macy joined Skunk Anansie, Mercury Rev, Robert Palmer and Mary Chapin Carpenter in our magic circle. It was series 13, the end of April 1999. There she was on our studio floor in her shimmering silver-grey three-quarter-length mac with a shock of hair and dark trousers, swaying on the mike as the keyboard bed of Hammond organ rose and fell, vamping over the chorus as the backing singers carried it home. The look was boho, the drummer's beats were R&B but Macy's 'I Try' was more romantic than sexual and a cool remove from the bump 'n' grind of the R&B of the time. These days any track played on the radio or on TV must be commercially available on a streaming service but back then the charts and the market were still largely phys-ical. I guess Epic felt Macy wasn't losing sales but making friends. She was in town to set up the release of her debut album, *On How Life Is*, at the beginning of July, three months later. 'I Try' finally came out as Macy's second single and went Top 10 in October and the album took off, eventually going three times platinum in the UK and selling nearly three and a half million copies in the US.

Macy was a stab in the dark. So were Coldplay and 'Yellow' the following spring, Norah Jones and 'Don't Know Why' in 2002 and Adele with 'Daydreamer' in 2007. Sometimes there's a song that's simply irresistible, that feels like a door opening, and all you can do is enter as quickly as possible. Neither Coldplay nor Adele were exactly seasoned performers when they made their debuts although Coldplay had been together for four years and released two EPs before we booked them in May 2000. They still looked like the University College London students they'd been until the year before with their shapeless clothes and Chris Martin's youthful curls. I don't know why I hadn't managed to catch them live but I was convinced that 'Yellow' was a world beater, a signature song, from the moment I played it in the car driving my two boys to the park and they both started singing along, demanding I play it over and over. Coldplay had opened on the *NME* Premier

Tour in January for Campaq Velocet, Les Rythmes Digitales and Shack before Alison went to see them at ULU in April and gave them the thumbs up, impressed by the songs and the spinning globe that stood on the top of Chris Martin's piano. I remember we had to ask an already nervous band to edit 'Yellow' during camera rehearsal in a flurry because the live version was nearly five minutes long and already Chris was terrified that they had to follow Primal Scream. Coldplay's debut album, *Parachutes*, came out a couple of months later and took off and when we had them back in December for the *Hootenanny* their ambition and stagecraft had visibly sharpened. Coldplay would return to the show five more times by 2014; their journey tracing the trajectory of popular music in the twenty-first century as they gradually left indie rock behind, morphing into arty stadium fillers with the help of Brian Eno before becoming a global pop group, collaborating with Chainsmokers and BTS, bent on bringing the world and even the universe together in ever larger gestures, wristbands twinkling in the darkness.

I'd been hearing about Norah Jones for at least a year before she finally released her debut album, *Come Away with Me*, in the spring of 2002. Kathryn McVicker, a Massachusetts-based booking agent I'd never actually met, had been emailing and calling me obsessively about Norah, insisting she had to appear on *Later...* as soon as possible. I loved Norah's winsome, pitch-perfect voice and her music's unhurried sense of space from the moment Kathryn sent me some songs. But there was no sign of her coming to the UK when Kathryn's campaign began. Jones had grown up in Grapevine near Dallas after her mother Sue Jones divorced father Ravi Shankar in 1986. Now she'd returned to her birthplace New York and had been working as a lounge singer and performing at the Living Room on the Lower East Side. She'd recorded with blues guitarist Peter Malick at Room 9 from Outer Space in Boston in summer 2000 which is perhaps where Kathryn first heard her. Soon after, Bruce Lundvall signed her to Blue Note and paired her with veteran Atlantic producer Arif Mardin. Mardin played it simple, placing Norah's intimate, breathless voice right up front so that she almost whispered in your ear, bringing in some of the city's best jazz musicians and keeping the arrangements unhurried, warm and acoustic. After all the melismatic pyrotechnics and kitchen-sink melodramatics of the 1990s, when so much vocalese

Florence + the Machine, 2018

Little Roy and Tony Bennett, 2011

Jools gets on his bike, 2009

Bobby Womack and Damon Albarn, 2012

Jools and Eddie Vedder, 2006

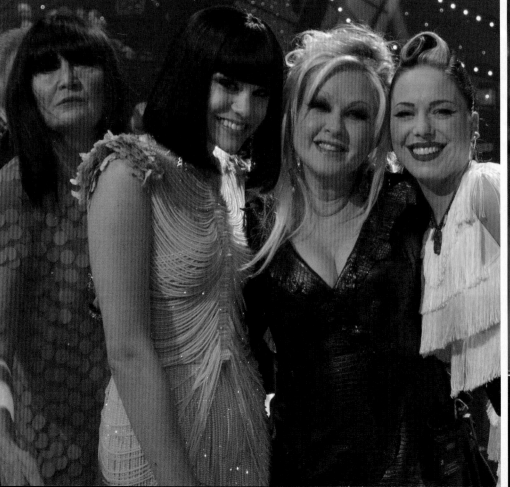
Sandie Shaw, Jessie J, Cyndi Lauper and Imelda May, 2011

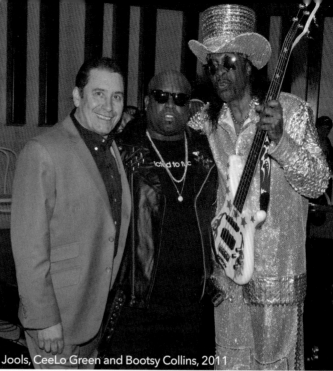

Jools, CeeLo Green and Bootsy Collins, 2011

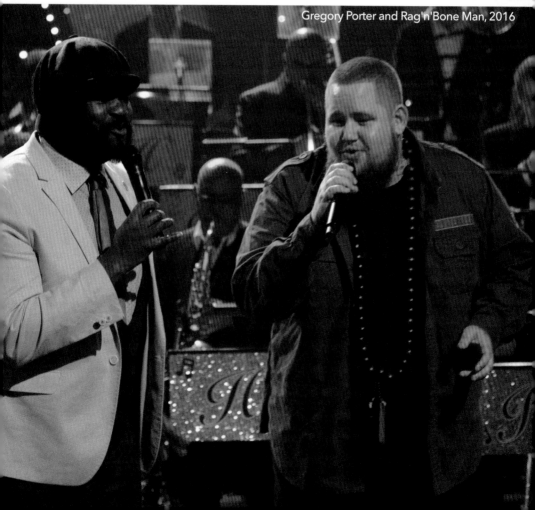

Gregory Porter and Rag'n'Bone Man, 2016

Floor manager Sam Ribeck and Jools watch V.V. Brown, 2013

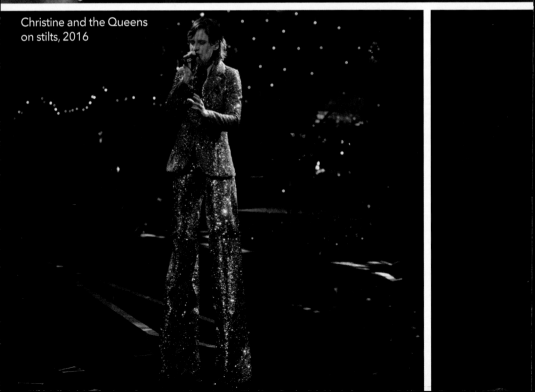

Christine and the Queens on stilts, 2016

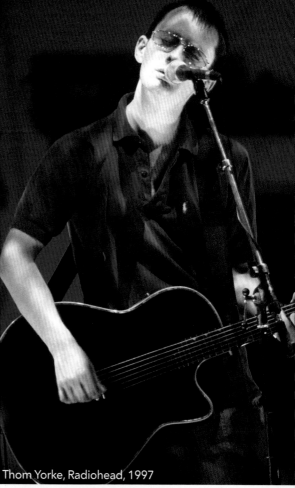

Thom Yorke, Radiohead, 1997

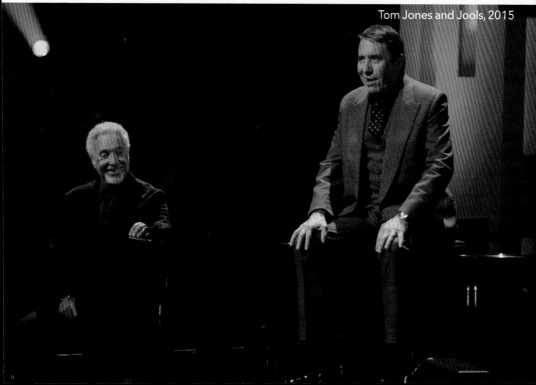

Tom Jones and Jools, 2015

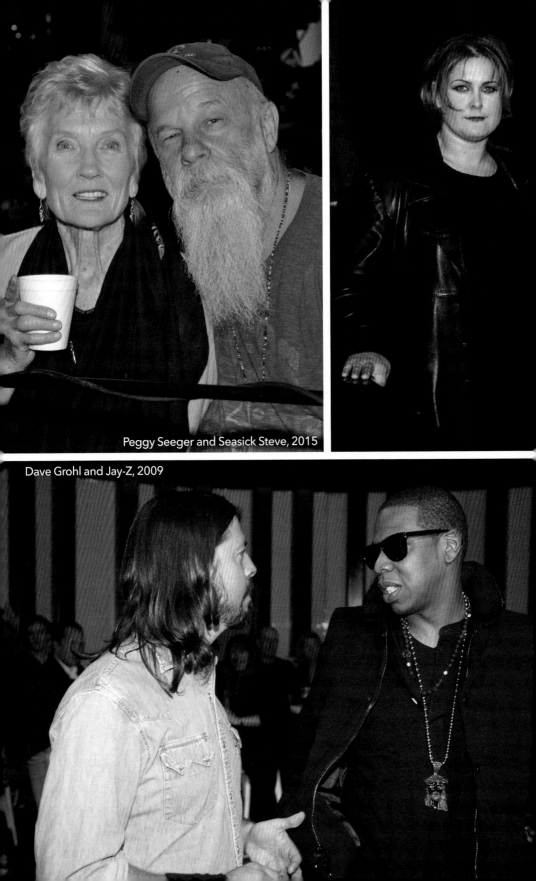

Peggy Seeger and Seasick Steve, 2015

Dave Grohl and Jay-Z, 2009

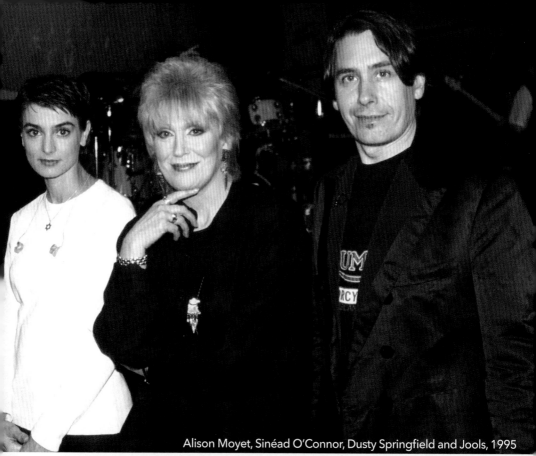

Alison Moyet, Sinéad O'Connor, Dusty Springfield and Jools, 1995

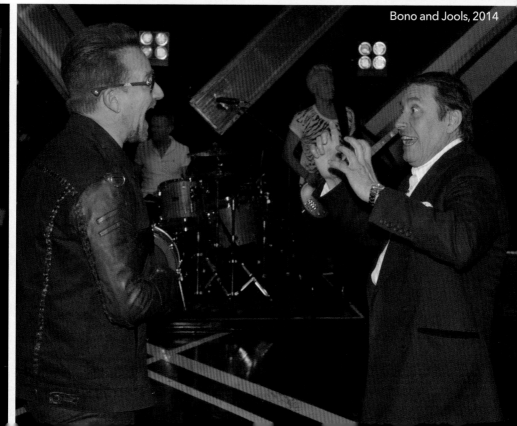

Bono and Jools, 2014

Ron Sexsmith, Everything But The Girl, Super Furry Animals, Burning Spear, John Martyn, 1996

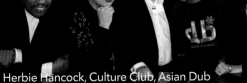

Herbie Hancock, Culture Club, Asian Dub Foundation, Faithless, Lucinda Williams, 1998

So Solid Crew, Cornershop, Doves, India Arie, Pet Shop Boys, 2002

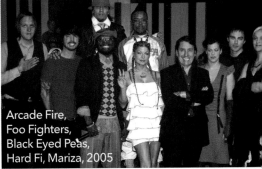

Arcade Fire, Foo Fighters, Black Eyed Peas, Hard Fi, Mariza, 2005

Dr John, James Morrison, Martha Wainwright, Snow Patrol, Gnarls Barkley, Franz Ferdinand, 2006

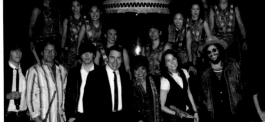

The Pigeon Detectives, Was (Not Was), the Charlatans, Eartha Kitt, Brandi Carlile, Lykke Li, Yamamoto Drummers of Japan, 2008

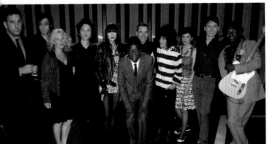

The Specials, Carole King, Yeah Yeah Yeahs, Franz Ferdinand, Karima Francis, the Mummers, 2009

Soul II Soul, Tift Merritt, Lana Del Rey, Nona Hendryx, the Weeknd, Tom Odell, Palma Violets, 2012

Paulo Nutini, Lucius, Neil Finn, Zara McFarlane, Royal Blood, Joan As Police Woman, 2014

Pumarosa, Aldous Harding, Lorde, Sheryl Crow, Stefflon Don, Oumou Sangaré, 2017

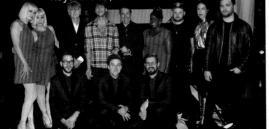

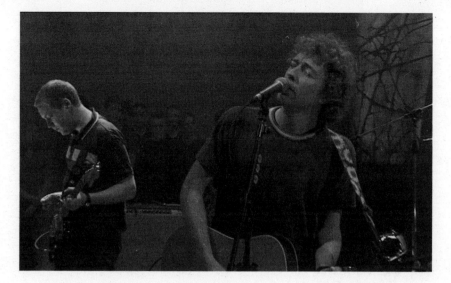

Coldplay turn the world yellow on debut, series 15, episode 4, May 2000.
(BBC film still)

became a form of showing off perfect for the pop talent shows that
were mushrooming on television, Norah's breathy, understated
delivery sounded radical in its intimacy. And then she had the song,
the kind that launches and sustains a career; Jones had met songwriter
Jesse Harris while at college and heard his beguiling 'Don't Know
Why' which he'd recorded with his own band the Ferdinandos a couple
of years earlier. Harris was Norah's secret weapon, playing guitar and
contributing five songs to her debut.

I was already sold when I finally got to see Norah for myself in
February 2002 when she played downstairs at the tiny Pizza Express
jazz club in Dean Street, Soho, to launch her album in the UK. There's
something discomfiting about eating while watching someone confessing
the blues, but the shy and unassuming Norah didn't seem bothered. She
and her band patently enjoyed one another and gave each other space
in the jazz tradition while she was equally happy to throw in a country
ballad from her Texas upbringing. There were a few reviews in the
broadsheets, and while the jazz reviewers were sceptical of Jones'
parentage, her pop appeal and even her beauty, they doubtfully acknowl-
edged she could melt the 'stoniest of hearts': 'It doesn't hurt that Jones
has the looks of Andie McDowell crossed with Kristin Davis from *Sex
in the City*. She also has a winsome shyness that comes from being new

to the bigger scene – six months ago, she was still playing coffee bars. Most importantly, however, she has a fabulous liquid voice that ebbs and flows like syrup pouring from a tin,' observed Sholton Byrne in the *Independent*. Norah didn't have any of the jazz virtuosity or smouldering wit of Diana Krall who'd swept all before her at *Later...* in 1999 with a knowing reading of 'Peel Me a Grape'. Instead, she seemed like a charming ingenue with pop instincts and, live, the wine-drenched, confessional reverie of 'Don't Know Why' languidly mused on ships that pass in the night in a manner that would surely sound perfect not only in jazz clubs and coffee shops, but crucially on the radio..

'Come Away with Me' was a slow burn at first and Norah was still largely an unknown quantity in the UK when she returned to London a few months later at the end of our spring series. Nevertheless, I'd begun to fear that I'd been sitting on this secret too long and Jones' ship had already sailed when she finally lined up alongside Beverley Knight, Wilco, Damon Albarn and Afer Bocoum and Detroit's Von Bondies. Norah had to share the piano with Jools, who was to accompany Eric Burdon on 'Careless Love'. She was tired and jetlagged when she arrived in the studio that evening , already a little weary of the promotional trail and a little aggrieved that she couldn't play 'something different', rather than the scheduled 'Don't Know Why' and 'Cold Cold Heart' which I'd placed together in the running order so she might take over the show in her own quiet way. Norah's combo of double bass, guitar and small drum kit were ranged around Jools' piano which was in the middle of a side wall pushing lengthways into the studio like the hull of a boat. There were a few audience members squashed behind her around tiny tables gesturing towards a supper club ambience. I wanted Norah's face and arms to rise spectrally from a darkened backdrop and the black piano but, try as we might, we couldn't stop her key light spilling slightly on to the audience behind her. No matter, she wore a simple black dress, her long dark hair fell over her bare shoulders, and she seemed to glow in the dark. It wasn't quite jazz or folk or pop but an instinctive blend of all three. As her spare and effortless piano playing unfolded and her seductive voice settled into its stately tempo, she seemed to hush the hurly burly of the show and mesmerise the room. What had seemed like diffidence in Dean Street worked like a magnet in the studio and on television where intimacy often prevails. I can't remember a more overwhelming reaction to an unknown artist in the

Norah Jones waits for the break of day, series 19, episode 6, May 2002.

studio, the applause rose and swelled while Norah looked abashed. Jools appeared as she finished and waxed lyrical in his praise, almost overcome with enthusiasm. *Come Away with Me* would go on to become one of the bestselling albums of all time after sweeping the 2003 Grammys and turning into the soundtrack of the fledgling coffee chains as they grew into a lifestyle juggernaut. None of this was Norah's responsibility and she's continued to go her own sweet way – writing and recording innovative albums, singing with elders like Willie Nelson who immediately recognised her gifts, and frequently returning to *Later...* Thank you, Kathryn!

Adele was even more of an unknown quantity when we booked her in a sandwich between Paul McCartney and Björk in June 2007. We figured with those two heavy hitters on board we should take the Robin Hood approach and shine a light on some brand-new talent. Jazz-funk DJ and producer Ben Westbeech, protest singer the Nightwatchman and electronic duo Shy Child would all debut on that show alongside returning indie band Editors and our two global stars. Our bookings

had always been driven more by musical curiosity than star-making ambition but as the alternative and the mainstream converged, taste making became ever more integral to the show's mission and longevity. The BBC's Sound of… polls and the Brits Critics' Choice award would professionalise tipping the next year, both prioritising future mainstream sellers and the stars of tomorrow. Although Adele wasn't so much a tip for us as a fan crush, she clearly had more commercial potential than our other debutants that night. We didn't have a clue what lay in store for her and that she'd become a superstar. But Adele's voice and songs already had character, command and confessional vulnerability. Less than a year earlier, she'd graduated from the Brits School where she'd been in the same year as Jessie J and Leona Lewis, signing to XL in the autumn after a friend posted a few demo recordings on My Space. Adele had only played a few open mike nights when parent label Beggars' in-house plugger Craig 'Magic' MacNeil shared those first three songs including 'Hometown Glory' and 'Daydreamer' with Alison, who by this point was the show's first contact for pluggers. I remember her telling me that there were a lot of good new singer-songwriters around and giving me four CDs to check out on a Friday. I don't remember the other artists, but I fell in love with Adele' songs and the emotional candour of her voice that weekend. So did Alison and we couldn't wait to share her on television. She sounded real. Back then there weren't the online sessions that would become ubiquitous during the 2010s where everyone can get a glimpse of what an artist looks and sounds like. We hadn't seen Adele perform or met her before she appeared on *Later...* and nor had anyone else. Our twenty-ninth series only had six shows and was ending in a couple of weeks but the demo instantly convinced us that she could write and that she could sing. We just knew that that naked middle-of-the-floor spot between Macca and Björk would be the perfect space for a voice like that. Someone young and unknown with emotional directness who clearly might go far. What mattered to us was that we loved the songs, that they gave us the shivers and that we wanted the world to feel the same.

Adele had turned nineteen the month before she first came to Television Centre and was already recording the debut album she'd title after her age at the time. Later, Adele would recall what would be a life-changing night for her with affection. 'I have the fondest memories of that, the whole experience. Meeting Jools, the hallway, the dressing

rooms, the floor – it was so much bigger than… I always thought it was tiny, because everyone's always like "Studios are never as big as they look on TV", but it was massive.' But she's also admitted how frightening the night was at the time, and even the running order contrived to pile on the pressure. 'Björk did "The Anchor Song", my favourite song of hers… It winded me.' I don't think Alison or I had ever stopped to think that we were throwing a novice to the lions. We'd heard the demo and we knew Adele was more than worthy.

Adele had confirmed her talent in her teatime soundcheck when the studio was almost empty and she'd perched on a stool and fingerpicked her way through 'Daydreamer', her voice filling TC1 like a soloist in a cathedral. And yet that moment of quiet is very different from show-time, when the studio is packed with bands, audience and crew, when Björk and her Icelandic choir are on one side and Sir Paul McCartney and his seasoned band are on the other, both just yards away, and Jools walks in front of you and says 'Now, making her television debut, from Brixton, Adele…' and the lights drop and it's just you and your guitar which hopefully is in tune and you'd better not stop and think that there's no way out of this and that millions are watching and this will be there forever…

There's a moment after Jools' introduction when Adele quickly checks the volume on her guitar and smiles nervously at him and the passing camera. She's looks like an ordinary London girl in an extraordinary situation. Her long auburn hair is tied up in a bun, there's a couple of large flower earrings, dark pumps for her feet swinging in time with the music, dark trousers, dark blouse, and a smock with a floral pattern. There's something of the 1960s in Adele's fringe and false eyelashes and then the lights go down, the white sticks of the set disappear, and the studio falls breathlessly quiet. Janet is filming the whole song without cuts in a single continuous flow on the jib arm which is parked to one side of the studio and slowly glides towards the girl on the stool as she starts 'Daydreamer's haunting guitar figure. She's illuminated by a single spotlight and up-lit by a floor light that pulls her out of the darkness. The camera crabs round into a close-up and already the voice is startling in its clarity and its pitch. The song hushes everything right down into a hazy glow of admiration as Adele pictures her 'daydreamer' who's a 'jaw dropper' and always there for her. She's unmistakably a London girl in her vowels and there's that quiet delivery and slowed-down tempo,

Adele on the edge of fame ... and her stool, series 29, episode 6, June 2007.

that intimate magic that Norah had brought five years before. So far so good and then... and then Adele reaches the doorstep of the chorus, full of elongated waiting and surprise, and her voice is suddenly bluesy and powerful, piercing out of the folksy swing of the verse. Now her eyes are fully open and she's looking out at the room and the camera and she's in command, those beautiful eyes that will open again and stare out of the giant screens at Glastonbury almost a decade later, and she doesn't look quite so ordinary anymore. There's the poise of a jazz singer when she's admitting that there's no way she can describe or do justice to her jaw dropper, she's picking her way through the notes like she's fording a stream stone by stone, and her adored daydreamer is as illuminated in the ring of her voice as is Adele's face in the glow of the up-light. The room is entirely hers and it's almost painful when she slows down for the final line and finishes. An involuntary gulp crosses her face that was so in command moments before and she's suddenly a nerve-stricken pupil who's just handed in her homework. We've been held by her performance in a single shot for three and a half minutes, holding our collective breath, and that gulp is entirely endearing. Paul McCartney

would later remember, 'This eighteen-year-old South Londoner, terrified at the time... but you felt she wouldn't falter.'

Like KT Tunstall before her, Adele helped enshrine the idea of the *Later...* debut as a stepping stone to glory. When *19* came out six months later, 'Daydreamer' was the opening track, the album went straight to Number 1 and would soon go eight times platinum in the UK. Adele was referred to as a soul singer then, frequently compared to Amy Winehouse and competing with fellow newbie Duffy in all the polls. She came back with her band and helped launch our first live show alongside Estelle and James Taylor in April 2008, and then sang her teenage heroine Etta James' 'I Just Want to Make Love to You' with Jools' Rhythm & Blues Orchestra to help welcome in 2009 alongside Martha Reeves, Annie Lennox, Lily Allen and Duffy. *19* firmly established her in the States and she didn't forget *Later...* when she was preparing to release her follow-up. Alison went over to meet Adele at her London flat in autumn 2010 where she played her a few tracks from the bigger bolder *21*, her heartbreak album. Hardly anyone had heard the songs when Alison enthused about the piano ballad, 'Someone Like You', that Adele had co-written with Dan Wilson and encouraged her to make her comeback with it on *Later...*

The Adele who appeared in the middle of the last show of that year after Arcade Fire, Robert Plant and Mavis Staples was an altogether more groomed figure than the teenager of her debut three years earlier, but she would give a similarly exposed performance. Again, no one in the UK had heard Adele's song. Once again, the lights drop out as the piano intro begins but this time Adele is standing at the microphone in Jools' new piano bar in a corner of the studio. There are tables and chairs, café style, behind the piano and the whole area is elevated slightly above the rest of the studio floor and hidden in darkness once the song begins. Adele's hair is pulled back, she's beautifully made up and there's something grown-up and womanly about her purple dress and the poise with which she tells her story, her arms raised and her hands gesturing for emphasis. The lights are the colour of her dress and the whole audience is watching again and this time just visible on camera as the words tumble out in this most personal of bittersweet confessions. 'Someone Like You' is an emotional roller coaster, an arrow to the heart, and there's no brassy or declamatory ending, just resignation that her former lover's married now, that their 'glory days' and

Adele and Jools rehearse 'To Make You Feel My Love' for the first
Later... Live, series 32, episode 1, April 2008.

their 'summer haze' are good and done even if Adele has felt compelled
to show up uninvited and remind her ex that, for her, it's not over.
Three months later Adele performed 'Someone Like You' once again
in the same, stark way at the Brits and went to Number 1 as the nation's
collective jaw dropped. *Later...* was the tastemaker moment, the Brits
the crossover bomb.

Slowly but surely, *Later...* became an institution on which nearly every
artist wanted a slot, no matter how famous or how obscure, whether
this was their umpteenth album or their debut. Even more than the
legends and the stars of the day, it's the debuts that inevitably quickened
our pulses as bookers and which fostered the show's reputation. The
artists we've championed with debuts have always tended to come back
when successful because they know we backed them first and not on
the basis of sales but of taste. Showcasing brand-new talent has always
been one of *Later...*'s key drivers but as our music department's work-
load grew with the rise of the digital channels, the gigs kept coming
and the series rolled on, we caught more and more artists not only at

gigs but at soundchecks and in rehearsal studios. It's always a privilege to see an artist alone in such intimate surroundings. The older I got the more I knew I must seem like Alan Whicker, the man from the BBC, and I'd always chat away ten to the dozen, trying to build bridges and put the showcasing singers at their ease. We could always talk about the music. I'd blabber away while Alison kept her counsel behind me. I'd often liken our awkward role in those small rooms to that of the girl co-stars in Elvis Presley's 1960s movies who could only stand and look on admiringly once he burst into song.

In the run-up and sometimes in the middle of a series, between the studio and the edit days, Alison and I would slip out of the office at Television Centre at the end of a working day and find ourselves in a tiny rehearsal room, often under the arches next to Shepherd's Bush Market's tube station. We met Lianne La Havas and her buzzing guitar amp, soul singer Cody Chesnutt who took it to church while wearing what looked like an army helmet and, in 2017, twenty-one-year-old Mabel who inevitably reminded me of her mother Neneh Cherry, a *Later…* regular since the early 1990s, and who gave a smouldering performance of what would become her New Jill Swing-style debut hit, 'Finders Keepers', before heading off on the tube with a knapsack on her back.

Alison saw KT Tunstall, Paolo Nutini, Ellie Goulding and many more on her own in such rehearsal rooms. I saw Boy Azooga and Lump sound-checking in different venues one afternoon in Stoke Newington and Dalston in 2018. Together we saw Michael Kiwanuka sound-checking at Bush Hall where we filmed the *Songwriters' Circle* series, just up the Uxbridge Road from the tube and Television Centre. On an afternoon in 2012 Kiwanuka played with his band but also finger-picked his way through 'I'm Getting Ready' from his debut album, *Home Again*, with a rolling guitar lick that reminded me of Bob Dylan's version of 'Corinna, Corinna'. The comparison seemed to delight a shy but determined Michael who wore his early influences on his sleeve. Although rehearsals and soundchecks couldn't quite tell you how the artists would perform in front of an audience, they did give us a sense of how they could play, how they saw and imagined themselves. One of the Shepherd's Bush studios had mirrors all down one wall and many singers would play facing themselves as if honing their moves. I always thought playing *Later…* must be as much like a rehearsal as a gig. They play to camera and their peers with the studio audience mostly behind

them, and when Jools appears in front of them, they perform as they wish to be seen and as they see themselves.

I first heard Amy Winehouse when her first manager, Nick Godwin, with whom I'd worked at Virgin in the mid-1980s, gave me a demo tape of what would become 'Frank' after I bumped into him in Great Marlborough Street in the spring of 2003. Amy's jazz phrasing and her candid lyrics immediately set her apart and Nick and her label Island set up a rehearsal for Alison and I at John Henry's rehearsal studios in North London. We stared down from a gallery as Amy and band went through their paces, which were both musically compelling and oddly disengaged. It was if Amy didn't quite know how to perform or inhabit her own songs. She ran through 'Stronger Than Me' and 'Take the Box', and while her singing was characterful and worldly beyond her years, Amy hadn't quite learned how to project the songs even if the voice never wavered and the phrasing never repeated itself, alive in the moment. She'd drift in and out of focus as she sang, sometimes present, sometimes oddly distracted. Amy hadn't played too many shows at this point, and I remember wondering if she just needed some more stage experience. I shared my reservations with Nick but nevertheless we booked Amy to perform on *Later...* in May 2003. She was clearly too good to miss. But she still had that elsewhere look at times in our studio as she plucked intermittently at her guitar and bent those notes. Jools loved her instantly, this London girl with her phrasing, her chords and her candid lyrics, and the next year we invited her back to perform 'Teach Me Tonight' with his Rhythm & Blues Orchestra on the *Hootenanny*. When she returned in 2007, she'd gained some armour in the shape of a beehive, a brilliant dress and a well-heeled band who came on like a soul revue, handclaps and all. She'd made a truly great album, but she was about to become horribly famous. I don't think Amy ever quite lost that air of distraction when she sang. Her phrasing was always fresh, original, in the moment, but she wasn't ever going to act out a song or grow a second skin. It was as if singing made her wonder where she was and why, questions she could never quite answer.

Booking is always about championing talent and backing winners. Sometimes those are the same thing, sometimes they aren't. Who can say if a cult following or a pop audience lies in wait? Sometimes it's about where an artist's talent truly lies and the reach of their ambition.

Amy Winehouse, 'Stronger than Me', series 22,
episode 4, November 2003.

'But when you're 19...' Taylor Swift shocked by blatant product placement,
series 34, episode 5, May 2009.

As the twenty-first century rolled into the 2010s, a *Later...* debut became more and more prized not only by artists but by the music industry. Debutants Coldplay had been joined by Keane, Franz Ferdinand, the Killers and Kings of Leon in the early 2000s while increasingly solo artists loomed large. Laura Marling, Bon Iver, Taylor Swift, Katy Perry and Paolo Nutini were swiftly followed by Jessie J, Lykke Li, James Blake, Emily Sandé, James Morrison, Lana Del Rey and the Weeknd as the next decade got under way. The alternative and the mainstream continued to converge. But I am not sure that Ed Sheeran seemed stadium-bound when he first came on in spring 2011. Ed had been scuffling around the music business for a few years already, playing open mike nights and grassroots gigs, supporting Just Jack and even trying his luck in LA where he'd been befriended by Jamie Foxx. He'd slept on more than his fair share of couches in his teenage years, which helps explain why he permanently looked like he'd just got up. Ed was already an unusual combination of folksy singer-songwriter and hip-hop raconteur, playing a tiny acoustic guitar but also experimenting with loops and beats on a keyboard. Early in January 2011, he'd independently released another EP, 'No. 5 Collaborations Project', with rappers like Wiley, Ghetts and JME from the British grime scene.

The same promotion team at Atlantic that had orchestrated James Blunt's launch in 2005 were pushing Ed, who also had the same personal endorsement and management support of Sir Elton John. The path seemed a little well trodden, which made me wary. One of the conundrums of the quest for new blood is that you are being endlessly plugged by all and sundry with major labels to the fore. They often have the good stuff and particularly the stuff that's going to sell but sometimes it's hard to keep your ears and heart open in the face of a determined sell. I likened the record industry to water or fire; they will find any entry point they can to get in the building. I always wanted to keep *Later...* independent and while I admired the percussive drive and persuasive melody of 'The A Team', a story song about a girl driven into prostitution by cocaine addiction, I was wary of the show becoming a promotional conveyor belt. Unfortunately, I'd picked quite the wrong artist to drag my heels over, as time would surely show. Alison had no such reservations but when Atlantic asked again if there might be a place for Ed on our fourth show some ten days prior, we'd politely declined. Ed headed out to LA while we'd carried

Ed Sheeran joins the gang, series 38,
episode 4, April 2011.

on curating an episode that we thought might become our first all-fe-
male show in years. PJ Harvey was about to unveil 'Let England Shake'
and would be joined by folk sisters the Unthanks and the doom pop
of Norway's Lykke Li. When we added the inspirational gospel-soul
of AverySunshine, our course seemed set. But then we couldn't find
the right female floor spots to complete the show and looking only
for women began to feel more political than musical. Canadian Ron
Sexsmith came on board, returning for the third time with his jaunty
shrug at depression, 'Get in Line', and then Damian at Atlantic sent
me a clip of Sheeran performing acapella online. 'Wayfaring Stranger'
is an early nineteenth-century American folk standard beloved of the
likes of Burl Ives, Ralph Stanley, and Emmylou Harris. Ed had rein-
vented it with his own beatboxing and looping, adding a ghostly vocal
accompaniment to this plaintive account of life as a lonely pilgrimage.
The clip had the kind of bravura, 'What's he doing in there?' intrigue
that had often made solo spots on the show stand out. Meanwhile
'The A Team' was shaping to be a radio hit. I'd forgotten Ed had gone
to LA, but he and his label were determined to seize the moment

when we offered a last-minute spot. It was Friday and he agreed to fly back in time for Tuesday evening.

Meanwhile we'd worked on the running orders for the live and pre-recorded show and while we'd initially only booked a performance of 'Wayfaring Stranger', we'd since determined that Ed should perform 'The A Team' in the pre-recorded show, taped before we went live at 10 p.m. So it is that in that Friday's show Jools walks past PJ Harvey clutching a dulcimer in her white dress and headpiece, and stands in front of the ginger-haired Ed who is placed in front of AverySunshine's darkened stage. 'Now a marvellous new artist from Suffolk, let's welcome... Ed Sheeran!' A large standing audience watches on as the studio lights dim, the pieces of set above the stage are picked out in lime green and Ed kicks straight off, strumming his tiny guitar with its rose sticker while sporting what looks like a vintage biker T-shirt. The words tumble over one another, and he bobs gently up and down to the rhythm throughout. He looks impossibly young, pale round face gazing out from under that shock of red hair, invisible eyebrows and a steely gaze that confronts the ped camera that is his main port of call. 'The A Team' is a classic 'Fallen Angel' narrative but there's no special pleading or sentimentality from Ed, who plays the reporter, only breaking to hit a falsetto note when he mentions the 'cold' waiting outside for his pipe dreamer. It's his first performance in the *Later...* studio but he's utterly assured after those countless solo gigs, more than ready for his close-up after those countless solo gigs.

Earlier during camera rehearsals, I'd discovered that Ed is a tad embarrassed to admit that while the performance of 'Wayfaring Stranger' I'd seen is all his, he's borrowed the song, the arrangement and much of the approach from Jamie Woon's debut EP from 2007. He's a little uncomfortable that the first time a large audience will get to see him is playing someone else's song. He's most concerned about offending Woon. When Lykke Li finishes 'Get Some' in the live show, Jools quietens the studio audience and changes the vibe, preparing the floor for Ed who is standing alone and guitar-less in front of a mike, this time framed in red lighting. He lays down a beat vocally and then builds a harmony line that he loops several times over before pausing to explain that what we are about to see is a cover. It's hauntology in the vein of KT Tunstall and as he continues to layer on vocal lines the harmony backdrop gets richer and spookier. There's a brief glimpse of the foot pedals that give a hint of the

'how' of what Ed's doing and then he picks up the mike and launches into the verse. Halfway through he opens up the performance with some breathy beatboxing and a simple snare-style beat before the layered backing drops out and he takes the last chorus solo acapella. The vocal power and command is stunning, as is the command and simplicity of the performance. As the studio applauds wildly Jools arrives to enthuse about 'the brilliant voice of Ed Sheeran!' Alongside the stellar songwriting, the twenty-year-old Ed has demonstrated what they used to call 'chops'. After the show I bump into him and his girlfriend in the Horseshoe. It's a warm night, he's in a duffle coat and they are heading back to Reading if my memory serves me right.

Six weeks later in June 'The A Team' goes Top 3 first week from downloads and will go on to become the bestselling debut single of the year. By the time he returns three years later in 2014 Ed is a global superstar. He gets the room jumping with 'Sing' and then introduces 'Thinking Out Loud' accompanied by Jools. He is now the nation's favourite singer-songwriter, and we are glad to have him back. We gave him an audience and, now, surely, he brings us one. When he comes back again for the *Hootenanny* that December, he plays Stevie Wonder's 'Master Blaster' with Jools' Rhythm & Blues Orchestra. Somehow Beyoncé gets to see the performance and together they reprise it early in 2015 at a Grammys Tribute show for Stevie Wonder with Gary Clark Jr on guitar. I think back to my early uncertainty about booking Ed and I am reminded yet again – what do I know?

Not every new artist we have fallen in love with and found a slot for has been destined to play the Pyramid Stage or top the charts. Many of the ones that are so destined have been kind enough to keep coming back and playing *Later...*, perhaps because we believed in them and were the first to give them a platform when they had no form. But the driver isn't how successful an artist might become but whether they sound like a somebody, whether there's something in their delivery or in the cut of their melodies that makes the heart skip and rearranges the world a little bit. That's what I got from seeing the Stones on *Top of the Pops* or the Wailers on *The Old Grey Whistle Test*. That's what I got one afternoon at Western – now Wogan – House in WC1 in 2013 where our office moved come the closure of Television Centre. Alison called me over to watch a performance clip of an artist she'd been

recommended in an unsolicited email out of the blue. We'd both get a daily flood of emails, homemade CDs and official releases in the days before links, files and the digital age took over and we'd try to listen to it all. Folk singers, jazz trios, singer-songwriters, bands of every description and genre – everybody thought they could, should, and even might get on *Later...* and sometimes, for somebody, it actually happened!

The email came from French electronica producer Matthieu Gazier and the performance clip sat on the website of St Pancras Old Church, a tiny chapel and sometime boutique music venue at the back of King's Cross which is supposedly one of the oldest sites of Christian worship in the country. In the clip, claustrophobically shot on a handheld camera, sat Benjamin Clementine at an upright piano, his angular face and upward shock of hair confronting a webbed microphone. His long fingers played a rolling repetitive figure on the piano, triplets that were more Erik Satie than Randy Newman, while his declamatory voice seesawed between the lyrical and the desperate. What we were watching is a shout of existential rage tempered by a chorus in which Benjamin seems to find some sort of safety at home except that home too turns out to be a prison where he's trapped in what he calls 'a box' of his own. 'Cornerstone' is an oxymoron of a song, both sophisticated and naive, as if Benjamin commands the melodic and harmonic conventions and yet refuses to be bound by them. It has that rare quality in which words and music tumble artlessly out on the spot and yet the whole is perfectly crafted. His singing is the same: raw and untutored, and yet rising to sustained operatic phrases that sound schooled, classical even. We were both intrigued, smitten even; our series was about to get under way, the Old Church concert was too far in the future. We had to find this guy and see him for ourselves. Immediately.

Alison went back to Matthieu in Paris and a week or so later we found ourselves early afternoon at the bar of Camden's the Forge, chatting with a charming French girl who'd come along to midwife the meeting, waiting to be ushered into the small venue at the back. We'd learned that although his name sounded French our quarry was from Edmonton and of Ghanaian parentage but had been living and working in Paris for the past five years where he'd painfully gone from penniless vagrant to arthouse cause célèbre, *'la revelation anglaise des Francos'*. He had a small record deal in France but still wasn't signed in the UK.

Inside the theatre was a high wall, a raised stage with a piano and the towering but slender figure of a ragamuffin Benjamin Clementine. His look was somewhere between Victorian street urchin and androgynous model from *The Face* magazine of the late 1980s with his high cheek-bones, towering hair, bare feet and long black woollen coat. Benjamin was standing next to the piano and initially almost comically contemptuous of what he would always refer to as 'an audition'. I tried to explain that this was the one way we could get to see him right now while he was still based in Paris and he seemed almost mollified. The room was narrow and long and he seemed a long way away as we bantered. Then he sat at the piano and rolled off three songs, including 'Cornerstone' and 'Nemesis'. He bent over the keyboard and that powerful tenor echoed up to the high ceiling – conversational, raging, now tender – often in a single song. His songs seemed to move from mood to mood, thought to thought, like the shifting expressions that scudded like clouds across his face. They were part confessional, part show tunes, and for all his proud defiance there was something vulnerable and wounded about him that the songs could barely contain. Yet he was also as haughty and mercurial as his most obvious influence, Nina Simone. The piano raced and slowed and then swelled into huge crescendos before subsiding to a whisper with an emotional intensity that almost made us want to look away. After those first three songs I questioned Benjamin about his defiant but wounded journey, how he'd been raised in a strict religious family in North London where he'd begun to learn piano before running away as a teenager, first living homeless in London, and then barely scraping a living in Paris. He answered patiently as I probed. Like Oliver Twist, I asked for more, and more and more, songs kept tumbling out, all of them performed as if Benjamin's life depended on it, the lyrics twisting and turning like an unfettered stream of consciousness, sometimes comically conversational, sometimes emotionally confrontational, as if Benjamin were facing down his demons. I couldn't tell if he was frightening or if I wanted to put an arm around him. We might as well have been facing into the wind. Only the Dexys rehearsal in East London where Kevin Rowland and band played the two of us a fifty-minute set, complete with exits and entrances, while we stood with our backs against the rehearsal studio wall, barely a yard from them, comes anywhere close for intensity, for intimacy, and for fearlessness.

By the time that Alison and I finally stumbled out into the late after-noon Benjamin had passed his 'audition' with flying colours. He'd shared his soul but retained his dignity, which was surely his prime intention. We never booked anyone on the spot because we always wanted to consult about what we'd seen and begin to work out where it might fit in the patchwork quilt of line-ups we'd begun to stitch from the list of artists and associated dates available for the unfolding series. We left the Forge without making a commitment while gushing in our gratitude. We felt we'd met someone who'd shared almost more than we could cope with. But finding a treasure is only half the job, the other half is finding the right place to share it. Once again, as with Adele, Sir Paul McCartney would play a part. He'd just released his sixteenth solo album, *NEW*, and could only make the show on which we'd already booked the newly arch Arctic Monkeys. Throw in Texan blues guitarist Gary Clark Jr and dance queen Katy B and we had a platform to be proud of. Imagine a show which starts with 'R U Mine?' and ends with 'Get Back'. Imagine it with the unknown Benjamin Clementine appearing out of the shadows in the middle of the show, alone at Jools' piano. When he arrived in the studio, dressed much as he had been at the Forge, he looked like he knew he was merely meeting his destiny.

Come showtime Benjamin sits perched on the stool of Jools' grand piano which stands alone sideways at one end of the long studio, eyeballing the room before him as he confronts his loneliness and the lies he's been sold. He still seems halfway between a concert pianist and a streetwalker at Speaker's Corner. He's barefooted again, his ankles exposed by short trousers and much of his chest naked under the ubiquitous knee-length woollen coat. His skin is a beautiful rich choc-olate, his expression wounded but defiant. The lid of the grand piano is open as if at a classical recital, but although Benjamin is seated at the keys and the microphone, he looks restless, caged, as if he might spring up at any moment. A week later the *Evening Standard* would describe his performance as that of 'a French chansonnier with the diction of a British grime star' although, rather, the odd word or phrase is oddly plummy like the speech of a ripe thespian.

There's a line in 'Cornerstone' about belonging, and that night the line seemed more a declaration of arrival than an existential complaint about being stuck in the box of the self. After the show I went to thank Macca. I was buzzing with Benjamin's debut and asked him what he

thought. Nina Simone was mentioned and a thumbs aloft afforded. What I didn't know was that the great man had already bumped into an emotional Benjamin in the corridors that led to the dressing rooms. 'Bloody hell!' Paul had told him, shaking him by the hand. 'He told me I should continue,' Benjamin told the *ES* in the article that followed. 'Paul McCartney. It's almost like I have to work my way down now.' Fourteen months later I stood chatting to Benjamin backstage at the BBC's Radio Theatre in Portland Place where we were filming the 2015 Mercury Music Prize. Ghostpoet, Slaves and Wolf Alice also played that night and Florence + the Machine and Jamie XX were among the other nominees. He seemed less wounded now and amused by how his life had unfolded. When Benjamin won that night Alison and I felt like proud parents. A piano still stood on the stage and rather than reprise 'Cornerstone' which he'd played earlier I asked him if he might play something else. The previous Friday, 130 people had died in Paris, 90 of them at music club the Bataclan in a jihadist terrorist attack. Many more were critically injured. He talked about playing 'La Marseillaise' which would have caused a stir in a BBC always struggling to defend its impartiality as the Brexit debate rumbled on. In the end he played the reluctantly hopeful 'I Won't Complain' in which he describes his heart as a melodrama but not before summoning all the other nominated artists onstage to join him and share the moment. 'I never thought I would say this,' he said after Lauren Laverne handed him the cheque and tears streamed down his face. 'If anyone is watching, any child or youngster or student. The world is your oyster. Go out there and get what you want to get.'

Two years later we were preparing to launch series 51 in Maidstone less than a week after filming *Later 25* at the Royal Albert Hall. Benjamin was about to release his second album, *I Tell a Fly*, a concept album of sorts although I couldn't exactly explain the concept. He'd been inspired by seeing himself described as an 'alien of extraordinary ability' in his American visa and told a couple of interviewers that the album explored alienation and bullying. But the music was dramatic and ambitious if sometimes wilfully difficult; the chanson, musical theatre and classical influences remained but this was more art-rock, with stacked harmonies and drums. I admired Benjamin's determination to be more than a confessional singer-songwriter. Alison and I loved the idea of this fragile and androgynous poet performing opposite Liam

Benjamin Clementine and a pregnant, star-spangled dummy,
series 31, episode 1, September 2017.

Gallagher whose solo career was launching, lining up alongside LCD
Sound System, Jorja Smith and Jimmy Webb. His plugger Sam Wright
had enthused about an Edinburgh Festival concert that August in which
Benjamin had premiered the new songs with a band and choir and the
reviews were encouraging. But then Sam called up in a tizz, almost in
tears, trying to explain the inexplicable. Benjamin wouldn't be using
the choir for *Later...*, in fact he wanted to perform to track with only
a rhythm section miming behind him while surrounded by manne-
quins. Planning for the Albert Hall continued apace, and after going
back and forth with Sam, I arranged to speak to Benjamin on the
phone. He was friendly, wary, determined. I tried to explain that *Later...*
wasn't *Top of the Pops*, that miming wouldn't make any sense. I insisted
that at the very least the bass and drums be live and that they should
add backing vocals. A day or two before the Albert Hall, Alison and I
found ourselves in a rehearsal room that stank of sweat in Shepherd's
Bush. Benjamin and the rhythm section were surrounded by naked
mannequins. There was no piano, and he prowled the tiny room like
a rock star, addressing much of his performance to the mannequins.

At one point he was down on his knees staring up at a mannequin. Now he was hitting those long operatic notes like Bowie in his prime while we watched from a couple of feet away. It was dramatic and bewildering but the rhythm section seemed more cosmetic than musically involved. Somehow, we'd strayed so far from the early promise of choirs but we had no time to turn back. We admired his conviction and ultimately trusted his vision even if we didn't follow what he was trying to say. I begged Benjamin to get the backing vocals going and we escaped to the Albert Hall.

When Benjamin follows Liam and LCD Soundsystem in *Later... Live* from Maidstone he stands with his back to the camera bathed in an electronic soundscape holding an American flag. He's standing in front of a naked, wigless and pregnant mannequin while a couple more doll figures are mixed in with the bassist and drummer like Antony Gormley statues. What looks like a large Perspex timer is placed centre stage at the back. Slowly Benjamin drapes the pregnant mannequin in the American flag and then proceeds to sing 'Jupiter' directly to 'her'. He's dressed in the kind of light blue overalls familiar from French janitors and council workers. His hair has ascended upwards like a 1950s pompadour or a handsome version of David Lynch's cult film hero *Eraserhead*. Twice he turns a circle and slowly spins the mannequin around with him. I catch a twinkle in Benjamin's eye occasionally and I am reminded of the dark sense of humour that weaves through his lyrics. He's having fun while singing of aliens and America. There's a chorus of sorts and similar threads of melody woven through the two songs he performs in the pre-recorded show, 'God Save the Jungle' and 'By the Ports of Europe'. The bass and drums are almost invisible back of stage. Vocally they join in the chorus, but our eyes and ears are all on Benjamin. It's performance art just like Christine and the Queens and 'Tilted'. I don't know what Liam Gallagher or Jimmy Webb made of Benjamin and 'I Tell a Fly' wouldn't match the commercial or critical success of that magical debut. But I hope he returns because what I admire in an artist and what *Later...* is there to champion, above all, is originality, character, musicality. Although I couldn't handle another 'audition'.

Ed Sheeran

I am of the YouTube generation. I didn't watch *Later... Live* when I was fourteen but there would always be rips on YouTube the next day, even before the BBC had their own channel on there. My friends and I would share performances on MSN Messenger or Myspace and that's how you'd find the acts that had played *Later...* the night before. When there was someone well known on Jools, it wasn't as exciting as when there wasn't. The whole point of watching was to discover new artists and be the first on the wave – to be like 'Oh my God, have you heard Seasick Steve?' and to be able to show someone that, that clip; more than being like Coldplay have a new song out – 'Did you see it on Jools?' The exciting thing about *Later...* was the discovery of new music. Jools was kind of an A&R before A&Rs.

I first saw Adele and James Morrison on *Later...*; I instantly went out and bought their music, but these were people you could also find on Radio 1 and, as a kid, all my friends were discovering them too. But you could discover things like Seasick Steve or Gregory Porter on *Later...* that wouldn't be offered up to a Radio 1 listener. I remember seeing India Arie with Jools and her voice blew me away. I remember seeing Bon Iver for the first time, KT Tunstall, bands too like Foo Fighters and Queens of the Stone Age, stuff like that was cool to watch. The good thing about Jools is that there's something for everyone. A lot of stuff didn't interest me much but that was why I did the YouTube thing. That's how I found Ray LaMontagne in a rip, and he was great.

As a singer-songwriter in my circle, if you got on *Later...* it was a benchmark that you were making it. Whenever I saw someone who I was sort of in the scene with on the show, I'd think 'Oh man, one day...!' I even signed to my record label Atlantic because I thought

Ed Sheeran travelling through this world alone,
series 38, episode 4, April 2011.

they would help get me on *Later...* because that was the only thing I wanted to do. The first time I got booked I remember thinking, 'This is my moment; this is my moment'. I really felt things shift after that night. I remember driving back to Reading that Tuesday night and watching back my performance online and seeing Twitter blow up.

Later... just moves the needle so much for artists like me. All my friends would catch it and all their parents would watch it, it's multi-generational. If you did a performance on *Later...* your ticket sales would go through the roof, or you would play a festival and thousands of people would turn up. I keep talking about singer-songwriters and the show is clearly good for lots and lots of genres, but for me and my genre and where I came from, if you got a slot on Jools – that's gold.

I know it's called *Later... Live* but I just hadn't worked out it actually was live, I thought it was all pre-recorded! That first time in 2011 was really exhilarating; it's the same thing with *Saturday Night Live.* You watch it on TV and you just kind of go, 'Oh, it's on TV like everything else is on TV...' But when you're there and you see the red light suddenly go on and it is live and you're like 'Oh my God, what if I mess this

up?'. The vibe was great. My parents came down, my girlfriend was there... I felt the pressure.

The first time I came on I sang Jamie Woon's arrangement of 'Wayfaring Stranger', which I'd been doing at gigs, in the live show and 'The A Team' in the pre-recorded show. Everything at the beginning of your career is a hustle; it's sort of you scratch my back and I'll scratch yours; there's a reaction for this action. There was no part of me that felt like I shouldn't do it. Weirdly, once I'd played 'Wayfaring Stranger' on that show, I stopped playing it. It was the beginning and end of that.

When you're on *Later...* no one on the show goes 'Who's this guy?' Like you don't deserve to be there because the team that book the show are so renowned for booking good people. Everyone feels the respect, even unknown artists will be completely respected by the super well-known artists. There's a veil of ego that gets left at the door because of how the show is booked. It's not like here's a big artist and here's an unknown artist and we're having the big artist play the beginning, middle and end and just squeeze in an unknown artist to play thirty seconds. Everyone gets equal billing and that's great. It's like the writers' rounds at the Bluebird Café in Nashville where songwriters take it in turn to share songs; *Later...* feels like that on a grand scale, you're sharing with other artists.

I had more confidence the second time around in 2014. I was on my second album and the first had done well and I played 'Thinking Out Loud' with Jools before it was even released, whereas playing 'The A Team', I felt nervous because it was my first thing. But the way the show works is always the same. There are artists that are brand new but they're on the show because they're good and a lot of them are probably better than the artists like me that have been around a while. It just keeps you on your toes, especially when you're performing after someone new, you have to bring your A game. There's no phoning it in on Jools.

I feel if you do a good job on *Later...* you'll get asked to do the *Hootenanny* because it's like the Best of the Year on *Later...* Record companies reckon if you get on the *Hootenanny*, you're guaranteed some sales because a lot of people tune in. Jools asks me to play a cover with his orchestra rather than shall we just play your new single. They are such fantastic musicians that I barely rehearse with them. I basically

choose a song, I walk in, play it twice and then we perform it. It's a nice comfort blanket to know that you've got these incredible musicians behind you and you don't have to worry. It's fun and it's very different.

I don't think you necessarily drink at *Later…*; it's quite sober, let's listen, whereas the *Hootenanny* – it says it in the name! It's a party. I always really enjoy it. I don't usually drink before I perform but with the *Hootenanny* you end up being a bit pissed by the end of it because it might as well be New Year. You let yourself go. The audience probably get pissed as well. I remember doing it with Paulo Nutini one year and he had a bottle of whisky next to his amp and by the end we were both absolutely shitcanned.

Jools is supremely talented, and he knows his stuff but he's a captivating person. When he walks on camera, you want to listen to him, and you've also grown up trusting him and trusting his judgement on stuff. I don't think there's another music show in the world where the host gets up with you and plays a song. I remember feeling really lucky when I did 'Thinking Out Loud' with Jools because whenever he picked a song to play on, that was usually the one that would do well, you know? I feel if he looks at the camera and says, 'You guys need to go out and buy this album of this new artist, you're going to like them,' then people do. He has the gravitas to back up what he says. It's like a brand you can trust.

To Jools

Thanks for having me back! 3 years ago it was my first ever TV show I'd played! I LOVE This show! love Ed

Later... goes live, series 32, episode 1,
April Fool's Day, 2008.

Lust for Life

Live and as Live

The clock is ticking high on the wall above the monitor screens in the gallery in TC1. It is 10.25 and we are careering towards the finale of the first *Later... Live* of spring 2011. Down on the studio floor, the bases are loaded. McCoy Tyner, the legendary jazz pianist who played with John Coltrane on 'A Love Supreme', should have wound up his dramatic composition, 'Fly with the Wind', a minute ago. Beady Eye, Raphael Saadiq, Anna Calvi and the Tallest Man on Earth have all had their shot while Elbow are coiled to unveil their latest anthem, 'Open Arms', which pushes many of the same buttons as 'One Day Like This', the epic singalong which united Glastonbury as dusk fell on the Pyramid Stage in 2008. It's a packed show and although the bands have all played at least two songs in the pre-recorded show that we finished taping less than an hour ago, each artist gets but one song in this crammed live edition. The laidback McCoy Tyner and his Quartet have been good as gold in the pre-record, delivering 'Suddenly' in just under their agreed four minutes. But PAs Lisa and Louise who keep time in the gallery, counting out each tune in bars and beats for director Janet Fraser Crook while periodically announcing where we are in programme duration, no longer sound their usual calm selves.

Voices are rising in the gallery while down in the studio Sam Ribeck, our floor manager who manages Jools and the artists during filming, is fielding a flurry of sometimes contradictory instructions on her headphones. Meanwhile the veteran Tyner with his white jacket and grey hair is oblivious to the rising panic. He is attacking the piano with his customary gusto and driving his Quartet forward with that percussive left hand, opening up variation after variation in his sinuous melody. He's bent low over the ivories and he isn't glancing up at his

rhythm section, let alone the waving arms of Sam, who's trying to get in his eyeline. Perhaps alarm bells should have rung when Tyner elected to play this title track from one of his 1970s' Impulse albums but it is only later that I discover that the recorded version of 'Fly with the Wind' never ends but fades out after eight minutes plus. When the Quartet ran the tune for cameras after supper break, they wound it up after a mere four and a half minutes and McCoy assured me he would bring it down for the show. 'Just get the girl to stand by the camera and give me a thirty-second count and I'll wind it up,' he'd promised. I loved the attack of the piece and had foolishly chosen to put it in this live half-hour. I should have recalled the discursive workouts and melodic meanderings that seemed to annihilate time itself when I first caught McCoy Tyner live in a snow-swept Buffalo in 1976, the year that 'Fly with the Wind' came out.

There's a maximum of five minutes now left in our live programme and that already includes a thirty-second overrun from channel Presentation who manage BBC 2's programme junctions to the split second. Anthems aren't brief by their very nature however and Elbow's latest is nigh on five minutes in the unlikely event that we ever get to it because McCoy Tyner is still soaring with the wind, pressing heedlessly forward, lost in the music. He's long past the three and a half minutes we'd agreed for this performance which left us a smidgeon of time to play with in case he overran. Time has evaporated for Tyner, whose flying fingers are following the internal dictates of his imagination while we are out of time altogether. Jazz is one of the live-est of musics and we are, after all, live. Elbow's manager must be getting nervous at this point, watching on a monitor at the back of the studio. Yet their lead singer Guy Garvey seems merely amused as he watches the Quartet in full flight and the gathering consternation on the studio floor.

The week before, Jools had spotted that Tyner was playing a rare Ronnie Scott's date the following Wednesday and urged that we book him for Tuesday's *Later*...; miraculously, the Quartet had arrived a day early for this rare London club date and although McCoy is already in his early seventies, he'd willingly sacrificed a rare day off to play amongst rock and roll bands more than half his age. Now the genial legend has morphed into an unstoppable force of nature who's swept past his precious four minutes and looks like he's just getting started. One of the PAs is already calling BBC Presentation to explain our dilemma and

Iggy, Jools and Josh Homme hold hands,
series 48, episode 5, May 2016.

Jools puts the great McCoy Tyner under starter's orders,
series 38, episode 1, April 2011. (BBC film still)

beg for more time. Meanwhile over talkback Janet is telling Mike Felton in sound to prepare to bring Tyner down in the mix while prepping Sam to explain to Jools that he is going to have to stand in front of the maestro – even if he continues to play – while introducing Elbow. Jools has never worn an earpiece and he isn't now. Once the show starts, the floor is his. Understandably, Jools isn't keen to be shushing a fellow pianist and undisputed jazz great. But Janet not only directs but bosses the show once it's up and running. Yes, her voice is raised, but she is at her most professional. I am sweating helplessly at the back of the gallery.

Moments later, the cameras back off Tyner and Jools edges doubtfully into frame, looking as if he'd rather be anywhere else. He keeps glancing over at the oblivious Quartet, clearly praying they'll finish of their own accord, while drummer Francisco Mela is caught on camera breaking into a knowing grin. McCoy drives into another unstoppable chorus and so it is that, after another hefty chunk out of a minute that we don't have, applause orchestrated by Sam suddenly rises from the studio audience and Jools, standing at a respectful distance from the action, raises his voice above the storming but increasingly inaudible piano crescendos to thank Tyner and, indeed, 'all our other guests'. Slowly the cameras pan across the room and away from the Quartet. Jools is carrying a cardboard sign that pushes towards the *Later...* website on 'bbc.co.uk' but he is too distracted to ever raise it to camera. He looks admiringly over towards the piano as if he personally would be delighted if the Quartet were to go on for hours. 'Now, we give you,' he explains hurriedly, 'because there's only a few minutes left... Elbow!' before retreating out of shot. It's only when Jools' quickfire introduction is complete that a faint cymbal splash and concluding piano chord can be discerned off camera just before the violins swell into the first bars of 'Open Arms'. Guy does his best to hide his grin, raises an arm characteristically aloft and launches into the most apposite of opening lines, addressing someone who simply does what he wants, whatever the consequences.

I'd left the choice of tunes up to McCoy. 'Fly with the Wind' had lasted a mere six minutes, at least two minutes over what he'd happily agreed he'd play. I don't think he was anywhere near done when he had to stop. I was more embarrassed that we'd halted the great McCoy Tyner in full flight than that we'd overrun our slot. So, I'm sure, was Jools. I suppose I was more in thrall to the jazz police than Presentation. No one at the BBC ever queried what I was doing programming a jazz improviser as the

penultimate act on a live show. Not even *Newsnight*. After the show McCoy looked a little sheepish and a tad amused. I think he'd enjoyed himself.

Television has always been a kind of variant on the speaking clock, its schedules designed to accompany viewers through their waking hours while managing their moods and catering to their desires. *Later...* was conceived as a loose, late-night show in an era when the schedules were expanding nocturnally before catch-up began to erode their grip. The occasion and the hour are hotwired into *Later...*'s very title and yet we always seemed to struggle with the clock. I was never very good at bringing the show in on time even when it was as live, pre-recorded. Our first series in 1992 generally went on air around midnight after *The Late Show* and although those early programmes weren't even close to an hour, no one at the BBC minded when they finished so I never worried how long they were. But as the show grew, I kept adding more numbers by more artists. By the second half of the decade, the average programme featured six artists and a total of around thirteen or fourteen songs including three by the opening act. Janet and the production team kept rolling their eyes at their burgeoning load but they all loved the music and the challenge too. I couldn't resist adding extra songs and even an additional artist – a Rufus Wainwright or a Mariza, say – who might pop up at the piano or in the middle of the floor by way of contrast. I always wanted to squeeze more music and more artists onto our platform. But I was also constantly having to ask artists I admired to edit their songs because the bursting programme was over-running. We weren't live to air but we always ran the show as live while striving unsuccessfully to keep on schedule. We hated any stoppages because the energy and the live-ness of the show seemed to mount as we careered onwards like a runaway train, each artist bouncing off their predecessors as the energy levels rose and the minutage expanded.

Live music and live chat are strangers to time and so, week after week, to my hapless surprise, the recorded programmes would tip towards the seventy-plus minute mark and even after Jools' chats were edited, more often than not we'd find ourselves five minutes over, coming in at around sixty-four minutes. For the first fifteen years or so, our single pre-recorded weekly episode of *Later...* would be scheduled around 23.30 on a Friday after *Newsnight* and the arts discussion programme, *Late Review*. I could never understand why the powers that be chose to schedule a few critics

chatting about the latest films and books around a small coffee table in a darkened studio before the packed and often starry extravaganza of *Later...* I guess my frustration and the lateness of the hour just tempted me to keep adding more songs. So, week after week, I found myself cap in hand calling up the BBCTWO scheduler and begging for a five-minute overrun at around half-past midnight where minutage surely didn't need to be quite so precisely managed?

Top of the Pops was still recorded piecemeal as the studio audience shifted from stage to stage with pauses to reset for different acts. The Nation's Number 1 pop show had always prioritised what then mattered most to music entertainment television, what pop stars actually look like, which is why it began with miming before latterly compromising with live vocal to track when such trickery came to be regarded as akin to cheating. *TOTP*'s audience primarily wanted the performances to sound just like the record and its producers traditionally saw it as an entertainment show for all the family. The pop stars and the kids in the audience came and went but the producers were always firmly in charge and clung to the chart narrative of the Top 10 and the Number 1. By contrast, *Later...* felt like a live event and then, of course, all our artists played live. Sometimes a camera or a light broke and we had to

Later 100 with Paul Weller, Moloko, Kirsty MacColl, Idlewild,
Craig David and Lakatos, series 15, episode 1, April 2000.

pause to fix it but, more and more, as director Janet and the crew grew ever more adept at moving the cameras around from band to band while staying invisible, the recording ran in a single take without a hitch. But the show still felt like a Jenga game where the pieces might tumble at any moment and, occasionally, they did.

When we came to record our hundredth show in April 2000, Paul Weller had just released his optimistic *Heliocentric* album, Kirsty MacColl had gone Columbian, the time was now for Moloko and we gave a television debut to Craig David who performed 'Fill Me In' with acoustic guitarist Fraser T. Smith who'd go on to produce Stormzy, Dave and many more. The studio audience was heaving and we'd invited a few famous friends down to celebrate including Macy Gray, Richard Wilson, John Thomson and Jonathan Ross. We'd printed up a raft of T-shirts with a simple *100...* logo on the front and the programme name on the back in the same script as the title page. Chris Cowey, the producer of *Top of the Pops* whom I'd worked with on Channel 4's *Wired* all those years ago, came down to do the warm-up and we were ready to go!

Five songs in, Weller switched to acoustic for 'Sweet Pea, My Sweet Pea' which he strummed with considerable vigour – so much vigour that, after he'd got about a minute in, a string loudly snapped. Often if an artist wasn't happy with a particular song we'd offer a retake at the end of the show, but this was coitus interruptus. Paul had a new guitar tech that night who was lurking to the side of the drum riser where he struggled to change the string while our charming old-school floor manager Barrie Martin explained to the studio audience what was going on. Barrie loved the bands and had assumed the job of warm-up and audience liaison alongside his floor managing responsibilities as *Later...* grew and grew. Finally, the string was changed, Jools repeated his introductory link and Weller was off again. But not for long. Once again, Paul thrashed away and, once again, a minute or so in, the same string broke. Not for the last time. There was no spare acoustic in the guitar case and, once again, the offending string had to be changed and the guitar tuned while we all sat on our thumbs muttering about Groundhog Day. The hapless guitar tech seemed to take longer and longer as tension mounted, and the more meandering Barrie's chat became, the more restive the studio audience became. Jonathan Ross began to yell out abuse at poor Barrie, the programme and the BBC as a whole. Finally, after what was probably only half an

hour and on the fourth or fifth attempt, Paul managed to get through 'Sweet Pea' without breaking a string and the programme stumbled forward. I'd learned that we could no longer afford to bumble along like novices, we needed a dedicated warm-up artist to entertain the studio audience. We'd put Barrie in an unfair situation and been found out on this most vainglorious of occasions. I remember wanting the earth to swallow me up in the gallery and slinking swiftly home from the Green Room afterwards. I guess if we'd been live to air Paul would just have had to strum away regardless. We were always torn between live-ness, letting the show roll and getting the best take we could.

Each show was both a unique collection of talent and a tangle of cables, a one-night-only music festival fraught with ambition and peril. Every show provided new challenges, both technical and artistic, and each had to be landed like your first wriggling fish. Once the groove kicked off and the show began, we were in the hands of the running order, Jools and the artists; whatever happened, happened, live in the studio. Yes, we were pre-recording, but the performances and the event came first, not the television capture; all we wanted was the artists to come alive. Some seized their moment more spectacularly than others. El Paso's At the Drive-In were at the heart of the American post-hardcore alternative scene, combining punk aggression with an almost prog approach to song structure when they recorded their third studio album, 2000's *Relationship of Command*. Alison had missed the band on her doorstep at the Reading Festival that summer and so braved her habitual fear of aeroplanes and flew to see them at the Bowery Ballroom in New York. She must have been pretty smitten to undertake such a once-in-a-lifetime trip to catch a band that had played first the Monarch and then the Astoria in London earlier that year. Jetlagged and unused to US protocol, she managed to get to the gig without her passport, only to be refused entry due to her lack of ID. Fortunately, a helpful tour manager managed to escort her round the back of the building, up the fire escape and into the venue. It was autumn and the clocks were about to change but At the Drive-In were on the rise and owned that stage, exploding with frustrated energy, combining punk intensity with sudden tempo changes and spiralling guitar lines. Heads banged, mosh pits moshed and the band careered around the stage like pinballs. Nothing like this was happening back in Blighty, which was still in a post-Britpop hangover.

A month later At the Drive-In returned to the UK for the fourth

Craig David, Jools and Robbie Williams hiding from At the Drive-In, series 16, episode 8, December 2000.

'Can I have my chair back please?', Robbie Williams views At the Drive-In from across the studio floor, series 16, episode 8, December 2000. (BBC film still)

time that year to play the *Later...* and the last of what had been 200-plus gigs in two years. They were road-tested and battle-hardened but if they were weary they didn't show it when they lined up at Television Centre alongside Robbie Williams, Van Morrison in tandem with Jerry Lee's sister Linda Gail Lewis, Guru's Jazzmatazz with guest singers Craig David and Angie Stone, and a solo John Hiatt. The bequiffed Robbie was in his imperial phase, already several singles into the bestselling album of the year, *Sing When You're Winning*. He's swaggeringly self-confident and beautifully groomed as he shimmies his way through 'Supreme' in a brown singlet, winking intimately at the camera like a Beatle while routinely flipping his vocal microphone. He's as anxiously confessional as ever, searching for 'a love supreme' to save him, but he's also endlessly knowing, an entertainer playing at being a rock star, an impression underlined by his closing cover of Elvis Presley's 'Suspicious Minds', the work of an affectionate impersonator who's studied the 1973 concert film, *Aloha from Hawaii*, frame by frame.

If Robbie is all charm and front, musically composite and meticulously rehearsed, At the Drive-In are a chaotic experiment, a mash-up in a test tube. The fourth song in the show, 'One Armed Scissor', explodes into life with a crash while the band jerk up and down like they've all just received an electric shock. Lead singer Cedric Bixier-Zavala is a big mop of curls screaming into his mike or swirling its long cord around his swaying head while, stage right, the equally hairy Omar Rodríguez-López's guitar jerks in and out of his hands like a bucking bronco. Neither of them ever stop moving, although it's unclear if they are dancing to the same drum or desperately trying to upstage each other. Founder guitarist Jim Ward and bassist Paul Hinojos are relatively restrained, anchoring the song, while Tony Hajjar drives the band forward, combining propulsive breakbeats with a rock-solid bass drum. Cedric and Omar can't keep still, hurtling back and forth towards the drum riser, both screaming the chorus, before dissolving back into the skittering chaos of the verses. The guitars shriek and distort or lock into discordant, circular riffs that pile on the claustrophobic pressure while the lighting is pulp-comic lurid, all deep reds and black. The band once told an interviewer that a 'one-armed scissor' is a drink that combines red bull and vodka and that the paranoid lyric telescopes the hardships of their incessant tours. The words are straight out of William Burroughs but you can't really hear them, you can only feel them.

A hundred seconds into this heaving maelstrom, Cedric grabs one of the horribly sensible, IKEA-style audience chairs loitering nearby and begins tossing it contemptuously about as if it's transformed into the embodiment of everything corporate and uniform. The chair's an awkward octopus of a thing to wrestle with but suddenly Cedric's standing on it, leaping on and off, tossing it high in the air before depositing it with exaggerated care in the middle of the studio floor. It sounds comic but, somehow, it's not: it's deranged. Now he's on the drum riser while Omar is tightening the screw with an uncomfortable riff that's drilling into your head like a hangover. It's like MC5 meets Mothers of Invention, straight ahead but squiggly. Omar's guitar is out of tune, which only adds to the discomforting intensity and maybe explains why he eventually hurls it aside and picks up a tambourine. Eventually Cedric's back on the drum riser, throwing himself high into the air, legs akimbo, as if he's landing from another planet. There's little of the brutal precision and calculated instability of the recorded version but it's an all-out theatrical assault, staggering and unrepentant.

As ATDI's screaming abdabs finally cease and Cedric swaggers back to the drum riser, the camera slowly segues across the studio floor and past the abandoned chair to find Robbie Williams leaning on Jools' piano, directly opposite the carnage, preparing to deliver an acoustic version of the post-therapy ballad, 'Better Man'. 'Can me mate have his chair back?' he deadpans in his best Potteries accent with that simpering look of innocence first perfected by Michael Crawford in *Some Mothers Do Have 'Em*. The audience risers are stacked arena high in the studio and when Robbie then sings the opening line, asking for someone to love him, spontaneous applause breaks out. It's the year 2000, he's in his pomp and most of the studio audience are primarily there for him. 'Thank you very much!' acknowledges Robbie like a nightclub singer amongst his faithful. He's knowing, confiding even, and everything he does is calculated for the camera, calculated to appeal. At the Drive-In never so much looked at the cameras. They seemed to spontaneously combust like they had no choice. Yes, they were intensely theatrical but even the audience in the studio didn't come into it. They were doing it for themselves, from some inner existential compulsion. Two worlds collide like ships in the night. It's not live to air but it's live in the studio. Unrepeatable.

Janet had already put lots of shots into 'One Armed Scissor' which

she'd captured brilliantly but the next day I went up to the edit and added yet more, upping the pace and trying to add to the sense that the whole band were exploding in different directions. We had two isolated feeds that we recorded for the edit in those days and those feeds had themselves been cut during the performance so there were plenty more shots and angles to add. There are 153 shots in the edited 3 minutes 45 seconds of 'One Armed Scissor'; that's a shot every second and a half, which makes it perhaps the fastest cut, most edited performance in Later... history, but it's also undeniably one of the live-est. It's post-produced and pre-recorded but everything about the performance is live and of the moment, as is the segue to the waiting Robbie with his deadpan refusal to be upstaged. Less than three months later, an exhausted and over-toured At the Drive-In split up in the Netherlands. Perhaps the music was already pulling them apart, perhaps they simply couldn't keep up that level of intensity, that degree of live-ness.

We'd make another hundred shows and celebrate our two hundredth with Radiohead, Mary J. Blige and Feist a couple of months before Later... finally went live to air in the spring of 2008. We'd been going fifteen years and what once had been like pulling teeth now mostly ran like clockwork. The camera crew and Janet knew each other inside out and while she would still experiment visually with a post-rock band like Battles, the show now had its own confident swagger and, more often than not, would get recorded in a single, uninterrupted take. After the early years of individual painted backdrops for each act, we now had our own jigsaw of a white set which would be reconfigured weekly once Strictly or whatever Saturday-night entertainment behemoth had occupied TC1 for the weekend had been stripped out. Every week we'd plot the set and lighting design for each individual band and artist. Every show was a labour of love, carefully constructed, obsessively pored over, and always bursting at its budget and its duration. We never thought we had enough money to make the show Later... had now grown into while the rebranded BBC TWO was facing the first of the many budget cuts that would come to occupy innumerable managerial hours in the years ahead. The powers that be had ruled that programmes above a certain budget had to play in peak to justify their funding. We thought our time had come but Roly Keating, then controller of TWO, wanted us to find a way of making two shows, the hour-long, 'complete

Estelle with Kano, her London Boy,
series 32, episode 1, April 2008.

repast' we'd been making for years and a half-hour snack special for
10 p.m. midweek. Both for the existing budget of course. I don't think
we'd been puzzling over this proposition too long when Alison simply
announced we should go 'Live!'

So it was that on a Tuesday night in 2008, April Fool's Day to be
precise, Jools strode into TC1 at 10 p.m. while pronouncing that he
was broadcasting live to the nation as if he were the queen. It must
have been one of the few times he'd been live on British television since
that infamous Tube trail when he'd called his potential audience 'Groovy
fuckers!' *Top of the Pops* had been cancelled nearly two years earlier
and suddenly once again there was a music show on British terrestrial
television in prime time, a bite-sized version of the hour-long extrav-
aganza, without the digressions and eccentricities, about as mainstream
as we could get.

Later… Live is live and Estelle is top of the singles chart. She's recently
moved to New York but this one-off version of 'American Boy' brings
her back home as Kano deps for Kanye West with a London boast that
seems to make her glow, gold dress and all. Four years earlier, Estelle

had made her *Later...* debut on one of our first HD episodes after Alison and I had been to see her rehearse in a dingy studio just off the Harrow Road. Now she's kicking off our live debut. It's ten months since Adele's *Later...* debut and she looks marginally less nervous, a tad more groomed. 'Chasing Pavements' which follows Estelle is still circling the Top 20, as is her debut album, *19*, which entered the charts at Number 1 back in February and from which she also offers a churchy take on Bob Dylan's 'To Make You Feel My Love' with Jools underpinning her heartfelt vocal with gospel breaks and slurs. There's the reformed the Only Ones with stick-thin lead singer Peter Perrett sporting dark shades and possibly someone else's hair, looking like he's recently been exhumed but managing to sing 'Another Girl, Another Planet's' barbed lyric even higher than the original 1978 cult single, the New Order/Cure-influenced Black Kids from Jacksonville, Florida, who deliver their imminent hit, 'I'm Not Gonna Teach Your Boyfriend How to Dance with You', with a punk fervour rather missing in the watchful studio audience, and the veteran James Taylor, all expressive eyebrows, bald pate and measured croon, picking his way sweetly through 'Sweet Baby James'. Finally, Estelle returns to round things off with 'No Substitute Love'. Lenny Henry drops in for what Jools loves to call a 'pass by' and the whole shebang is over before you can draw breath. Wham bam thank you mam.

The first *Later... Live* looks like we've been doing it for years and, in a sense, we had. We'd had fifteen years' practice for this moment and so we aren't blinking as we sail into the prime-time spotlight. In fact, our delivery was already so smooth that the powers that be would eventually complain that it wasn't 'live enough'. We'd spent weeks working on refining the schedule, cutting back Janet's rehearsal time while adding to the number of songs to be performed during the evening with the hope of catering to viewers who might catch both shows. There were seven songs in the live show, twelve in the Friday pre-record including a slot for Neil Cowley's punchy jazz trio whom we sadly couldn't squeeze into the streamlined live show; fourteen songs in all, and the whole evening rushed by in a blur that many of the production team would never quite get used to. Initially we thought of the live half-hour as a kind of sampler for the pre-recorded 'proper' hour where the artists and the music could breathe, where there was room for six artists and exploratory moments like

Cowley's Nibs, where Jools could properly chat to Adele or a visiting Marshall Chess.

We were still the music show where all the artists play live and play together but the opening groove would become the closing groove of the pre-recorded show while *Later... Live* would kick off with the briefest of introductions from Jools and go straight into a big bold opening song from our opening act. There was less time to experiment, less time for Jools' links, but a new excitement in the air. Quickly the pre-recorded show became like an extended rehearsal in which the artists settled in before going live at ten o'clock. Going live raised everyone's game, all the bands performed with greater intensity, swimming in the moment, and Jools was back in his natural element. Live quickly meant that the bands were live-r, more intense, in the now. Better even, but in a way that was easy to experience in the studio but harder to quantify on television where it was always difficult to know if the viewers could feel the difference. The artists knew however and would constantly ask us to 'drop' their live performances into the longer, edited show. They rarely seemed to think they were better pre-recorded.

The Live half-hour rebooted *Later...*, giving it a new audience and a new electricity. But the show was still an eclectic smorgasbord, it was still all about the music, we had no narrative and not much jeopardy. Television was changing, becoming all about winners and losers, reality shows and talent competitions. *Later... Live* couldn't be that kind of beast. It was thrilling to be there in the studio, watching the audience and the artists rush out for a pee, a cigarette or a touch up from make-up when the recorded show finished some fifteen minutes before 10 p.m. A few minutes later the whole room would have reassembled, Jools would beseech the studio audience to tense up and give their all before the nation and, once again, we'd rush out of the traps. But it was hard to find a shape and a pace for the live show or leave enough space for Jools to own it. The live chats shrunk to a couple of minutes which barely gave him time to get going. We were a music show, after all, often the only one on British television. Alison and I always wanted to pile in more acts and more songs and there wasn't time in the schedule to offer more than an abbreviated version of the pre-recorded hour. We hadn't time to produce two different shows so we made two different versions of the same one. The direction, the camera work, the

lighting and the sound remained state-of-the-art even as mainstream television broadly retreated from live-to-air shows in favour of the greater polish and control of the edit. The cast remained a blend of the now and the then, the new and the older, but the live show always felt a bit breathless, as much hurried as exciting. Live television loves a bit of danger, a twist, and we were more intent on making the artists look and sound as good as possible than turning the show into a competition or deliberately fucking up. Our essential narrative in both shows remained an epicurean delight in music and a study in contrasts, more of a vibe than a plot.

Jools would always effortlessly bring a little live-ness. He knew instinctively when the show was too regimented, and he loved to unpick its seamless surface. He'd come to a stop in the middle of the floor during one of his links in the live show and suggest to the viewers that they all simply enjoy a moment of contemplation together, poking fun at the clock-watching rush of live TV. Television loves to move seamlessly on and Jools loved to ruffle its ordered regime where every second is assigned. Sometimes he'd deliberately walk across the studio in the opposite way that Janet had rehearsed, exposing all the cameras and the floor crew desperately trying to get out of shot. He'd play with the brief time allotted for his introductions, his hellos and goodbyes, his chats, but the relentless schedule of delivering two shows in a night didn't leave much time for gambolling. Our artists were always topical, the music kept changing and we'd find ways to signal that yes, we were live with a unique, one-night-only collection of artists, by grouping our bill together at the start or getting Jools to hold a daily newspaper or share some tidbit from that night's news. What we didn't have time to manufacture – even if we wanted to – was more car crashes or more play. The clock was now in charge.

That isn't to say that we didn't enjoy the occasional embarrassment; it's just that our shocks were more Brian Rix than Sex Pistols. Crowded House had first appeared on our third series in 1994 when they were in the first flush of their post-*Woodface* fame. Drummer Paul Hester had just left, but Neil Finn, Nick Seymour and Mark Hart delivered an epic performance of *Together Alone*'s 'Private Universe', culminating in a gauze screen behind the band featuring a projected Pacific Island landscape dropping Kabuki-style to reveal six bare-chested Polynesian male drummers in full headdress hammering away on a raised platform.

Jools lectures Neil Finn of Crowded House on timekeeping,
series 36, episode 5, May 2010. (BBC film still)

Staging this extravaganza was a bonding experience and although the
band split up for the first time a year or two later, Finn had frequently
returned to *Later...* with different projects over the years. In fact,
Crowded House were well into their second coming and had just
released their sixth album, *Intriguer*, when they joined Kelis, the
National and LCD Soundsystem in the studio in May 2010. The band
had just limped off a twenty-four-hour flight from Sydney on which
Neil must have refined the porno moustache he was then sporting. The
new 'Saturday Sun' was archetypal Crowded House and they offered
up 'Weather with You', their biggest British hit, as a treat for the finale
of the live show. Neil had attempted it on the show once before, back
in 1996, audibly struggling with his voice and a head cold. Unfortunately,
he was not about to make amends...

Right before Jools crossed the floor to thank his guests and welcome
back Crowded House at the end of the live half-hour, he'd joined the
Medway's very own Pete Molinari on piano for his rockin' 'Streetcar
Named Desire'. As a rule, Jools preferred not to deliver links right after
he'd played. Meanwhile the PA team in the gallery had calculated that
he had one minute and fourteen seconds for a closing link, a calcula-
tion which stage manager Antonia Castle promptly scribbled on one
of the idiot boards and brandished in Jools' direction, right in front of
Neil. The one minute and fourteen seconds were calculated for Jools'

Lana Del Rey, Jools and Abel Tesfaye of the Weeknd,
series 41, November 2012.

closing link which would follow Crowded House. But the band were
already into the first chorus of 'Weather with You' and figured the
timing on the board was addressed to them and therefore all that we
now had time for. Ever a willing participant, heavily jetlagged and
probably still juggling with what was for the band this new concept of
a live *Later...*, a laughing Neil proceeds to drop a verse or two, repeat
a chorus and wind up with a sadly abbreviated 'treat' that's done and
dusted in just under two and a half minutes total.

Jools is visibly delighted at this temporal confusion and the fact that
he has a situation on his hands. He's probably already a little weary of
being asked to talk to time because, well, he's not a robot. He also
knows he's standing in front of a seasoned live performer who's pretty
much game for anything. 'The fantastic Crowded House!' he announces,
lunging towards Neil whom he pulls out on to the floor. 'It turns out
we've got another minute!' laughs Jools. Neil makes to get back behind
the mike and play some more while Jools shrugs, 'Oh it'll only be thirty
seconds by now!' Neil apologises that he's messed up but Jools is having
none of it, he's ready to have his say. 'Hang on a minute,' he shushes

Neil while turning to camera. 'I'm just explaining. You see this is one of the exciting things about live television, sometimes it's perfectly timed and sometimes it isn't.' Crowded House are now sniggering back of shot while Jools holds court. 'A lot of you are probably sitting out there thinking, "Well, they could have been a lot more professional, maybe they could just give us a little bit more of a song?"' 'Alright, you want another one, then?' asks a confused but willing Neil. It's not clear whether Jools' 'they' is the show's production team or the band. 'What would you like to play?' rejoins Jools.

Neil is already strumming the opening chords of 'Better Be Home Soon'. He's crooning the first lines while Jools stands in front of him, almost humming, conspicuously in charge. 'Yes, nice,' Jools sighs appreciatively. 'You've only got thirty seconds now,' he threatens moments later, pointing to his wristwatch. 'We'll get to the chorus real soon,' Neil reassures his host. 'Yes, the chorus, come on,' urges Jools, who is walking up and down in front of the band as if conducting them. Jools claps boisterously as the final note tails off some thirty seconds later, the graphic end board cuts away from the live studio, while Jools can still be heard, clapping away and yelling 'Perfect telly, Crowded House!', just before an impatient Presentation whip the live transmission off air to make way for a couple of trails and *Newsnight*. TV Gold even if it's more *The Play That Goes Wrong* than L7 dropping their pants on *The Word*.

Later... had been live for five years when the BBC decided to sell off Television Centre and its studios. When we finished an emotional series 41 with a tenth and final episode featuring Lana Del Rey, the Weeknd, Palma Violets and Soul II Soul's 'Keep On Movin', we were homeless. We'd already spent months visiting every possible studio in London, too many of which seemed to be closing. We'd recced Pinewood, Wimbledon, Teddington, Elstree and ITV, to name but five. None of them clicked. We couldn't afford the hire, they had a curfew, they couldn't guarantee the weeks we needed, the studio was too small etc, etc. Then I remembered Maidstone Studios out in Kent, former home of such 1980s kids' shows as *Number 73* on which Iggy Pop once attempted to mount a teddy bear. The place was now co-owned by Geoff Miles, a former BBC entertainment director, and, as I now discovered, only a twenty-five-minute drive from Ebbsfleet where trains speeding to Europe then made their first stop, a mere seventeen minutes

'Why are all those people staring at me?' Jools rehearsing his
opening link in front of the queuing studio audience at Maidstone studios, 2018.

out of St Pancras International. Maidstone could not have been more welcoming, the studio itself was more than large enough, albeit rectangular rather than square like our old home at Television Centre, it was affordable, and it had the same fit-for-purpose sound mixing desk as TVC, a Studer Vista 8.

Jools, the deputy lieutenant of Kent, was initially a tad wary that we'd be simply too far from the capital and then realised that he'd only be twenty minutes from his country estate near Rochester. We were all nervous that artists might regard Maidstone as a bridge too far but touring bands just need a hotel nearby and our new location was never an issue. Most of the production team lived conveniently close to Television Centre, including myself. But in spring 2013 we commenced a new routine. Key production staff would stay overnight in Kent after the soundchecks and pre-lighting on Monday, travelling home after the show on Tuesday. There was a train at Ebbsfleet just after 11 p.m. we could make if we got our skates on and left promptly after the live show finished. We'd traverse a few Kentish motorways and scuttle down the stairs with seconds to spare to see the headlights of the London train rounding a curve and heading for our platform. We could be back in the smoke before 11.30, still buzzing.

Maidstone Studios are on a hill some distance above the town surrounded by roundabouts and a garden centre. There's nowhere else to go so the bands congregated in the canteen and in the dressing rooms which were just across from the studio on ground level. We no longer had the spurious but imposing authority of the BBC with its guarded entrances, newsrooms and occasional wandering actors. It was just us and the artists. Suddenly we were all in it together. We began to discover all of this when we started camera rehearsing the first episode of series 42 in spring 2013 featuring Laura Mvula, teenage rockers the Strypes, soul singer Charles Bradley, Cat Power and American singer-songwriter John Fullbright. We'd been going a long time already; Suede who'd starred on our early series were to open the show and had found time to split up for ten years until recently reforming for their seventh studio album, *Bloodsports*. *Later...* had grown and grown in the meantime at Television Centre. Now we were in a new venue with a room packed full of gear, musical and televisual. What could possibly go wrong?

Nothing does at first. The audience file in around 8.15 and we are on course to go live at 10 p.m. after recording the hour-long Friday show first. Of course, we are still getting used to our new colleagues from Maidstone Studios, our taciturn new engineering manager in charge of running the show technically, the Studios' electricians and their operations manager. But we've sailed this ship over and over without a hitch. The Kentish studio audience necessarily all seem to have cars and, week on week, will turn out to be older, less diverse and perhaps even more pleased to be there than those in White City. Halfway through the pre-recorded show, just after Cat Power has inched her way through 'Bully' at the piano, looking as radiant and as on the edge as ever, most of the electrics in the studio fail. Half the bands suddenly can't raise a sound from their monitors because the stage box into which all their microphones are routed and which connects to the main sound desk has failed. The team from John Henry's who provide the monitors and the PA are running around the walkways behind the curtain that encloses the studio floor, looking at miles and miles of cables. I keep asking Maidstone's operations manager Roland what the problem is and how quickly it can be fixed but I am not sure he knows. Our team looks worried and so does theirs. We have never worked together before. The bands are now sitting on the drum risers or have

retired to their dressing rooms. The electricians look baffled and the clock is ticking.

Janet is in her element. Not only is she a brilliant director but she's a vastly experienced operative and she's coming up with a plan to get us on air at 10 p.m. come hell or high water. It's 9.45 when we get the nod that at least the bands on the far wall of the studio are sorted and that both Charles Bradley and the Strypes can go live. But Suede and Laura Mvula seem to be more of a problem. Laura is making her show debut at the start of her career but we have known Suede and Brett a long time now and they are fatalists who know we are doing the best we can. We can't go live without our two opening acts. But Janet has come up with a brainwave. We have an EVS machine which can digitally play in recorded material. We have half of the pre-recorded show in the can including Suede's dramatic opening number, 'It Starts and Ends with You' and Laura Mvula's 'Green Garden'. So, we rehearse Jools' opening link outside the studio so that he can make an entrance and then we can cut to the performances we've already recorded. The opening of the show will be live and the first two numbers pre-recorded an hour or so earlier. We can record the rest of the pre-recorded show after the Live one has come off air if ever anything ever gets fixed. With five minutes to go, Suede's stage still isn't working but we have the green light for Laura Mvula. So, Laura will now finish the live show with 'That's Alright'.

Most of *Later... Live* will be live including Jools' chat with Brett about Suede's comeback and meanwhile the electricians are rerouting the cabling around the room so that we will be able to have power to all the band areas by 10.45 and can finish the pre-recorded hour. When *Later... Live* comes off the air, the electricians work feverishly and we are finally able to record the second half of the hour-long show including two Suede songs, 'For the Strangers' and 'Hit Me'. It is a baptism of fire with Maidstone Studios, a bonding experience. They immediately invest some money in their power supply and back-up, and we never have such technical problems again in the eighty-plus *Later...* episodes and six *Hootenannies* that we shoot there between April 2013 and winter 2018. It's a lot more travelling for everybody, but the Studios are a home from home. We all love the new intimacy and camaraderie with the artists there. Now we are all in it together. But I also love seeing the train come out of the darkness at Ebbsfleet at 23.02 to whisk us

back into the bustle of night-time London, even though I hate rushing off so quickly after the Live edition with no time to chew the fat with the production team or the artists post-show.

Later... has always thrived on the integrity and the emotion of performance, whether it's At the Drive-In bouncing around like jumping beans screaming their truth or Portishead rooted to the spot, smouldering their way through 'Glory Box'. They are both scintillating – Portishead tear at the heart but I guess only ATDI threaten the furniture. It's true that rock 'n' roll thrives on the small screen when there's a whiff of danger in the air, right back to Elvis Presley grinding his way through 'Hound Dog' on *The Ed Sullivan Show*. But I am finally not sure it matters if rock 'n' roll TV is broadcast live to air or is recorded as live as long as it's visceral and in the moment. Iggy Pop is the proof. Iggy had dropped into the show for an interview at Television Centre in 2010, bumping into fellow chat guest Ozzy Osborne, watching Courtney Love and Hole do their thing and Mumford & Sons make their debut and no doubt sizing up what he would do to the *Later...* joint if his time ever came.

Come May 2016 and here he was back in England, at the very end of touring the *Post Pop Depression* album which he'd written and recorded with Josh Homme of Queens of the Stone Age with Arctic Monkeys' Matt Helders on the drums, both *Later...* regulars. Iggy was still bright-eyed and tiny, one shoe much higher than another, as one of his legs is an inch-and-a-half shorter than the other due to scoliosis, the sideways curvature of his spine. He didn't look sixty-nine except when he took his shirt off. They'd played the Royal Albert Hall a few nights before and now here they were in Maidstone, Josh and co. coming on like an Irish show band in maroon dinner jackets, hamming up the sleaze, Iggy returning to the scene of his molestation of a stuffed toy on children's television some thirty years earlier. Some of the new songs even had moves – Iggy, QUOTSA guitarists Dean Fertita and Troy Van Leeuwen stage right at the start of *Post Depression*'s 'Sunday', riding Josh's circling riff, arms swinging back and forth in unison with their two backing singers, then clapping to the beat and swinging their hips. It could have been hammy but actually it was joyous, while Josh's flair for funky metal and architectural riffs ignited both Iggy the primal showman and Iggy the savvy, battle-worn poet.

Both shows finished with an Iggy classic neither of which we

rehearsed. I think Janet agreed with Iggy that the room should now belong to him and placed her cameras to give him maximum space while catching as many of his moves as possible. The pre-recorded 'as live' show ended with 'The Passenger', and the moment that seesawing riff kicks in, Iggy is out in the middle of the floor, arms flailing madly, the Lord of Misrule having a toddler tantrum. The show's usual geography and discrete areas are chaff in the wind. Moments later he's back at his mike and the jacket is coming off to cheers from the crowd as Iggy gets into character. The trousers are hung low, the hair is flailing, Iggy is doing what he does. Then he's back out in the floor, the white mike stand is discarded, and he's prowling the room while the band churn away. Thank God for in-ear monitors because the whole studio can now be his oyster. He's high-fiving the guests seated uncomfortably at tables while the rest of the room is on its feet. He's stalking from corner to corner to hang with the studio audience who have dissolved into a seething mass of joy, bouncing and clapping, and everything is looking good tonight. He's dancing through reggae singer Protoje's stage, nodding to the man himself, and then he's over with country singer Margo Price who scoops up her long dress at the knee so she can shimmy with Iggy. It's a rock 'n' roll bacchanalia, no alcohol required, and it builds and builds as Iggy croons the verses as if the city where the song is set and this very studio are one and both belong to him. Then there's the singalong chorus and the whole room is 'la la'ing' along, almost shouting it out because it's too much fun just to sing it, and there's a sea of faces in every corner of the studio, just singing and clapping in a frenzy. Iggy comes across the white mike stand still lolling on the floor and kicks it away. Now he's The Passenger again, watching the stars come out as the band first drops out and then kicks back in for the chorus while Iggy dances back-to-back with a game blonde girl in a corner of the crowd. When they finally finish, Iggy waves to all, calling out his thanks to Margo and French singer Lou Doillon, saluting his dance partner and the particularly rampacious crowd in her corner. He's treated the whole room as his own, dissolved all the usual separate stages into a single ecstatic throng and sung his heart out. *Later... Live* is twenty minutes away when Iggy's finished but the whole studio is already aglow.

It's hard to know how Iggy can top 'The Passenger' in the live show but we've thrown caution to the wind, he and Josh are playing five

songs over the two shows, no repetitions. The minute Matt Sweeney kicks off the bass riff that drives 'Lust for Life', around 10.25 p.m., the bacchanalia is on again. Iggy and David Bowie wrote the song on a ukulele nearly forty years earlier, around that irresistible beat they reportedly nabbed from the Armed Forces Network call signal in Berlin which also harks back to the Supremes' 'You Can't Hurry Love'. The band build and build, hips swaying, knees dropping, and Iggy's nowhere to be seen. That's because this time he's making an entrance like a footballer emerging from the tunnel. He's been malingering at the back near the drums and then thirty seconds in, right on a key change, here he is, bursting into the centre of the floor, arms waving everywhere, marvellously uncoordinated as if no pattern or choreography could possibly contain him. Josh shimmies forward into the room before retreating to his mike for a showbiz intro, 'Ladies and gentlemen, Mister Iggy Pop!'

For the first half Iggy's rooted to his mike, fronting the band, but halfway through as he hits the chorus, there's 'Here we go, baby!' and he's off, stomping round the room, one leg almost trailing now as his scoliosis worsens, with a bad-ass grimace on his unshaven face and the light of battle in his eye. Initially he's indifferent to the cameras, charging towards the large crane which catches him as he passes by beneath like a rioter who's stormed the building. The jacket's coming on and off his shoulders, that wrinkled torso is out and now he's singing to Margo and her band who are all lined up and wigging out as Iggy tells us that he's just a 'modern guy'. There are cameras everywhere backed into the corners of the floor and now Iggy's all over them, singing into the lenses, beaming into your home in close-up. The female BV's aren't on this one but Iggy seeks them out in their corner, hips wiggling along, giving him the glad eye, and then he's off again, roaming the floor. There's a lot of lyrics to 'Lust for Life' which draw on William Burroughs' cut-up novel *The Ticket That Exploded* so Iggy's busy on the mike throughout, swapping it from hand to hand, and with more singing, he's maybe less mobile. But the whole room is churning again, levitating, every corner a sea of bouncing faces. Finally, he heads back towards the band for the finale with a sudden 'Alright, cocksuckers!' whose possible offending impact on the viewer has been anticipated by a pre-show language warning from Presentation in accordance with BBC and Ofcom policy. The whole band is singing as they speed to the end,

chanting the anthemic title line over and over, they've all got a lust for life. It's ecstatic, Dionysian, and while Iggy is the master showman, the centre of attention, it's curiously communal. No other artist has ever shrunk the fixed *Later...* circle into a single stage, bands and audience united in one churning frenzy. Both performances break the fourth wall, both are joyous, both feel live and in the moment. One is broadcast live to air and one isn't, but you can't choose between them. They are both as live as it gets. Live and as live.

Iggy on the rampage, series 48, episode 5, May 2016.

Jack White

Every time I walk into the *Later...* studio, the first thing I think is 'God, I wish we had something like this in America', and the second thing I think is 'This wouldn't last too long in America. It's too good!' That's not an insult to Americans but to the system of prime-time television here; they only want those glossy competition shows, *America's Got Talent*, *The Voice*. If the music's too good or too interesting, you lose middle America.

When I first came to *Later...* with the White Stripes in 2001, I was bewildered, I didn't understand the concept, I was like 'All the bands are here in the same space at the same time, what is this? Is this like a competition?' I didn't know exactly what was going on, it hadn't been explained to me properly. I almost didn't know how to take it and it was hard for me to know if we could fit in, I was like 'Wow, I hope we don't look terrible compared to all these great musicians!'

But I walked away really happy, it was very cool to experience, and I couldn't wait to tell my musician friends back home, show them a VCR and tell them, 'Look at what they have over there, it's beautiful!' What it really communicated in a bigger way along with John Peel and the way the White Stripes were welcomed and championed in England was that 'Wow, people in Britain really love music!' Why can't we have a John Peel, why can't we have a Jools Holland show?'

The show is inspiring because you're in the company of greats and people you don't know who are all incredible musicians: it's a good thing as an artist to absorb it and use it to your advantage. When we first went on there we were intimidated and we didn't know how to respond, the second time I couldn't wait to get in there. The same thing happened when I did the *Cold Mountain* soundtrack. I walked in the first day to a room full of great bluegrass players and they asked me

Dave Stewart plays gooseberry between Amy Winehouse and Jack White, series 28, episode 1, November 2006.

to sit in and I was like 'Oh no, no, no, you guys go ahead...' I realise how stupid it was of me to refuse that invite because I should have jumped right in and been confident enough to get their approval. I lost a little bit of their respect and I had to fight to get it back from that crowd. Some of them I never got it back. So, I've learned from that and from that first time on Jools, to jump in.

Then you're back in that *Later...* studio and Nick Cave's there, and you're hoping to do something that will turn him and everybody in this room on, and that he'll do something that will inspire the artist next to him and it happens, it really happens! As the music goes round the room, the temperature rises as the bands bounce off each other. It's a brilliant concept; it pushes people to be creative and it's not like you're just putting six rock 'n' roll bands together, there's maybe an R&B act and somebody from Africa and somebody who plays the sitar and then it's a pop singer... It's just brilliant to have that kind of forced community in a room and I love the idea of encouraging the artists to stay on set, that's a smart move that makes it feel even better.

I'd never even heard of Amy Winehouse until I was in that studio the second time with the Raconteurs in 2006 so it was great to discover

her. We were next to each other when they took the group photo and she seemed quite cold to me and disinterested in talking. I thought, 'Hmm, she doesn't seem to be a fan of mine or interested in speaking about music or anything.' So, I was like, 'Er, OK.' Years later I met her in the hallway of a festival with Jay-Z and Beyoncé and she apologised for being that way. I said, 'What do you mean?' She said [Jack does a female North London accent], 'My boyfriend at the time said if you eye-fuck Jack White one more time, I'm breaking up with you!' So, you can never know why someone's coming off cold to you! How cool is it that these moments on the show breed these encounters?

I was on the same show as Smokey Robinson when I came with the Dead Weather in 2008; we're both from Detroit, we're from different generations and different genres, and now we're sitting across the room from each other playing music in the same room in London. How bizarre is that! He arrived late and I didn't get to speak to him. When you create a programme like *Later...* you create these moments and these scenarios that would never have happened anywhere else. I have never been in the same room as Smokey Robinson since.

Fifty per cent of the time when I am with my kids and we see a cool band or artist on television, I can say I met them or saw them at Jools Holland! It's a meeting place where you're able to commune with another musician. Even at festivals it's hard to meet up with other musicians and bands and discuss the paths and careers that we have in common. By chance, Muse were on both the first two times I did the show and, years later, they came backstage at one of my gigs and we're chatting about music because we met at Jools. Bon Iver as well, that's where we met – when he came on for the first time and did 'Skinny Love' in 2008 when we were back there with the Raconteurs. We've seen each other again several times at shows and hung out since, late-night drinking in New York. I'd never heard of Grimes until she played in front of me on my first solo album in 2012 and I always check out her music now. Seasick Steve I saw just in footage; I wasn't there with him. We're good friends now, I have recorded with him and played onstage with him and that's just from watching clips of the TV show.

The Seasick Steve thing is the perfect example of what can happen with Jools Holland. You can have this moment when the stars align and everything's in the right place at the right time, somebody can go up and play a block of wood and it becomes sensational, everyone's

watching the clip even if they didn't see the show, and they talk about it and share it the next day at work, every once in a while, that's going to happen. Somebody maybe nobody would have cared about otherwise, releasing albums and playing festivals and being on the pop charts and not in any kind of a fake way either. The music was real. He's a great example, I love telling people about that.

Later...'s a great place like that. You never know what's going to happen. I am sure you have moments when you have a couple of shows in a row when nothing magical happens but then, all of a sudden, it happens again. Things align and the magic happens. And what was different? You didn't set out the lights any differently, it's just the air in the room and the spinning of the world, but you gotta keep the cameras on and keep pushing and keep trying, waiting for those moments to occur. It's the same in the recording studio; you write a great song but when you come to record it, nothing happens on Monday, then you come back to it on Wednesday and Boom! Nobody knows why but thank God that tape machine was running! But it's so great that the institution is there and stays there, you know?

MR. JOOLS

THANK YOU KINDLY
SIR. I WILL THINK
ON THAT IDEA OF
TAKING OVER THAT
SHOW FROM
YOU IN THE UNLIKELY
EVENT OF YOUR
PASSING.
HAH!

RESPECT
JACK
WHITE
|||

Kanye West, Yeezus, gets minimal with Charlie Wilson, series 43, episode,
September 2013.

11

Ready Or Not/Fix Up, Look Sharp

Hip-Hop/Grime

When Kanye West finally walked into our studio in Maidstone in September 2013, Alison and I were chatting at the other end of the long rectangular room and we both held our breath. Kanye had first come on *Later...* back in 2004 when his rap career was taking off with his debut album, *The College Dropout*. Nine years and five albums later Kanye was now a troubled and increasingly confrontational superstar. He was about to release his inflamed sixth album, *Yeezus*, while beginning to establish himself as a designer successfully blending streetwear and high fashion. Kanye had been fighting a one-man war against institutionalised racism and glass ceilings in the United States since he first charted while he was recurrently demonised as uppity, mad or both. It was Kanye who'd called out the president in the immediate aftermath of Hurricane Katrina back in 2005 – 'George Bush doesn't care about Black people...' and Kanye who'd bum-rushed Taylor Swift at MTV's VMAs to protest her video being preferred to Beyoncé's in 2009. He was still a year away from marrying Kim Kardashian, which would take his fame to yet another level, and his fortune was a long way from the $1.8 billion at which it would be estimated come 2021. But he was already Kanye West, goddammit, and Alison had spent much of the last two weeks in late-night conference calls with his label and management negotiating whether he would come at all.

For my tuppence worth, I'd insisted Kanye had to come with a singer because the vocals were so integral to the single 'Bound 2' that I couldn't imagine a performance without one. I couldn't see Kanye performing to a disembodied vocal backing track like an exaggerated PA. In the end, and despite budgetary constraints, he'd brought along

Charlie Wilson, the singer who was all over the record and would prove to be a brilliant and dynamic foil come showtime. But many of Alison's evening calls had focused more on staging and lighting and so we watched as Kanye and his plugger Helena McGeough walked into the room and stared at his performance area. It was the first show in our forty-third series and our already battle-worn set had been hung from the rafters over the weekend. The abstract white pieces behind Kanye had been suspended in mid-air in the formation we nicknamed 'pick-up sticks'; they looked as if they'd been hurled at the black curtain backdrop and then freeze-framed in a random but geometrical configuration. Kanye had the stage at the far end of the room to himself, Charlie and two DJs stood waiting beneath the sticks ready to sound-check. Kings of Leon, Sting, Lorde, Drenge and former Righteous Brother Bill Medley had already been booked when Kanye finally came on board and their gear was already set for action around the room. Helena had dealt with an exact rider that required a totally white dressing room, full of white flowers. After a couple of minutes staring upwards and then round the studio, an exasperated Kanye muttered something to Helena and his aides and spun on his heels. Alison made her way over to discover the verdict. 'Anyone who knows me knows I can't work with angles,' he'd shrugged, pointing at the airborne pick-up sticks.

I don't know what had been said in those conference calls, but I am not sure that either Helena or Alison had gleaned the impossibility of angles. Or perhaps we simply hadn't listened hard enough because the set was an integral but understated part of *Later...*'s identity and no artist had ever taken against it before. In Maidstone the set would be hung at the start of the series and then stand for the six-week run. We hadn't yet reached the point where each configuration above each stage would remain unchanged throughout, but, while we would tweak the height and layout most weeks, the set pieces largely remained in situ. It was expensive and difficult to move them. Neither Kanye nor Helena was interested in our budget-driven logistics, however. Kanye simply wanted to be filmed against the black cloth curtain behind the set pieces. He didn't want angles, he wanted stark. He wanted our set gone. Fortunately, the studio hands and machinery required to lift the pieces were still on site and Kanye was assured the pieces would be raised or removed overnight. He

Kanye and Lorde make friends, series 43,
episode 1, September 2013.

put up with their continuing presence long enough to sound-check
while he and his team informed director Janet and lighting director
Chris Rigby about how he wanted to be lit and shot. This wasn't
uncommon; a growing number of visually attuned artists now came
with their own lighting directors in tow. Over the next few years any
major label act making good money came with a creative team whose
job was to instruct our production team in the precise nature of
their vision and, frankly, how to do our job. The big budgets and
unique performances required by award ceremonies and *The X-Factor*,
let alone the vital importance of videos and arena tours, would
quickly turn global artists and their creative entourages into aesthetic
storm troopers. Kanye's outfit were politer than many but no less
determined.

Meanwhile Charlie Wilson was a revelation in soundcheck. I
couldn't believe that the voice of the Gap Band whom I'd adored in
the early eighties was now sixty and in the house. He looked and
sounded fantastic. Although he regularly featured in the US adult
contemporary and R&B charts, 'Uncle Charlie' had never launched

a successful international solo career and hadn't been to Britain in years. He was a sleeper in the UK if you hadn't been checking Snoop Dogg's collaborators or Kanye's 2010 album, *My Beautiful Dark Twisted Fantasy*. Now here he was, going toe to toe with Kanye, chucking out searing vocal phrases while lighting up the room with his energy and enthusiasm. Uncle Charlie radiated bonhomie alongside the brooding Kanye.

When the artists assembled for the show the next evening, Kanye was last in while the rest of the cast waited for him to join the group photo. He chatted with Jools and then the teenage Lorde who was debuting with her hip-hop inflected global hit, 'Royals'. I am not sure the studio audience were quite his crowd but then he hadn't come to entertain, he was there to do his thing. Overnight the pick-up stick sets had been raised and a couple of pieces removed. Kanye had returned for his camera rehearsal and barely looked behind him. He'd been assured there were now no angles to work with. KOL, Sting and co. were all framed by the iconic *Later...* 'sticks' while his area looked undressed and unformed to the naked eye. But, still, Kanye was palpably there in Maidstone, in the room, on the show.

Back in 2004 *The College Dropout* had turned hip-hop on its head with its soulful production and the poetic intensity of Kanye's lyrics. Kanye's hip-hop was radical because of the emotional complexity of both his arrangements and his sentiments. His father had been a Black Panther and a photojournalist, his mother was a college professor. Kanye was one of the first middle-class, college-educated rappers. He wanted to make you feel his self-belief and his self-loathing. He wasn't afraid to implicate himself in his takedowns even as he confronted the white-dominated society that maddened him. He hated the things that he loved, and he loved the things he hated. Nine years before, Kanye had been accompanied at Television Centre by soul singer Syleena Johnson, a violinist, and the then unknown John Legend whose debut album, *Get Lifted*, wouldn't come out until the end of the year. Kanye famously dressed preppie back then in a colourful striped sweater and roamed his area like a man on fire, spitting 'All Falls Down's' tale of a coasting college girl that morphs into a critique of the contradictions of Black materialism in white racist America. 'Things we buy to cover up what's inside/'Cause they make us hate ourself and love they wealth'.

Kanye's *Later...* debut was a late addition to a show that already featured Ash, PJ Harvey, Tinariwen, John Martyn and Amp Fiddler. John Legend 'borrowed' Jools' piano, with Kanye, Syleena and hip-hop violinist Miri Ben Ari out front. There was no set in the piano corner at the time so Kanye and co. were surrounded by standing studio audience, many of them follicly challenged and in the characteristic poses of wary onlookers, arms folded or hands in their pockets. There was something mortifying about watching Kanye and Syleena in full flight in front of our largely bewildered and predominantly white studio audience, especially when Kanye struck his Jesus pose, already the Black Christ, suffering for the sins of his society. Four years before Jay-Z headlined Glastonbury, hip-hop was still largely antithetical to British rock culture.

Perhaps Kanye had done his research and watched this 'All Falls Down' before he returned to the show because this time his staging stripped away any sense of the studio at large. Janet's cameras simply doubled down on Kanye, Charlie and the barely lit DJs on 'Bound 2'. Kanye had come out in camo coat and a gold chain, and as Charlie repeated the chorus, he simply spread his arms wide, striking his Jesus pose for half a minute or more. 'Bound 2' has something of the soulful feel of Kanye's early productions like 'All Falls Down'. British DJ duo Sigma would take their version to Number 1 a year later. 'Bound 2' was followed by the searing 'New Slaves', a takedown of systemic racism and how Black people in America, rich and poor, continue to be enslaved. Charlie's in dark sunglasses freestyling passionate vocal lines as if into Kanye's ear, while Kanye himself stands stock still before launching into his verses in a diatribe against racism and consumerism, a man who can't and won't be stopped. Janet's cameras barely move, Kanye and Charlie's energies caught in complete contrast, especially in the cross shots. There's nothing communal about these performances – the studio lights are dropped so the pair are framed in darkness; no set is in sight, no audience, and no other artists. It is almost anti-*Later...* Kanye is half-lit, framed against the black backdrop, and we are totally in his world.

Kanye finishes on his own with the devastating 'Blood on the Leaves' with its sample of Nina Simone's 1965 version of 'Strange Fruit'. I am not sure this was even in our original running order, but Kanye ran it on the floor in soundcheck and it was spellbinding, an almost suffocatingly

intense six-minute soliloquy, Nina's sampled and ghostly voice echoing around the studio with its ghastly evocation of lynching – Black bodies, a Southern breeze, poplar trees – while Kanye excoriates an affair gone wrong, an unwanted pregnancy, something and someone painfully lost. As the tune builds to its end, his heavily autotuned and distorted voice is hitting a high note that's almost a scream of pain. He's telling himself to 'breathe' and then 'breathe' becomes 'breeze' as the terrifying scenario of the lynching and the emotional devastation of the affair intertwine. It takes daring to recontextualise 'Strange Fruit', the two narratives shouldn't work together but they do. Kanye's performance that night was minimalist in the extreme. There were no angles and nowhere else to look, just the sheer power of his personality, his arrangements, his partnership with Charlie and his rapping. He'd designed his stage and the aesthetic of his television 'capture'. Our team had delivered it but it was his vision. Bruce Springsteen praised his performance in interview, Christine and the Queens singled it out as her favourite *Later...* session in one of the archive and interview shows during lockdown and it heavily influenced the aesthetic of her own debut performance of 'Tilted' in 2016, although Héloïse had no issue with the pick-up sticks behind her. Or the angles.

Hip-hop was part of *Later...* from the beginning, with conscious rappers like dc Basehead and Me Phi Me appearing on the first series. I'd written about the emerging rap culture since the last eighties, visiting the Def Jam offices in New York, interviewing EPMD, Big Daddy Kane and Chuck D, analysing this new phenomenon as it crossed over to white teenagers as the new rebel music. I'd headed out to the West Coast to interview Ice Cube on his porch in Compton as NWA took on the police in LA. I'd experimented with filming hip-hop performances for *The Late Show*, bringing the likes of Boogie Down Productions, Queen Latifah, Public Enemy and Jungle Brothers to Lime Grove in 1990. But *Later...*'s emphasis on musicianship as theatre and early 1990s hip-hop's tendency to stick to PA-style performances with just a rapper, DJ and optional hype man didn't always gel. Hip-hop was its own economy and its own tribe then, a world apart, and most of its stars didn't go on television in the US, let alone in the UK where they'd jet in for a couple of days, chat to Tim Westwood on the radio, play a show and fly home.

Guru's Jazzmatazz helped bridge the gap. Keith Elam hailed from Roxbury, 'the heart of Black culture in Boston', the son of a judge and a director of public libraries. Keith became Guru, an acronym for Gifted Universal Rhymes Unlimited. He teamed up with DJ Premier from Houston, Texas, and formed the innovative hip-hop duo Gang Starr, who put out their debut album, *No More Mr. Nice Guy*, in 1989. Gang Starr were streetwise, smart, part of the Afrocentric artistic surge in Black America at the dawn of the new decade. Their funky history lesson, 'Jazz Thing', featured in Spike Lee's 1990 jazz-based comedy-drama, *Mo' Better Blues*, while the archive-heavy video paid loving tribute to the Afro-American jazz tradition, from New Orleans to Count Basie. Guru's rhymes were smart and sassy, hardcore but socially conscious; in an era that now seems almost innocently combative he's positively educational, seeking vital knowledge for what he calls his 'street ministry' while calling out his enemies as 'suckers'. Guns and bullets are still just metaphors, this isn't gangster, but there's a sombre authority to Guru's flow and the groove is always pure funky-dark New York with its low-slung shuffle and bass-heavy undertow. Gang Starr were signed by Chrysalis, the British-originated label, and accordingly spent a lot of time in London where jazz was hip and happening, thanks both to the Acid Jazz scene and the generation of young Black British players who'd got a start in the Jazz Warriors in the late 1980s.

Guru was a substantial voice and he clearly knew how to sell a vision. He launched the solo project *Jazzmatazz* so he could move from crate digging and sampling to cutting live music with the best of the veteran and new young jazz talent. As he explained to Jools, 'The concept is basically to bring the generations together so I'm trying to get the older jazz cats who regard jazz as a living music together with the younger jazz cats who are close to the era of hip-hop together with some vocalists and put it all together in a mixed bag.' There was a lot of money about in the record industry in the 1990s and Guru was already on his second *Jazzmatazz* album when he came on *Later...* in late 1995, opposite the Human League, Cast, Emmylou Harris, Daniel Lanois and Steve Earle. Spread out across their stage with a giant New York cityscape hung wide above them, Guru featured a brass section of the legendary jazz trumpeter Donald Byrd whose career spanned from hard bop to fusion alongside young British saxophonist Steve

Williamson. He teamed up with the Style Council's Dee C. Lee for the swinging 'No Time to Play' while Jools sat in on the chill-out groove, 'Feel the Music'. The vibe and the musicianship were cool, *Jazzmatazz* suited the *Later...* forum but I am not sure the project really resonated with hardcore hip-hop fans. Maybe it was just too conceptual or perhaps just too right on.

The Fugees had no such problems connecting a year later. Black and white music were utterly segregated in the States back then, especially on American radio. The Fugees drove a truck right through this and their second album, *The Score*, went on to sell 22 million copies worldwide. I'd been to catch a showcase in central London in early spring 1996 as their debut album *The Score* began to blow up. They had a live band, they had three dominant personalities, they set out to entertain and Lauryn Hill was palpably a star. The Fugees had a powerful sense of where they came from, quoting from Bob Marley and reworking Roberta Flack's 'Killing Me Softly with His Song' around Hill's silky, soulful vocals. This was the gangster rap era when hip-hop was all guns and bling so, in contrast, the Fugees felt like a warm summer breeze with their 'One time, two time' and the doe-eyed Lauryn advancing upstage to charm the audience. When they brought their band and crew to Television Centre, they lit up the studio. They had live drums, Wyclef played the odd guitar solo, they had huge choruses. But they also highlighted once again how our studio audience wasn't sure how to respond to hip-hop; they'd come to watch, not party, and they were set behind the band. The Fugees brought the show while our punters eyed them warily and shuffled their feet. Half the Fugees' crew sat on their stage, grooving along while Pras Michel dedicated 'Killing Me Softly' to 'the hard core' who were palpably not in the house. Lauryn drew all the light in the room but our presenter, nearly all our crew, our audience and all the other artists on the show – Crowded House, Ash, Patti Smith, Booth and Badalamenti, Norma Waterson and Richard Thompson – were white. BBC Television Centre itself still represented the white establishment and the old guard. Our bills back then were always pretty eclectic and consistently featured Black music, from Nu Soul to so-called World Music, but the norm was probably still white guys with guitars. Indie mutated into Britpop and then eased anthemically towards the

The Fugees, 'Ready or Not', series 7,
episode 5, June 1996. (BBC film still)

mainstream with Travis and Coldplay in the new millennium. But, unlike hip-hop, guitar music didn't thrive televisually on a crowd reaction; it wasn't call and response like the Fugees. You could always watch the solos and the drums.

Ice-T was nearing forty and a gangsta rap veteran when he came on *Later...* in 1996, six years after his stellar performances down the road in Lime Grove. *Late Rap* had demonstrated Ice's natural command of the camera and he continues to enjoy a screen career to this day. He began acting in the 1991 movie *New Jack City* and has starred as Odafin 'Fin' Tutuola in *Law & Order: Special Victims Unit* for twenty-two seasons, making him one of the longest-running prime-time live action heroes of all time. Despite his hustling teenage years, he's ironically mostly been cast as a cop. He's hosted true-crime documentaries and even had his own reality series with his wife Nicole 'Coco' Austin, *Ice Loves Coco*. His hardcore band Body Count nearly brought Time Warner to its knees in 1992 with their 'protest song' 'Cop Killer' which took NWA's beef with the LAPD several steps further and was widely condemned by the likes of George W. Bush,

the PMRC and Charlton Heston. Incredibly, Body Count are still going, winning a Grammy in 2021 for 'Bum-Rush'. Although Ice was already old skool compared with younger mid-nineties rap stars like Tupac, the Notorious B.I.G. or Snoop Dogg, he had plenty of form when he released his sixth album, *Ice-T VI: Return of the Real* with its anthemic centrepiece, 'I Must Stand', a hymn to Black solidarity and fallen gangster comrades from back in the day.

We built a high platform tower for Ice-T's DJ, topped by a large portrait of the man himself who sat on the steps leading up to the decks, flanked by two of his posse fronting as bodyguards. When the lights dropped in the studio after Cowboy Junkies' 'Blue Moon Revisited', Ice kicks in with his opening lines, shaking his head over how tough life seems to be on the street before standing up slowly while the chorus plays. The DJ tower is flanked by six television monitors filled with Ice's close-up from the video. He's his own Greek chorus, helped out by the lamenting voice of soul singer Angela Rollins played in by the DJ. Ice sports shades, a double-breasted suit and a homburg as he strolls slowly into the middle of the floor where he delivers his sorrowful account of the gangsta life he's managed to swerve while jousting with a handheld camera. His right arm echoes his flow as he gestures down the lens and he bosses the camera, before retreating to his tower and his echoing TV monitors for the choruses, telling it like it is. His tone is measured, his voice deep. It's as much spoken word as rap, even as he keeps rhythm with the snare. He's recounting his hustling days and the fall he should have taken, courtesy of the FBI, who could have brought multiple charges and an unending sentence. He knows he's had a lucky escape, his buddies in the pen who paid the price tell him so, and he ends the piece by admonishing his Black brothers to get a grip and not succumb to crime while he and his crew drop their heads and raise a fist, Black Power style. It's pure hokum and that's a compliment, the kind of drama that works best on a stage. Ice-T had become a surviving elder statesman; his younger peers were selling albums by the truckload even as their life expectancy shrank with their success.

Ice-T kept his hip-hop career and his hardcore rock band Body Count strictly separate. There's always been a tension in hip-hop between artists who focus their live work totally around their rapping

with a DJ in the background almost as an afterthought and those who want to bring an element of musicianship to the table. Philadelphia's the Roots are perhaps the ultimate embodiment of the latter tradition, live musicians to their core. They've been described as 'hip-hop's first legitimate band', a proposition that made so little sense when they started out at the end of the 1980s that they had to come to London to build a rep and release their 1993 debut album, *Organix*. They've been Jimmy Fallon's house band since 2009, collaborated with everyone from Elvis Costello to Betty Wright, and drummer Ahmir 'Questlove' Thompson is one of Black music's great enablers and archivists, directing 2021's *Summer of Soul* documentary which rescued 'The Black Woodstock', 1969's Harlem Cultural Festival, from the vaults.

The Roots were on their third and breakthrough album when they came to *Later...* in 1999 opposite Stereophonics, Texas and Beth Orton. The Roots perform beneath a giant portrait of their ferocious-looking drummer who proudly boasts a natural Afro, and they are palpably a live band, honed in performance, Hub's bass and Questlove's drums ebbing and flowing behind Tariq 'Black Thought' Trotter's profound rhymes celebrating the 'hot, hot music' on their manifesto 'The Next Movement' with its early take on what would eventually become an internet craze, the so-called Mannequin Challenge. Cue the whole band freezing into a pose for a few seconds, like your television's suddenly frozen on pause. What better way to demonstrate that this band is live?!

The Roots have their own groove and their own presence with shout-outs to the BBC and Jools Holland into the bargain, even if the *Later...* studio audience still don't seem quite sure how to respond. Main rapper and co-founder Black Thought fronts 'You Got Me', a complex study of trust and independence in a relationship whose lyrics lend the album its title, *Things Fall Apart*. The Roots were close affiliates of the Nu Soul school and they'd recorded this troubled love song with breakout Texan superstar Erykah Badu while touring it live with co-composer and fellow Philadelphian Jill Scott, who'd yet to launch her own solo career. Scott didn't make it to London this time around but was depped by the soulful Lynette Braithwaite. But alongside their R&B links, the fluidity of the rhythm section and Black Thought's verbal and philosophical skills, what distinguished

the Roots as a live outfit was the extraordinary beatboxing of Rahzel Manely Brown. Another Roots discovery who'd go on to collaborate with Björk, Toots Hibbert and Bring Me the Horizon, Rahzel is a verbal turntablist and beatboxer who can sound like a DJ scratching while pumping beats out of his lungs, lips and cheeks. Rahzel took solos on both Roots' tunes, replacing DJ Jazzy Jeff on 'The Next Movement', and we pulled him out of the band for a solo demonstration. The Roots had found their own solution to live hip-hop and broken through on their own terms, as a band.

Later... was so well-established as a musicians' forum by this point that we could now celebrate the dynamic exchange between rapper and live DJ. When Guru returned to Television Centre just a couple of weeks after the Roots' visit, performing in the classic hip-hop style – just DJ Premier's decks and a couple of mikes – Gang Starr had already been going a decade and were on their first 'Best of...' collection, *Full Clip*. There were no jazz sidemen to focus on this time around, but Premier is one of the great live DJs and what had once seemed rudimentary now seemed authentic, just a rapper and a DJ. Classic. We wanted to find a visual aesthetic that would suit Guru's rapid-fire delivery and animate such stark presentation. Premier's decks and table were rolled out on to the floor while the Mavericks played and placed in front of the Pretenders' stage backdrop, a Maoist-style portrait of Chrissie Hynde, the cover of the *Viva El Amor* album. All the ped cameras and the jib arm parked in front of the bands or hid in audience corners, leaving the whole centre of the floor for Guru and a handheld camera. After Jools' introduction the studio lights drop, and beams rotate randomly across the floor like searchlights. Guru and Premier start off together round the decks, copping a tough pose and calling out the haters with a vintage boast and the obligatory metaphorical gunspeak. Premier sports a do-rag round his head and acts the hype man, echoing Guru's boasts while scratching. Meanwhile Guru is in dark glasses, a leather jacket, and a trilby. He looks like one of those streetwise undercover cops from the movies, but the room is all his as he kicks off into his rhymes, sparring with the opposition. The studio's transformed into a hip-hop battle ground and Guru's sparring with the opposition, dropping all manner of firearm references as he roams the studio floor while the handheld camera circles round him, getting close,

Gang Starr in the house, series 13,
episode 6, May 1999. (BBC film still)

then backing off. One moment Guru's spitting directly into the moving camera, the next he's turned his back and he's off again, striding the floor, a man on the run. The handheld backs off and he's framed from above by the stationary jib raised to its full height, a helicopter-style aerial view while the spotlights sweep search the floor. Mostly, though, Guru's up close and personal on the handheld, one moment looking down the lens, the next spinning on his heel and stalking away while the camera tries to catch up with him. He's ducking in and out of the searching lights all the time, in and out of shadow. You can't see the studio audience or the bands, the communal context is locked out to create an almost threatening environment. It's hip-hop theatre, search and arrest in reverse, as both studio floor and camera lens belong to the prowling Guru. This stark 'who's stalking who?' aesthetic created a model to which we'd later return with Atlanta-based rapper Ludacris and his 2003 Kanye West co-produced smash 'Stand Up', and again for Stormzy and Skepta a decade later.

*

Mary J. Blige, Queen of Hip-Hop Soul, Everything's 'Just Fine',
series 31, episode 1, February 2008.

Although Black American hip-hop stars like Kanye and Ludacris were infrequent and occasional visitors, especially compared to nu soul singers like Mary J. Blige, Maxwell and Jill Scott, Black British rap-based music was a lot closer to hand. Yet until grime started to edge its way into the mainstream around 2015, Black British artists would often struggle for profile and support, living in the giant shadow of American hip-hop despite their often considerable originality. Around the new millennium UK Garage and two-step went increasingly overground, putting Craig David, Ms Dynamite, MJ Cole and the Artful Dodger on the radio and on *Later...* A year later So Solid Crew were riding high with their garage-heavy hip-hop, grime before there was grime. '21 Seconds' went to Number 1 in August 2001 and suddenly they were a nationwide phenomenon. They'd never played live in a television studio when they arrived in Shepherd's Bush in April 2002, mob heavy, just as they released 'Ride Wid Us'. Things were already proving tricky for the collective. They'd squared up to Westlife a couple of months earlier at that year's Brits while the charismatic Asher D, the future star of the drama series *Top Boy* whose

So Solid Crew count down the seconds,
series 19, episode 1, April 2002.

TV career was building steadily, was serving time in a young offend-er's institute for carrying a firearm. So Solid came from tough South London estates, they were tracksuited and bling, but they were already being demonised, blamed for anything bad that happened at Black gigs and clubs, even when trouble was far away in Birmingham. As their main female member, Lisa Maffia, told the *Guardian* in 2005, 'We were underground for a hell of a long time and our supporters were just everyday street people. We didn't play in flash clubs, we played in south London. Our fans were rougher and they were the ones causing the trouble.'

There wasn't any trouble in the *Later...* studio, whatever the clouds rapidly gathering around the collective. So Solid had so much energy and were so delighted to be there – to be visible, to have made it on the BBC – alongside Pet Shop Boys, Doves and Cornershop. *Later...* had already been going for a decade and so meeting Jools was like meeting royalty for most of So Solid, many of whom were still in their late teens. He'd been on the box their whole lives, like the news or the queen. Megaman, the group's leader, was so taken with Jools that he

suggested having his own piano moment with him, improvising his rhymes over some boogie-woogie. But first, director Janet had to work out how to capture the collective in all their frenetic, multi-voiced glory. They hadn't brought any musicians, just some decks and a bewildering succession of rappers. '21 Seconds' was so named because each member had been allotted 21 seconds to rap while they put together a three-and-a-half-minute single. Half of their South London posse took over a stage with their own audience riser included so So Solid were mobhanded on two levels, shouting each other on. Rather than chase after each rapper in turn, Janet decided to leave a couple of cameras out front, just beyond their stage, and choreographed each rapper in turn to come out and perform into their allotted lens, either singly or in pairs. The whip pan was fast becoming all the rage and another handheld took sections of the tune, whipping back and forth between rappers on the chorus like a drunken fly. Romeo and Lisa come out together for their section, sweetly holding hands while the rest of the crew mill around behind them, arms aloft. When '21 Seconds' finishes half the Crew are out in the middle of the floor. Like an end-of-season pitch invasion. So Solid Crew are, as they say, in the house.

So Solid's moment in the spotlight was short-lived as they were rapidly demonised by the media and the police. They came from difficult beginnings that they couldn't shake off and perhaps the sheer size of the Crew made them particularly vulnerable. Their second album, *2nd Verse*, came out in late 2003 and was almost completely ignored. Dylan Kwabena Mills came out of the same sound system scene and the same type of estate as So Solid, albeit over in Bow. Dylan had mentors like the footballer Danny Shittu and the pioneering DJ/rapper Wiley, but he had a troubled adolescence and was kicked out of a succession of schools where only a few music lessons and workshops caught his attention. A music teacher called him a 'rascal' as if he were a character out of *Oliver Twist*, he adopted it and 'Dizzee Rascal' was born. Dizzee rubbed around the drum 'n' bass, jungle and garage scenes but he also took a liking to Nirvana and heavy metal. He formed the Roll Deep Crew with former school mates and recorded his first single, 'I Luv You', in 2002. Shortly before his debut album came out, Dizzee and Wiley were performing with Roll Deep in Ayia Napa in Cyprus alongside So Solid Crew. Trouble had been brewing all summer and Dizzee got stabbed six times. Weeks later, *Boy in da Corner* won the Mercury Music Prize at the Grosvenor

House Hotel on Park Lane. Dizzee was still a week shy of his nineteenth birthday and he looked stunned, wary even, as he took the cheque from Jools, as if he were afraid he might wake up at any moment. 'I come from nothing,' he told a BBC interviewer at the event when he escaped the podium. 'I come from the underground, pirate radio stations, I come from the ground, man.'

A month or so later, Dizzee came on *Later...* with his schoolmate DJ Carnage. He still seemed to be in shock and kept looking around doubtfully from under the peaked cap he sported at a jaunty angle and which, in the style of the time, looked too big for him. We staged the pair close together in front of one of the band areas and framed them against the geometric set. The room was lit dark blue throughout while a Gobo light splayed across the studio ceiling behind Dizzee's cap. The handheld cameras mostly look up at Dizzee and drift slowly around him and Carnage, as if in a dream. Occasionally Dizzee buttonholes the camera and stares down the lens to make his point but he's still shy and, anyway, as he's explaining, he's wary of where machismo might lead him. 'Brand New Day' is pure early grime, the beats are empty bins bouncing down a set of stairs while what sound like Andean pipes or a grandfather clock chime away behind them like maddened wasps in a jam jar. It's organised chaos, it shouldn't work, but it perfectly evokes the claustrophobic world Dizzee's describing. He's trying to grow up and not get engulfed in all the negativity and drift around him back home. He's looking for respect, opportunities and a brand-new day. He and Carnage even sit down for a brief and awkward chat with Jools at a table. The teenage Dizzee is too wary and too shy to truly engage and he can't really explain how his Mercury Prize triumph has made him feel. It's like he's been hauled up in front of the teacher as Texas, Starsailor and Kanda Bongo Man look on.

Dizzee didn't come back to *Later...* until his third album, 2007's *Maths + English*, a title which suggests his schooldays still weren't too far behind him. On the opening track, 'World Outside', Dizzee explains how he's grown and that he can now glimpse a world outside the ends where he grew up. The lead single 'Sirens' even samples American underground rock band Korn. He was still street and still grime but he was flexing his musical muscles. He no longer looked like a downcast kid: he'd muscled up and he was ready to stare down any camera that came close. Second time around he'd brought live bass and drums and he was no longer shy. 'My name is Raskit, Jools Holland is the

Dizzee Rascal and DJ Carnage setting up for 'Brand New Day',
series 22, episode 2, December 2003.

situation...' announces Dizzee, sporting a baggy T-shirt emblazoned
with a giant portrait of Marcus Garvey. 'Excuse Me Please' is a bouncy
account of a world gone mad and Dizzee's delivery is transformed by
the swing and propulsion of the live instruments, particularly the
supple groove of Massive Attack's veteran bass player, Winston Blissett;
there's a singsong, nursery-rhyme quality to his delivery – he even
sounds like he's been listening to Mike Skinner of the Streets who was
already a veteran of the festival circuit with his live band. Dizzee
wonders comically who's in charge of this stupid world with a blend
of bemusement and swagger before admitting he's just looking for
someone to blame. He doesn't wander too far from the instruments,
there's still something self-contained, reserved even, about his perfor-
mance, but he's grown up since his debut five years previously.

This first outing with a tiny live band was an early sign that Dizzee
was ready to raise the stakes and that live musicians were increasingly a
sign of ambition for rappers who wanted their music to reach beyond
what was then euphemistically called the 'urban' genre. Dizzee was about
to go on a golden run, transforming himself into a pop star and national

treasure. The next summer he released the Eurodance anthem 'Dance Wiv Me' with R&B singer Chrome and Calvin Harris who'd just started out as an indie pop singer and would himself headline *Later…* a year later before transforming himself into a world-dominating DJ and producer. We filmed an impromptu performance at Glastonbury around the backstage BBC campfire around midnight. A couple of weeks later Dizzee had scored the first of three Number Ones in a row and soon he was starting to pop up everywhere, even doing a *Newsnight* interview to reflect on Obama's US triumph from a British Black perspective in November 2008. An entitled Jeremy Paxman boomed patronisingly at 'Mr Rascal' who simply made his interrogator sound obsolete. Paxman asked Dizzee if he felt British and if a Black man could govern the UK. 'Of course I'm British!' responded an incredulous Dizzee. 'It doesn't matter what colour you are. I think a Black man, a purple man, a Martian could run the country as long as he does right by the people.'

A month after that awkward *Newsnight* Dizzee starred on the sixteenth *Hootenanny* alongside Martha Reeves and the Vandellas, Adele, Duffy, Lily Allen and the Ting Tings. There's a palpable frisson of shock some fifteen minutes before midnight when Dizzee and Chrome take to the floor in front of Calvin's decks and proceed to goose the whole studio. There's a sense that the more mainstream *Hootenanny* guests and celebrity audience aren't quite au fait with this rapping thing(!) but Dizzee isn't here to watch warily from the wings but to entertain. He's coming of age and ready to take centre stage. He and Chrome stride the floor beneath wandering light beams while Old Father Time gestures wildly with his sickle and Lenny Henry gurns to camera. It's shot like 'Full Clip' or 'Brand New Day', all handheld cameras and whip pans, but instead of street menace, this is Ibiza good times, the underground gone mainstream. The beat is irresistible, Calvin sings the chorus in some mirror-speckled sunglasses while Dizzee works the room beneath the glitter balls, fronting with absolute self-confidence. He's becoming a pop star before our very eyes and the *Hootenanny* falls at his feet.

Dizzee headed into 2009 in style, and he didn't blink once. He wasn't scared or scary anymore. He was no longer crazy, he was Bonkers. Or on Holiday. His fourth album was entitled *Tongue 'n' Cheek* and he was enjoying himself, refusing to be demonised. Now he was the party MC and when he came back to *Later…* in September it was like a victory parade. This time Dizzee came with a full band led by the young guitar

maestro Guthrie Govan. He wasn't a rapper with a DJ anymore, he was a pop star with a band. It was as if he'd decided that if he was going to star on *Later...* he had to show off his musical muscles. 'Bonkers' was reinvented as a hillbilly hoedown, kicked off with an acoustic slide guitar as Guthrie channels Seasick Steve. The backing singers sport those iconic 2009 T-shirts with Dizzee's face gurning out in green like a friendly Martian. The studio is packed with Dizzee fans recruited via BBC 1Xtra and he's all about the vibe from the get-go. When Guthrie kicks off 'Holiday' with some flamenco runs, Dizzee looks on admiringly and then he's getting the crowd to clap along as if it's the *Hootenanny*. A few months later it actually is and Dizzee's back, dressed for the occasion in a DJ, ready to party all over again. This time there's an electro version of 'Bonkers' with drum pads and phased keyboards. Florence Welch bounces her red hair and jumps up and down in her corner while Dizzee proclaims himself free. 'Holiday' is a unique duet with Shingai Shoniwa from the Noisettes who were riding high with 'Don't Upset the Rhythm (Go Baby Go)'. Dizzee's rubbing shoulders with Tom Jones and Boy George between numbers. The world is at his feet and he's ready to run for prime minister. Yet sadly, his triumph is also a kind of full stop.

Dizzee had embraced the mainstream and crossed over and there was no way back to the ends. He became a festival favourite, signed a massive deal with Island and didn't release his fifth album until 2013. There were duets with the likes of Robbie Williams and Jessie J but no one really wanted to know this time around. The tunes weren't good enough, and it was as if Dizzee wasn't sure what he had left to say or who he wanted to say it to. Eventually he started sending himself up in TV ads for Ladbrokes with 'Bonkers' playing in the background. He'd gone from being crazed to acting cuddly. Grime is all about authenticity and pop stars aren't authentic. Dizzee now lives out in a mansion in Kent, but wherever he's ended up, he's always going to be about where he came from. Hence the title of his 2020 album, *E3 AF*, the postcode for Bow. He still has the respect of his peers, judging from *E3 AF*'s 'Eastside' where he goes toe to toe with Kano and Ghetts, both fellow grime originals who have stayed the course and gradually expanded their musical framework without ever going pop. Dizzee still has the MC skills as he showed while bestriding the Royal Albert Hall for *Later 25*, he's a trail blazer and he was made an MBE in 2020. But in April 2022 he was sentenced to a

curfew and ordered to wear an electronic tag for assaulting his former fiancee Cassandra Jones with whom he has two children. His website currently states 'Sorry, no shows currently.'

Dizzee transformed his brand to become a pop star, Jay-Z went global on his own terms. When Shawn Carter finally came on the studio floor in November 2009, I don't think he could quite believe it. The studio was pumped, Foo Fighters were warming up, Sting was across the room and there was the multi-Grammy winning Norah Jones sporting a new bob and a lot of shoulder. I guess Jay knows a high-powered gathering when he sees one and he was as appreciative of the debuting Stornoway and guitarist Erik Mongrain as his fellow superstars. Once he'd strode through the studio doors and saw the BBC 1Xtra-sourced audience spilling onto the floor next to his band, he just straightened his shoulders, walked over to his band and turned into royalty. I think he realised he'd kept the room waiting and so he moved along the cast ensemble at the photo call, presenting his hand to each artist in turn, looking them in the eye and simply saying, 'Jay'. He was gracious to Jools and to our floor manager Sam who briefed him on how the shows would run.

But Jay really tuned in when Foo Fighters started off the the taping of the first show by crashing into 'The Pretender' from just a few yards across the room, guitars on overload, Dave Grohl at his most disillusioned and yet anthemic, calling out a duplicitous political leader and a wheedling voice in his own head. There's a cutaway of Jay-Z and his guitarist nodding along in time, Jay hidden behind his shades, egging the Foos on but also eyeing up the competition. He'd just released his first British Top 10 album, *The Blueprint 3*, and so he followed the Foos with 'Empire State of Mind'. His Roc Nation signing Bridget Kelly covered Alicia Keys' pneumatic chorus, derived in part from hip-hop royalty Sylvia Robinson and Burt Hayes' 1970 hit for the Moments, 'Love on a Two-Way Street'.

Like Grohl, Jay-Z is one of those performers with commanding authority and energy to burn. Soon he's prowling the stage, mike up, finger beneath his nose, the bounce and beat of the band irresistible, Jay declaring that he's the new Sinatra and that if they love him in New York, they'll love him everywhere. Jay's backed by the same band with which he'd headlined Glastonbury the year before, rocking and funky, driven by prodigy drummer Tony Royster Jr with guitar, bass, keys and

decks all pushing him forward. After Pearl Jam backed Jay-Z in 2012, bassist Jeff Ament commented: 'It's the first time I've been that close to somebody who really, really raps. Just to see his body while we were playing: it basically becomes a metronome. You see him stretching things out over notes, bringing it back in. It was really cool. His eyes were closed the whole time. It's all rhythm.'

Jay's rocking back and forth like a prize fighter and urging Bridget on in the chorus with interjections and asides, 'yeahs', 'uh-huhs' and 'that's right'. He's owning it. By the second chorus his homebodies in the studio crowd are making the pyramid sign while there's a cutaway of Dave Grohl nodding back, looking serious as a judge. As the band climb into the third chorus, guitar pushing the song forward and over the edge, it's as if the room is going to levitate. Then Bridget is exhorting the crowd to put one hand in the air for the big city and arms are aloft everywhere, swept up in Jay's magnetism and his tribute to the Big Apple which encompasses the Yankees, street hustling, Afrika Bambaata and Bob Marley. Come the live show, Jay-Z goes first, reprising 'Empire State of Mind' and then closes proceedings with the incendiary '99 Problems', his signature song produced by Def Jam veteran Rick Rubin for *The Black Album* in 2004. It's as much rap-rock as Run DMC's 1986 collaboration with Aerosmith on 'Walk This Way' with Rubin bringing beats and samples from early 1970s rockers Mountain and Billy Squier to the party. It's all swagger and 'Hit me' for the chorus but it's also Jay's account of a run-in with the NYPD while running drugs. Did he know his rights? You know he did. As for the chorus, it's borrowed entirely from none other than Ice-T who premiered his '99 Problems', a collaboration with 2 Live Crew's Brother Marquis, in 1993 on his *Home Invasion* album. But Jay's '99 Problems' takes swagger and self-belief to a whole other level and it takes the studio along with it. Come the final chorus, Jay even drops out after his 'I got...', and the studio audience finish it for him. It's a cry of triumph, of self-assertion and of survival against the odds.

Jay-Z was my sons Luke and Cian's main man. Cian was twenty-one in 2009 and looking to start out in the music business despite all his father's admonitory advice. He'd grown up on Jay-Z, gangster and garage and now he was a passionate student of Black British music, heading out to Fabrik at weekends, later checking out the grime scene at Visions in Dalston, living the life. Dizzee's commercial success was followed by that

Jay-Z rocks the house, series 35,
episode 8, November 2009.

of Tinie Tempah, Professor Green and Wretch 32, all of whom fused
electro with featured vocalists and brought their hits to *Later...* in the
early 2010s. But despite their success, grime as a genre seemed increas-
ingly commercialised and predictable. We hadn't hosted a British rapper
for three years when Cian started talking up a young MC called Stormzy.
Cian came to nearly every *Later...* episode in Maidstone and he rarely
advocated artists he encountered on the grime scene but there was clearly
something different about Michael Ebenezer Kwadjo Omari Owuo Jr.

Stormzy grew up in South Norwood in south-east London and after
working for a couple of years in quality assurance at an oil refinery in
Southampton he started putting out a series of freestyles on classic grime
beats entitled 'Wicked Skengman.' In July 2014 he independently released
his debut EP, 'Dreamers Disease', a collaboration with grime producers
the Heavytrackerz which had most of the usual sonic tropes, especially
the slightly demented bells that aren't that far from those on Dizzee's
'Brand New Day', and the excitable, skittering beats. But it was the video
for lead track 'Not That Deep' that really excited me. Alongside Stormzy's
fierce flow, wordplay and wit, he had charisma; he was likeable and

although still shy, he radiated warmth. Shot by Jaiden Ramgeet who would become Stormzy's first resident videographer, the promo's set in Croydon in a vast empty car park and what looks like the Centrale shopping centre near Keeley Road. It's a sunny day and the video is mostly Stormzy and a bunch of his mates horsing around on bikes and a couple of random shopping trolleys in an empty car park. There's an easy camaraderie on display that's a million miles from the relentless demonising stories about young Black men and knife crime that already dominated London's headlines. Stormzy's in shorts and he dwarfs his bike, barely keeping his long legs off the ground. He's clearly king of the crew but when he raps it's as if they're all speaking through him with one voice. But it's when Stormzy flashes the occasional smile that his whole face lights up like a summer's day. There's a chorus too alongside the bravura verses but it's the smile that makes it feel like pop music.

I don't know what finally pushed me into calling Sian Anderson who worked at BBC 1Xtra and Atlantic Records and inviting Stormzy on *Later...* Cian told me that Sian would be the best contact and so I cold-called her. I didn't know Stormzy was unsigned and that he'd released his EP independently and it wouldn't have made any difference anyway. Neither Alison nor I had seen him live but the video convinced us he would deliver. Robert Plant and Counting Crows were already on the bill which meant this could be any show since we'd started, but we also already had debutants in the shape of the gay electro pop of Years & Years, the playful percussive vocal explorations of tUnE-yArDs and the retro soul of Gedeon Luke and the People. But there was space for a moment in the middle of the floor and the middle of the show and I wanted something new and brave, something for tomorrow. It was clear that grime was on the edge of a resurgence with a new generation of MCs but there was certainly no sense that here was the key British cutting-edge pop music of the second half of the 2010s, that hip-hop and grime would soon come to replace guitar bands on the radio and at festivals.

I booked Stormzy on the Monday, the night before a *Later...* episode pairing U2 and Sam Smith with local boys Slaves thrown in late in the day to shake it up. Two days later Smith won an armful of Mobos at Wembley Arena and – against a strong field of the old guard and the new kids including Skepta, JME, Novelist, Wiley, Lethal Bizzle, Meridian Dan, Big Narstie and more – Stormzy won Best Grime Act. The Mobo kind of legitimised our speculative punt in the dark but,

equally, it was a little disappointing that they'd got there first. But at least Stormzy now had some sort of public form. I loved the theatre of the video and wondered aloud to Sian if Stormzy would want to bring all his mates along and re-enact the video as a takeover in the middle of the studio. Understandably Stormzy chose to make his television debut accompanied solely by DJ Tiny.

Roll forward to Tuesday, 29 October, teatime at Maidstone Studios. All the other artists were sound-checked and camera-rehearsed when Janet and I went out on to the floor to meet Stormzy who'd brought along his friend and soon-to-be manager Tobe Onwuka. Stormzy towered over Tobe, me, and everybody in the studio as we discussed how best to stage his performance. He was shy but confident enough and he had the 'rehearsal' of the pre-recorded show before going live. Once again, we dropped the lights so the audience and other artists disappear and Stormzy has the floor to himself. The crowd in Maidstone tended to be older and whiter than those at Television Centre and, dare I say it, a little resistant to rap. When Kanye had appeared there a year before, a few of the crowd leaving the studio grumbled about finding him arrogant and aggressive. Too much even. So, we simply gave Stormzy his own space, as cathedral dark as Kanye's empty black backdrop. The audience and other artists are invisible. Stormzy's dressed in a grey tracksuit, beanie and with shades raised. He begins by announcing himself as the Skengman from South London and shouting out to Murky and Jools Holland and then the beats kick in and he's taking those tiny grime steps that are almost camp. The lights, the laptop and the tracksuit are all shiny grey. A handheld camera swoops around him but Stormzy's in control, not the camera, and commands the floor. There's a couple of mugging exchanges with DJ Tiny, Stormzy with his arms folded across his chest, nodding back and forth, London comedy, and then he's off again, roaming the floor, bossing it. 'Not That Deep' is mostly stream-of-consciousness gags, combative, self-aggrandising, territorial. On the final fading chorus Stormzy folds his arms again and breaks into giggles, suddenly shy. He spins on his heel and heads off away from the camera back to Tiny. There's nothing necessarily new about the performance except the energy and the fire in Stormzy's belly and his engaging sense of humour. 'Not That Deep' went straight up on the BBC's YouTube site. In the comments beneath the clip there's a discussion as to whether grime can work on *Later…* that probably applies to most of the rappers who've ever appeared on the show.

Stormzy rehearsing for his television debut in Maidstone,
series 45, episode 7, October 2014

westhamboy95

I like Stormzy but he doesn't belong on jools holland

Franklin Freshman

WHY NOT ??? IT GETS GRIME TO A DIFFERENT AUDIENCE

westhamboy95

I know what you're saying But that audience are not grime people lol

Franklin Freshman

wHAT is grime people ??? people on council esates , who wear tracksuits... lots of middle class people enjoy grime... being on Jools is an honour for any artist... if Kanye can be on there so can Stormzy... who is ok but not great

westhamboy95

As a middle class teen myself I can say I like grime, but grime is still majority listened to by young people the majority of jools holland viewers are middle aged

Captain Hindsight

Says a lot about jools to have him on here. Guy loves music and doesn't care where it comes from, shows respect where it's due. The people who watch it aren't really grime people in general, but there's been so many genres represented on his show that there will be people from anywhere who will watch and love.

The Real Captain

@westhamboy95 that don't matter tho 1. he's making appearances 2. jools asked him on so respect to him for helping man make money and movements

I guess if *Later...* had ever decided not to try to be a pure and inquisitive music forum, we might have aimed the programme solely at an older and largely white demographic, £50-Quid Bloke as the cliché went, and played conservatively to what we might have assumed were his predilections. I guess Robert Plant, Counting Crows and Gedeon Luke and the People did that on this show and Stormzy, Years & Years

and tUnE-yArDs did not. I don't think *Later...* would have endured or thrived if we'd played to the supposed prejudices of what research suggested was our core audience.

Stormzy opened the door and ushered in the new era of British grime. Emboldened by the conviction and excitement of his performance, I used Cian's contacts to reach out to Skepta and JME the next spring. Skepta delivered 'Shutdown' in a white tracksuit, staring into the camera as the complaining voice played out in the skit extract: 'A bunch of young men all dressed in black, dancing extremely aggressively onstage, it made me feel extremely intimidated and it's just not what I expect to see on prime-time TV'. Janet no longer followed the delivery with a handheld but parked her cameras round the DJ and his performance area while Skepta ran the show, moving from camera to camera as she cut between them. Little Simz followed with 'Wings', making an entrance at the far end of the studio and walking across the floor to her backing vocalists, before delivering her tale of self-empowerment by switching between stationary cameras as her tale ebbs and flows, owning the lens. Steff London, Dave, Wiley, Bugsy Malone and Ghetts and Kojey Radical all followed in the next few years. Grime didn't need go pop this time around to become part of the mainstream; instead the mainstream shifted and opened up.

Stormzy didn't come back for a long time. He pulled out of the show in May 2017 when he ran out of time to rehearse with a band right off the back of a triumphant DJ UK tour for the *Gang Signs and Prayer* album. We filmed his stunning Glastonbury 2019 stage show which demonstrated his vision, range and ambition. A few weeks earlier, I went with the team to interview Stormzy at Atlantic for our introductory video to his set. He was up to his eyes trying to finish the *Heavy is the Head* album while facing the challenge of his headline slot. He'd already admitted to his share of nerves in taking on what he called 'the biggest stage in the world'. I'd asked our interviewer to ask Stormzy why he thought he was the one who'd risen from his grime roots to headline Glastonbury and the question utterly floored him. He welled up, the interview ended, and he left the room not to return. Does anybody know if they are worthy or why they have been chosen or whether they are up to the challenge? Before we left the Atlantic offices, I went to find Stormzy where he was finishing a meeting in a separate office and tried to stretch upwards and put an arm around his shoulder by way of apology.

A couple of days before the Pyramid Stage performance, Janet and I went to Birmingham to see Stormzy run the whole set on a sound stage with the entire cast. He was drilling the DJ, the choir, the dancers, hot on every edit and transition, a perfectionist. He came over and thanked us for coming like a gentleman. Janet won a BAFTA for her brilliant capture of his performance that night, her first. Finally, Stormzy made it to the 2019/20 *Hootenanny*, bringing a couple of the powerful spiritual songs from the *Heavy is the Head* album, complete with choir and band. But he also found time to perform his Number 1 hit, 'Vossi Bop', with just a DJ, delivering to camera in homage to his debut with 'Not That Deep' five years earlier. Band or DJ? Both are good. He'd changed the game and on his terms. The *Hootenanny* showbiz crowd just lapped him up, the hippest person in the room and a British icon.

At the beginning of 2022 I managed to interview Stormzy about that 2019 headline set for the BBC documentary *Glastonbury: 50 Years and Counting*. His performance had always felt like a changing of the guard for him, for the festival and for pop culture that had been years in the making. I'd pitched the film back in 2018 and continued to executive produce it two years after I'd left the corporation. I'd had to wait through the pandemic, but here we finally were in Damon Albarn's West London studio where he was recording his third album. Stormzy had had terrible problems with his in-ear monitors at Worthy Farm and thought he'd blown the gig until he watched it back a couple of hours after coming offstage. Despite the tears that had curtailed our interview prior to the festival, I don't think I'd ever fully understood quite how traumatic that night had been for him, or how much had been riding on it for him. Towards the end of the show, he'd gone down to a smaller stage in the crowd and recited a long roll call of MCs, past and present. 'All the shine, all the applause, all the congratulations was for me but, yo, there is a whole world that came before me and is coming after me, that is around me and that has built me up and allowed me to exist,' Stormzy explained, as if I were his confessor and this was his moment of truth. 'It was super important to me that people understood that. This isn't one Black guy who was exceptional. I'm not the one token Black guy who was exceptional and excelled above my peers, no. Like the older grime artists or back to Soul II Soul, there's so much Black British culture that has allowed me to exist and be the Glastonbury headliner. I would have felt guilty if I came off that stage and the show was all about me; it would really have ate me up.'

Kano

I feel at home on *Later...* even if I'm always that bit nervous playing in front of my peers. For me now, in a way it's almost my only home. There aren't many other platforms where I can express myself freely. When I've got a new album coming out and we talk about what to do, the label ask me whether I might go on a Saturday morning kitchen show and perform after they finish cooking. And it's 'No!' You're only allowed to do this or bring this and it's 'No!' There's always so much I am not going to do because I can't express myself. *Later...*'s the place where I can show people who I am and Yes, fit into the format of the show but stand out as much as I want. That's what it's about; individualism and all existing together on the same platform. You don't really find that freedom in other spaces. You feel that energy in the room and that must translate to the viewer because you tune in to see the artist you want to see on the show that day but you're always going to catch something else; it feels like an open space and that people's ears are going to be opened.

The first time I came on was with Damon Albarn in 2007 to do 'Feel Free' off my second album, *London Town*. I remember we had a plan of how we were going to perform. Damon being Damon when we came to camera rehearsal, he was like, 'Nah, nah, we're not going to do that' and I was like 'Oh...kay!' When we came to our moment, we hadn't rehearsed it too much and I remember it as a bit of a daunting experience. It's one level playing to an audience and another playing to an audience of musicians who are all surrounding you. I don't think it's just me, I think that feeling of having a bit of nerves is always there no matter how many times you do *Later...* Peers are lining up next to you; but I enjoyed it, especially from the grime world I was coming

Kano, 'This is England', series 48,
episode 1, April 2016.

from, coming more from a DJ background in terms of performance. I
wanted to play and perform with musicians and evolve.

I came back for the first live show with Estelle, doing a London
version of 'American Boy' and then in 2010 with Gorillaz. That was a
mad one, I'd be looking left and looking right, seeing people you've
grown up with next to you; Bobby Womack was there and Mos Def.
Me and Bashy came on and did 'White Flag' with the Syrian Orchestra.
We'd toured America but we hadn't done much in Britain, so my mum
got to see how mad it was.

That's what was attractive to me about *Later...* that it's cross-
generational and cross-genre. You might have Beenie Man or Mike
Skinner or some jazz musician. I've been on *Later...* and come across
artists I've never heard before and been like, 'Wow!' Often, they are
things I just wouldn't have come across otherwise. I discovered Berwyn
during the pandemic, Little Simz has been on there a few times, these
young artists alongside legendary artists. That's the one.

When I came back in 2016 with my brass band, *Later...* still felt
inclusive, perhaps even more so because of the shape our scene was

now in compared with that first time in 2007. It was natural that artists from my world would feature more and more on a show like *Later...* Grime and UK rap had become more visible so naturally more of our fans began to watch. I don't think that my audience were watching it the first time.

When I looked back through the *Later...* archive during the pandemic for the lockdown show I realised there were always artists that I grew up on spotted throughout the shows, Buju Banton and stuff like that, but it wasn't something me and my brother and my mum watched. Now, with the number of artists from my world featured on there, it's got a new audience as well as retaining the old audience. I'll go on *Later...* and the person I least expect will always say, 'I saw you last night on *Later...*' There's a neighbour of mine who I don't think listens to my music at all and he wouldn't be doing that ever. But last time I bumped into him outside the front door, and he says, 'Nice suit and a really good song...' It reaches an audience that I wouldn't normally reach.

I come from dancehall and the artists often perform with a band. I love the way the tunes constantly shift with live musicians. We are constantly speaking about what's next and how to grow the live show and even having venues in mind while we're recording. We knew we wanted to take this to the Albert Hall. I know rappers perform with a DJ but when you only get to do one track, it doesn't feel as though the DJ is part of the performance. If you see a hip-hop act with a DJ who's scratching and punching into the next tune, yeah, they're a musician and they're performing. But if it's just one tune and the DJ is just there with his headphones, it's more like a PA. If someone's really having a moment like Skepta in 2016, it maybe feels wrong not to have him on, and you do look at him as an artist and performer. But artists like Ghetts or Little Simz who come with a live band probably do make a better fit on *Later...* amongst all those players.

I think it's important and the right call to showcase that talent from grime and rap in that studio; rightly or wrongly *Later...* always feels like a stamp of credibility as an artist and as an art form. It's important to treat these artists coming from that environment and making that kind of music in the same way as an artist who went to school and learned to play an instrument. Our words are what we do; we are songwriters but sometimes not respected as such because it's regarded as a lesser art form. That was the attitude then and now it's definitely changed.

Jools has always been welcoming and having a musician as a presenter makes all the difference. He knows how for many artists it's a big deal and he encourages you. He watches your rehearsal, and he seems interested and knowledgeable. Last time he asked me about our piano player Sam Beste who has his own solo project the Vernon Spring. Sam was doing this stuff that wasn't straightforward, Jools really took notice of him and thought it was beautiful. He's so inquisitive but respectful of what you do. You're going through all the extent and rehearsals of putting a band together; it's good to know the presenter can hear and see all the work that's gone into it, and you can see how seriously he takes it. Getting that vibe and feedback from someone you know knows, it's like, 'OK! Yeah!' You feel seen and you're speaking the same language.

Camille and co. go rat-a-tat-tat at the Royal Albert Hall,
Later 25, September 2017.

12

Times Like These

Later 25

I am standing on the edge of the stage at the Royal Albert Hall on a Thursday night in September 2017, punching the air. At the other end of the room Dave Grohl has gone full rock star. Foo Fighters are tearing into their 2003 anthem 'Times Like These' and Dave has rushed off the amphitheatre floor where the late great drummer Taylor Hawkins and the band are pounding away, up the nearest aisle and down a row of seats. His guitar seems to have turned into a rattlesnake, twisting and turning in his hands, and his hair is a sweat-drenched torn curtain that doesn't quite hide the huge smile across his face. The punters he's surprised in their expensive seats look awkwardly delighted. They aren't necessarily mosh-pit veterans but they know to gurn appropriately. Not that my fellow producer Alison Howe and I can see their facial expressions from our end of the Hall. Across from where we are standing, stage left, Van Morrison is getting ready to close the show with 'Gloria', the garage rock anthem he wrote in 1963 while touring Germany with Irish showband the Monarchs as a teenager, while across from Van and a few feet away from us twenty-three-year-old Colombian American R&B singer Kali Uchis and her band are already dancing to the Foos. But it is the bell-like dome of the Albert Hall we are staring up at as Dave runs back to join the band for the final chorus. Tier upon tier of this vast dome is stacked with people on their feet, arms aloft and waving like daffodils in the wind. The joint is jumping. 'Times like these you learn to live again' indeed.

We'd been dreaming of taking *Later...* to the Albert Hall for years and properly planning this twenty-five-year celebration since we'd pencilled two days in London's busiest venue some eighteen months previously. We'd first taken *Later...* out into the world as part of the

BBC's short-lived Music Live festival. In 2000 we'd brought the likes of Gabrielle, Moby and hometown boy Craig David to Southampton Town Hall, a year later we'd recced various warehouses and aircraft hangars in Yorkshire before welcoming Faithless, Catatonia and Martin and Eliza Carthy to Bradford's Pennington's nightclub under the shadow of the Pennines. On each occasion we'd peppered the venue's stage and main floor with artists, encircling them with audience. We'd experienced some of the perils of taking our studio show into an adapted live environment in Southampton when our lighting design struggled to encompass the late addition of Peter Gabriel's collaboration with the Black Dyke Brass Band and Mike Felton's sound desk decided to scramble itself on eels' opening song. But we'd also loved escaping the confines of the studio and surrounding our starry casts with hometown crowds who overheated when we went live to air. Both shows felt like live events and basked in the real air of an actual venue with a local crowd.

We'd always dreamed of taking *Later...* on the road but quickly learned that it is both challenging and expensive to stage and light four or five bands outside a television studio environment. Yet the Royal Albert Hall had always seemed a perfect match, a cathedral-like and legendary bowl with the central floor transforming into a stage for sporting competitions, ballets and 'in the round' concerts, whether by Coldplay or classical pianist Lang Lang. We'd filmed the odd concert there over the years and I'd been overseeing the television coverage of the Proms since 2013, getting used to the venue's particular acoustics and the labyrinthine warren of its backstage layout. Only a couple of weeks before *Later 25* we'd produced the Stax Prom with Jools and his Rhythm & Blues Orchestra backing Sam Moore, William Bell and Eddie Floyd alongside British soul fans Tom Jones, James Morrison and Beverley Knight. But these were all conventional linear shows with the audience all looking towards the performers on the main stage. Now we wanted to bring the *Later...* modus operandi out of the studio and into the open so that our way of staging and shooting would be visible to and surrounded by the adapted Hall's 4,000-plus capacity. Our regular studio shows had taught us that *Later...* audiences are at least as fascinated by the dynamic choreography of the camera crew as by the unfolding of the show from corner to corner, artist to artist. The Royal Albert

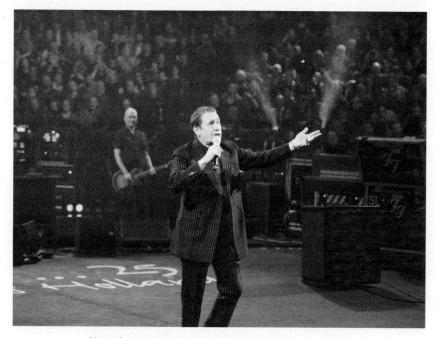

'Friends, Londoners, countrymen – lend me your ears',
Jools warming up the crowd, *Later 25*, September 2017.

Hall would enable production and artists to unite in a one-off spec-
tacle for the paying punters while our cameras would provide a
front-row seat for our viewers at home.

I'd begun to believe the *Later 25* dream could become a reality when
my wife and I went to the MusiCares Concert for Tom Petty filmed at
the Convention Center in LA just before the Grammys in February
2017. I'd become friendly with Tim Swift who'd long executive produced
the annual fundraiser tribute concerts and he invited me to the star-
studded show. I hadn't been to the US for years but decided the time
had come to go and fly the flag for *Later*... Dazed and jetlagged, I
popped in to visit veteran manager John Silva, whose impressive stable
of artists includes a high number of *Later*... regulars, at his offices off
Melrose Avenue and we met up again downtown at rehearsals for the
Petty show where Foo Fighters and Gary Clark Jr. were to cover
'Breakdown'. As John and I chatted we gradually realised that the release
of Foo Fighters' ninth studio album, *Concrete and Gold*, in September
that year would coincide perfectly with our plans for a *Later*... event.
The next night I watched Randy Newman open the show with 'Refugee'.

John's table was nearby, and I said a shy and unusually showbiz 'Hello' to his clients Norah Jones and Dave Grohl. Stevie Nicks floated by, as did Jackson Browne. The whole evening was impossibly and delightfully LA music biz royalty.

I'd done my very first interview for *Record Mirror* with Tom Petty at Shelter Records on Hollywood Boulevard in 1978, hitching down from Santa Barbara and getting picked up by a succession of psychos. Los Angeles is a cruel town when you have no money, no car and no hotel. At the time I was as much would-be punk rocker as fledgling music journalist. In my own mind, at least. Meanwhile Petty was struggling to get his band's second album, *You're Gonna Get It*, on the radio, which back then was all Fleetwood Mac, Eagles and disco. 'I feel that there's a generation out there', he'd drawled amiably to me. 'I think that this group, in America at least, is a people's band. The group stands for rock 'n' roll more than anything. And that's an attitude. We all know where that line's drawn, you're either a rock 'n' roller or you're something else, a pop star maybe.' Now here I was, almost forty years later, picking my way gingerly through the typically dodgy award show dinner and watching the high rollers bid in the rock 'n' roll auction. The Heartbreakers had stuck to their guns and a couple of hours later Tom and Jeff Lynne wound things up with a resilient 'I Won't Back Down'. I am not sure if my younger self would have been impressed or appalled to see me gladhanding the LA rock aristocracy, but if Foo Fighters were coming to *Later 25* at the Albert Hall, I didn't care.

I was determined that the moment had come to bang the drum for *Later…* after twenty-five years, fifty series and over 350 shows. A returning strand inevitably drifts below the radar and gets taken for granted in the schedule. Although there'd been some generous press articles around *Later…*'s twentieth anniversary in 2012, the show's profile had diminished since we moved to Maidstone while media hostility towards the BBC in general had steadily gathered pace. I wanted to fight back. We set about filming interviews with star guests like Sting and Norah Jones as they passed through Maidstone, plotting the 'A–Z of *Later… with Jools Holland*', a ninety-minute tongue-in-cheek romp through many of the show's finest moments and biggest stories which would eventually broadcast the week before *Later 25*. Although I had a handshake from John and Foo Fighters, we didn't yet have a commission or a budget from the channel or sign off from the Royal

Later 25 school photo – Anyone missing? September 2017.

Albert Hall, an institution that's almost as bureaucratic as the BBC. We suggested using the budgets from two episodes of our autumn series and ticket sales as our primary funding model with additional and essential help from BBC Music, the champion of music across all the Beeb's services. In addition, we had to pitch channel commissioning for a further budgetary top up while BBC Studios had to underwrite the commercial risk that we might not sell enough tickets and lose money. We were determined that the show would go on sale without naming any artists on the bill. The studio audience came to Maidstone every week, not knowing who they'd get to see; we reckoned the show itself had a following who would trust us to deliver.

Meeting followed meeting; email followed email. Months went by. Sometimes the whole project seemed to be drowning in internal bureaucracy and a certain unwillingness to commit while the Albert Hall politely screamed for a deposit and a signature. We had to make a case to Editorial Policy for selling tickets to a BBC event who required us to provide additional value to our paying punters above and beyond what we were delivering to the licence payers at home. We would end up writing and designing a free brochure to hand out at the show with

help from the programme team at the Proms. Meanwhile we had to begin to wrestle with how to make our format work in the vastness of the Albert Hall. Alison and I had decided early on that we would take out the seats and treat the amphitheatre as our studio floor, just as the ATP Champions Tour used it as their tennis court. But we clearly also had to use the permanent stage and somehow integrate it with the rest of the show, light a dozen or so band setups and design a PA that would enable each tier and gallery to enjoy every note.

When the budget meetings and the production challenges exhausted me, I started to get nervous that our circular approach wouldn't work and that we'd have to resort to a revue-style show on the main stage. But Jools insisted that we could pull it off, that our show had to be true to our *Later...* aesthetic. Jools and the Rhythm & Blues Orchestra have long had what amounts to an annual residency at the Royal Albert Hall and he'd been a guest performer on the Concert for George in 2002. He knew the venue intimately and from the first he agreed that we could take it over *Later...*-style and that he would roam the floor, cueing the artists in turn. Jools gave Alison and me heart. We knew that we couldn't and shouldn't put Foo Fighters on the stage like a headliner. We wanted the show to feel as democratic and equal as ever. I remember worrying that the band wouldn't get coming to the Albert Hall and not playing stage centre. But I should not have worried. The Foos may be one of the biggest live acts on earth, but they are also and always a garage band. They didn't blink when we asked them to set up facing the stage on the floor and in the round like any studio *Later...* show. Slowly we edged beyond the point of no return, budgets were met, PA companies booked, lighting specs designed, the channel gave us the thumbs up. Tickets went on sale in July, a couple of months before the show. Now booking began in earnest.

Later... has always been about the mix and the bill, the sum of its parts. Every weekly episode has always been painstakingly put together to build the best blend possible. These weren't fantasy line-ups doodled on a blank sheet of paper but the best we could fashion from the practical challenge of diary availability – who's free and could make the studio on that date. Alison would build a grid of artist availability across a series and, as we continued to discover new music and potential choices, we'd begin to make booking

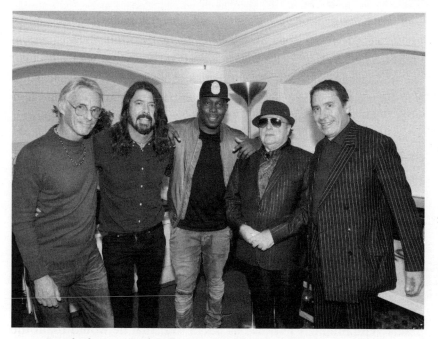

Boys backstage – Paul Weller, Dave Grohl, Dizzee Rascal, Van Morrison and Jools, *Later 25*, September 2017.

commitments, starting with the biggest acts – the headliners or cover stories – juggling with what was on offer while actively going out and targeting artists for specific shows to set up the contrasts and clashes that are the grit in the show's oyster. There's something delicious in having Jess Glynne, Idles and Soft Cell bouncing off each other in the studio or Let's Eat Grandma segueing into the Temptations. We never had an exact blueprint – each show was more a matter of feel and emotion than boxes ticked – but we consistently mined particular genres, themes and combinations. We didn't want all legends or all new artists or all headliners but the right combination of these elements. We booked artists because they were topical, good and available but it wasn't just having them on that mattered but when and with whom! We wanted *Later 25* to work like any episode of the show but writ large; like a Greatest Hits, with plenty of returning artists who are synonymous with the programme while also introducing a couple of new ones. We were determined to mix young and old, legends and newbies, genre with genre, rockers with ballads, artists from the UK with artists from around the world. We wanted

both new and classic songs and some performances you might not get to see anywhere else. We wanted the apogee, the perfect edition.

I'd invited our most regular guest, Paul Weller, when he'd come to Maidstone for his fifteenth appearance back in May. He'd just put out *A Kind Revolution*, his thirteenth solo album, and he'd done four songs from it, full band with backing vocalists and strings in tow. Now we asked him for an intimate acoustic performance. I think Paul would have preferred another electric outing, but we wanted to ring the changes and he was kind enough to support us. Gregory Porter felt like family by now and he was about to release an album of covers of his childhood hero, Nat King Cole. He was either leaving or heading to a concert in Russia, but he rerouted via London to be there. Meanwhile Van Morrison told Jools he wanted to come on board. He had the *Roll with the Punches* album coming and I loved the second track, 'Transformation', a spiritual call to arms in the vein of Van's 1970s songbook. He was doing shows with fellow 1960s veteran Chris Farlowe as vocal foil and he was happy to do 'Gloria' as a finale. Van was in. Mali's Songhoy Blues had just put out their second album, *Resistance*, a funky rock 'n' roll collection, and although they'd gone home after summer European dates and were heading to the US for a major tour at the end of the month, they came back from Africa a week early.

The jigsaw was coming together. I'd been to see my daughter Ceri's then favourite new artist, Walsall's Jorja Smith, at the Electric in Brixton that July and earmarked her for *Later...* She had just turned twenty that summer and had a languorous, post-Amy Winehouse delivery and glowed with a charming naivety onstage at her biggest London show so far. She'd sampled Dizzee Rascal's 'Sirens' for her breakthrough anthem, 'Blue Lights', which highlighted Black boys' fear of institutional police racism, and the encore of piano ballad 'Don't Watch Me Cry' was a melodic heartbreaker. Jorja was clearly going places and would become the Brits Critics Choice for 2018 that December. She'd already toured with Drake in the US and contributed a verse to Kali Uchis' 'Tyrant' single that spring. Uchis too felt like a breaking star. She'd grown up in Virginia although her father is Colombian which perhaps helps lend her pop R&B its streetwise Latin feel. She'd been steadily making a name for herself as a singer-songwriter with a persona, a sexy vamp who isn't about to let herself

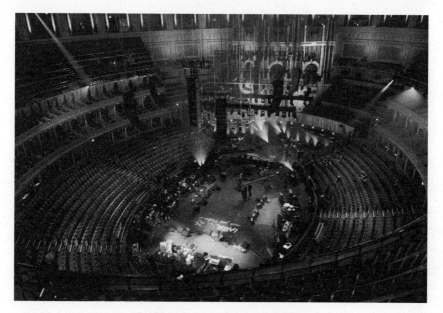

Checking the sound up in the gallery,
Later 25, September 2017.

be taken for granted by some guy. I loved her 2015 lowrider anthem, 'Ridin Round', she'd duetted with the sweet soul star Daniel Caesar on his 2016 debut single, 'Get You', and she'd just featured on Gorillaz, 'She's My Collar', from their *Humanz* album. Uchis was clearly of the moment and I knew she'd bring some sass as well as her duet with Jorja. When her label plugger Helena McGeough offered to bring Kali and band over I felt we had our two debutants, two proud young women who would show no fear, collaborate, and who looked like they were about to go overground.

The French singer Camille had been on *Later...* in 2006 and 2011 and rearranged the furniture each time. She'd sung pop and bossa nova with the witty Nouvelle Vague and her own music has a kind of vocal curiosity that often verges on performance art. She manages to be deadly serious and cheeky at the same time. She's an original. The first time she came she somehow merged beatboxing and opera while face painting, the second she sang while lying on the studio floor. You could never quite believe what you were seeing. I'd watched a clip of Camille and her band performing 'Seeds' from her fifth album, *OUÏ*, while banging out a rhythm, on marching drums. Despite its odd, umlauted

title, a portmanteau of 'Yes' and 'To hear', OUÏ went to Number 1 in France, but she remained a largely unknown wildcard in Britain. She had a gig at Festsaal Kreuzberg in Berlin a couple of days before our show and I spent most of that summer trying to get in touch with her manager and agent and persuade them that Camille simply had to be part of our Albert Hall celebrations. I stuck to the task, they would have to reroute, but eventually they committed. Finally, we added two show regulars that we knew would deliver. Dizzee Rascal had just released *Raskit*, his first album since *The Fifth*, his disastrous attempt to go pop, and returned to the rapid-fire delivery and sparse beats that had made his name. He would come just with a DJ and he'd own the joint. KT Tunstall's 'Black Horse and the Cherry Tree' remained a standout *Later...* moment, a stomping singalong built with loops in quick time before your eyes. If our audience was coming to celebrate the show's journey, KT's 2004 unexpected showstopper should be part of it and would get everybody going.

We had our bill which we'd built slowly over weeks with an eye on the Royal Albert Hall. We'd simply kept expanding the bill until the show felt full of contrast, tempo and spectacle. We had ten artists and a collaboration on board and as we began to finalise the material each artist would perform, we realised we'd need a variety of setups. Gregory would be at the piano with Jools, Jorja would be there too with her own pianist and then sit in with Kali's band. Kali would be main stage left, Van stage right and they'd leave a space for KT to perform solo and stage centre. The Foos would face the stage with Songhoy Blues on one side of the amphitheatre and Paul Weller on the other. The piano would be in the centre of the floor, as would DJ MK's decks, while Dizzee himself would be free to prowl. As for Camille, she had a troupe rather than a band and provided they all wore portable mikes and in-ear monitors, they too could roam the building. Even though there were seven of them and, as it turned out, a large and immovable drum kit on 'Seeds', we thought we could work out how best to stage her two numbers in rehearsal on the day of the show. Information was scarce, we decided we'd have to suck it and see. We had twenty-four songs and just under two hours of music. A show of two halves with an interval no less. Jools would chat briefly to Dave Grohl and Gregory Porter, Paul Whitehouse would pop in from the stalls and tease Jools about his

presenting style. BBCTWO had commissioned a ninety-minute show but were happy to take two hours when we shared the complete cast with them in late August. Once again *Later...* would overrun. They'd been remarkably patient because I was reluctant to share the line-up until we had the whole story, the sum of the parts. The Royal Albert Hall announced the full line-up on 7 September 2017, two weeks before the show when the tickets were already nearly sold out.

I think *Later 25* was the easiest running order we ever wrote. We liked to start every show with a bang, build a head of steam, get a bit funky and make sure we weren't too square on the beat, then take a diversion or two of genre and tempo before building back to the big finish. This show had two halves, but we figured if the first half worked the audience would be on board for the second. Four bands with up-tempo tunes kick us off – Foos, Songhoy Blues, Van with Jools sitting in and Kali Uchis – before we take it down a bit with Paul Weller and a haunting 'Wildwood'. Then suddenly KT is standing centre stage between Van and Kali's bands, thirteen years on from her *Later...* debut. Any solo artist looks pluckily endearing when standing alone amidst a bunch of bands but KT has come to party in a sparkling purple shirt – 'Black Horse and the Cherry Tree' always brings out the busker in her! In rehearsal KT and I had chatted about opening it up and bringing the audience in, but they were ahead of us, clapping from the first moment she starts beating out that Bo Diddley rhythm on her black acoustic, and when she gets the Hall singing along with her 'No, no, no's', they are in the palm of her hand. The kazoo solo must help too.

Five thousand punters are now part of the show while Dave Grohl nods along enthusiastically, chewing gum. The journey from song to song, mood to mood, is orchestrated by Chris Rigby's lighting as it always is in the studio: arena rock style for the Foos, plenty of the crowd and the Hall for KT's bravura turn, intimate for Jorja's heartbroken piano ballad, 'Don't Watch Me Cry', Van up onstage in his pinstripe suit and titfer, full band lit like a concert and promising spiritual uplift, a transformation for all, before the lights fall again and Dizzee and MC Scope joust with each other face to face on the floor, surrounded by darkness and DJ MK for the tongue-twisting 'Space', Janet's cameras circling them before they pull away from the vocal interplay so Dizzee can deliver straight down the lens. Back to

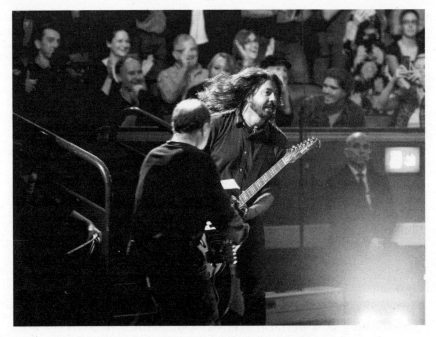

Camera operator Julian Penrose following Dave Grohl into the stands during 'Times like These', *Later 25*, September 2017.

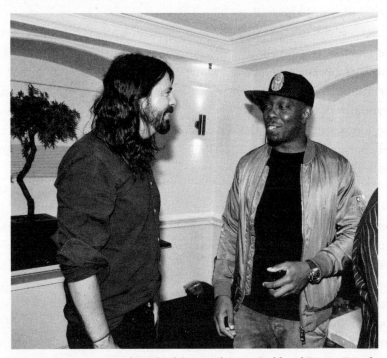

'Are you going out into the aisles?', 'Me too!', Dave Grohl and Dizzee Rascal, *Later 25*, September 2017.

the seated Weller for a mellow and unplugged 'Out of the Sinking' with Paul Whitehouse doing the introduction in an affectionate parody of Jools and then intimate for Gregory, bringing the house down with an epic reading of 'Mona Lisa', stately in a white shirt glowing against black with Chris picking out the pillars that surround the Hall's middle tier in glowing purple. Jools and Gregory have long been the best of friends and Jools' solo is inspired, melodic and playful. The Foos take us to the interval with a blazing 'All My Life' before we hold the crowd from exiting so we can do a rapid retake of 'Ridin' Round' as we'd discovered the bass rig had failed first time out. Kali carries it off in her teasing voice with hips shaking in her bikini-topped blue jumpsuit, a public retake which must have taken a lot of what the urban dictionary calls 'ovarijones', a dubious variant of 'cojones': the retake is a brief reminder that this a television show as well as an event.

We'd always loved using every possible space in the studio – staging is everything in a performance show. The Royal Albert Hall is an august but surprisingly adaptable space and after the interval we used it a bit more imaginatively. We'd spent an hour in soundcheck walking round the hall with Camille, exploring how best to stage her two songs, the percussive 'Seeds' and the solo acapella 'Tout Dit'. We'd kept back Camille as a secret weapon to launch the second half, not least because we needed time to position her and her gang on the main stage where we'd also set up the multi-drum kit and keyboard that underpin 'Seeds'. Jools had loved Camille's playful sonic approach since the first time she came on *Later...* and had collaborated with her on 'La France' in 2011 so he wanted to give her a properly enthusiastic introduction.

I just knew Jools had to have a go on the Albert Hall's Grand Organ, the second largest pipe organ in the UK, so he started the second half sitting with his back to the audience high above the main stage, picking out the 'Da da da dum' theme of Beethoven's Fifth Symphony in classical recital mode but with a wink to camera and a guffaw from the crowd. Jools milks the applause his brief excerpt arouses before looking down to the stage beneath him where Camille and her troupe are standing in a line all dressed in blue with snare drums around their shoulders and drumsticks at the ready. The drum kit and keyboard are fixed and wired down to the stage but Camille

and her troupe of drummers – four women including Camille plus a towering giant of a guy with long hair and beard – will soon be revealed as a portable New Orleans-style 'second line' marching band. This isn't initially apparent as the women weave punctuating harmonies around Camille's pretty lyric on the use and misuse of seeds, life's most vital germ or embryo. The drums beat out a simple tattoo and a couple of minutes in they all come out of the song to click out a counterpoint response with their drumsticks alone, joined by the keyboard player and drummer who've both now left their instruments and strapped on a drum. After one last long sighing note sung acapella, the newly snare-clad drummer leads the troupe across the stage, down steps onto the floor, up the nearby aisle stairs and along the passageway while they all beat out their circular tattoo and the audience clap enthusiastically along. Janet had a handheld camera stationed in the corridor so that in the edit we could cut in shots of them marching along, occasionally playing the walls with their sticks. Their tattoo continues to echo around the Hall while they are out of sight and then suddenly here they are again, still drumming, reappearing in a doorway above the gangway to descend a second aisle back to the amphitheatre floor. The audience is cheering now and clapping along as the drummers make their way down without faltering, before they all line up again in front of Foo Fighters who are barely visible behind the wall of light beams that now frame Camille and co. Their mark is the words *Later... with Jools Holland 25* which are written on the floor, these graphics our only attempts at a set. Why try and compete with the Royal Albert Hall itself? One last hurrah of percussive sticks held aloft and they finish grinning, with a joyous wave to the crowd.

The second half is off and running, the crowd united and right behind us after this coup de théâtre. Later Dizzee too will make his own entrance down an aisle for his anthem, 'Jus' A Rascal', from 2003's ground-breaking debut, *Boy in da Corner*. Jorja will sidle on to sing her verse and shake her hips alongside Kali for 'Tyrant' and Chris Farlowe will trade vocal lines with Van on Sam Cooke's 'Bring It on Home to Me'. Gregory and Jools will tackle 'Sweet Country Love Song', the song they wrote together for Jools' 2012 album, *The Golden Age of Song*, Weller will sit at his own piano for *A Kind Revolution*'s soulful 'The Cranes Are Back' and Camille will reappear, back in front

of the Foos, hidden again behind that wall of lights, but now alone, 'toute seul', in a diaphanous long white dress cut low for her 'Tout Dit' in which circular breathing and some beatboxing seems to enable her to sing with herself. It's a simple but stunning tour de force as she stands alone and unaccompanied, her voice echoing around that cathedral-like space as Chris Rigby picks her out via a Gobo that fragments her spotlight into freckled patterns on the floor. You can hear a pin drop in that vast Hall as audiences and bands alike hang on her every phrase, jaws dropping.

Then we are back where we began, Dave Grohl shredding amidst the punters and Van winding up proceedings with his urgent teenage anthem, 'Gloria', the whole Hall on their feet yelling along. The whole second half has run like a dream. The audience have been able to watch our floor team and camera crew perform their silent and seasoned choreography as they shift from band to band, keeping out of sight behind the leading camera; those cameras are always to the fore, providing the proverbial 'best seat in the house' for the BBCTWO viewers who will watch the whole two-hour extravaganza edited together as a seamless spectacle a couple of days later.

Earlier that evening, while the cloakrooms and the Hall filled up, BBC Publicity had convened a small gathering of the great and good to mark the occasion. Director General Tony Hall attended and so too did the then BBCTWO controller, Patrick Holland, the eighth and last in *Later...*'s long history. Television has since dispensed with the channel controller role to further empower iPlayer and genre commissioners. Most long-running shows inevitably spend most years just getting on with it and trying not to feel unloved. Occasionally one of those controllers would ask if we couldn't make the show more popular, cheaper and, let's face it, more watched. Jane Root encouraged us to invite more 'celebrity' guests to chat and even tried a spring *Hootenanny* to see if we couldn't match the success of the New Year's Eve show on a Saturday evening around May Day 2003. Despite a Green Man, the Dogrose Morris dancers, Prince Buster, Macy Gray, Blur and Michael McDonald, we couldn't. Inevitably we missed the Midnight Moment and the shared sense of occasion and so did the viewers. Mostly, however, a succession of BBCTWO controllers had simply left us alone.

Jools, Alison and I gathered in a bar in the basement, hopping from

foot to foot given the bumper show that loomed ahead upstairs, facing various BBC executives and a smattering of journalists. The DG and then Patrick Holland – who I should point out is no relation to the host – spoke passionately of the journey so far. 'Twenty-five years is a very long time. When *Later...* launched, Clinton hadn't been elected, the world wide web was only just emerging, there were only four channels on UK television, when Ebenezer Goode by the Shamen hit the Top 5 with a song that many parents thought was some sort of Dickensian tribute. Some television shows have to grow and develop over a number of seasons before they find their voice, *Later...* arrived into this world as a fully formed creature; it immediately established its unique voice, eclectic, innovative, risk-taking, confident, bringing the BBC2 audience must-see established acts while also introducing the most exciting new talent... The format had the intimacy of a speakeasy, a mates' get-together that we as the audience were part of. Jools wasn't just the host, as the audience we felt he had chosen these acts, invited them to his soiree, drew connections through his own remarkable knowledge, passion and musicianship. *Later...* felt like a brilliant party that we could all go to.'

Jools and I both said a few words in reply. I thanked the BBC for giving us the freedom to fail, to follow our noses without fear or favour. Then we got on with that night's 'brilliant party', a celebration and reaffirmation of the show's eclectic voice. The artists bounced off each other, the heat in the Hall rose like steam and Jools was in his element.

When the primal groove of 'Gloria' starts pulsing for the finale, Dave Grohl leaves the Foos behind and runs past Mali's Songhoy Blues and Paul Weller's band who face each other across the amphitheatre floor to the pit of the main stage where he is joined by KT Tunstall and Dizzee Rascal to urge Van on, helping the Hall chant out her name letter by letter, G.L.O.R.I.A, Gloria in excelsis.

Dave Grohl

One of the reasons we love playing *Later...* so much is because the diversity of each episode is always fucking exciting because not only are you surrounded by your heroes and your peers but musicians we'd only ever come across on Jools' show. We've always been exposed to music that we might not otherwise have heard; it's a voyage of discovery for us as well as the viewers. I remember being on the show in 2005 with Arcade Fire, Black Eyed Peas, and this Portuguese singer we'd never heard of. She looked like an opera singer and suddenly there she was in front of us in the middle of the floor. I was absolutely reduced to tears with this fucking magical talent. I couldn't believe that this sound and this emotion was coming out of a human being – Holy Shit! – she's doing it with the body she was born with and the sound coming out of her mouth is stunning. How long is it since we played on the same show as Mariza? It must be twenty-odd years and yet to this day I remember sitting on the drum riser and thinking, 'O God, I am so fucking happy I'm a musician!'

I said in my book, *The Storyteller*, 'It's hard to put into words the belief that I have in music. To me, it is god. A divine mystery in whose power I will forever hold an unconditional trust. And it is moments like these that cement my faith.' I was writing about a different night with the Preservation Hall Jazz Band but I've had those moments at *Later...* When you watch or play Jools' show, you're always going to find something that you weren't looking for. When we were down to do the show, we'd always look to see who the other acts were and we might know one or two of them but the other three, we wouldn't have a clue and we couldn't wait to discover what they had to offer. Nowadays algorithms decide for you and steer you in a direction that takes you away from the things that you might not have discovered. Life is more

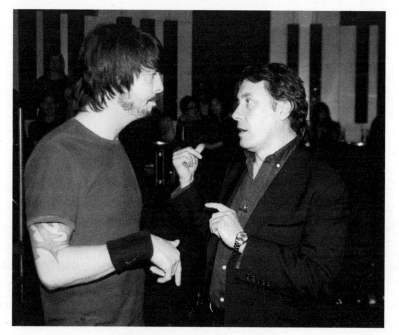

'Fancy going out to dinner after?',
series 25, episode 1, May 2005.

beautiful when you know there's so much more out there and when you're discovering a world that you didn't even imagine was there.

I am the least competitive musician that I know. It comes from being a punk rock kid in Washington DC in the 1980s. We had a small music scene of friends; if someone needed an amp or a van you'd help and vice-versa. I felt like I had their back and they had mine. I always loved it when fellow musicians stood on the side of the stage to watch our band play, I always loved watching other people's bands. There were never any career opportunities in music when we were young; we were playing crazy, dissonant, loud punk rock so things like airplay and album sales, nobody took any of that into consideration. It was just about watching other people and being inspired by them. Whenever we play *Later...* I feel like I'm a kid on the side of the stage again, watching my friends' bands kill it.

We've been on with so many big hitters – Coldplay, Jay-Z, Arcade Fire, Black Eyed Peas, Radiohead – and they are all people I've been bellied up to a bar with over the years. Watching all these bands do their thing just makes me feel happy. I've had a bottle of whisky with

members of Coldplay, I've had cocktails with Radiohead, everybody except Jay-Z – I didn't know that dude. But his drummer that night was Tony Royston Jr who'd been famous at a really young age, maybe eight or nine, for going to drum seminars and playing like Buddy Rich. We all watched his videos a thousand times on YouTube. We just couldn't believe such a kid could do that. When we got to *Later...* that day, someone tapped me on the shoulder and nodded over to Jay's band, 'See that guy, that's Tony Royston Jr!' I'm like 'Oh my God!' I think I literally got on my knees and bowed in front of him. I felt like I was meeting a legend. I didn't pay so much attention to Jay-Z because I was watching Tony the whole fucking show! What a legend! I'm a drummer so I always watch the drummers...

The first time we came on, in 1997, we played 'Monkey Wrench' and 'Everlong'. Radiohead had just put out *OK Computer* and I honestly thought it was a revolution in music and they're one of the greatest live bands of all time. They are twenty yards from us playing 'Paranoid Android' and they are challenging the audience to join them in this crazy revolution. It's a bit different to the album version, maybe better, and I remember thinking as they played, 'Oh my God, here we go again it's time for another music revolution, it's actually happening!' k.d. lang was on too; I'd heard her music and seen her on TV but when you're in the same room you see how brilliant and engaging she is. Her talent is magical and marvellous; it's in those moments that the rock 'n' roll poster on your bedroom wall turns into 3-D flesh and bone; you realise that music is a human art and it pulls you up when you see someone performing you've listened to all your life, you realise, 'Oh my God, this is real!' Somehow, you're reminded that life actually happened, it's thrilling.

When you sit down to have a conversation with a fellow musician, you're speaking the same language in shorthand. Jools not only knows how to translate what another musician is saying but how to get it out of them. Not to mention that he's such a loveable person that you feel comfortable the minute you sit down with him. If you were to sit down with some cold, steely journalist and talk about songwriting, you'd give them a different version than you do a fellow musician who seems genuinely interested and understands your language. Jools is a massive asset. Jools has one of the keys to longevity in this game because one of the things that helps you get by and keep going is to remember that it's only rock 'n' roll. Songwriting, recording, performance, of course

you take them all very seriously, but we're here to make people laugh or cry or fall in love; it's not rocket science and Jools understands that.

When we played *Later 25* at the Royal Albert Hall, the atmosphere was even more amplified than usual; the audience could see everything and everyone and every musician wanted to give their all. Whenever you step foot into one of those legendary venues, you feel the ghosts of the musicians who've played there before you. You're on hallowed ground and you want to live up to that. You take into consideration the weight of it. We always love playing *Later...* because it makes you feel part of a community of musicians; the diversity that night was incredible because not only are you surrounded by your heroes and your peers and you're checking out artists you've never heard of, but they're also all there to hear and appreciate what you do. It's a lot more moving than stepping out onto another arena stage on your own and blasting out for two and a half hours like you do every night. Put those things together and that's one memorable night – except I went out with Jools all night afterwards and I can't remember that much of it anymore!

Jools......
All I've ever wanted is to be just like you.

Love Taylor

Thank you

Later... in its post-Covid home at Alexandra Palace Theatre,
series 60, May 2022. (Michael Leckie, BBC)

Epilogue
Better Days

Spring 2022 has finally arrived, and green trees line the grounds of Alexandra Palace as my wife Siân and I drive up the hill to attend the recording of the first show of *Later...*'s 60th series. Ally Pally, initially known as the Palace of the People, was built in 1873 in the fledgling era of Victorian popular entertainment as a North London counterpart to Crystal Palace in the South. BBC Television launched its very first broadcast from here in 1936 and stayed in various guises until the late 1960s. The Brits have been here and the Miss World pageant, but after some years in disrepair, the place remains a little off grid. When we reach the Palace itself, the whole of London is spread out beneath us like a carpet. We head round the Great Hall and the giant aerial to the show's new home at Alexandra Palace Theatre which regularly entertained an audience of 3,000 in the music-hall era, but has been closed for the best part of 80 years, only partly reopening in 2018. The skating rink next door resounds with an ice hockey game but walking up a darkened staircase to the balcony of the theatre is like entering a forgotten world. Mark Gatiss has described the theatre as a 'lost gem', and although the refurbishment is well under way, you still want to brush metaphorical cobwebs aside as you step into the venue itself.

Alexandra Palace Theatre was built within a couple of years of the Royal Albert Hall by the same company, and once again the *Later...* team are using the floor of a venue as their stage – much as we did in Kensington five years previously. During the Covid pandemic they shot a specially staged performance by Wolf Alice in this theatre for series 57, while weeks later, in March 2021, in the era of social distancing, 6 Music staged their annual festival here behind closed doors. Looking across from the balcony, the stage itself is dark, hosting only a mixing

Women to the fore! Series 52,
episode 3, May 2018.

desk and a few standing lights. The floor seats have been removed and all the artists are sharing the empty theatre floor: blues-rock star Joe Bonamassa directly beneath the stage, Isle of Wight indie sensations Wet Leg directly opposite Joe and hidden beneath us, Nigerian-born Obongjaya and his band, whom Spotify describe as Afro Indie, are stage left halfway along a wall, opposite Jools' piano and the adjacent former busker and TikTok phenomenon Cat Burns.

I can see the camera and sound teams clustered around Jools as he runs through his various links. I have a profound sense of déjà vu and a twinge of sadness; I spent 26 years participating in this pre-show fine-tuning but now the floor belongs to others. Jools is chatting to Samantha Wynn, our researcher four years ago and now the producer. I haven't attended a *Later...* recording since December 2018 and this is the first multi-artist show since series 54 in autumn 2019. It is heartwarming to see so many familiar colleagues going about their business and to see so many players gathering on the floor, summoned together to make music and television together at last. We wave at floor manager Sam Ribeck running the floor with all her residual calm and charm. I

can't quite believe that the *Later...* circle has finally reconvened. While I wait for the show to begin, I find myself travelling back down what Jools calls the time tunnel, back to September 2017...

Four days after *Later 25* at the Royal Albert Hall, we were back at Maidstone Studios, soundchecking for the first show of series 51 with a solo and resurgent Liam Gallagher, finally ready to spar for the spotlight with Noel, his band's guitars on overdrive and a sign by the drums simply stating 'Rock 'n' Roll'. Mercury Prize winner Benjamin Clementine and his mannequins were there too, alongside a reformed LCD Soundsystem, Jorja Smith still glowing from her Royal Albert Hall television debut, now with her own band in tow, and old friend Jimmy Webb who'd just published his memoir, *The Cake and the Rain*. We'd returned to business as usual with plenty of musical treats in store.

Khalid, SZA, Nick Mulvey, Hiromi, Moses Sumney, Dua Lipa and Hurray for the Riff Raff were the debutants that autumn series while show veterans like Beck, Stereophonics, Richard Thompson, Noel Gallagher and Jessie Ware were amongst the regular returners. But we'd devoted so much effort to *Later 25* and the A–Z, there was little time to refresh the show or evolve it forward. Bands always say it's hard to begin again once you've put out your Greatest Hits, and the relentless demands of our schedule – two shows and 90 minutes of television in a single evening – gave us little time to experiment. For the first time, I felt like we'd peaked. We'd climbed the mountain top and now we were just smelling the flowers.

But there was plenty of gold still to be mined. Josh Homme and Dean Fertita from Queens of the Stone Age were on the second show, their 'Villains of Circumstance' and 'The Way You Used to Do' re-arranged as torch ballads with specially commissioned string quartet arrangements. Josh had first come to the show as a touring guitarist with Portland's Screaming Trees in 1996, we'd featured his Desert Sessions side project and, most recently, he'd been Iggy Pop's foil as they turned the studio into a playground. Now here he was in yet another guise, demonstrating his gifts as a sweet crooner in a biker jacket. Tom Petty had died suddenly the day before the show. The National led a groove around the chords of 'I Won't Back Down' with Morrissey and Jessie Ware joining in in tribute while country champion Marty Stuart and his Fabulous Superlatives gathered around a single mike and added a brief coda from 'Runnin' Down a Dream' to their

'Time Won't Wait'. Tom and the Heartbreakers had pre-recorded a couple of songs in the *Later...* studio one afternoon back in 1999 before heading down to Shepherd's Bush Empire for a gig. They'd never quite joined the circle itself. I'd forgotten how hard it was to find time in the rehearsal schedule to add even these little tweaks in Tom's memory.

Yet the need for change was in the air as the government sought to challenge the BBC and energise the broadcast industry. In house production had long been regarded as demonstrable evidence that the BBC was too much of a closed shop. BBC Production, newly entitled BBC Studios and with a commercial brief to make shows for other broadcasters as well as its alma mater, was summarily separated from BBC Television – channels and commissioning – now BBC Content which remained in Public Service. Many long running in house BBC shows were ordered to be put up for tender so that independent production companies could pitch to win the business to increase creative competition. The BBC Music Television department I ran had three regular returners – Glastonbury, the Proms and *Later... with Jools Holland* – alongside our documentary and archive business. The latter two returners were to be immediately put up for tender in 2018 and Content would decide who should then produce them, choosing between pitches from our team in Studios and several indies, one led by my old boss at Wired, Malcolm Gerrie. *Later...* was no longer ours. It belonged to the BBC, and we weren't quite in the BBC anymore. We had two more series in Maidstone in 2018 and BBCTWO Controller Patrick Holland encouraged us to challenge and refresh the show as much as possible, not least to reach the younger viewers who seemed to be abandoning both programme and channel and to prepare us for the looming tender.

In spring 2018 the pre-recorded hour-long show was moved from Fridays to around midnight on Sunday evening where it languished, becalmed and unwatched. We brought back themed episodes – a Welsh flavoured show with Manic Street Preachers, Gwenno and Boy Azooga, an all-female cast with Bjork, Les Amazones d'Afrique, Deva Mahal and the Breeders. New band Shame who I'd seen igniting the Electric Ballroom a month earlier, kicked off the May series, lead singer Charlie Steen stripping to the waist of his boiler suit for 'One Rizla', staring down the cameras like a younger Liam in a vintage *Later...* debut, while across the floor veteran Bay Area soulsters Tower of Power funked up the storm they'd been brewing since the late 1960s. We began to shoot the odd interview

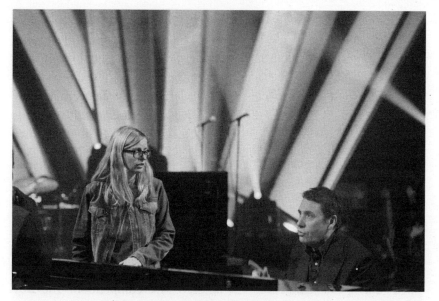

Alison Howe and Jools Holland plan the future,
series 44, episode 2, April 2014.

outside the studio so that Jools and guests like Neneh Cherry or the Manics
could relax without feeling the weight of the waiting other musicians or
the imminent live show pounding on their backs. We gathered the cast
together for a pre-titles tease in the television gallery. But the schedule
remained as challenging as ever, our set hadn't changed in years and the
live show was still a jampacked blur. We didn't really know how to reinvent
the wheel while in the heat of battle. We'd perfected how to run the shows
in the time available and while we kept playing with Jools' presenting
positions, trying to break up the show's predictable gestures, we were only
fiddling. But the music never stopped. We introduced new acts like Sam
Fender, Easy Life and Lady Leshurr and welcomed back those whose
careers we'd ignited like Björk, Ray Lamontagne, Christine and the Queens
or Sigrid. On the last show of the spring series, Nile Rodgers' Chic brought
their classic groove, collaborating with young British artists Nao and Mura
Masa and then invoking our first stage invasion as audience and members
of Nathaniel Rateliff and the Night Sweats, Goat Girl and Nakhane joined
Nile and his singers for 'Good Times'.

By the end of October 2018, we were concluding series 53 in Maidstone
while preparing our Tender bid on how we would refresh and take the
show forward. BBCTWO had now moved the hour-long show to late on

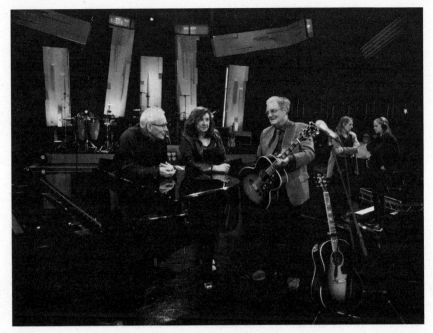

The author, Janet Fraser Crook and Terry Reid mature
together like fine wine, series 53, episode 6, October 2018.

Saturday night after Sunday had proved a Bermuda Triangle, but the Tuesday live half-hour slot was still alive and kicking. Alison had a bug and had to go home, leaving me in charge of what would turn out to be my last *Later...* and the last show at Maidstone Studios. My old friend and sparring partner Damon Albarn was there with the Good, the Bad and the Queen, causing the usual consternation about durations and timings, before delivering the melancholy Brexit lament, 'Merrie Land'. Grime rapper Ghetts made his debut with his anthem 'Preach', urging forward the small choirs on either side of him, veteran Scandinavian pop star Robyn finally made her show debut and reprised her sad core anthem, 'Dancing on my Own', and Terry 'Superlungs' Reid, the mercurial singer-songwriter who'd toured with both the Rolling Stones and Cream before turning down the job of lead vocalist for Led Zeppelin in the late 1960s, flew home from California to have his moment in the spotlight before his approaching 70th birthday. We'd filmed Terry at Womad a decade before and Rumer had been championing Terry to me for a year or so. I'd been corresponding with his publicist in the US since before the series began and here he was, wandering out onto the floor, ready for his close-up in this series' last chance saloon.

Terry hadn't been on a BBC television show since *The Old Grey Whistle Test* in 1973. It was immediately apparent that he had lost none of his ability to inhabit the moment, to climb inside a song. He still had a child-like enthusiasm and little concept of time. Most artists professionalise their gift in order to maintain and manage it, but Terry seemed never to have grown a second skin. Each rehearsal was different in feel and duration. He came out dressed for the show in the kind of purple suit favoured by the Joker, and after a scattershot interview, he and Jools wrung every emotional drop out of 1969's 'May Fly'. Then, forty minutes later in the live show, he played 'To Be Treated Rite' solo. From the moment he eased into the strummed introduction, building the mood, and repeating the bars, Terry took it deep. It's nearly 6 minutes on its parent album, 1976's *Seeds of Memory*, and as he strummed, I realised I should have known better than to put it in the live show. The length of the intro alone suggested we were in trouble as Reid slowly nursed the song into life. In the end, he only came in a minute over, a long minute in television, no time at all lost in music. You could feel his talent and see why he'd never quite mounted something as focused and conventional as a career. Terry was like a naughty but happy schoolboy after the show and it would have been disappointing if he'd been any other way. It was as good a way as any to end, still grappling with the clock, still re-presenting legends, still providing a springboard for debutants like Ghetts and Mattiel.

A few weeks later, Alison and I had to submit our *Later…* Tender pitch – on the same day we recorded the 2018–2019 *Hootenanny*. We didn't share it with our guests that night who included Michael Bublé, Chic, Rudimental, Yola and George Ezra. Nor did we go through it with Lewis Macleod and Ronni Ancona who came as Donald and Ivana Trump. It's always tricky re-pitching as the incumbent as David Cameron's government had recently demonstrated trying to make the case for Remain, but we'd written the best document we could to reimagine the show. We'd suggested the hour-long show start to feel less like a longer version of the live show and more like a public rehearsal, relaxed and open.

Days before the *Hootenanny* I'd been told that the way to demonstrate Studios would deliver a refreshed *Later…* going forward was for me to step away and for Alison to take the wheel. I'd been captain of the ship for 26 years and, post-split with Public Service, BBC Studios wanted a different relationship with BBC Television than I could provide after so long at the helm. I felt like both Television and Studios now regarded me as a sort of

Captain Ahab, blindly locked into his own relentless mission, self-tied to the mast of the ship I'd steered for so long. Now the powers that be wanted to have their hands on the tiller too. I wanted the show to survive and remain with the team, so many of whom had worked on it for decades, and with BBC Studios. Alison had booked many of the breakthrough artists, overseen the day to day running of the show, and managed its relationship with the music industry for many years. She had long since won Jools' trust and, ladies and gentlemen, she would win the tender on her own pitching to the BBC Television jury. I could not have been prouder of her.

Almost a year after my swansong, series 54 in autumn 2019 was back at Television Centre for the first time in seven years with a bright new set, a sofa, and weekly guest co-presenters like Mark Ronson, Lady Leshurr and Sir Tom Jones for *Even Later... with Jools Holland* late on Saturdays. The live show was now on a Thursday. And remained much the same as pre-tender. Regular viewers might have struggled to find either show in the schedule given the new title and the switch of TX days but at least Jools, Alison and Janet were still at the helm, even if they now had company. For so long, *Later...* had flown under the radar, amiably ignored by the channel. Post the Television/Studios split and with the struggle to attract younger viewers, the show suddenly had many cooks.

Then came the pandemic and circumstances suddenly dictated a different show altogether. Jools could finally have proper time to chat to a single guest in the comfort of Helicon Mountain without the pressures of a packed studio and a relentless timetable. Like the rest of us, he suddenly had to master how to chat on Zoom. His fellow feeling for musicians as varied as Dizzee Rascal, Olly Alexander and Héloïs of Christine and the Queens was immediately apparent as was the extraordinary depth of the archive after 26 years and 54 series. There was new music too, shot in session in a variety of intriguing settings as the likes of the Lankums, Self Esteem and Berwyn made their debuts, albeit in solitude. Five interview-driven and archive-based series followed that reminded music lovers of the variety and power of *Later...*'s archive and Jools' gifts as popular music's ultimate elder statesman. Five series of archive-based shows were rolled out between spring 2020 and winter 2021. Two Hootenannies were recorded with the Rhythm & Blues Orchestra in an empty studio with archive extracts but without audience or other acts. It was life but not quite as anyone had known it. Time seemed to have stopped...

*

Wet Leg get off the chaise longue, Alexandra Palace Theatre, series 60, episode 1, May 2022. (Michael Leckie, BBC)

I am still taking in Alexandra Palace's restored theatre as I emerge from the time tunnel back in May 2022 – its statues and high ceiling, its original wooden floor, the empty balcony that surrounds the floor on three sides, its distressed and undecorated walls. If walls could talk, these would have plenty to say. Television programmes in television studios require sets but Alexandra Palace Theatre has its own character and its own presence; it doesn't require any dressing. I am reminded of the sessions we filmed for the BBC at Union Chapel in Islington and at LSO St Luke's in Shoreditch between 2005 and 2015, beautiful and historical buildings both, but neither with quite this look of faded grandeur or this aura of Tutankhamun's tomb. There are some 30 people around us on the balcony facing Joe Bonamassa, not so much an audience as a sprinkle of friends of the show or the artists beneath. We are as incidental to proceedings as the smattering of people who lurked behind the *Late Show* banners in TC7 at Television Centre when *Later...* began in October 1992. We can at least provide the applause that Jools had to carry on his own in the lockdown shows at Helicon Mountain. Around 7.30 p.m.,

Sam calls us all to attention and introduces Jools who looks calm and collected in a dark suit. He's his usual self-deprecating self, explaining that we won't be caught on camera and so won't need to stifle a yawn while he's explaining something interesting or worry about getting caught out if we are with somebody we shouldn't be. He's not in cheerleader mode and he's speaking quietly as if still back in his studio in lockdown.

There are other hints that this refreshed *Later...* is building on its recent past. Jools is explaining that we aren't, of course, live, and that there will be a couple of brief recording breaks when he introduces an archive clip. We always hated stopping when filming the old *Later...* in case the energy building between the bands evaporated. But these shows will have a more considered pace. Up in the balcony, we are clearly eavesdroppers and not performers. I am gathering that we are attending a recording rather than a spectacle, a session rather than a show. Moments later Jools waves a familiar introductory arm and Wet Leg kick into 'Wet Dream' beneath us.

I'd first heard Wet Leg on Steve Lamacq's 6 Music show while driving in the Cotswolds in early summer 2021. I can still remember the sunshine, the green hedges, and the cheeky immediacy of 'Chaise Longue', sounding at once delightfully amateur and yet wise beyond its years, harking back to pre- or post-punk, Jonathan Richman's Modern Lovers and the Au Pairs, but so fresh and instinctive. The kind of tune and attitude that makes you instantly cheer up. Lamacq had interviewed frontwomen and old friends Rhian Teasdale and Hester Chambers, both in their late 20s, whose witty repartee and wry take on foibles, male and otherwise, are the drivers of the band. They sounded bemused by all the fuss, as if they were being distracted from enjoying their own private joke. They didn't exactly suggest a schooled rock 'n' roll band focused on fame and fortune, which made their sudden success and 2022's Number 1 eponymous album even more pleasing, as if you'd stumbled upon some secret and carefree gang and been welcomed with open arms.

Wet Leg had been filmed for one of *Later...*'s lockdown shows and now here they are in Ally Pally, kicking off the relaunch with the 'here we go' chant of 'Wet Dream'. They have their name on a neon sign behind them like a Britpop band. A few bars in, Wet Leg grind to a halt and Rhian laughingly admits, 'I fucked it up'. I'd forgotten how many of the show's opening acts have always fallen apart on the first and pre-recorded opener, as though briefly overawed by the weight of

the room. Rhian and Hester are accompanied by three long-haired blokes and have clearly dressed up for the occasion. On television, they will all look like they and their outfits have been randomly assembled from early 1970s episodes of *The Old Grey Whistle Test*, but above and behind them in the balcony at the recording, we can only hear the punchy guitar lines and the ironic glee of their delivery as Rhian shreds a former lover who'd repeatedly texted her after they'd broken up. Never has blushing sounded so gleeful or so derisory.

If Wet Leg shamble delightfully, as if making it all up on the spot, Joe Bonamassa at the other end of the floor is all professional authority and musical chops as he and his band kick off the blues stomp of 'The Heart That Never Waits'. Now in his mid-40s, Bonamassa opened for B.B. King when barely in his teens and was raised on the British blues of John Mayall's Bluesbreakers, Free and Humble Pie: blues with a youthful thrust and strut. He's wearing dark glasses and his band are spread out beneath the theatre's stage with two female backing vocalists dressed like croupiers from a casino, throwing the familiar shapes. Joe solos with panache and authority, he deploys the tropes of the rock-blues brilliantly. He's a grown up while Wet Leg aren't at all sure if they even want to be adults. Their juxtaposition in the running order is vintage *Later…*

Rob Harding from John Henry's is sitting next to me in the balcony where the vocals are a little hard to distinguish. He's done the band's monitors and the studio PA since the beginning. Rob's explaining that he hasn't yet put in much of a sound system because there's no rush to invite an audience while the show finds its feet in this theatre. The stripped walls of the theatre tower high above the artists, who stand to attention on the floor throughout the taping, watching Jools and each other almost formally, as if partaking in a ritual. The walls are so high we could be watching a religious sevice in a cathedral. Janet has installed a Furio camera around the perimeter that circles behind the bands and frames them against each other and the passing camera crew.

Rob explains that the theatre still has its original flooring from 157 years ago so the cameras can't glide from band to band as they once did in the studio. Instead, there's a Steadicam that's borne aloft and around by its operator, a Jimmy Jib that swoops above and into the bands, a couple of handheld cameras and a ped camera or two. When the peds need to reposition, there's a brief recording break as they are moved gingerly across

the antique wooden boards. Chris Rigby's lights focus on the building and barely move; it is portrait lighting, understated and discreet.

There's none of the temple-tightening helter skelter through the double whammy of the combined pre-recorded and live shows. This is a single show of a mere 45-minute duration including two full-length performances from the archive to be broadcast as part of BBCTWO's Saturday music evenings. As always, *Later...*'s tempo and aesthetic are creatures of its moment in the schedule. Jools explains to the Steadicam that, for this opening show, he's chosen archive of Amy Winehouse debuting a live 'Rehab' back in 2006. This will be dropped in later in the edit, as will Joe Bonamassa's pick of Peter Gabriel performing 'In Your Eyes' in 2002 as he explains to Jools how he was raised on Prog as well as British blues.

Back down on the floor, Joe is now sitting on a stool next to the piano, preparing to chat as Jools introduces Streatham's Cat Burns nearby. Cat is a Brit school graduate whose break-up song has recently been catapulted into the Top 10 by TikTok. 'Go' disappeared without trace when first released a year ago but Burns built a social media following by posting during lockdown and now both radio and a drum 'n' bass remix are extending the party. She's only 21 and proudly gay. She stands alone with her guitar in the classic solo spot and tells her story. Cat's blocking her lover who she's discovered being unfaithful at their Uni hall. When she'd called, she'd only got voicemail. Now, post-discovery, she's telling her ex to never call again; to pack up their shit and go. Like Wet Leg's Rhian, Cat's cancelling an ex. The vocabulary is contemporary, the scenario archetypal; Cat's chords are almost jazzy and her delivery poised. She's cited India Arie and Ed Sheeran as influences. During his succeeding interview, Joe Bonamassa says the song's chorus is the best he's heard in ten years.

Bonamassa's interview is run long, like one of the artist interviews that drove lockdown's archive shows. 'I never thought we'd be back here,' he remarks at one point. 'It's been so bleak for so long...' He can't believe he and his band are finally back on the road. Joe chats about opening for B.B. King in Seventh Grade and their 25-year friendship, his vast collection of guitars and amps and the 1957 Fender Nocaster he regularly uses. He comes over as an enthusiastic journeyman, fashioned from his many influences but bringing a new vigour to an established tradition. The interview concludes by Joe inviting Jools to join him on 'Lonely Boy', the song they co-wrote with Dave Stewart for his 2020 album, *Royal Tea*.

The rest of the recording seems to rush by. Jools walks across the floor from the piano to introduce Nigerian-born, British-based sing-rapper Steven Umoh, stage name Obongjayar, whose debut album, 'Some Night I Dream of Doors', is on the brink of release. I haven't seen Obongjayar before, although he's featured on Richard Russell's 'Everything is Recorded' project in 2018 and Little Simz's track, 'Point and Kill', 'but he's immediately dreamily impressive, stalking in front of his band in wraparound shades and a tracksuit, dreads piled up high. He'll be easier to see and hear on television, I figure, as he half raps, half sings his way through 'Tinko Tinko (Don't Play Me for a Fool)'. He's admonishing a lover who's maybe not quite as committed as he'd like, the drums and bassline are jazzy Afrobeat and Obongjayar's delivery sounds like he's talking to himself or thinking aloud as much as speaking out. There's a trumpet that underscores the melody which Obongjayar drifts across, sometimes hitting the beat, sometimes musing around the tune. He feels like a discovery.

Jools chats to Cat Burns who reveals she's flown back from her mother's 60th birthday celebrations in Antigua to appear. She explains that her mother is a hard worker and encouraged her to come. Burns muses on her busking skills and how she adapted to her South Bank pitch and then Jools is accompanying her on 'Free', an uplifting ballad with a beautiful melody about finally coming out to her mother. It's an understated cry of liberation which concludes with a sigh of relief. Moments later Wet Leg crash into 'Ur Mum', another kiss-off song which ends with the whole band turning their backs on the cameras and screaming as loud as they can. Another cry of freedom. Finally, Jools is thanking all his guests in time-honoured fashion and hammering away on 'Lonely Boy' as he might have done at any point in the last 30 years. Perhaps because Jools has played piano and chatted with both Bonamassa and Burns and because there are fewer acts to behold, he feels less like the ringmaster and more like the star of the show. Without audience, the old hectic rush of the two shows back to back, and with fewer live acts, *Later...* 2022 is retro and pure, almost slow TV.

I go back to Alexandra Palace Theatre the next day for Show 2 and catch up with Janet Fraser Crook perched in a small van out the back by the delivery entrance. She's thrilled to be back in the saddle, revitalising the show. She loves the fact that the room is lit tobacco-sepia and is captured like a rehearsal space. She was always previously determined to 'hide' her cameras and keep them invisible, but the eavesdropping Furio

Liam Gallagher, Better Days ahoy! Alexandra Palace,
series 60, episode 2, May 2022. (Michael Leckie, BBC)

passes artists and the rest of the cameras as it traverses round the back of the room and she's excited about this new, 'relaxed' atmosphere of the recording which she finds newly inclusive. Janet laughs that the show has gone back to its naive beginnings when we had no audience. Although she cannot move the ped cameras across the floor, she's retained her gliding style in which cameras seem constantly on the move, pushing in or pulling out, always dynamic. Janet and the new Camera Supervisor, *Later...* veteran Sophie Penwill, have even picked out special lens which limit the depth of field so that the background is relatively flat and the foreground stands out; it's a filmic look which emphasises the artists in close-up.

Tonight, the featured artists include Liam Gallagher and Oumou Sangaré, both show veterans from the 1990s. I pass Liam on the back stairs. He's gone from strength to strength since finally going solo back in 2018 with 'As You Were'. He's already on his third solo album *C'mon You Know* alongside two live albums. A couple of weeks earlier, BBCTWO had repeated the documentary *Right Here Right Now* which Director Mike Connolly and I had made with Oasis as they were about to release 1997's behemoth, *Be Here Now*. I'd forgotten how beautiful Liam was then and

how intimidating. Noel had the gift of the gab, but Liam's genius was for withholding. Suddenly, there he was all over again, looming towards me in his filmed interview, sipping on a beer and explaining, 'You've got to live it, haven't yer? I just live my life the way I want to live it. You've got to have fun, haven't you? Everyone has their fair share of fun, sure you have your fair share of fun, don't yer? You obviously do. Gotta have fun, haven't yer? How the fuck could I not have fun, right? 24 years old in the Biggest – not the Biggest because that doesn't matter – the Most Important Rock 'n' Roll Band in the bleeding world. 24 years of age, got a load of money, what do you expect me to do, stay at home and clip me toenails and pick me nose all day? Gotta go out and have it, 'cos you'd have it, wouldn't you? So come on...!' I was already well into my 40s in 1997 and I remember quailing as Liam mused on how much fun I surely had as he leaned over towards me while grabbing his beer. I can't help wondering if he too had caught the documentary repeat and what he'd made of his 25-year-old self, but I simply say 'Liam Gallagher!' and we shake hands and pass on.

Oumou and Liam both seem glad to be back. So is Jools, who loves the theatre. He's always loved old things and when he's shooting his opening link up in the balcony he simply states, 'I think it's the best room we've ever had.' Liam will be 50 in September 2022 but he's back on top, with two headline shows back at Knebworth, 26 years after Oasis' 1996 triumph there at the height of Britpop. He kicks off the show in the familiar crooked stance, arms behind his back, the lean to the right, nose on the microphone, the right foot tapping, the voice that cuts through steel. After Oumou's funky 'Wassulu Don', Jools plays in archive of Oasis performing 'I Am the Walrus' back in 1994. A couple of songs later, he chats to Jools about the theatre, nodding approvingly. 'It's like when we get old, we all do a bit of decay.' Liam even approves of the Oasis archive clip although he admits ruefully that 'the suits were awful'. His archive pick is a stunning Jimmy Cliff solo performance of 'Many Rivers to Cross' with Jools on the piano from 2008. 'Yeah, man,' muses Liam. 'I like all music. I don't drive; I just walk and listen to the birds.'

Even with Liam recording an extra song for the iPlayer, the show is over well before sunset. There's no last-minute dash to Ebbsfleet station for the train home, just a gentle drive down through the park towards Muswell Hill. So much has moved on and so much remains the same: *Later...*

doesn't change but it's always evolving. Terrestrial television is hemmed and harried on all sides these days. The appointment to view scheduling of live television is rapidly being challenged by iPlayer and catch-up. Entertainment shows, drama, sport and news can still bring live viewers together in big numbers, but arts and music shows perhaps not so much. I remember arguing passionately around 2010 that we shouldn't break up the show so that single songs could be shared on YouTube etc. I wanted to preserve the experience as a single journey, a magical mystery tour with Jools as your trusted guide, but the world was moving rapidly on and the top down, linear days of television were coming to an end.

I had always loved the idea that our audience trusted *Later...* enough to sit through an act that didn't much interest them to discover one that did. We'd got excited by and plumped for all the acts on show in all their variety, but such negative capability wasn't only a matter of taste, it was the job. Alison and I were trying to build a narrative, a show that ran on contrast bound together by enthusiasm. We wanted it to feel meant, intended. But what was a gripping journey to us no doubt came across as random to some. When I talked to Nick Cave for this book, I told him that if the cast chimed for me and was chosen with integrity, I couldn't expect anyone else to 'get' every artist in the room but there was a good chance they'd stay with us. Nick nodded in agreement even though he'd clearly been mortified by a fair few of his fellow acts on his many appearances on the show. I think he recognised that the show had a grip because it was curated with passion. 'That's the horror and the beauty of it,' he'd mused.

Audiences have always taped *Later...* and fast forwarded through acts that didn't interest them, these days they can fast forward digitally or they can find individual performances online and share them on social media. The iPhone is rapidly taking over from the television set. Millions can watch a single *Later...* clip of Harry Styles' 'Watermelon Sugar' or Amy Winehouse's 'Stronger Than Me' on BBC Music's YouTube channel, while thousands more may discover a rapper like Obongjayar or a jazz pianist like Abdullah Ibrahim without ever watching the television programme. We are fully in the digital age right now and there's something analogue and naturalistic, literal even, about several artists gathered in a studio in real time. Television and rock 'n' roll have grown up together and maybe they are both slowly morphing into something new. I am not sure what a hit is in the days of streaming and more and more, we

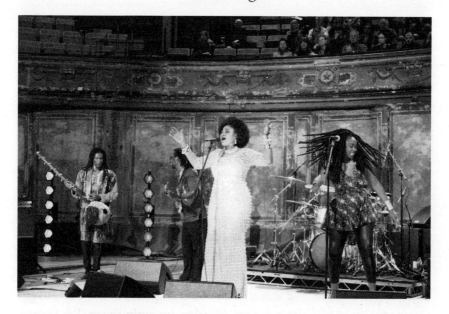

Oumou Sangaré back again, Alexandra Palace, series 60, episode 2, May 2022.
(Michael Leckie, BBC)

watch and listen to music on our own. I doubt that there will be a new live music television show ever again and, if there is, I am certain it won't last anything like 30 years. Only the BBC would have stuck with a show that is all about the music, that's public service to the tips of its toes. *Later... with Jools Holland* is surely the last terrestrial music show of the pop and television era that began back in the 1950s.

But that's not the last word. Not as *Later...* returns for its 60th series and musicians from around the world can gather once again in Jools' circle of dreams. That second evening at Alexandra Palace Theatre, I'd found Oumou Sangaré upstairs in make-up hanging out with her old label boss and producer Nick Gold. She's in her mid-50s now, resplendent in a magnificent yellow dress, and she seems to remember me. She talks in French through an interpreter with a big smile on her face and she has the last word on thirty years of *Later... with Jools Holland*. 'I have grown up with this programme', she smiles. 'I meet with artists I have met on this show all over the world. I take the energy playing off and across from the other musicians. We vibe off each other. Jools just shares his happiness; he's joyful and he lives the music with the musicians in the room.'

St. Vincent

I'd seen so many iconic performances on Jools, but the one that always springs to mind is PJ Harvey doing 'Down by the Water'; it was a real inspiration to me, so real and yet so theatrical. The first time my band and I came to *Later...* it was still at Television Centre back in 2012. I was touring like a crazy person back then, crossing the globe. I was a little nervous for sure but very excited to be there and to be in the round with a bunch of other bands – like a talent show! I remember I was walking down the hallway and one of the doors was open to the room where Rita Ora's wardrobe and hair and make-up people were; there were suitcases and suitcases and clothes that were scattered all over the room like they'd exploded! I guess they were trying to figure out an outfit at the last minute. I remember Damon Albarn was there doing *Dr Dee*, this English folk music that was cool.

What's so great is that you have a ringside seat in the studio; when you're on tour, you don't get to run into or see other musicians because they were here the night before or are coming the night after. You're crisscrossing each other on the road and maybe you get to meet briefly at a festival. *Later...*'s great because it's a bunch of musicians, new and established, from all over the musical map, so it's a good place to have time to say hello to people you admire and to get to see them do their thing from close across the floor.

I remember in 2014 getting to say 'Hi!' to Brian Eno who was on with Karl Hyde from Underworld. After touching base with Brian there at the show, I got to be invited to one of his nights of singing and singalongs where he invites musicians and non-musicians, all kinds of people, who get together and sing acapella, which was fun and very powerful. George Ezra was also on that same show in

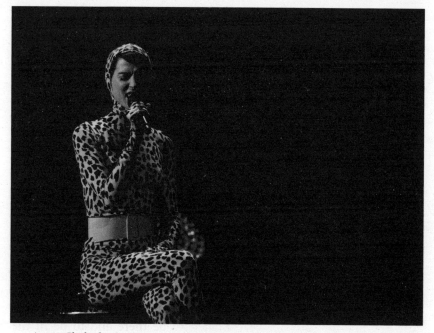

Annie Clark aka St. Vincent as catwoman, series 51, episode 3, October 2017.
(Andy Heathcote)

Maidstone and he sang 'Budapest' solo; he was just getting his start and after that the song was on the radio and everywhere and I'd seen him do it there first.

I always want to make sure that what I do is not only different from my own performances elsewhere but that they are special and specific to Jools. In 2014 for 'Prince Johnny' I stood on these white stairs and then the song ended with me rolling slowly sideways down the stairs, sprawled out; a slow roll down the stairs that ends up with my head on the ground. I was doing it on the shows on tour, but I hadn't done it on TV. I remember when I came in 2017 with my friend the piano player Thomas Bartlett to play 'New York' and 'Los Ageless' from *Masseduction*; he played in a Mexican wrestling mask and I had a leopard-spotted bodysuit, complete with hoodie. Thomas is a good sport! Television is a visual medium and I try to lean into that and have the performance and the look expound on the music and add new layers of meaning to it.

Jools being a musician makes him part of the jam and the band, not an outsider; it makes the whole construct a lot friendlier and more

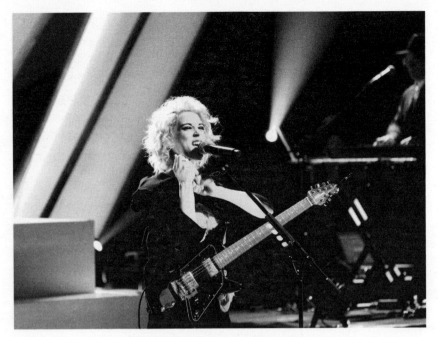

Brian Eno's watching you, you know...
Series 44, episode 5, May 2014.

inviting; he's like, 'Come on, let's all jam!' and because he's one of us, it makes the whole experience less of a strange power dynamic and more of a good hang. Oh yeah, it feels like home because unlike other late-night shows it's not all about actors with musicians getting three minutes at the end, it's only about the music. When you have other musicians in the room, you are kind of playing for the other musicians, you're trying to impress them, to have other musicians go 'Yeah! That was cool!' There's definitely a feeling of rising to the occasion and pushing yourself but I don't think it's competitive, it's more like stepping up because you want to make the other musicians in the room take notice. When I came back with the band in 2018, Kamasi Washington was also there and it was so great he'd played on my album; he's like our guy, our Sonny Rollins, and for him to come and sit in with us on *Later...* was just the coolest.

I don't know of another show that's completely about the music. There's not another show in the world that's all about showcasing new talent, and artists from all around the world at all stages of their careers, there's not another one like it. There's a sense of camaraderie and

achievement amongst the bands who come together for a *Later...* show. Being a musician is like being on a pirate ship or being a sailor out at sea. You're out there travelling the world on your own, you have your little ship with your little road family, you're going from port to port; only other musicians know what that's like. So even if you don't get to talk to somebody for very long, when you meet on Jools, you have an unspoken understanding of what this gig is, of what your lives are like, and that's a great bond that pulls everybody together and drives the show. You're in harbour for a night together.

Jools —

Such a pleasure playing the show again —

Thank you for having us & thank you for SQUEEZE !!!

xoxo

St. Vincent (A.K.A. Annie)

Old geezers up front! The *Later...* production team, Maidstone, 2018.

Acknowledgements

There are so many people to thank but first and foremost, thank you to all the artists for the music and for embracing our circle of dreams, and to all the pluggers, managers and agents for supporting the programme. The joy of booking new artists always gladdened the heart and always saddened it when there was no room left at the inn! Grateful thanks are due to the show regulars who were kind enough to share with me their memories and thoughts on the *Later...* experience – k.d. lang, Richard Thompson, Paul Weller, Björk, Alicia Keys, Nick Cave, John Grant, Baaba Maal, Gregory Porter, Ed Sheeran, Jack White, Kano, Dave Grohl and St. Vincent. Their handwritten messages come from *Later...*'s guestbook.

Although this book is told from my point of view, I hope it is clear throughout that like any television show, *Later...* has always been a collaborative effort. Jools Holland, Janet Fraser Crook and Alison Howe are everywhere in this book, and each could write their own – I hope they will! Thank you for your friendship, your passion, your patience and all the good times. So good, so good, so good!

Later... has only ever had four producers – myself, Alison and, latterly, Caroline Cullen and now Samantha Wynn who both started out on the show researching as did several excellent assistant producers including Stephanie McWhinnie, John Williams and Lori Duncan, all of whom had the doubtful pleasure of watching Alison and I 'discuss' running orders, argue over bookings and what was for dinner while bringing their own enthusiasms and skills to the table.

The studio team has remained remarkably tightknit and stable over the years and has always felt like a family. Up in the gallery, Janet had the support of script supervisors who loved the music, broke it down and noted every beat and bar: thank you to Amelia Price who was key

to establishing *Later...* in the early years, Jo Hatley, Amanda Crayden, Helena Taylor, Vikki Biram, Lisa Seabrook and Lou Johnson. Thanks also to Janet's brilliant vision mixers, notably Priscilla Hoadley, Ian Trill, Rod Wardell and Dan Winterburn.

The camera team was led by Gerry Tivers, then Eric Metcalfe and now Sophie Penwill. Together they built the show from scratch, lived with Janet in their ear and brought every shot to life. On cameras, Mark Cruickshank, Julian Penrose, Mark Marvin, Chris McCullough, Curtis Dunne, Dave Box and Dave Hitchcock. Thank you too to the watchful eyes of our many engineering managers, notably Jeremy Turner, Patrick Steel and Pete Manual.

Sound Supervisor Mike Felton understood the delicate art of mixing for television better than anyone, while making the artists welcome, ably assisted first by Dave Lee and then Tudor Davies who has now taken over the desk. They collaborated with a fantastic floor team including Jon Sweeney, Doug Prior, Chris Healey, Neil Cooper, Ian Turner, Carol Clay, Gafyn Owen and Paul Brice. Robert Harding led the John Henry's team on the monitors and PA.

Lighting Director James Campbell created the *Later...* look with a painterly eye while Chris Rigby then brought the lights into the foreground while always feeling the music. Oli Richards also rolled his eyes and tolerated my comments while always doing a sterling job. The lighting electrician team at TVC loved their music and empowered the show: thank you Gary Bryan, Trevor Crafer, Trevor Shepherd, Harry Stephenson, Gary Bacon, Mark Thaxter and Richard Harris.

Designers Sarah Greenwood, Miranda Jones, Simon Rogers and Alan Sullivan succeeded one another in giving the studio a character and a presence that only supported the music we hosted, aided by the scenery crew of Mark Osborne, Jeff Beland and Tommy Dobbs.

Antonia Castle has long been an utterly committed and ever thoughtful Stage Manager for whom nothing was ever too much, and a more than worthy successor to the equally generous Mel Carter.

Floor Managers Barrie Martin, Caroline Boocock and Sam Ribeck guided the artists and the audience through the process – from rehearsal to recording – and reassured them they were in professional and sympathetic hands, with the kind, patient and professional support of floor assistants Mandy Reed and Annabelle Fitzgerald. It is their welcome on the shop floor that has always let the musicians know they come first.

All the artists loved the calm support and subtle shadings of make-up artist Jules Francis and the iron and thread of Marianne Mercer in wardrobe.

Warm-up came from The Man with the Beard, Kevin McCarthy, his charm and dodgy jokes ably supported by his wife Rita's comforting baking.

A word too for the welcome and support of Maidstone Studios that provided a happy home for the show for five years between 2013 and 2018. Thank you, Rowland Kinch, Geoff Miles and Andy Heathcote, confidante, driver supreme and emerging photographer.

Thanks to Jools' manager Paul Loasby for managing to survive the twists and turns of the relationship between presenter and producer.

Later... has always been blessed with a brilliant editor in Perry Bellisario who also acted as father confessor to all of us over the years. Thank you Perry. Sonia Brimble managed Ace Editing with skill and kindness; thanks to the rest of the team who worked there over the years in what became a home from home for the *Later...* editorial team.

Behind the scenes, the show was blessed with a passionate and music loving Production Executive in Stephania Minici and a succession of committed and brilliant Production Managers who organised and cared for the team, ran the budget and kept everybody sane. Thank you, Tina Bolton, Jo Housden, Jo Sinkins, Jackie Lee and Vicky Singer.

Later... came out of The Late Show in Music & Arts, then BBC Music Entertainment, BBC Audio & Music and latterly BBC Studios. I had many bosses who were largely kind and trusting enough to leave me alone – my thanks to Kim Evans, Trevor Dann, Wayne Garvie, Graham Ellis and Suzy Lamb.

Later... began with the encouragement of Michael Jackson, who quickly became BBC TWO Controller. His successors continued to support the show and keep it on air so take a bow Mark Thompson, Jane Root, Roly Keating, Janice Hadlow and Patrick Holland, joined from 2005 by music commissioner Adam Kemp and then from 2009 by Jan Younghusband. Since 2014 BBC Music have also always supported the show under the stewardship of Bob Shennan, James Stirling and Lorna Clarke.

This book wouldn't have crossed the finishing line without the relent-less determination and enthusiasm of Charlie Viney at The Viney

Agency and the support at HarperCollins of Tom Killingbeck, Myles Archibald and Hazel Eriksson, who has done a meticulous and enthusiastic job overseeing the text and photographs.

Thanks to my friends Gordon Johnston, Anthony Roche, Jill Nicholls and Michael Jackson who all read a chapter or two and gave insightful encouragement. The faults are, of course, all mine.

Massive thanks to photographer Andre Csillag who came every week, occasionally subbed by Dave Cartwright, somehow avoided the cameras, and has built a priceless record of the *Later...* studio which distinguishes this book throughout.

My wife Siân Davies oversaw *Later...*'s publicity from the get-go and was ably assisted by the much-missed Kelly Pike and then Ian Wade: together they passionately nurtured the show's profile and kept us punching above our weight in the tv listings.

Sian and I have lived this journey together while our children grew up on it – love and thanks to them for their support and for sharing their love of music – Luke for Aloe Blacc, Cian for Stormzy, Evan for Hak Baker and Ceri for Jorja Smith.

As I have stressed, *Later...* has been a group effort and a family affair so many, many apologies if I haven't named you in person for your contribution, you know what you did and perhaps you are even in the photo!

Index of Artists